Magical Reels

CRITICAL STUDIES IN LATIN AMERICAN CULTURE

SERIES EDITORS:

James Dunkerley
Jean Franco
John King

This major series – the first of its kind to appear in English – is designed to map the field of contemporary Latin American culture, which has enjoyed increasing popularity in Britain and the United States in recent years.

Six titles will offer a critical introduction to twentieth-century developments in painting, poetry, music, fiction, cinema and 'popular culture'. Further volumes will explore more specialized areas of interest within the field.

The series aims to broaden the scope of criticism of Latin American culture, which tends still to extol the virtues of a few established 'master' works and to examine cultural production within the context of twentieth-century history. These clear, accessible studies are aimed at those who wish to know more about some of the most important and influential cultural works and movements of our time.

Other Titles in the Series

DRAWING THE LINE: ART AND CULTURAL IDENTITY IN CONTEMPORARY LATIN AMERICA by Oriana Baddeley and Valerie Fraser

PLOTTING WOMEN: GENDER AND REPRESENTATION IN MEXICO by Jean Franco

JOURNEYS THROUGH THE LABYRINTH: LATIN AMERICAN FICTION IN THE TWENTIETH CENTURY by Gerald Martin

Magical Reels

A History of Cinema in Latin America

JOHN KING

VERSO

London · New York

Published in association with
the Latin America Bureau

First published by Verso 1990
© John King 1990

Verso
UK: 6 Meard Street, London W1V 3HR
USA: 29 West 35th Street, New York, NY 10001-2291

Verso is the imprint of New Left Books

British Library Cataloguing in Publication Data
King, John
Magical reels : a history of cinema in Latin America. -
(Critical studies in Latin American culture).
1. Latin America cinema films, history
I. Title II. Series
791.43098

ISBN 0-86091-295-7
ISBN 0-86091-513-1pbk

US Library of Congress Cataloging-in-Publication Data
King, John, 1950-
Magical reels : a history of cinema in Latin America/John King.
p. cm. – (Critical studies in Latin American culture)
Includes bibliographical references and index.
ISBN 0-86091-295-7 (hard). – ISBN 0-86091-513-1 (paper)
1. Motion pictures – Latin America – History. I. Title.
II. Series.
PN1993.5.L3K45 1990
791.43′098–dc20

Typeset by Textflow Services Ltd
Printed in Great Britain by Biddles Ltd

In memory of
Evangelos Proestopoulos

Table of Contents

Table of Contents

Acknowledgements

I would like to thank the British Academy, the British Council and the University of Warwick for providing research grants for study in Latin America.

In a work which attempts to map the field of Latin American cinema, I have drawn on the research of dozens of scholars; they are acknowledged in the footnotes. Many people have offered help, encouragement and intellectual guidance over the years. I found the energy and enthusiasm of Don Ranvaud very stimulating in my early years at Warwick University, especially his organization of the magazine *Framework*. The scholars who attended the cinema symposium which I convened at the Americanists Conference in 1982 became friends from whom I have learned a great deal: Bob Stam, Randal Johnson, Jean Claude Bernadet, Michael Chanan, Malcolm Coad, Alberto Ruy Sánchez, Margarita de Orellana, Pedro Sarduy. Julianne Burton's and Michael Chanan's pioneering research has been essential in the formulation of my ideas. I am particularly indebted to Ana López for generously providing me with her brilliant doctoral thesis on new Latin American cinema; this will be appearing very shortly in book form. My focus is different to hers, but her study helped me in many ways in my attempt to synthesize such an unwieldy and amorphous body of work.

I would also like to express particular thanks to Carlos Monsiváis, Margo Glantz, Carlos Fuentes, Gabriel Figueroa, Luz del Amo, Luci Fernández de Alba, Tere de la Rosa, Raúl Ortiz, Elena Uribe, Zafra Films, Lita Stantic, María Luisa Bemberg, Bebe Kamin, Beatriz Sarlo, Paulina Fernández Jurado, Paulo Antonio Paranagua, Roberto Schwarz, Marcos Zurinaga, Angel Quintero Rivera, Jorge Sanjinés, Dale Carter, Callum McDonald, Nissa Torrents, Holly Aylett, Malcom Deas, Ana de Skalon, Jean Stubbs and Jackie Reiter.

I have been privileged to work with the National Film Theatre in London for a number of years and have received constant encouragement from Sheila Whitaker and, more recently, from Rosa Bosch.

Pauline Wilson at the University of Warwick transcribed several versions of this book with great dedication and accuracy. Her word-processing skills came to the rescue of the last computer illiterate in the new world of electronic signs and pulses.

Gerald Martin gave me considerable encouragement and many acute critical insights. James Dunkerley proved invaluable in keeping me to my task, steadying my nerves and offering editorial skill and a vast knowledge of historical, political and cultural developments in Latin America with great selflessness and good humour. My greatest thanks to Dimitra, once again.

John King
Warwick, March 1990

FILM STILLS used in illustration are courtesy of the following: Cineteca, Mexico City; Pelmex; Gabriel Figueroa; Embrafilme; Cinemateca do Museu de Arte Moderna, Rio; GEA Cinematográfica; Lita Stantic; Fundación Cinemateca Argentina; Workers' Film Association, Manchester; Metro Pictures.

A NOTE ON TRANSLATIONS. Where no published translation of a text is referred to, translations are my own. In the case of film titles, many Latin American films are never distributed in English. Where there is a commonly agreed translation of a film title, I have used it, but in the majority of cases, translations of the Spanish/Portuguese title are my own.

Introduction

In fact Funes remembered not only every leaf of every tree of every wood, but also every one of the times he had perceived or imagined it. He decided to reduce each of his past days to some seventy thousand memories, which would then be defined through means of ciphers. He was dissuaded from this task by two considerations: his awareness that the task was interminable, his awareness that it was useless.

Jorge Luis Borges[1]

In Jorge Luis Borges's short story 'Funes the Memorious' we are presented with a crippled young Uruguayan, blessed or cursed with total recall. He remembers everything. Funes is faced with the overwhelming problem of classification: how can the simple word 'dog', for example, embrace so many different breeds and categories? It bothered him that a dog seen at 3.14 from the side should have the same name as a dog seen at 3.15 from the front. In the end, overwhelmed by so much detail, Funes dies of pulmonary congestion. The narrator of the story, however, seems to offer some degree of hope. 'To think is to forget differences, generalize, make abstractions. In the teeming world of Funes, there were only details, almost immediate in their presence.'[2]

The story, by a famous writer who was himself an enthusiastic film-goer and outstanding critic, sounds a cautionary note to any historian ambitious or foolhardy enough to attempt to classify such a wide-ranging and amorphous subject as Latin American cinema. The critic is not blessed with total recall, but only has access to copies, memories and reconstructions. The problems of classification are also immense. Yet however simplificatory any book of this sort must be, the activity need not be seen as 'useless'. As yet, there is no study in English that analyses the different currents in Latin American cinema in the twentieth century. This work attempts to fill the gap by mapping the main contours of the field of investigation.

What are the major difficulties and limitations in such an undertaking? Film historians in Latin America are faced with the painstaking task of reconstructing

1

data from many imperfect sources. As Ana López points out in a recent study of the latest historiography,[3] very few early films have survived the ravages of history and geography. In 1982 the Cinemathèque in Mexico City burned down, consuming one of the most important collections of Mexican and Latin American cinema. The need for conservation has been recognized in recent decades, but there are few resources available and in most cases the material has already disappeared: one notable early film-maker who fell upon hard times, the Argentine Federico Valle, suffered the ignominy of having his footage melted down and recycled in a comb factory. The restoration and preservation of early prints is high on the agenda of the recently formed Latin American Film Foundation, as Gabriel García Márquez, its president, states:

> Most important is the creation of a Latin American film archive. I coined the phrase, 'we're working for oblivion': We're not achieving anything by teaching kids how to make films, if what they do doesn't last twenty years. What already exists is going to come to an end, nobody's going to remember what we did. The idea of the Foundation is to preserve this.[4]

In many cases this oblivion already exists.

Much of this early information about cinema must be gleaned from newspaper accounts, for,

> in most instances, there simply were no trade periodicals in Latin America to record for posterity business deals and strategies. Without an extensive business and legal infrastructure to produce copious paperwork, the records of long-extinct early film production companies were never preserved.[5]

Yet a number of critics have not been deterred by the practical and methodological problems incurred. This study draws, as the footnotes reveal, both from a personal viewing of early films at different cinemathèques throughout Latin America, but also from the increasingly sophisticated secondary material available.

Such work helps to break with a tendency which is very visible in English-language criticism of Latin American cinema – namely that the only films worthy of discussion have been made in the last thirty years, as part of the loosely defined 'New Cinema' movement. The earlier works tend to be left aside as a commercial, melodramatic prehistory before the dawn of modern, revolutionary consciousness. Yet an analysis of pre-1950s cinema is essential for understanding a number of important factors: the way in which industries have been set up and developed in some countries, while in others progress has been limited and achieved with great difficulty; the specific development of the internationalizing forces of global capital in the cultural sphere, in particular the Hollywood film industry; and the way in which public tastes have been formed for specific genres produced by Hollywood and also by the two major powers in Latin American

cinema: Argentina and Mexico. Above all, the analysis recognizes the very real achievements of early cinema: the directors (Mauro, Fernando de Fuentes, 'el Indio' Fernández), cinematographers (in particular Gabriel Figueroa, one of the most interesting lighting cameramen in the history of cinema) and actors (Dolores del Río, María Félix, Pedro Armendáriz, Jorge Negrete, Pedro Infante, Cantinflas, to mention just a few Mexican 'stars' who became firm favourites throughout the continent).

The cinemas of the last thirty years pose a different set of methodological problems. The prints are more readily available and are in better condition. They have also generated a much greater critical literature both within Latin America and abroad. Yet most of the literature still tends to privilege a few films, by a few directors made at a particular moment: the sixties and early seventies. This cinema, following the lead of the theoretical statements written by the film-makers themselves, has been called 'a cinema of hunger' (Glauber Rocha), an 'Imperfect Cinema' (García Espinosa) or 'a Third Cinema' (Solanas and Getino).

These polemics are clearly seminal to an understanding of developments within national cinemas and, as will be seen in Chapter 3, to an appreciation of a more global, Latin American, anti-imperialist consciousness – what has been called the 'Pan Latin American movement of cultural and ideological libera-tion'.[6] They become less useful if they are torn from history and become essential, holistic models, repositories of theoretical purity against which other films are judged in a negative fashion. The analyses of 'third cinema' made by Solanas and Getino in the late sixties explained and accompanied their extraor-dinary film *La hora de los hornos* (The Hour of the Furnaces, 1966–68). Solanas does not use the same language today. In the book that accompanies his latest film *Sur* (South, 1988) entitled *La mirada* (The Gaze), he is much more conscious of the evanescent nature of desire. In the late sixties there seemed no doubt – the revolution was imminent, Perón was a revolutionary leader. Twenty years later, after near civil war, disappearance, exile, military dictatorships, and the return of a precarious democracy – all of which completely altered the mental landscape of the sixties in Argentina – Solanas is more introspective, more cautious, more prepared to examine the nature of individual as well as collective desire. His final sentence in *La mirada* could have been taken from the Mexican Octavio Paz's utopian poetics, in particular his essay *El laberinto de la soledad* (Labyrinth of Solitude, 1950). 'Beauty and passion awaits us, the utopia of a gaze that can invent a world.'[7] It is important, therefore, that analyses of this cinema are culturally specific, and sensitive to the development of history.

For this reason, the present study prefers to keep to a country-by-country analysis in the modern period, whilst acknowledging the similarities and differences between processes in different nations. In this way it explores the rhetoric and reality of terms such as 'the new Latin American cinema', viewing the movement not as a static category, but as a dynamic, constantly changing

mosaic of influences. This focus is not a repudiation of internationalism or a hankering after some essentialist ideal of a national identity. Within each country there is a constant process of transculturation, an awareness of the hybrid nature of cultural formations.[8] It does imply, however, that the desire to collapse Latin American cultural practices into broad categories such as 'Third Cinema' or 'Third World Cinema' are at best premature and at worst misplaced. Whilst Homi Bhabha is correct to state that 'in the language of political economy, it is legitimate to represent the relations of exploitation and domination in the discursive divisions between First and Third Worlds',[9] it is still unclear whether it is possible to premise some sort of unitary aesthetic for non-American and non-European cinemas. Here Paul Willemen's critique of the most ambitious theoretician of Third Cinema, Teshome Gabriel, is appropriate:

> Gabriel's homogenization of the Third Cinema chronotope into a single aesthetic 'family' is thus premature, although the analysis of the differentiation between Euro-American cinema and its 'other' constitutes the necessary first step in this politically indispensable and urgent task of expelling the Euro-American conceptions of cinema from the centre of film history and critical theory.[10]

Latin American culture cannot be stereotyped in terms of a crude 'Third World' opposition to metropolitan discourses: it has evolved, in part, as a dialogue with the West. Octavio Paz's appreciation of Borges makes this point:

> The eccentricity of Latin America can be defined as a European eccentricity: I mean it is *another* way of being Western. A non-European way. Both inside and outside the European tradition, the Latin American can see the West as a totality and not with the fatally provincial vision of the French, the German, the English or the Italian.[11]

The study thus concentrates on the unfolding, overlapping histories of cinema in the continent. The first two chapters move from the beginnings of cinema up to the 1950s. They concentrate on Argentina, Brazil and Mexico, the only three countries that can be said to have established film industries, however precarious or lop-sided, in that period. Chapter 3 attempts a brief synthesis of historical and cultural development in the continent from the late fifties to the present, offering a framework for the subsequent chapters that deal with individual countries. The order of these country chapters tries to give a sense of a developing continental movement. Renovation in cinema occurred, almost simultaneously, in Argentina, Brazil and to a lesser extent Mexico, in the late fifties and early sixties (Chapters 4, 5 and 6). This renovation was given a new impulse and a new focus with the development of the revolution in Cuba (Chapter 7). The reforming impetus spread to Chile by the late sixties (Chapter 8). In Bolivia, the Ukamau group also sought to establish a national revolutionary cinema which could reflect the very particular dynamics of Andean culture (Chapter 9). In all these

countries, the expansive optimistic mood of the sixties gave way to more sombre realities in the seventies. As a wave of military dictatorships swept through the Southern Cone, stifling many cultural practices, in Peru, Colombia and Venezuela, state funding helped to create a temporarily vigorous film culture (Chapters 9 and 10). Though the revolutionary dreams of the sixties were stifled in the south of the continent, in Central America from the late seventies, national liberation movements fought to overthrow the local oligarchies (Chapter 11). The conclusion to the study looks at the possibilities for cinema into the 1990s.

The phrase 'magical reels' refers to two arguments that permeate the book. The first attempts to cut through the myths of utopia and dystopia which have surrounded the continent since it was originally 'named' by *conquistadores* and chroniclers in the sixteenth century, and which have their most recent incarnation in the sloppy use of the term 'magical realism' by Western critics eager to bracket and to explain away the cultural production of the region. The realities are infinitely more complex. If this study seeks to demystify, it also hopes to underscore the continual fascination with the medium that drove film-makers to produce works against the odds. Jean-Luc Godard puts it well, in a recent appreciation of Truffaut, referring to the mid fifties in France:

> In those days there still existed something called magic. A work of art was not the sign of something, it was the thing itself and nothing else (and it depended neither on a name nor on Heidegger for its existence). It was from the public that the sign would come, or not, according to its state of mind. ... What held us together as intimately as a kiss – as when we used to buy our pathetic little cigars on emerging from the Bikini cinema on Place Pigalle or the Artistic, from a film by Edgar Ulmer or Jacques Daniel-Norman (Oh Claudine Dupuis! Oh Tilda Thamar!) before going to burgle my god-mother's apartment to pay for the next day's movies – what bound us together more intimately than the false kiss in *Notorious* was the screen and nothing but the screen. It was the wall we had to scale in order to escape from our lives, and there was nothing but that wall. ...[12]

The magic of watching movies, making movies, scaling the wall or knocking down the wall – all these contradictory desires were shared by the Latin American film-makers and their publics.

Notes

1. Jorge Luis Borges, 'Funes the Memorious' in *Labyrinths*, Penguin, Harmondsworth 1970, p. 93.

2. Ibid., p. 94.

3. Ana López, 'A Short History of Latin American Film Histories', *Journal of Film and Video* XXVII, Winter 1985, pp. 55–69.

4. Gabriel García Márquez, 'Of Love and Levitation', an interview with Patricia Castaño and Holly Aylett, *Times Literary Supplement*, 20–26 October 1989, p. 1152.

5. López, 'A Short History', p. 55.

6. Ana López, 'Towards a "Third" and "Imperfect" Cinema: A Theoretical and Historical Study of Film-making in Latin America', D. Phil. thesis, University of Iowa 1986, p. 162.

7. Fernando 'Pino' Solanas, *La mirada: reflexiones sobre cine y cultura*, Puntosur, Buenos Aires 1989, p. 244.

8. See Homi K. Bhabha, 'The Commitment to Theory' in J. Pines and P. Willemen, eds, *Questions of Third Cinema,* BFI, London 1989, pp. 111–31.

9. Ibid., p. 112.

10. Paul Willemen, 'The Third Cinema Question: Notes and Reflections', in *Questions,* pp. 16–17. Gabriel's theses are to be found in his *Third Cinema in the Third World*, UMI Research Press, Ann Arbor 1982, and in *Questions of Third Cinema*. See also Roy Armes, *Third World Film Making and the West*, University of California Press, Berkeley 1987 and John D.H. Downing, ed., *Film and Politics in the Third World,* Autonomedia, New York 1986.

11. O. Paz, 'El arquero, la flecha y el blanco', *Vuelta* 117, August 1986, pp. 26–9.

12. Jean-Luc Godard, Foreword to François Truffaut, *Letters*, Faber and Faber, London 1989, pp. ix–x.

1

Rugged Features: The Silent Era

Dazzled by so many marvellous inventions, the people of Macondo did not know where their amazement began. ... They became indignant over the living images that the prosperous merchant Bruno Crespi projected in the theatre ... for a character who had died and was buried in one film and for whose misfortune tears of affliction had been shed would reappear alive and transformed into an Arab in the next one. The audience, who paid two cents apiece to share the difficulties of the actors, would not tolerate that outlandish fraud and broke up the seats. The mayor, at the urging of Bruno Crespi, explained in a proclamation that the cinema was a machine of illusions that did not merit the emotional outbursts of the audience. With that discouraging explanation many felt that they had been the victims of some new and showy gypsy business and they decided not to return to the movies, considering that they already had too many troubles of their own to weep over the acted-out misfortunes of imaginary beings.[1]

In García Márquez's novel, *One Hundred Years of Solitude,* the modern world is introduced to Macondo by Aureliano Triste through an 'innocent' yellow train which links outlying areas to the metropolis. Aureliano Triste has aspirations to become the local entrepreneur, though as a child he was marked by his success in smashing everything that he laid his hands on. He makes ice into a commodity, he opens up the village to the shock of the new: electricity, phonographs, movies. The short passage quoted above neatly encapsulates a number of points that this chapter will address. It talks of the beginnings of cinema as corresponding to the time of the incorporation of the Latin American economies into the world division of labour, on unequal terms. The train to Macondo brings not just moving images but also the forces of imperialism in the form of the banana company which would soon control the region ('Look at the mess we've got ourselves into', says one of the protagonists of the novel, 'just because we invited a gringo to eat some bananas').[2] The very technology of cinema is seen to highlight uneven development in the region: cameras, film stock, expertise all

7

came from outside, though they could be exploited by local adventurers or entrepreneurs like Bruno Crespi. They brought with them new ways of seeing, 'a machine of illusions' that could entertain, instruct or obfuscate on a massive scale, generating pleasure in its 'showy gypsy business' and/or a critical consciousness, as the audience sought to 'share the difficulty of the actors'.

Unlike the inhabitants of Macondo, who turned their back on the movies, audiences in Latin America flocked to the cinema. García Márquez who, as we shall see, is one of the major figures in contemporary Latin American cinema, has spoken of his wonder at encountering for the first time (in the early 1930s) this magical invention:

> When as a young child Colonel Nicolás Márquez took me in Aracataca to see the films of Tom Mix, my curiosity for cinema was aroused. I began, like all children then, by demanding to be taken behind the screen to discover the intestines of creation. My confusion was very great when all I saw was the same images in reverse. ... When at last I penetrated the mystery, I was tormented by the idea that cinema was a more complete means of expression than literature.[3]

Certainly it was a means of expression that spread quickly. Within months of the first Lumière projection in December 1895 in the Grand Café, Paris, Lumière cameramen were in many parts of Latin America looking for new exotic locations to film and providing the first projections. Inevitably, at first, they concentrated on the commercial, bureaucratic cities which increased dramatically in size at this time.

> Buenos Aires held 20 per cent of Argentina's population by 1930; one-third of all Uruguayans lived in Montevideo, while both Havana, Cuba and Santiago, Chile claimed 16 per cent of their national populations by 1930. ... Furthermore, between 1870 and 1930, the capital of every country increased its percentage of the national population: La Paz, Bogotá, Santiago, Mexico City and Caracas had doubled that percentage in sixty years, while Rio de Janeiro and San José fell just short of the mark.[4]

From these centres, the itinerant film-maker/projectionists could follow the tracks of the railways which, in the interest of the export economies, linked the urban metropolis to the hinterland, projecting in cafés and village halls or setting up their own tents (carpas). Throughout Latin America these early developments were very similar in different countries. A detailed analysis of cinema in Argentina, Mexico and Brazil allows these elements of similarity and difference to be charted with some precision.

Argentina

> To enter a cinema in Lavalle Street and find myself, (not without surprise) in the Gulf of Bengal or Wabash Avenue seems preferable to entering the same cinema and finding myself (not without surprise) in Lavalle Street.[5]

Jorge Luis Borges, Argentina's great man of letters, started going regularly to the cinema from the early 1920s, after an adolescence spent in Europe. He would by then have had plenty of choice. In 1930, cinema projection outlets numbered about one thousand,[6] there was a small national cottage industry and a wide range of foreign, mainly North American, features. The cinema appealed to intellectuals such as Borges but also to the flood of immigrants transforming the nature of Argentine society. When moving pictures arrived in Buenos Aires in 1896, they were received with enthusiasm by a society in the process of rapid economic and demographic growth.

The pioneers of Argentine cinema who shot short newsreels and documentaries had a wealth of detail to observe. They filmed the *estancias* (estates) and town houses of rich landowners who controlled the Argentine economy and the political system: it is estimated that at the turn of the century less than two thousand families owned an area equivalent to Italy, Holland, Belgium and Denmark put together. They witnessed the building of wide boulevards and elegant houses and offices which gave Buenos Aires the appearance of the Paris of Latin America. (The French, in fact, commented on the large numbers of Argentines who flocked to their country – the phrase 'riche comme un argentin' entered the vocabulary in the early twentieth century.) The cameramen could also go down to the bustling ports, linked to the rest of the country by railways built by the British, to the freezing plants preparing the Argentine beef served at lunch tables all over Britain. They would witness the massive tide of immigrants mainly from Southern Spain and Southern Italy: the nation's population grew from around 1,200,000 in 1852 to roughly eight million by 1914 as a result of this immigration. In 1910, three out of every four adults in the central district of the city of Buenos Aires were born in Europe. The pioneers of cinema, the itinerant showmen and cameramen came from France and in particular from Italy.

Argentina developed in the early twentieth century a highly sophisticated elite culture. The Colón opera house was opened in 1908, and attracted the world's greatest artists. A British diplomat remarked that 'it was a boast of the Argentines that not long before (1919) Caruso had been hissed for a false note at the height of his fame, and the manager had told the weeping maestro that his contract would be broken if he made another fault'.[7] In Buenos Aires, painters were to revolutionize culture in the early twentieth century, and create their own vanguard schools and *cénacles* (literary groups). There was also a strong working-class culture, as people flocked to popular melodramas and farces (the *sainete*) and to the music-hall, danced and listened to tango and subscribed to serialized novels, women's magazines and political newsletters. Cinema was to draw many of its early themes, actors and techniques from theatre and vaudeville, the popular entertainments such as French *opéra buffon*, Spanish *género chico* (comic one-act pieces) like the *zarzuela*, (operetta), North American vaudeville or the more serious drama from writers such as the brilliant Uruguayan Florencio Sánchez. Early cinema tends to look as if a camera had merely been left in row 14 of the stalls (which it often had).

Early cameramen such as Eugenio Py and Federico Valle filmed military parades, official ceremonies, rural exhibitions, walks on Sundays, naval manoeuvres. Small distribution networks run by the Casa Lepage or Max Glucksmann offered projectors and films to restaurants and cafes. In 1900, the first movie theatre, the 250-seat El Salón Nacional was established, and on 24 May 1908, the first Argentine fictional film was shown, Max Gallo's *El fusilamiento de Dorrego* (The Shooting of Dorrego) using well-known theatrical performers. A number of rudimentary historical dramas were to follow, all filmed with low budgets and artisanal painted back-cloths. Melodrama was increasingly a style in vogue, copied from the theatre and from foreign, in particular Italian, cinema.

The development of foreign cinema in Argentina and Latin America

Argentine film production supplied only a tiny percentage of films viewed in the country. Up to the First World War, the main exporters of films to Latin America were the French (Pathé, Eclair), either through branch companies or through local agents such as Max Glucksmann in Argentina, and the Italians. In 1914, Argentina imported $44,775 worth of European films and only $4,970 from North America.[8] By 1912, Italian film production dominated the world market[9] and the millions of first- and second-generation Italian immigrants in Argentina were enthusiastic followers of the costume historical dramas, melodramas, the epic last days of Pompeii, or the fall of Troy with their teeming crowd scenes, and the stylized gestures of the great divas Francesca Bertini, Pina Menichelli, Hesperia and Maria Jacobini.

These European cinemas would be displaced after 1916 by a concerted US sales drive as the industry emerged from the internecine squabbles of the 'patents war' and took advantage of the conditions created by the First World War, which disrupted European production. The big American features, *Civilization* and *Birth of a Nation,* achieved a great success in Latin America and by December 1916, the *Moving Picture World* journal could remark: 'The Yankee invasion of the Latin American film-market shows unmistakable signs of growing serious. It may before long develop into a rush as to a New Eldorado.'[10] From 1916 to 1917, Argentine import figures reveal that US cinema had almost entirely replaced its European competitors. 'It was possible for American films to achieve this dominance', writes Thomas Guback,

> because they usually were amortized in the home market, which had about half the
> world's theatres and thus could be rented abroad cheaply. Such a policy, of course,
> was a blow to foreign producers who suddenly found their own home markets
> glutted by American pictures. A result of the war, therefore, was that American
> distributors were able to gain control of the foreign field without competition. And
> by the time capital was once more available for production abroad, American films
> had obtained almost complete control of world markets.[11]

By 1926, Argentina was the second largest US market outside Europe. In 1920 Jacobo Glucksmann, who was a chief buyer for his brother Max's major import firm, could estimate that 95 per cent of screen time in South America was taken up by US films.[12] The American film industry could achieve a remarkable 'vertical' integration of production, distribution and exhibition, becoming a mature oligopoly in Tino Balio's phrase. Hollywood would create and universalize modern myths. 'Who could dare to ignore', asked Borges, 'that Charlie Chaplin is one of the most assured gods of the mythology of our time, a colleague of the immobile nightmares of di Chirico, of the fervent machine guns of Scarface, of the majestic shoulders of Greta Garbo?'[13] They would provide models against which the timid, crude national product would be judged, usually unfavourably: 'To idolize a ridiculous scarecrow because it is autochthonous, to fall asleep for the fatherland, to take pleasure in tedium because it is a national product – all seem absurd to me.'[14] Foreign cinema was big business. Max Glucksmann had offices in New York, Paris and other European capitals. He owned over fifty movie houses in Argentina, Uruguay, Paraguay and Chile.[15] In such a climate, local cinema struggled hard to survive.

Buenos Aires: city of dreams

The City of Dreams is the title of a popular Argentine film of 1922 by the tenacious José Agustín 'El Negro' Ferreyra. It is borrowed in turn from the great Nicaraguan *modernista* poet, Rubén Darío, whose dream city had always been Paris though he too had lived in Buenos Aires. Buenos Aires aspired to be the Paris of the southern hemisphere, a metropolis positioned ambiguously on the periphery of the world. And the film-makers would always suffer on the periphery of modernity despite the pomp and ceremony of the Centenario in 1910, the celebration of the hundredth anniversary of Argentine independence. They would work, as we have seen, with episodes from history, low-budget costume dramas, adaptations of literary texts, the emblems of a nationalism in evolution. Occasionally there would be successes. Enrique García Velloso filmed in 1914 an adaptation of José Mármol's literary classic *Amalia* (1852), a Manichean view of the struggle between European 'civilization' and native 'barbarism' under the nineteenth-century dictator Rosas. In 1915 Eduardo Martínez de la Pera, Ernesto Gunch and Humberto Cairo directed *Nobleza gaucha* (Gaucho Nobility) which became, exceptionally, a major box-office success, showing simultaneously in some twenty theatres. It is a simple melodramatic tale of a country girl, raped and taken by force to be the mistress of a wicked landowner, who is rescued by a noble gaucho. Yet it managed to show some incisive scenes of rural poverty and exploitation (reinforced by captions taken from the popular poem *Martín Fierro* by José Hernández, an elegy to the gaucho, and a critique of developmentalism) and it revealed something of the dialectic between town and country in Argentina. This struck a chord, the film gaining six

hundred thousand pesos on an initial outlay of two hundred thousand pesos.[16] Its success spawned several imitations, which lacked the spontaneity of the original.

Three other films from the 1910s merit brief comment since they served as precursors for later developments. Alcides Greca, an anthropologist, filmed in 1916 *El último malón* (The Last Indian Uprising), a fictionalized documentary reconstruction of an uprising that took place at the beginning of the century. This remarkable film traces the impoverished living condition of the Indian, then uses the Indians as protagonists in their own account of the earlier massacre. We are some forty years away from the work of Fernando Birri, fifty from Prelorán and Solanas and seventy from Raúl Tosso, all film-makers that would later adopt such low-budget, non-professional, ethnographic and socially responsible film-making tactics. Another film to show an immediate awareness of contemporary struggles was the Frenchman George Benoit's *Juan sin ropa* (Juan without Clothes), a dramatized account of the massacre of striking workers by the government in the 'tragic week' of 1919. The ever inventive Federico Valle was the most dynamic film-maker of the decade, producing more than a thousand newsreels and short films, most of which were lost in a fire (and a number of which were recycled by a comb factory, when Valle became bankrupt in the 1920s!). Valle had worked with Meliès, and a list of his 'firsts' includes an aerial sequence taken from a plane piloted by Wilbur Wright, work on rudimentary subtitling techniques, and the production of the world's first feature-length animated picture *El apóstol* (The Apostle) – a caustic look at the presidency of Hipólito Yrigoyen.

The twenties, which were marked by vanguard experimentation in a number of the arts,[17] saw rather modest advances in cinema. The director who defined the decade was 'El Negro' Ferreyra who, in a number of closely observed features, turned his back on the glittering centre of Buenos Aires to shape the raw materials for his fiction from the life of the *arrabales*, the suburbs or outskirts of the city. This was a reality already mythologized by popular song and literature, of the *barrio* (the neighbourhood), the *conventillo* (the working-class tenements), the tango, knife fights, persecuted innocence, evil overcome, providential destiny.

Ferreyra's *arrabales* offered innocent pictures, often of prostitutes. A European traveller in Buenos Aires, some years later, however, would give a different view of the relationship between prostitution and the movies. Norbert Jacques's lively account of dockside temptations is worth quoting in some detail.

> He came up to me and pointed across the harbour, saying 'Isla Maciel', then in internationalese, 'Cinematógrafo. Niña, deitsch, francés, englishmen, amor, dirty cinematográfico'. ... I arrived at the house with the arc light. A large inscription was written on it: 'Cinematógrafo pars hombres solo' (sic). ... The screening was in progress. It was a large hall with a gallery running around the sides. A screen hung from the ceiling. On it the cinematographic theatre played out its scenes. ... While dull pricks chased each other above, women roamed among the guests. Mostly Germans. The dregs of the world's brothels. It was all so stupid, so immeasurably

dull and absurd. ... A modern technical invention, lighting up the faces of men staring up out of the darkness, acted as a pace-maker for the cat house, shortening the agitated and nervous trail into the chambers. Men and hookers disappeared noisily and quickly up dark steps.[18]

Buenos Aires was a notorious centre of prostitution in the early part of the twentieth century, and it was clearly geared to the latest technologies. Argentine cinema at the time rose-tinted the sordid reality.

The tango lyrics for *La muchacha del arrabal* (The Girl from the *Arrabal*) of 1922, written by Ferreyra himself, capture something of the mood of this world of 'fallen angels'.

My girl/let me remember you/when there in the music-hall/drunk with sorrow, alcohol and grief/you sang happily/selling smiles/and false caresses/love songs. In this way/night after night/killing your wound/with mad excesses/of kisses and love ... you threw away your life/foreshortened by defeated/by pain and grief. ... For this reason my girl/once so good/let me cry over your pain with you/and thus in moments/of bitter laughter/we will relieve the fatal/burden of grief.

This tango, co-written by Leopoldo Torres Ríos, one of the major film-makers of the thirties, was set to music by the famous band leader Roberto Firpo and played at the opening of the film, the first time a silent film had been accompanied by a live orchestral backing. The tango, a sad song that can be danced, in Discépolo's laconic definition, provided the metaphysics for these films full of nostalgia, loss and fatalism. They capture a time, a place and a (sentimentalized) sector of society: the poor, the marginals, those left out of the liberal dream of Argentina.

Ferreyra was self-taught. His work was artisanal and often improvised: he never let his cast, which included such 'stars' as Maria Turgenova, Lidia Liss, Jorge Lafuente and Florentino Delbene, know what was to happen more than one scene in advance in order to keep their reactions fresh.[19] His work was systematically blocked by the major exhibitors, programmed for the worst times in the week, such as Monday afternoons. He was also largely ignored or vilified by the critical establishment, and spoke out on occasion against this hostility or lack of interest.

Not only has Argentine cinema been denied the direct or indirect support of the government and the press, they have remained indifferent, excessively concerned with foreign production and forgetting or ignoring perhaps that some of these countries, jealously guarding their industries, do not allow foreign films.[20]

This plea, in 1921, for government support for a fledgling industry would be repeated in various forms over the decades, in all parts of Latin America. It would not be answered until the mid forties in Argentina. The early film-makers and

their backers were in an area of extremely high risk. However, the formula first adopted by Ferreyra would become more marketable with the advent of sound, when the public could hear the plangent tones of the tango, the argot of *lunfardo* and the word-play of popular comics. Music would rescue an ailing national industry.

Mexico

> We nonetheless did not see the end of the movie because something happened unexpectedly that obliged us to flee the spot we occupied just behind the screen. Don Venustiano of course was the personage who most often appeared on the screen. His appearances, increasingly more frequent, had been becoming, as was to be expected, more and more unappreciated by the Conventionist audience. From the hissing mixed with applause on the first occasions he was seen, it progressed to frank hissing; then to hissing bordering on whistling; to open hooting and finally to bedlam. And in that way, by stages, it finally resulted, when Carranza was seen entering Mexico City on horseback, in a hellish uproar culminating in two gunshots. Both projectiles punctured the screen in the exact spot on which was outlined the First Chief's chest and they struck the wall, one half a meter above Lucio Blanco; the other, closer even, between Domínguez's head and mine.[21]

Martin Luis Guzmán's fine evocation of the revolutionary period in Mexico leaves no doubt about the enthusiasms and antagonisms created by moving pictures. Unlike in other countries in Latin America at this time, the newly developed technology could be put immediately to the service of the revolution- ary struggle. This was a war in which representation was to become important, a field of destruction, but also of perception: 'War can never break free from the magical spectacle because its very purpose is to *produce* that spectacle: to fell the enemy is not so much to capture as to "captivate" him, to instil the fear of death before he actually dies.'[22]

Pancho Villa was very conscious of the power of spectacle, and he became a filmstar during the Revolution, signing an exclusive contract with the Mutual Film Corporation. The Revolution was to offer unique opportunities to the documentary film-maker. The Brazilian critic Jean Claude Bernadet has argued that film histories tend to privilege the feature film at the expense of the documentary.[23] Such an emphasis gives a mistaken view of film production in Latin America especially in the silent era. With markets saturated in the early years by French and Italian cinema and from the 1910s by high-production-value North American movies, the work of local cineastes was confined largely to depicting what Salles Gomes has called 'the splendid cradle of nature' and the 'ritual of power':[24] the abundance of nature and the celebration of the dominant political cliques. The Revolution was, however, to shatter that ritual of Porfirian power, throwing up strange, dynamic new combinations.

The first moving images in Mexico were supplied by the indefatigable Lumière agents, and the new technologies were espoused by early Mexican impresarios who bought film-stock, cameras and developing equipment from the metropolitan suppliers. Salvador Toscano, Enrique Rosas and Carlos Mongrand were the most active of these pioneers, establishing a presence in Mexico City and venturing along the railway lines newly established by the 'modernizing' regime of Porfirio Díaz (1876–1910), the Porfiriato. These travelling shows often became integrated into vaudeville and music-hall theatres or were shown in cafés and tents. After initial resistance, which included a temporary municipal ban – the authorities considered the cinema a corrupting, low-class entertainment, the site of lascivious excess – cinema managed to establish a strong presence in Mexico City from about 1903.[25] Picturesque landscapes, the architecture of the cities, popular festivals, the movements of Díaz, his family and their entourage were all favourite themes, and there were some rudimentary fictional features. There was a slow build-up of an industry. Since Pathé did not build studios in Mexico as it did in many other countries, there was room for Mexican entrepreneurs. By 1910, most production, exhibition and distribution was in the hands of Mexicans.

The Revolution

> The reporters were there, too, the gringo newspapermen and photographers, with a new invention, the movie camera. Villa was already captivated, he did not have to be convinced a second time. He was well aware that the little machine could capture the ghost of his body if not the flesh of his soul – that belonged only to him, to his dear dead mother, and to the Revolution; his moving body ... that, yes, could be captured and set free again in a dark-room, like a Lazarus risen not from the dead but from faraway times and spaces, in a black room on a white wall, anywhere in New York or in Paris. He promised Walsh, the gringo with the camera: 'Don't worry Don Raúl. If you say the light at four in the morning is not right for your little machine, well, no problem. The executions will take place at six. But no later. Afterwards we march and fight. Understand?'[26]

From the compilation film made from the archive of Salvador Toscano, *Memorias de un mexicano* (Memories of a Mexican), there are clear images of the celebrations of the hundredth year of independence in 1910. These lavish festivities would prove to be the final celebrations of the Porfiriato as the northern liberal Francisco Madero announced a call to armed struggle in November 1910. Madero succeeded where so many others had failed in that he mobilized simmering discontent in the countryside: Emiliano Zapata led a rural revolt in the southern state of Morelos and Pancho Villa was the head of one of a number of armed uprisings in the north. Díaz resigned his power and Madero won an election in 1911. It marked the beginning of nine years of intense revolutionary struggle.

The brief liberal regime of Madero and the rebellions against his gradualist approach to change were captured by film-makers in Mexico and from abroad. As the violence escalated, there was a great demand for news from the front. The US media were particularly interested in what was happening below their southern border.

South of the border, down Mexico way

Tom Mix, García Márquez's early screen idol, fought in Cuba during the 1890s as one of Theodore Roosevelt's rough riders. He also, at the invitation of Madero, joined the Mexican Revolution and nearly got shot. After this he returned to the safety of the screens of Hollywood as an emblematic cowboy hero with an ambiguous relationship to the 'greasers', 'bandits' and 'revolutionaries' down south.

Mexico, filtered through the documentary and fictional film-makers of the 1910s, whose ideas were also filtered through the stereotypes of the dime novels of the late nineteenth and early twentieth centuries, became a constant and extremely popular presence on North American screens. The United States followed events in Mexico closely, and had a very ambiguous attitude towards successive leaders. Taft supported Madero, but a year later Woodrow Wilson played an important part in the plot of General Huerta against him. Wilson later moved against Huerta, and also Pancho Villa, helping the Constitutionalist General Carranza to defeat the revolutionary leader. Wilson then almost declared war on Carranza. The newsreel men, freelancers or those under contract from Universal and Mutual Films, would thus be forced to cut their footage to suit the policy of the day. Fictional films could themselves also be the source of conflict: one of the many *Hazards of Helen*, the popular serial, was to be abducted by libidinous Mexican bandits.

According to Mexican historian Margarita de Orellana, US feature films of the period either created or developed a series of stereotypes of the Mexican: the greaser, the beautiful señorita, the exotic Aztec.[27] The North Americans created a vision of the Revolution and of an 'other' – the Mexican people. The United States was seen as a repository of democratic values with a 'Manifest Destiny' to democratize other childlike or incapable nations. The imaginary construct of Mexico could then be plotted in terms of geography and the people. The frontier was seen as the dividing line between order and anarchy or chaos. The Mexican side was the home of the lawless and the wilful and provided a justification for North American intervention: it was a new space to be ordered, a landscape to be fashioned. The indigenous inhabitants of this landscape were depicted in the stereotype of the 'greaser': the Mexican was innately violent, irresponsible, treacherous and possessed of an uncontrollable sexual appetite. Both the bandit and the revolutionary – the terms were often interchangeable – shared these characteristics. The women were viewed differently, and put in the category of

'the beautiful señorita', a mixture of docility and sensuality; exotic, but with creole or Spanish rather than *mestizo* looks and clothes. They were innocent but passionate and often chose North Americans as companions or husbands (the reverse – a Mexican with a white woman – was an impossibility). In this way the fictional film was a blend of popular southern literature (dime novels, the Western) and the daily press and newsreel reporting of the Revolution. It reinforced and justified North American expansionism and racial and social prejudices.

The US cameramen who went to Mexico had an apprenticeship that would serve them well in the later battles of the First World War. The most enterprising took the example of journalist John Reed and rode with Pancho Villa (on trains usually, rather than horseback). Villa signed a contract with the Mutual Film Corporation and, in return for $25,000, he agreed to keep other film companies from the scene of his battles, to fight in daylight wherever possible and reconstruct scenes from the battle if satisfactory pictures were not obtained in the heat of the conflict.[28] Mutual Movies ('Make time fly') were soon proudly boasting on hoardings that they were offering films of the 'Mexican War, Made by Exclusive Contract with Gen. Villa of the REBEL Army. First reels just in and being rushed to our branch offices. These are the first moving pictures ever made at the front under special contract with the commanding general of the fighting forces.'[29] The early North American film critic Terry Ramsay recounts many anecdotes of Villa's fascination with his own self-image, and the young actor and cineaste Raoul Walsh received his training in the battlefield.[30] 'I used to get Villa to put off a lot of executions. They used to have them at four o'clock in the morning, when there was no light. I got him to put them off until seven or eight. I'd line the cameramen up, and they'd line these fellows against the wall and shoot them. The fellows on this side, they'd run in with the rocks, open the mouth and knock the gold teeth out.' [31]

The reality of the conflicts, however, in particular the bloody battle of Torreón in 1914, destroyed much of the idealism surrounding US accounts of Villa. Relations deteriorated and in March 1916, when Villa led a raid on the frontier town of Columbus, Wilson sent an expeditionary force into Mexico to hunt him down. He was to become another of that decade's screen bandits. His image, however, would continue to fascinate Hollywood, which tried many approaches to his character, from Wallace Beery to Yul Brynner.[32]

Following the caudillos, 1910–17

It was not just North American film-makers who could capture these images. Critics agree that the early years of the Revolution were a dynamic period for documentary film-makers and for the public, especially in Mexico City, which became a meeting-place for the revolutionary troops and a refuge for many internal migrants escaping the anarchy in the countryside. Some two weeks after Madero's arrival in Mexico City, forty-six theatres were programming cinema,

with a capacity of 25,000 seats.[33] 'I believe', states the major historian of the
period, Aurelio de los Reyes,

> that during the Madero regime, cinema reached its golden age. It informed the
> public, although the intention of the cameraman was not to make 'political'
> cinema. The exhibition of Mexican production did not meet with official obstacles,
> despite its depiction of political events and uprisings against the government. ... In
> the Maderista interlude, the cameramen gave more importance to the remarkable
> events unfolding than to the daily life of the city. Their films, for the first time,
> became the principal attraction of programmes. Events and *caudillos* attracted a
> widespread public which made national production profitable.[34]

He argues that the techniques of Mexican film-makers were in advance of their
North American colleagues in the 1910 to1913 period in terms of structuring a
documentary narrative, but that their technical ability had no international
resonance. The Alva brothers were the most prolific and competent of these film-
makers and their *Revolución orozquista* (Orozco's Revolution, 1912) is a good
example of their neo-positivist 'objectivity' as they scrupulously filmed the
troops of both Huerta and Orozco.

As the Revolution developed and fragmented, each of the warring leaders
took with them their own film-makers. From the few moving images that remain
and from the illustrated press, it is possible to gain a sense of the vitality of the
moment. With the overthrow of Madero in 1913, by Victoriano Huerta, however,
censorship became increasingly the norm, with the film-makers careful not to
upset whoever was in power at the time. Even though Huerta was forced to give
way to the Constitutionalist front of rebel forces led by Carranza and Villa, the
country had no respite from malnutrition, graft and banditry as the victorious
Constitutionalists fought it out amongst themselves. Carranza's faction emerged
victorious in 1917, beginning the process of revolutionary institutionalization
and stabilization which continues to the present. From this moment, cinema
would be tempted to duplicate the discourse of a growing revolutionary nation-
alism.

Dreams of the nation 1917–30

> I have seen abroad ... films that are called Mexican and in which we are presented
> to the eyes of foreigners as real savages. In the United States they are primarily
> interested in showing an uncultured Mexico, our supposed evil and viciousness,
> doing us no justice, not showing our goodness and greatness, and my task will be
> precisely to make it known abroad, by using Mexican actors, that in our country
> there are cultured people, that there are things worthy of attention and that that
> savagery, that backwardness which is used to depict us in false movies might be,
> perhaps, an accident of the revolutionary period that we have lived through, but not
> a general state of affairs.[35]

This statement of principles by Manuel de la Bandera, co-signed by Mimi Derba, the actress and film-maker, reflects a rather naive optimism that national and nationalist cinema in the aftermath of the turbulence of the Revolution, could reach a mass audience at home and abroad, correcting stereotypes and affirming the dynamism of Mexican history, the beauty of its landscape and the harmonious civic responsibility of its inhabitants. Such a transformation could probably only have occurred with massive state backing to promote a film industry. Strangely, however, the state ignored the cinema in the 1920s, except for the occasional punitive skirmish against Hollywood when stereotypes became too gross and offensive. *Her Husband's Trademark* of 1922, for example, in which Gloria Swanson is nearly raped by a gang of Mexican desperadoes, who manage to kill her husband, an innocent businessman helping with the Mexican oil economy, provoked the fury of the government, leading to a temporary embargo of all films of the Famous Players Lasky Corporation (Paramount). These pressures helped to convince Hollywood to change its images: the dashing Zorro and the guitar-strumming Cisco Kid gradually replaced the rapacious bandit. But the state placed no quotas on Hollywood cinema, which by 1925 accounted for 90 per cent of the local market. Also, importantly, the state offered no funds to promote cinema: Vasconcelos, the famous educationalist, favoured other areas of culture, in particular classical books and mural-painting.

Weak and unprotected, Mexican cinema could only lay down markers for its future development. Italian cinema offered the earliest models, with its stars and successful melodramas, but this was gradually replaced by the fresher look of Hollywood. Hollywood would also lure away thousands of Mexican extras to play bit parts in the Californian dream factories. It also recognized the exotic looks and dynamism of Dolores del Río, Ramón Novarro, Lupe Vélez, and incorporated them into the expanding star system.

Certain Mexican film-makers struggled against the odds. The remarkable Mimi Derba directed and starred in a number of films which tried to promote a positive image of Mexico: she and her colleague set up production companies with grandiloquent nationalist names such as Azteca Films, Quetzal Film or even Cuauhtémoc Films. The products, however, were in the main sentimental melodramas and did not often live up to such ringing nationalist sentiments. Crucially, they could not capture an international audience and could only maintain a toe-hold in Mexico. Their main device was to film the countryside in all its aspects, equating nationalism with the variety and 'difference' of the land. Such films tended to fall back on rather static forms of still photography rather than developing the theory and practice of images in movement.

The most interesting film of the period, *El automóvil gris* (The Grey Car, 1918) followed on the traditions of Mexican documentary realism, overlaid by North American gangster serial films.[36] Directed by Enrique Rosas, it drew on the daring raids of a gang who operated in Mexico City in 1915. Having filmed the execution of several of the gang members, Rosas embarked on a reconstruc-

tion of their notorious careers. The film makes every effort to document its fiction, including shots of the execution, hiring the detective who captured the gang to play himself, and making expressive use of the urban and rural landscape of Mexico. In the car chases, the camera is often more interested in the streets than in the dramatic tension of the chase. The film avoids the political debates generated by the robberies (it seems clear that they were abetted by high-ranking political leaders),[37] but concentrates on an agile reconstruction of the robberies and the subsequent police investigation, with good use of suspense and modern camera techniques.

In general, however, cinema failed to capture the cultural vitality of the twenties in Mexico. This was best expressed either by vanguard movements in literature and painting, or at a more popular level in the 'teatro frívolo' (variety or light entertainment theatre). In the case of women in the arts, a number – Lupe Marin, Tina Modotti, Frida Kahlo, Antonieta Rivas Mercado, María Izquierdo – could break the traditional structures left shaky by the Revolution. But these were exceptions. It is in the 'teatro frívolo', as Carlos Monsiváis and Gabriel Ramírez point out, that women's freedoms could be seen.[38] Here was a hugely popular movement in an expanding city still structured around an oral culture. The musicians and dancers showed that for some women the Revolution had not been in vain. The vitality of the precocious teenager Lupe Vélez seemed to personify the contagious new customs and new relativity ('Si me han de matar mañana, ¿que me importan la decencia y la virtud?' – 'If they have to kill me tomorrow, what use is decency and virtue?').[39] She was talent-spotted not by local producers but by a Hollywood executive who persuaded her to make the trip north. Her success was meteoric – Whoopee Lupe was soon the cry of the day in North America. Mexican cinema preferred the safer areas of family melodrama. There were a small number of distinguished features by directors such as Miguel Contreras Torres, Guillermo Calles and Manuel Ojeda, but in general Mexican cinema would have to wait until the advent of sound to make significant advances, sound that allowed the music, humour and spectacle of popular theatre to be transferred to the screen.

Brazil

The arrival of cinema in the 1890s coincided with the early years of the Brazilian Republic, a newly formed national government which was the site for power struggles among the oligarchies of the local states, which maintained considerable autonomy under the new constitution. Growing political stability, the relative strength of the primary export economy run by the coffee *fazendeiros*, the growth of export-led industrialization,[40] increased urbanization, especially of Rio and São Paulo, the improvements in urban facilities,[41] and mass immigration, all created favourable conditions for the growth of cinema. Some two

million Italian immigrants settled in the country, and it was the first-generation Italians who were to figure among the early pioneers of film distribution and exhibition. In 1897 the Segreto brothers established the first exhibition outlet for moving pictures, the Salão de Novidades.[42]

It would take nearly a decade for the new industry to develop. The building programme in the cities, undertaken by President Francisco de Paula Rodrigues Alves (1902–6) would help to eradicate disease and, in particular, lead to the widespread introduction of electricity:

If cinema did not become a Brazilian habit for approximately a decade, it was due to our underdevelopment in electricity. Once energy was industrialized in Rio de Janeiro, exhibition halls proliferated like mushrooms. The owners of these halls at first merely traded in foreign films, but soon began to produce their own, and thus, for a period of four or five years, starting in 1908, Rio experienced a flourishing of cinematic production that the period's major film historian calls the *Bela Época* of Brazilian cinema.[43]

The optimistic term Bela Época should be treated with some caution, as Randal Johnson points out:

Although precise statistics are unavailable ... and although Brazilian cinema did achieve undeniable success, it seems unlikely that even then, Brazilian cinema occupied more than a minority position in the market due to the vast numbers of foreign films imported. What was important during this period was that there existed a certain 'peaceful co-existence' between Brazilian cinema and foreign cinemas; there was plenty of exhibition time available for both foreign and national films, a situation that would not occur again for several decades.[44]

The dramatic increase in the exhibition of Brazilian films is shown in Jean Claude Bernadet's exhaustive study of the press in São Paulo. In 1908, he has twenty-one entries for Brazilian films, in 1909, sixty-three, in 1910, eighty-five, in 1911, fifty-five.[45] A breakdown of his figures show that whereas the ideal of the period might have been to make fictional films, the vast majority of film-makers worked in documentary. They could carve out a niche that international competitors were not concerned with: regional topics, football competitions, civic ceremonies, military parades, often organized into film 'journals'.[46] These documentaries reflected society's self-image, especially that of the aristocracy: its fashions, its powers, its ease and comfort in modern cities and in a spectacular rural landscape. The scenes of virgin landscape could be incorporated into this discourse of modernity, by showing the raw strength of a young developing nation, not yet prey to the decadence of Western civilization. (Western philosophers like Spengler would later give support to this view in works such as *The Decline of the West*.) These documents adopt the point of view of the aristocracy or the self-confident dependent middle classes: there are almost no records of the growing working-class, anarchist or syndicalist, presence.[47]

The producers of these early films tended to be those who had already reaped the profits of the distribution and exhibition circuits. Thus a rather shaky vertical integration was achieved from 1908 to about 1912, with local entrepreneurs such as Paschoal Segreto, Cristóvão Guilherme Auler, Guiseppe Labanca, Antonio Leal and Francisco Serrador profiting from the new conditions. One weakness in their position was their lack of unity: they tended to produce films for their own theatres and did not conceive of a 'national' industry that might help to form a pressure group in the face of foreign cinema.[48]

Soon, especially in Rio, there appeared a whole range of fictional as well as documentary films, comedies, reconstructions of notorious crimes, melodrama. Even if, as critic Maria Rita Galvão, points out, they tended to be somewhat inferior copies of foreign models, it did not much matter to the public who had not yet acquired the sophisticated expectations of higher-quality imported cinema.[49] The most popular of these genres was the crime story, the reconstruction of events already sensationalized by press accounts. Leal's *Os estranguladores* (The Stranglers, 1908) based on a recent savage crime in Rio was an early, successful example of what would become a continuing interest in Brazilian cinema: the examination of the nature of urban society, its poverty, its criminality, its outlaws. Cinema also drew on the popular traditions of vaudeville and musicals. One temporarily successful attempt to harness the popularity of music to the silent screen was the 'singing films', where duos or even whole companies sang behind the cinema screen, attempting a rudimentary synchronization.

Local cinema could only remain dynamic as an artisan industry: it was bound to fall behind the technical advances in Europe and Latin America and it could not resist the aggressive global marketing, especially of the United States, in the 1910s. The decline was swift: from 1908 to 1910, there were some eighty fictional films released. This fell to twelve in 1911, eight in 1912 and three in 1913.[50]

From 1912 or 1913, the temporary vertical integration of Brazilian cinema crumbled. Exhibitors and distributors saw clearly the profitability of Hollywood cinema and in the main turned their back on the local product. The US domination of the market followed the same course as that outlined in Argentina: in the 1920s, Brazil became Hollywood's fourth largest export market after Britain, Australia and Argentina. From the mid 1910s, the US film corporations opened branch offices in Brazil, often cutting out the local distributor. By the 1920s, they had over 80 per cent of the market share in Brazil, followed by the French with 6 per cent (European influence in Latin America was shattered by the First World War) and Brazil with 4 per cent.[51]

This 4 per cent share represents a toe-hold in the market, but the work of local producers was increasingly fragmented and decentralized, falling back on explicitly nationalist themes (costume dramas, historical romances, literary classics, regional types such as *caipiras* or 'hillbillies') in order to chase an audience whose tastes were increasingly formed by Hollywood models. One

particularly enterprising producer/director to swim against this flood was Luiz de Barros, who made some sixty features between 1914 and 1962. He tried everything, including successful adaptations of the Indianist novelist José de Alencar such as *Ubirajara* (1919) which saw the debut of Carmen Santos, an actress and film producer. (Her films of the 1920s, however, were never released and a mysterious fire destroyed the copies. A jealous husband may have been responsible.[52])

As in other countries, cinema did not benefit from the interest of the vanguard movements that helped to transform and modernize Brazilian culture in the 1920s. The 'Week of Modern Art' held in São Paulo in February 1922, which is usually taken as the beginning of modernism in Brazil, included music, plastic arts, poetry and prose readings and discussions on aesthetic theory, but very few references to cinema. The 'anthropophagous' movement, pioneered by the writer Oswald de Andrade and his companion, the painter Tarsila do Amaral (see in particular her painting of 1928 *Abaporu* 'the one who eats'), suggested that the way of dealing with cultural imperialism was through creative cannibalism, digesting and recycling foreign influences through sarcasm and parody. They could not point to immediate ways of digesting and remoulding Hollywood. Oswald de Andrade reclaimed the Tupy Indians as nationalist cannibals. His famous version of Hamlet's self-doubts, 'Tupy or not Tupy, that is the question', was not a question that film-makers could answer with any certainty. When a film journal, *Cinearte*, did appear in Brazil in the 1920s, it followed the model of US photo reviews such as *Photoplay*, trying to create a local dream factory of stars, a rather uncritical digestive process. Its image is one of hygiene, of formal elegance and correct framing,[53] rather than of desiring the undesirable.

Against this standardization, one genuinely avant-garde experimental film stands out: Mario Peixoto's *Limite* (The Boundary, 1929).[54] A boat floating in the ocean contains three strangers, two women and a man. The opening shot is of a woman chained by handcuffs and, as the narrative develops in a fragmented, indirect manner, so the images of imprisonment and limits begin to proliferate: in the workplace, in personal relationships. Robert Stam points out certain audacious features in the film:

> Imagistically the film tends towards abstraction, often recontexting objects through excentric framing and disorientingly outsized close-ups. The plastic beauty and sensuous tactile quality of the images contrasts strikingly with the structural pessimism of the film. ... The editing places identical shots in diverse syntagmatic contexts, structurally varying their meaning. Visual analogies link train wheels and sewing machines, telegraph wires and trees, a fish and a boat's prow. And the climactic tour-de-force storm sequence consists of roughly seven shots of crashing surf and eddying swirls of water, edited into a frenzy so as to suggest a tempest on the high seas.[55]

Peixoto, independently wealthy and well travelled in Europe, had material advantages but also a vision and a technical mastery uncommon in Brazil at the

time and extraordinary in one so young: he was eighteen when he began making the film. (*Limite* was voted best Brazilian film of all time in 1988, almost fifty years after it was made.)

Limite was an exception to the pattern of film-making in the late 1910s and 1920s which continued on a small scale not just in Rio and São Paulo but also in a number of regional centres. These 'regional cycles' as they have been called, took place in Minas Gerais, in particular Cataguases; Recife, in the northeast of the country (especially the pioneering work of Edson Chagas and Gentil Roiz); Campinas, in the state of São Paulo; Porto Alegre in the south, the capital of Rio Grande do Sul.

The most significant director to emerge from these regional movements was Humberto Mauro in Cataguases.[56] His early work shows the artisanal dynamism of these regional groups. Mauro began by dabbling in the new technologies, working with electricity, building loudspeakers for radios, learning the techniques of photography from the Italian immigrant Pedro Comello. Together Mauro and Comello taught themselves the techniques of making movies. In 1925 Mauro set up a group called Phebo Films and made a film *Na primavera da vida* (In The Spring of Life) using family talent: his brother as the hero who rescues Eva Nil (Comello's daughter) from a band of bootleggers. The film has subsequently disappeared, but it brought Mauro to the attention of the Rio-based critic Adhemar Gonzaga. His next feature *Thesouro perdido* (Lost Treasure), which starred himself together with his brother and his wife Lola Lys, and is modelled on the Western, won the *Cinearte* prize for the best film of the year. After this, Mauro began to hear the insistent siren call of the Rio producers and critics. Bernadet explains the dilemma:

> This tension between an urban Brazil, modern but deformed by the influence of the industrial bourgeois societies, and the *sertão* (the interior of the country), protected from these influences, is one of the structural features of Brazilian cinema. Humberto Mauro personally lived this tension ... Mauro in his Cataguases and Adhemar Gonzaga, the Rio leader of Brazilian cinema and critic of the journal *Cinearte,* who did all that he could to pluck him from the interior of Minas Gerais: 'Come here, cinema is the art of tarmac.'[57]

Mauro stood between the two influences, as his next film *Braza dormida* (Burned Out Embers, 1928) reveals. A landowner from Minas lives in Rio, but is forced to return to his country estate with a new overseer. This man falls in love with the landowner's daughter, and she is sent to Rio to avoid his amorous advances. The film comments on the tension between Cataguases and Rio as opposite poles of desire. Rio would eventually prove stronger when Mauro was asked by Adhemar Gonzaga to film the stylish *Lábios sem beijos* (Lips without Kisses, 1930). His last feature in Cataguases was only financially viable thanks to the investment of Carmen Santos, who also starred in the movie *Sangue mineiro* (Minas Blood, 1930) which once again places sophisticated characters in a love

triangle set in the interior of Minas. By this time Mauro, aided in his last two films by the splendid cinematographer Edgar Brasil, was recognized as the most accomplished and stylish director of the day.

Adhemar Gonzaga, a critic and cineaste, was the centre of film activity in the late 1920s, encouraging talents such as Mauro, Peixoto and Carmen Santos, launching a homespun star system in the photos of *Cinearte* (in particular Eva Nil, the girl from Cataguases), defending a certain nationalism based on foreign models and setting up his own production company *Cinédia*. Gonzaga greeted the arrival of sound with joy: these developments, he felt, would deal a death-blow to foreign films, drowned out by the songs and vernacular of contemporary Brazil. He ought surely to have been right; but he was wrong.

Elsewhere in Latin America

The fate of cinema in Argentina, Mexico and Brazil, which had the most dynamic urban cultures in Latin America, was repeated on a smaller scale in other parts of the continent. The stories told in a number of film histories can be synthesized briefly.[58]

The first moving images from different countries are clustered around the turn of the century, though in more remote districts the new invention took longer to penetrate. Thus we find in Venezuela 'A celebrated specialist removing teeth in the Grand Europa Hotel' and 'Boys bathing in Lake Maracaibo' (Guillermo and Manuel Trujillo Durán, 1897), 'A general fire drill' in Chile in 1902; 'An exhibition of all the famous people in Bolivia' in 1907; 'A fake fire in Cuba' in 1898, and a display of the Peruvian cavalry, 'the Peruvian centaurs' in 1911. This early phase of flickering beginnings and itinerant showmen began gradually to be replaced by a more stable commercial infrastructure, especially in the capital cities. In Cuba, by 1910, there were some two hundred established movie houses. In Bogotá, the famous Olympia theatre opened in 1912, a symbol of the modernity of new picture palaces. Local capital was involved in production and exhibition and had some limited successes. In Cuba, for example, the director Díaz Quesada entered into a consortium with two local entrepreneurs, Pablo Santos and Jesús Artigas, who owned many of the exhibition outlets on the island. Together they made the first Cuban feature film and collaborated in some nine projects in the decade of the 1920s. In other countries, even though exhibition networks developed and local businessmen fought the foreign consortia for control of distribution, local production became increasingly marginalized.

Yet a certain level of artisanal production could be maintained: everywhere there were adventurers willing to try one or two features. In Chile, in the 1920s, for example, there was quite a healthy level of film production: fifteen features were produced in 1925 and eleven in 1926. These figures were exceptional and

the norm was much lower. In an attempt to compete with the Italian divas and the Hollywood stars, film-makers turned to deliberately national and nationalist themes. In Colombia in the 1920s, for example, cinema drew on literary best-sellers, in particular Jorge Isaacs's *María,* brought to the screen in 1922, or José María Vargas Vila's *Aura o las violetas* (Aura or the Violets), filmed in 1924. In Bolivia, two films from the mid 1920s, *Corazón aymara* (Aymara Heart) and *La profecía del lago* (The Prophecy of the Lake), addressed indigenous themes, although they ran into censorship problems. In 1929 *Wara Wara* (The Stars) dealt with Indian resistance to the *conquistadores.* The best-known Chilean film of the 1920s, which was carefully restored in the 1960s, *El húsar de la muerte* (The Hussar of Death, 1925), traced the independence struggles of Manuel Rodríguez.

Film historians also point to the continuity of documentary film-making, often at a very local, regional level. As Paulo Paranagua points out, these films almost invariably adopted the point of view of their patrons – either private individuals or state bodies – and tended to offer an optimistic, sanitized view of reality. On occasion, however, the force of the images could escape the frame set by the film-makers. A documentary made for the Braden copper company in Chile in 1919 by the Italian Salvador Giambastiani shows very clearly faces marked by the grim conditions of mining; it has a number of scenes of men at work.[59] Here we are far from the 'cradle of nature', in a landscape that was to engender one of the best-organized union movements in the continent. Such images are, however, very rare.

For the most part the consolidation of North American cinema in the local market dominated exhibition, set standards of quality and created desires which local artisanal production struggled to replicate. The novelist Miguel Angel Asturias gives a vivid description of the disturbing impact of cinema in the traditional, autocratic society of Guatemala in the 1920s:

> Camila pestered her nurse to take her to the moving pictures. ... They went without her father's knowledge, biting their nails nervously and murmuring a prayer. ... Suddenly the room grew dark. Camila felt as if she were playing hide-and-seek. Everything on the screen was blurred. Figures moved around like grasshoppers. Shadowy people who seemed to be chewing as they talked, who walked in a series of jumps and whose arms moved as if they were dislocated.

The shock of the new triggers conflicting desires and memories in the adolescent girl, which cause her to hurry away from the moving pictures

> with her eyes full of tears, among a crowd who were leaving their seats and hastening through the darkness to the exits. ... And there Camila learned that the audience had left so as to avoid excommunication: a woman in a tight-fitting dress had been shown dancing the Argentine tango with a long-haired moustachioed man wearing a flowering artist's tie.[60]

North American cinema, with its hegemonic control over taste, was also a purveyor of cultural modernity, as will be explored in the following chapter. Jorge Schnitman sums up the period as follows:

> Local film entrepreneurs found it more profitable to specialize as commercial bourgeoisie than as industrial bourgeoisie, even though the commercial success of some Latin American films of the silent era indicated that the potential was there. It is clear, then, that film as an innovation found a completely different fate in the two Americas. While the US had the technical, financial and market size conditions to allow for innovation in its production, distribution and exhibition aspects, Latin American dependent capitalism could only develop its distribution and exhibition aspects on the basis of foreign films, to the detriment of local production.[61]

Local production, the artisanal experiments of scattered individuals, could find a small space in the market. The coming of sound, however, offered some advantages but also imposed crushing financial and technological burdens on local production.

Notes

1. Gabriel García Márquez, *One Hundred Years of Solitude*, Penguin, Harmondsworth 1972, p. 209.

2. Ibid., p. 189

3. Eduardo García Aguilar, *García Márquez: la tentación cinematográfica*, UNAM, Mexico 1985, pp. 103–104.

4. James R. Scobie, 'The Growth of Latin American Cities, 1870–1930' in Leslie Bethell, ed., T*he Cambridge History of Latin America*, Cambridge 1986, Vol IV, p. 248.

5. J.L. Borges, in E. Cozarinsky, ed., *Borges y el cine*, Sur, Buenos Aires 1974, p. 54.

6. Beatriz Sarlo, *Una modernidad periférica: Buenos Aires, 1920 y 1930*, Nueva Visión, Buenos Aires 1988, p. 21.

7. Sir David Kelly, *The Ruling Few*, London 1952, pp. 125–6. For a more detailed analysis of this cultural moment, see J. King, '*Sur': An Analysis of the Argentine Literary Journal and its Role in the Development of a Culture, 1931–1970*, Cambridge University Press 1986, Chapters 1 and 2.

8. Kristin Thompson, *Exporting Entertainment*, British Film Institute, London 1985, p. 76.

9. Pierre Leprohon, *The Italian Cinema*, Secker and Warburg, London 1972.

10. Quotes in Thompson, p. 79.

11. Thomas H. Guback, 'Hollywood's International Market' in T. Balio, ed., *The American Film Industry*, revised edition, University of Wisconsin Press, Wisconsin and London 1985, p. 465.

12. Thompson, p. 139.

13. J.L. Borges, 'Films', *Sur* 3, Winter 1931, quoted in Cozarinsky, p. 28.

14. J.L. Borges, 'La fuga', *Sur* 36, August 1937, quoted in Cozarinsky, p. 54.

15. Gaizka de Usabel, *The High Noon of American Films in Latin America*, UMI Research Press, Ann Arbor 1982, p. 45.

16. See José Agustín Mahieu, *Breve historia del cine argentino*, EUDEBA, Buenos Aires 1966, p. 10.

17. See Sarlo, pp. 31–67.

18. Curt Moreck, *Sittengeschichte des Kinos*, Dresden 1956, p. 180–82, quoted in Gertrude Koch, 'On Pornographic Cinema: the Body's Shadow Realm'. Paper given at the Conference of European Popular Cinema, University of Warwick, September 1989.

19. For an analysis of his work see J. Couselo, *El negro Ferreyra, un cine por instinto*, Freeland, Buenos Aires 1969.

20. Quoted in Couselo, p. 113.

21. Martin Luis Guzmán, *El águila y la serpiente* (The Eagle and the Serpent, 1928). I am using the translation of Carl Mora quoted in his book *Mexican Cinema: Reflections of a Society 1896–1980*, University of California Press, Berkeley, Los Angeles, London 1982, p. 18.

22. Paul Virilio, *War and Cinema: The Logistics of Perception*, Verso, London 1989, p. 5.

23. Jean Claude Bernadet, 'Le documentaire' in P.A. Paranagua, ed., *Le Cinéma Brésilien*, Centre Georges Pompidou, Paris 1987, p. 165.

24. Ibid., p. 165.

25. Aurelio de los Reyes, *Cine y sociedad en México 1896-1930: Vivir de sueños*, Vol 1, (1896–1920), UNAM, Mexico 1983, pp. 61–71. See also Gustavo García, *El cine mudo mexicano*, Cultura/SCP, Mexico 1982.

26. Carlos Fuentes, *The Old Gringo*, Harper and Row, New York 1985, pp. 170–71.

27. Margarita de Orellana, 'La mirada circular: intervención del cine americano en la revolución mexicana', paper given at Americanists Conference, Manchester 1982. See also her Sorbonne doctoral thesis of 1982 '"Le Regard Circulaire". Le Cinéma Americain dans la Révolution Mexicaine (1911–1917)'. Emilio Garcia Riera's fascinating study *Mexico visto por el cine extranjero, Vol 1. 1894–1940*, Era, Mexico 1987 acknowledges its important debt to de Orellana's research. See also Arthur G. Pettit, *Images of the Mexican American in Fiction and Film*, Texas University Press, Austin 1980. Allen Woll, *The Latin Image in American Film*, UCLA, Los Angeles 1977.

28. Margarita de Orellana, 'Quand Pancho Villa était vedette de cinéma', *Positif* 251, February 1982, p. 43.

29. Ibid. p. 43.

30. Terry Ramsay, *A Million and One Nights*, Simon and Schuster, New York 1926. See also Raoul Walsh, *Each Man in His Time: The Life Story of a Director* (Farrar, Straus and Giroux, New York, 1974), for a lively if historically inaccurate portrait of his time with Villa.

31. 'Kevin Brownlow on Raoul Walsh', *Film*, 49, Autumn 1967, pp. 18–19.

32. See Deborah E. Minstron, 'The Institutional Revolution: Images of the Mexican Revolution in the Cinema'. Indiana University Ph.D. 1982.

33. Moisés Viñas, Historia del cine mexicano, UNAM, Mexico 1987, pp. 27–8 and de los Reyes, *Cine y sociedad*, pp. 109–10.

34. De los Reyes, p. 122.

35. Manuel de la Bandera in *Excelsior*, 1917, quoted in Aurelio de los Reyes, *Medio siglo de cine mexicano (1896–1947)*, Trillas, Mexico 1987, p. 60.

36. For a detailed analysis of the film, sequence by sequence, see *El automóvil gris*, Cuadernos de la Cineteca Nacional, 10, Mexico 1981.

37. See Aurelio de los Reyes's discussion in his *Cine y sociedad*, pp. 175–91.

38. Carlos Monsiváis, *Escenas de pudor y liviandad*, Grijalbo, Mexico 1988, pp. 23–45. Gabriel Ramirez, *Lupe Vélez: la mexicana que escupía fuego*, Cineteca Nacional, Mexico 1986.

39. Monsiváis, p. 39.

40. W. Dean, *The Industrialization of São Paulo, 1880–1945*, Austin 1969.

41. See Scobie, pp. 233–65.

42. Vicente de Paula Araújo, *A Bela Época do cinema brasileiro*, Perspectiva, São Paulo 1976 offers the most complete study of these early moments in cinema. Randal Johnson's *The Film Industry in Brazil: Culture and the State*, University of Pittsburgh Press, Pittsburgh 1987, pp. 19–40 is the best guide in English.

43. Paulo Emilio Salles Gomes, 'Cinema: A Trajectory within Underdevelopment' in R. Johnson, R. Stam, eds, *Brazilian Cinema*, Associated University Presses, New Jersey and London 1982, p. 245.

44. Johnson, p. 27.

45. Jean Claude Bernadet, *Filmografia do cinema brasileiro 1900-1935*, Secretaria da Cultura, São Paulo 1979.

46. Jean Claude Bernadet, 'Le documentaire', in P.A. Paranagua, *Le Cinéma Brésilien*, Centre Georges Pompidou, Paris 1987, p. 165.

47. Ibid., p. 167.

48. Johnson, pp. 29–30.

49. Maria Rita Galvão, 'Le Muet' in *Le Cinéma Brésilien*, p. 53.

50. Ibid. p. 64.

51. For tables, see Johnson, pp. 36–7.

52. Elice Munerato and Maria Helena Darcy de Oliveira, 'When Women Film', in Johnson and Stam, p. 341.

53. See Ismail Xavier, *Sétima arte: um culto moderno*, Perspectiva, São Paulo 1978.

54. See Saulo Pereira de Mello, *Limite: filme de Mario Peixoto*, Funarte, Rio de Janeiro 1978.

55. Robert Stam, 'On the Margins: Brazilian Avant-Garde Cinema', in Johnson and Stam, pp. 308–309.

56. The most complete study of Mauro is that by Paulo Emilio Salles Gomes, *Humberto Mauro, Cataguases, Cinearte*, Perspectiva, São Paulo 1974.

57. Jean Claude Bernadet, 'Meandres de l'identité', in *Le Cinéma Brésilien*, p. 231.

58. See the bibliographies in G. Hennebelle, A. Gumucio Dagrón, eds, *Les Cinémas de l'Amérique latine*, Lherminier, Paris 1981 and Peter B. Schumann, *Historia del cine latinoamericano*, Legasa, Buenos Aires 1987. For a guide to the literature, see Ana López, 'A short history of Latin American film histories', *Journal of Film and Video* XXXVII, Winter 1985, pp. 55–69. One important film history, published after López's survey article is M. Chanan, *The Cuban Image*, BFI, London 1985.

59. Paulo Antonio Paranagua, *O Cinema na América Latina*, L & PM Editores, Porto Alegre 1984, p. 22.

60. Miguel Angel Asturias, *The President*, Penguin, Harmondsworth 1972, pp. 81–2. For an analysis of Asturias's use of cinema as contributing to a process of cultural modernization, see G. Martin, '*El Señor Presidente*: una lectura contextual', in R. Navas Ruiz et al., *El Señor Presidente [Edición Crítica]*. Klincksieck and Fondo de Cultura Económica, Paris and Mexico 1978, pp. C1–C11.

61. Jorge A. Schnitman, *Film Industries in Latin America: Dependency and Development*, Ablex, New Jersey 1984, p. 19.

From Sound to 'New Cinema':
1930 to the 1950s

Anyone born there [on the Pampa] who never leaves, does not know what life is
or what the world is. For that reason, when my mother took me for the first time
to the cinema – I was four years old – I thought that was where life was, it all seemed
so real to me.

Manuel Puig[1]

The coming of sound generated optimism throughout Latin America among
cineastes who were fighting a tenacious rearguard action against the Hollywood
invasion of the 1920s. Though the image could be understood everywhere, surely
language and music were specific to particular cultures? The coming of sound
also coincided with the Great Slump of the late 1920s in the United States, which
slowed down, albeit temporarily, the development of the Hollywood studios. A
space, it seemed, was opening up, a possibility to work within the interstices of
North American hegemony. That space did exist and allowed for the develop-
ment of industries in Mexico, Argentina and, to a lesser extent, in Brazil.
However, the expense and sophistication of the new technologies were too much
for most of the poorer countries, who took many years to make the conversion
to national talking pictures. And the United States recovered quickly from the
Depression, finding successful strategies to deal with the new conditions.

Hollywood in Latin America

Hollywood. ... through the work of a malign artifice called 'dubbing', proposes
monsters which combine the illustrious features of Greta Garbo with the voice of
Aldonza Lorenzo.

Jorge Luis Borges[2]

In the long run, as history would show, the advent of sound strengthened the
market position of US films abroad. The hugely increased costs entailed simply
made precarious film production in small markets even more precarious. In the

short term, however, sound threw Hollywood into some confusion. Dubbing proved an impossibility in the early years since there was no means of mixing sounds. The first, rather desperate, attempt to preserve audiences abroad was to make foreign-language versions of Hollywood films. In 1930 Paramount set up its own version of the Tower of Babel in the form of a huge studio at Joinville, in the outskirts of Paris, which had the capacity to make foreign versions in five languages. By working a twenty-four-hour schedule it increased its language capacity to twelve. The experiment, which lasted some three years, was a disaster. In 1930, thirty 'Hispanic' films were made, a figure that went up to over forty in 1931 and dwindled to fifteen in 1932. There were a number of very obvious reasons for this flop. The films were very expensive to make and could not return a profit. Audiences had acquired a taste for Hollywood stars and were extremely put out when they were replaced by unknown Spanish speakers. The problem of accent, dialect and even physiognomy was almost insurmountable: Argentines, for example, were not anxious to watch and listen to Mexicans, and would have great difficulty understanding a Cuban accent. There was some attempt to attract Latin American stars such as the great Argentine tango singer Carlos Gardel to Joinville, but these intermittent successes were exceptions. By the early 1930s, dubbing and subtitling had improved, and these were used increasingly to reach Latin America (favouring, in the main, subtitling over dubbing); by 1934, with the improvement of the economy coming out of the Depression, Hollywood had regained – or even increased in many places – its position abroad. The Motion Picture Producers and Distributors of America (MPPDA) operated effectively as a pressure group for US films abroad, seeking to maintain an 'open door' policy in the face of possible tariff, quota or exchange restrictions.

Moving pictures were part of the Roosevelt government's successful 'Good Neighbor' economic penetration of Latin America in the 1930s. They did excellent business – and could also form consumer tastes, as an American diplomat noted with ingenuous surprise:

> A group of well-dressed Argentine businessmen called on the head of a United States film company some years ago with a request. 'It may seem ridiculous', they explained, 'and you may turn us down. But we are in the men's furnishing business and the new Clark Gable film, *It Happened One Night,* is ruining our trade.' 'How?' asked the movie man. 'Well, in one scene Gable takes off his shirt to go to bed and he wears no undershirt. Now our young Argentines are refusing to buy undershirts and our business is being seriously affected.' The movie man was first amused, then astonished. If one Made-in-Hollywood film could set such a trend, what might a whole series of pictures do?[3]

The Good Neighbor policy was the US administration's strategy for defusing what they perceived as revolutionary nationalism in Latin America, not by wielding the Big Stick but by more pragmatic measures. According to Michael

Grow's analysis, it was also based on the Depression-induced need

> to restore employment, production and prosperity in a domestic US economy
> crippled by the events of 1929 and after. In the context of hemispheric foreign
> policy, this goal translated into a concerted US effort, undertaken in the face of
> direct German economic competition, to expand export markets in Latin America
> for United States industrial products, to defend and enhance the position of private
> United States investment capital in Latin America, and to maintain secure access
> to Latin American natural resources and raw materials.[4]

A more 'open-handed' approach would, it was felt, take away all the reasons for
conflict, as Secretary of State Sumner Welles optimistically concluded:

> Gone were the grounds for that bitter hostility toward the United States which had
> inevitably stemmed from this country's insistence during many generations upon
> utilizing the Monroe Doctrine to impose its will by fiat upon the weaker nations of
> the hemisphere. Gone were the reasons for the deep-rooted suspicions among the
> Latin American peoples that the great power of the North was in reality bent upon
> a policy of imperialist expansion.[5]

However utopian these observations by Welles might seem, they were based
on a very concrete reality which is of great significance to the present study. The
United States could supply the goods of the second industrial revolution, it could
satisfy the increasing demands of consumption. A contemporary observer,
Hubert Herring, puts it engagingly in his notes on Argentina.

> The typical porteño-about-town admires the same things which the North Ameri-
> can-about-town cherishes: two-car garages with cars in them, skyscrapers, fine
> shops, good neckties, good food, old Scotch, theatres, fine houses, well-dressed
> women, quiet plumbing, radios – and a bank balance which makes these things
> possible. The North American seems to have more of these. The Argentine wants
> more.[6]

At the levels both of practical and symbolic consumption, the Hollywood cinema
demonstrated, and was a product of, the modern, the new. It revealed the speed
and complexity of new technologies. It set up aspirations and desires which could
often not be satisfied as the brilliant novels of the Argentine Manuel Puig
demonstrate. Many millions all over Latin America would be seduced and
'betrayed by Rita Hayworth', to paraphrase the title of Puig's first novel.

As part of its Good Neighbor project, the United States became more
conscious of the images that it projected of Latin America. Even the stereotype
of the Latin American in Hollywood films of the time suffered some improve-
ment, as the Warner Brothers superproduction *Juárez* (1939) reveals, portraying
Juárez as an enthusiastic fan of the democratic ideas of President Lincoln.[7] The

Cisco Kid remained a debonair neighbour; Lupe Vélez, the Mexican spitfire with the broken English, was very much at home in modern New York.[8]

Yet with the outbreak of war, cultural diplomacy was seen as too important to be left to the unsupervised imaginations of movie producers. In 1940 Nelson Rockefeller set up the Office of the Coordinator of Inter-American Affairs (CIAA)[9] to orchestrate economic and cultural programmes in Latin America, as part of what Frank Ninkovich describes as a 'craze' for Pan-Americanism by the winter of 1941.[10] The CIAA policy in the cultural sphere was to invite journalists, publishers and democratic politicians to North America and send to the South materials such as films, newsprint and financial assistance. The objectives of the Communications Division of the Coordinator's officers were laid out in a memorandum by Nelson Rockefeller, addressed to the US Vice-President on 1 April 1941:

1. To offset totalitarian propaganda in other American Republics.
2. To remove and correct sources of irritation and misunderstanding arising in this country – as when our motion pictures burlesque Central and South American characters.
3. To emphasize and focus public opinion on the elements making for unity among the Americas.
4. To increase knowledge and understanding of one another's way of life.
5. To give greater expression to the forces of good will between the Americas in line with the Good Neighbor Policy.[11]

One example offered in the memorandum of the production of films 'containing characters or incidents offensive to Latin Americans' is worth quoting in full.

The Motion Picture Section of this Division has obtained the full cooperation of Hollywood to these ends. For example, just as this section began to function, one producer released an elaborate feature film entitled 'Down Argentine Way'. It was an excellent film of its kind, but examination showed the following content likely to be offensive to the people of Argentina:
1. Three Argentine business men and one Argentine government official shown in it were comedy characters;
2. The second most prominent Argentine character in it was a gigolo;
3. The only Argentine character heard speaking any Spanish spoke with an obvious Mexican accent; and
4. Finally, the whole plot revolved around an allegedly crooked race at the famous Buenos Aires Jockey Club – an institution of which Argentinians are proud.
When these objections were brought to the attention of the producer, he agreed to rephotograph those scenes at a cost of about $40,000 before releasing the picture in these countries.[12]

Among the pictures Rockefeller noted were being 'prepared and produced with special attention to authenticity and friendly feeling' was Irving Cumming's

That Night in Rio, starring Carmen Miranda and Don Ameche. After Miranda has 'chica chica boom boomed' her way across the cabaret floor, Don Ameche appears on stage dressed in a US naval uniform singing:

> My friends I send felicitations
> To our South American relations
> May we never leave behind us
> All those common ties that bind us
> One hundred and thirty million people send regards to you.

Brazil at this time was perceived as extremely important to the US hemispheric defence strategists. Vargas, the president, was being wooed with a number of blandishments (including a steel mill) in return for his cooperation in the Allied war effort.

Nelson Rockefeller sent Orson Welles as a goodwill ambassador to Brazil. The original proposal was that he should make a 'Good Neighborly' film and give some lectures. However, when he began filming in the slums and in poor remote rural communities, his studio, RKO, the Brazilian government and also Rockefeller began to doubt the wisdom of the project: Carmen Miranda and carnival was one thing, a gritty realist exposé of deprivation quite another. Everyone quietly dropped the proposal, much to Welles's chagrin:

> 'Nobody was ever more cowardly in the world than Nelson, you know', says Orson of Nelson Rockefeller. ... 'He didn't want to be near anything that was under any kind of shadow'. By the time Welles got back to the States, Rockefeller was definitely not interested in acquiring the Brazilian footage from RKO, who were trying to unload it.[13]

One very positive indirect effect of Welles's trip to Brazil for Latin American cinema was that he used the journey to escape from marriage with Dolores del Río. Rejected by the precocious genius and with her career in Hollywood in stagnation, she was ready to listen to the overtures of Emilio Fernández who persuaded her to return to Mexico in 1943. Her return and her association with Fernández and the cinematographer Gabriel Figueroa marked a turning-point in the fortunes of Mexican cinema. Walt Disney, another film ambassador, produced what Rockefeller wanted: two cartoon films, *Saludos Amigos* (1943) and *The Three Caballeros* (1945), where Donald Duck teams up with his new pals, the parrot José Carioca, symbol of Brazil, and Panchito, the pistol-clad *charro* rooster. Panchito leads the gang, 'three birds of a feather' on a folkloric jaunt through Mexico: Brazil, Mexico and the United States, all the best of friends.

One bird conspicuously absent from the party was Martin the gaucho. Argentina maintained a stubborn neutrality during the Second World War, and incurred the wrath of the State Department. The country became a particular obsession of Secretary of State Cordell Hull, who was convinced that Argentina

openly supported fascism and could harbour the possible emergence of a Fourth Reich. The United States openly mounted a campaign to overthrow the Argentine government and, as part of a packet of restrictions, denied Argentina's access to raw film stock, while simultaneously building up the film industry of Argentina's great rival, Mexico, 'to support the war effort and hemispheric solidarity'. As a result, as we shall see, Argentina could not maintain its position as the leading film producer in Latin America. Mexico, on the other hand, with US funding, entered into a very temporary 'Golden Age'.

After the war, Hollywood moved swiftly to recapture markets. In 1945, the MPPDA changed its title to the Motion Picture Association of America and gave special emphasis to its export section, the Motion Picture Export Association. The MPEA began

> to act as the sole export sales agent for its members, to set prices and terms of trade for films and to make arrangements for their distribution abroad. ... The MPEA facilitated the international activities of its members by expanding markets and keeping them open, expediting transfers of income to the United States, reducing restrictions on American films through direct negotiations and 'other appropriate means', distributing information about market conditions to members and negotiating film import agreements and rental terms.[14]

Jack Valenti, head of the MPEA, could boast that 'to my knowledge, the motion picture is the only US enterprise that negotiates on its own with foreign governments.'[15] It was against this background that Latin American film-makers struggled to build up industries in their own countries. The leaders were, once again, Argentina, Mexico and Brazil.

Argentina: From Tango to Perón

The years of relative harmony, the 1920s, were shattered by the Great Slump, a military coup in 1930 and the advent of what is known as the 'infamous decade' of Argentine history, during which a small group of conservative landowners maintained its power through falsifying elections and banning other political parties. Liberalism could no longer be equated with democratic values; new, more populist and nationalist groupings were to emerge in opposition to these governments and were to gain power under Perón in the elections of 1946. The crises of oligarchic liberalism were not reflected on the screen in these years – such analyses would come in the late 1950s, with the work of Torre Nilsson and in the 1980s with films such as María Luisa Bemberg's *Miss Mary*. What is apparent is the increasing North American influence, rapidly eroding fifty years of British hegemony. With the coming of sound, local entrepreneurs sought to duplicate, albeit in miniature, the studio systems of Hollywood, incorporating

the latest US technical advances in the field of communications. Within a short space of time, optical sound studios were built in Buenos Aires and the first films incorporated the major popular successes in other media, in particular the tango.

One of the first sound pictures produced in Argentina, directed by Eduardo Morero, featured ten songs by Carlos Gardel. Gardel was soon attracted by North American movie corporations, as we have seen, but the films he made in Paris and New York (such as *Melodía de arrabal* (Arrabal Melody, 1932), *Cuesta abajo* (Downward Slope, 1934) and *El día que me quieras* (The Day You Love Me, 1935), were to have an enormous impact in Latin America, spawning a number of similar formula films in Argentina, using the basic combination of comedy, melodrama and good songs. Gardel's popularity also clearly helped to create an audience in Argentina for sound cinema. Simon Collier points to the enormous enthusiasm Gardel could generate in Latin America. One Buenos Aires cinema cabled Paramount with the ecstatic headlines: '*Cuesta abajo* Huge Success. Delirious Public Applause Obliged Interrupt Showing Three Times to Rerun Scenes Where Gardel Sings. Such Enthusiasm Has Only Rarely Been Seen Here.'[16] Gardel, the most popular singer of the 1920s, was already a superstar before the advent of sound cinema but cinema increased his status throughout Latin America, and Argentina would later be able to export its own versions of musical comedy throughout the subcontinent.

Gardel is the most striking example of an entertainer already well known through theatre, vaudeville, records and radio (in particular radio theatre). Cinema was to draw heavily in its early days from stars, styles and genres from other media. Gardel's first film in France in 1931, for example, came out of a travelling theatre group and a travelling tango band who happened to be in Paris at the same time. The librettist of the theatre group, Manuel Romero, would later become one of the most successful film directors of the 1930s, with such films as *Mujeres que trabajan* (Working Women, 1938) and his extremely popular *Los muchachos de antes no usaban gomina* (Back Then Boys Didn't Use Hair Cream, 1937), which starred Mireya, the tart with the heart, oblivious to the advances of rich men about town. He followed this with a series of musical melodramas which often took well-known tangos as their titles, such as *Tres anclados en Paris* (Three People Anchored in Paris, 1938). Couselo, the major Argentine historian of the period, sums up the work of Romero:

At heart, they are simple anti-bourgeois films, unafraid of stereotypes, with a villain who is always a gentleman, genuine or would-be. A show-business jack-of-all-trades, Romero had a sure instinct when it came to casting: he used Sandrini and stage veterans such as Florencio Parravicini and Enrique Serrano; he took advantage of Mecha Ortiz's appeal; he discovered Nini Marshall and Hugo del Carril.[17]

Local producers soon realized the commercial potential of tango-led national cinema. Two studios were set up immediately – Argentina Sono Films and

Lumiton – and there was an investment in advanced technology and a cultivation of a homespun star system, with luminaries such as Luis Sandrini, Pepe Arias and Libertad Lamarque. In 1933, six films were produced, in 1936, sixteen, in 1937, twenty-eight and fifty in 1939. These features successfully captured a share of the Argentine and the wider Latin American market.[18] Comedies, musicals, melodrama, combined in different ways, were the staples of this period, perhaps the most successful moment of Argentine film history. The period still awaits its historian. Film criticism which developed in Latin America in the politicized sixties has too rapidly dismissed the movies of the thirties and early forties. An influential essay by Enrique Colina and Daniel Díaz Torres illustrates what has become a critical consensus:

> Commercial Argentine cinema, impregnated with the prevailing pessimism, trans-
> lated the collective sense of hopelessness into sentimental explosion, thus becom-
> ing a hindrance to the development of the people's political consciousness. Taking
> refuge in a frustrated, sceptic individualism, promoting a fatalistic vision of
> existence and offering eternal sadness as an element of the Argentine character,
> this cinema is the refuse, the excrescence of a reactionary populism. ... God,
> Fatherland and Home make up the inseparable trinity of social equilibrium in these
> films.[19]

Such a statement bears little relationship to Argentine history in the period since it seems to be taking at face value such 'essentialist' essayists of the 1930s as Scalabrini Ortiz, Martínez Estrada and Mallea with their vision of Argentine loneliness and sadness. It makes a blunt assertion of cinema as escapist false consciousness and it dismisses melodrama as failed political realism or failed tragedy. There are signs that this attitude is beginning to change – García Márquez in particular has talked of the need to make progressive *telenovelas*, melodramas of the small screen.[20] There is therefore an awareness that these forms generate pleasure and are not 'in themselves' reactionary or progressive, but can be adapted to both purposes. There has as yet been no attempt to analyse the possible radical potential of melodrama in Latin America, which is a fertile area of critical debate in studies of Hollywood cinema and British Gainsborough melodramas.[21] Even though there is a danger of adopting critical models that do not accurately reflect the conditions of Latin America – Hollywood melodrama is seen as fissuring the patriarchal cultural codes of classic cinematic realism while in Latin America, in literature and in film, there was no strong tradition of realism – these studies do at least warn us not to divide off high from low culture in such a facile way. In the early twentieth century, according to Christine Gledhill,

> the gestural rhetoric of melodramatic acting was displaced by 'naturalist' perform-
> ance styles. Tragedy and realism focused on 'serious' social issues or inner
> dilemmas. ... Sentiment and emotiveness were reduced in significance to 'senti-
> mentality' and exaggeration, domestic detail counted as trivia, melodramatic

utopianism as escapist fantasy and this total complex devalued by association with 'feminized' popular culture. Men no longer wept in public.[22]

Successful melodramas do not have to be dismissed so easily as escapist or manipulative: they can serve as points of clarification and identification. As Gledhill notes, the characters of good melodrama becomes objects of pathos because they are constructed as victims of forces that lie beyond their control and/or understanding. But pathos, unlike pity, appeals to the understanding as well as to the emotions. The audience is involved with the characters, but can exercise pity only by evaluating signs that the protagonists cannot have access to.[23] A film such as *Prisioneros de la tierra* (Prisoners of the Land, 1939) clearly uses melodrama in its ferocious critique of the conditions of near slavery existing in the maté tea plantations in the north of Argentina. It is a film which evokes pathos but also gives a very clear political analysis.

Ferreyra was perhaps the most popular film-maker of the early thirties, contributing a series of evocative portrayals of the *arrabal* such as *Calles de Buenos Aires* (Streets of Buenos Aires, 1934), and *Puente Alsina* (Alsina Bridge, 1935). In the second half of the decade, however, he found a formula: light operettas, the talents of Libertad Lamarque, tango after tango, and the slow decline of a genuine talent. Other, younger directors began to make use of the favourable conditions, working slightly against the grain of the growing commercial expectations. Luis Saslavsky's *La fuga* (The Flight, 1937) is an interesting comedy thriller, which, as Borges points out, is narrated crisply, without resorting to local colour: '*La fuga*, in contrast, flows smoothly like North American films. Buenos Aires, but Saslavsky spares us the Congress building, the Port, the Obelisk; an *estancia* in Entre Ríos, but Saslavsky spares us the horsebreaking ... the guitar duels and the very predictable gauchos.'[24] Leopoldo Torres Ríos made the stylish *La vuelta al nido* (Return to the Nest, 1938), which almost uniquely for the period turned its back on the streets of Buenos Aires and the countryside, in order to explore, slowly and minutely, with great technical complexity, the disintegration of a family relationship. It now seems a modern film: at the time the public rejected it en masse, confused by a rhythm and psychological exploration uncluttered by tangos or one-line jokes. Mario Soffici, by contrast, began to make the first recognizable anti-imperialist and socially conscious films of Argentine history, culminating in *Prisioneros de la tierra* (Prisoners of the Land, 1939) mentioned above. He based his script on several short stories by the Uruguayan naturalist writer Horacio Quiroga, and depicted the savage conditions of exploitation suffered by maté tea plantation workers in Misiones, the jungles of the north of Argentina. There is a memorable cast of characters: a young worker victimized by a brutal overseer, who takes a savage revenge, whipping the man brutally to his death in the river; a dypsomaniac doctor who murders his daughter in a fit of delirium tremens; and finally the suffocating landscape of Misiones which determines the destiny of the characters.

Argentina entered the 1940s in some style. Even the comedy of manners could find a fresh form in Mujíca's *Los martes, orquídeas* (Orchids on Tuesday, 1941) in which a father invents a romance for his melancholic daughter, Mirtha Legrand (who suffers from reading an excess of romantic literature), an invention that gradually becomes a reality. Such romances were clearly 'women's films', with women as a central protagonist, aimed at a women's audience. However, there is not yet sufficient research in Argentina to answer Mary Ann Doane's questions:

> Because the woman's film of the 1940s was directed towards a female audience, a psychoanalytically informed analysis of the terms of its address is crucial in ascertaining the place the woman is assigned as spectator within patriarchies. The question then becomes: As a discourse addressed specifically to women, what kind of viewing process does the 'woman's film' attempt to activate? A crucial unresolved issue here is the very possibility of constructing a 'female spectator'.[25]

This industrial optimism is demonstrated in the founding in 1942 of Artistas Argentinos Asociados (Associated Argentine Artists), a group of actors, writers and a director – Lucas Demare – who banded together to make two melodramatic epics on nineteenth-century topics, *La guerra gaucha* (Gaucho War, 1942) and *Pampa bárbara* (Barbarous Pampa, 1945). The achingly noble, Manichean nationalist sentiments of these films and their rather rudimentary attempts to capture the grandeur of the landscape were successful at the box-office, but they came at a moment when the mirror of liberal nationalism was shattering, offering up new, unexpected and murky reflections. The US government was about to starve the Argentine film industry of raw film stock, seriously hampering its development, and Perón was about to change the rules of the political game.

A bitter debate is still raging as to the true nature of these first Peronist governments, between 1946 and 1955. Suffice it to say that this ten-year period can be seen as a deliberate assault on the aristocratic liberal values that had guided Argentina for so many years. Peronism claimed for itself a new synthesis of democracy, nationalism, anti-imperialism and industrial development and railed against the undemocratic, dependent, Argentine oligarchy. Its basis of support rested on a heterogeneous and potentially conflictual alliance between a massive working-class vote (with Evita acting as political broker between the unions and the state), sectors of the armed forces and certain members of the traditional political parties. This populist class alliance prospered at a time of economic growth, from which all sectors could benefit, but came into crisis with the economic stagnation of the 1950s. Perón's much vaunted international 'Third Position', between the USA and Russia, capitalism and communism, was always rhetoric rather than reality, and Perón was obliged to come to terms with North American capital in the 1950s.

The period 1946 to 1955 was viewed as one of cultural obscurantism by most intellectuals and artists. Film, for example, fell under the control of the Sub-

secretariat for Information and the Press, which acted as a form of propaganda ministry, monitoring newspapers, radio broadcasts and the cinema. Perón, with his deliberately cultivated Carlos Gardel filmstar looks, and also Evita, as befitting a minor star of the radio and the cinema, were very conscious of the power of imagery; and the subsecretariat kept a close eye on the content of the movies. Because of this official censorship, few intellectuals and artists supported Perón in this period, unlike the following generation who were to commit 'parricide' in reviving Perón as a revolutionary leader. Many film critics and actors such as Luis Saslavsky, Hugo Cristensen and Libertad Lamarque went into exile, gave up cinema or adopted a strict self-censorship. In these conditions, the quality of Argentine cinema fell and there was a dramatic decline in box-office receipts.

Perón did organize the first state support for Argentine cinema. In the thirties and early forties, despite the success of Argentine films, producers still remained weak and divided and largely at the mercy of distributors and exhibitors either controlled by foreign capital, or with a strong investment in promoting North American films. Ana López details Perón's initiatives:

> Before and after becoming President in 1946, Perón promulgated state protectionism of national industries in order to strengthen the industrial development of Argentina and its position in international markets. His government sponsored various measures to protect the Argentine film industry which included the establishment of screen quotas and distribution on a percentage basis for Argentine films, state bank loans for financing film productions, a film production subsidy programme funded through a tax on admissions, and restrictions on the withdrawal of earnings from Argentina by foreign-controlled companies.[26]

Yet these measures had little effect: the USA could soon bully the government into lifting credit restrictions, exhibitors could flaunt the quotas and production money tended to be channelled into safe, non-innovative, producers. Money therefore chased mediocrity, which bred on these conditions of plenty. There were a number of honourable exceptions to this state of affairs, including distinguished films by Torres Ríos, his son Torre Nilsson, Hugo Fregonese and Hugo del Carril, but in the main, quality stagnated. The downfall of Perón in 1955 was greeted with the optimistic hope that Argentina could once again enter a period of cultural modernization.

Mexico

> Figueroa's vision of nature is like a beautiful though carnivorous orchid. One would have to list thousands of expressions ... just to capture the nature of the terror and fascination that grips us when we watch his work.
>
> Carlos Fuentes[27]

Let's show them how a Lion of San Pablo dies.

From the film *Vámonos con Pancho Villa.*[28]

I think life is melodramatic. Why shouldn't cinema imitate life?

Agustín Lara[29]

The first picture filmed in Mexico with direct sound was *Santa* in 1931, based on the famous novel of the same name by Federico Gamboa. *Santa* reveals a number of influences which were to be important to the subsequent development of cinema. The production team and the main actors had all been trained in Hollywood, though the film was supported by national capital. The director Antonio Moreno was a Spanish actor who had made his reputation north of the border. The Canadian cinematographer Alex Phillips had a great deal of experience in North American cinema and the two main actors, Lupita Tovar and Donald Reed (Ernesto Guillén), were Mexicans who had played a variety of Hispanic parts in Hollywood. North American styles and technical expertise would be alternately revered and reviled within Mexican cinema.

Secondly, the film drew very deliberately on popular music disseminated through the theatres and the radio. The most celebrated singer-composer of the period, Agustín Lara, had already mapped out the brothel as the space of exalted passions and sensibilities. 'The audiences of the twenties and thirties shuddered at (Lara's) double daring: a music of Notorious Sensuality and lyrics that exalted perversion.'[30] Of course, the prostitute is idealized, poeticized – there are few traces of the sordid reality which affected tens of thousands of women in the capital and in the provinces. For Lara, Santa, the innocent girl who is forced into prostitution due to an adolescent pecadillo, is not 'a sinner whose evil can only be cleansed by death, but rather an unfortunate woman condemned to imminent disappearance, to whom – from the blindness of his love – he asks for support and guidance.'[31] Lara would often adopt the mask of the blind pianist Hipólito, who plays in the brothels where Santa works and who burns with unrequited love and tenderness.

From this moment Lara's music and the cinema would develop a symbiotic relationship. The long sequence of 'cabaret' films which populate the screens from the thirties to the early fifties draw sustenance from Lara's lyrics and embody their desires: good women who bear the stigma of fate, weak men caught in the trap of a man-eater, rooms and brothels reeking with smoke and moral turpitude, eyes bloodshot with alcohol and grief, innocence, violent death.[32] *La mujer del puerto* (The Woman of the Port, 1933), stylishly directed by Russian emigré Arcady Boytler, firmly established the prostitute melodrama. The heroine is betrayed by her fiancé, who causes the death of her father. Bereft, she drifts into prostitution and, unwittingly, sleeps with her long-lost brother. In desperation she jumps into the sea and drowns. Andrea Palma – a Marlene Dietrich in Vera Cruz style with her deep voice, hanging cigarette and haughty

disdain – is a splendid Mexican vampire.[33] The final scenes of incestuous love reach genuine tragic status.

Another Russian film-maker was to have a major impact on early 1930s Mexican film aesthetics: Sergei Eisenstein. In the autumn of 1929, Eisenstein, his assistant Gregori Alexandrov and the cinematographer Eduard Tissé had been sent by the Russian government to Western Europe and the United States to learn the new techniques of talking pictures. After a frustrating stay in Hollywood, where he received no backing for film projects, Eisenstein travelled to Mexico in December 1930. Charlie Chaplin had put Eisenstein in contact with the writer Upton Sinclair who agreed, together with his wife, the wealthy Mary Craig Sinclair, to finance a film in Mexico. Eisenstein was given total freedom over the script and its direction, but the clause which referred to editing was left vague; in the long term, this caused major difficulties.[34] For a number of months he travelled the country and met the leading cultural figures, including Diego Rivera. He found an early image to describe the contrasts he encountered:

> Do you know what a *sarape* is? A *sarape* is a striped blanket that the Mexican Indian, the Mexican cowboy, in fact all Mexicans, wear. And the *sarape* could be the symbol of Mexico. The cultures of Mexico are also striped and full of violent contrasts: they develop together, but at the same time there is a gap of centuries between them. ... And we take as the starting-point for our film the contrasting nature of these violent colours: six episodes, different in character, with different people, animals, trees and flowers. Yet at the same time, they are united in the development of the plot, in a rhythmic and musical construction, a display of the Mexican spirit and character.[35]

These six episodes consisted of a prologue entitled *Skull* (a meditation on the Mexican's fascination with death), an untitled epilogue and four aspects of Mexican life and history: *Sandunga* (a wedding in Tehuantepec); *Maguey* (an episode of class struggle set in Porfirian times); *Fiesta* (a bull-fight in Mérida) and *Soldadera* (dealing with the Revolution of 1910).

In nine months of shooting, Eisenstein laid the basis for the film, but his work was hampered by the extreme caution of his hosts and his backers. Fifteen years later he spoke of the pressures put on him by the sponsors and also by the Mexican government.

> The group which was paying for the film was afraid, above all, of any 'radical' content in the film. Also the treatment was examined, equally meticulously, by the censors. In reply to our thesis that only an exact depiction of the class struggle in the *haciendas* could explain and make comprehensible the revolution against Porfirio Díaz in 1910, they said to us, 'Both the *hacienda* owners and their workers are Mexicans and it is not necessary to stress the antagonism between the different groups of the nation.'[36]

In the end, the film was sabotaged through a series of incidents. In November 1931, in a cable to Sinclair, Stalin declared that Eisenstein 'has lost the

confidence of his comrades in the Soviet Union'. Despite Sinclair's subsequent defence of Eisenstein in the face of Stalin's attack, it was clear that he had also become nervous about the project. The film was running dramatically over time and over budget; one of Eisenstein's North American 'minders', Hunter Kimborough, accused him of salacious behaviour; and the Mexican government was clearly apprehensive that an expected folkloric paean to Mexican culture was threatening to expose the reality behind the official revolutionary rhetoric.

Faced with all these pressures, Sinclair abandoned Eisenstein. He gave him no more money, denied him access to the editing tables of Hollywood and did not send the rushes out to the Soviet Union when Eisenstein returned to make his uneasy peace with Stalin. Instead, the footage was sold off to different directors – Sol Lesser, Marie Seaton and Grigori Alexandrov – who made their own, extremely limited, films from the material. The only way to capture some idea of Eisenstein's intentions is to see the rushes, edited consecutively – the British Film Institute has some five hours of these – and to read Eisenstein's own shooting scripts. The legacy for Mexican cinema was to be an assimilation of the 'painterly' aspects of Eisenstein's work, which became accessible mainly through stills published in different magazines: the architecture of the landscape, the maguey plants, the extraordinary skies, the noble hieratic people, an emblematic nationalism. The radical potential was largely ignored.

One further foreign traveller instrumental in developing the aesthetics of Mexican nationalism was the photographer Paul Strand, who was invited to work on a documentary to be funded by the Secretariat of Public Education, run by the progressive Narciso Bassols. He was committed to rural education and viewed cinema as an important tool in this endeavour. Strand and the young Austrian director Fred Zinnemann collaborated with the Mexican Gómez Muriel in *Redes* (Nets, 1934) a film focused on the struggle of Vera Cruz fishermen against exploitation. It argues for collectivization, one of the few instances of a socially progressive cinema in the 1930s. It also assimilated some of Eisenstein's lessons in terms of filming landscape, although this was filtered through Strand's very particular vision. Eisenstein and Strand were to influence greatly the works of the 1940s film-maker 'El Indio' Fernández, and the cinematographer Gabriel Figueroa.

> Paul Strand, the American who shot *Redes*, captured those elements of beauty in the lives of the fishermen who were both harmoniously in tune with nature and with the dignity of their work. ... In the end it was Paul Strand who became the forerunner of the most notorious aesthetic of Mexican cinema, with its correspondences between the physiognomy of landscape and natural landscape, and the changes that these inspire in everyday life.[37]

By 1934, the fledgling Mexican film industry was showing signs of vitality, producing over twenty films a year. It had also revealed one exceptional film-maker, Fernando de Fuentes, who directed eleven films between 1932 and 1936.

Unlike a contemporary, Ramón Peón, who could turn out mediocrity at an amazing speed, de Fuentes's films are major contributions to the medium.[38] A trilogy of films focus on the development of the Mexican Revolution, *El prisionero trece* (Prisoner Number Thirteen, 1933), *El compadre Mendoza* (Godfather Mendoza, 1933) and *Vámonos con Pancho Villa* (Let's Go with Pancho Villa, 1935). The vision is bleak. In *El prisionero*, in a plot structured according to the conventions of classical tragedy, an unscrupulous military leader is forced, through a series of complex circumstances, to order the death of his own son. Censorship enforced an unfortunate 'happy ending' – the general wakes up sweating, relieved that it had been just a nightmare – but this does not detract from the film's sombre power. *El compadre Mendoza*, directed in the same year, examines the corrupted ideals of the Revolution. An opportunistic landowner is faced with the dilemma of remaining loyal to a kinsman, a general in Zapata's army (this character is clearly modelled on Zapata, in particular his looks), and thereby facing economic ruin, or betraying his friendship and saving his own skin. (The moral issues confronted in the protagonist's choices were to be reworked, some thirty years later, by de Fuentes's nephew, Carlos Fuentes, in *The Death of Artemio Cruz*, an equally bleak vision of a chameleon whose choices (which betray other people) lead to his own political advancement but cause his moral disintegration.) In *El compadre*, there is a nuanced analysis of the tensions involved which eschews Manichean simplifications. The Zapatista evokes our sympathy in particular in his pure, unstated, impossible love for Mendoza's wife, and there is a clear rejection of the corruption of the *Huertistas* and the opportunism of the *Carranzistas*, who make Mendoza the offer that he agonizes over, but in the end cannot refuse. Mendoza, under the mute, accusing gaze of his housekeeper, chooses to preserve his *hacienda*, but in the end he drives away in anguished fury, to be haunted forever by the sight of his *compadre*, hanged by Carranza's forces at the entrance to the estate.

The view of the Revolution in *Vámonos con Pancho Villa* is equally sombre: riding with Pancho Villa leads to death and disillusionment. By 1935, de Fuentes had access to major funding. The new reformist president, Lázaro Cárdenas, anxious to develop nationalist sentiment, provided funds for the building of studios which de Fuentes used (CLASA studios), donated army regiments as extras and laid on a train, which became one of the structuring features of the narrative. However, de Fuentes was not to produce a panegyric for the revolutionary process. His analysis was similar to the novelists of the Mexican Revolution, in particular to that of Mariano Azuela in *Los de abajo* (The Underdogs, 1916): the Revolution generated noble sentiments and cataclysmic activity, but in the end developed into anarchy, stagnation and corruption. A band of friends, the Lions of San Pablo, decide to join up with the forces of Pancho Villa. Several die heroic but meaningless deaths, while the last three enter Villa's elite cadre, *los dorados* (The Golden Ones). One is wounded and kills himself after a version of Russian roulette: a loaded rifle is thrown into the air, landing

in a circle of soldiers and firing, supposedly, on the most cowardly. This theme of blind fatalism is continued when the youngest Lion dies of smallpox and the last remaining friend Tiburcio is forbidden to continue in the army, for fear of contamination. Disillusioned, Tiburcio – magnificently played by Antonio Frausto, who was also the Zapatista general in *El compadre Mendoza* – walks away along the railway tracks, tracks which earlier had sent combatants speeding the length and breadth of the country in a creative cavalcade.

El compadre Mendoza and *Vámonos con Pancho Villa* are de Fuentes's most complex works. The film for which he is best known, however, and which broke all box-office records, established Mexican cinema in the Latin American market and spawned innumerable sequels is *Allá en el Rancho Grande* (Out on the Big Ranch, 1936). The image of the singing *charro,* the emblem of Mexican virility, was at one level clearly a reworking of Roy Rogers and Gene Autry films. But the film is more complex than a mere imitation of Hollywood's singing cowboys. It drew on established popular culture, the *canción ranchera*, and helped to transform this song form into part of a very successful culture industry, an industry that would later prostitute the form, tearing it away from any authentic traditions. Song became an essential part of national cinema, the sentimental underpinning which linked scenes together and gave greater weight to specific situations. Singing stars – in this film Tito Guízar and in later *comedias rancheras* Jorge Negrete – became popular all over the continent. An image of Mexico was created, in Monsiváis's terms, which delighted Mexican moviegoers,

> who knew that what they were watching wasn't Mexico, but maybe only what it could or should have been, recognizable in physical details but unrecognizable in psychological terms, with a repertoire which would become classic: self-sufficient *haciendas,* statuesque *charros, jaripeos* (horse shows), minimal evil and maximum nobility, song duels that prove the musical nature of consciousness, the innocence personified in rural wisdom.[39]

The paternalist feudalism of the film, with its cast of honest landowners and noble workers, harked back to a time before the Revolution, when God was in heaven and benevolent firm fathers such as Porfirio Díaz were in control and everyone else knew their place. It is a clear reaction against the radical impulses of the regime of Lázaro Cárdenas (1934–40), who made one of his main priorities the developemt of agrarian reform and the establishment of the *ejido* (a form of collective land ownership and use). This was the time when the feudal *hacienda* was being dismantled, although efficient landlords were not expropriated, but even encouraged by the government. It was the moment of the strengthening of organized labour and its incorporation into the government's structure. In 1938, Cárdenas signed a decree to expropriate foreign oil companies. This radical nationalist was instrumental in strengthening both the economy and the structures of the state, but he was perceived by many, including de Fuentes, as a

dangerous militant, (hence the reactionary thrust of *Allá en el Rancho Grande*[40]). Similar reactionary nostalgia would be found three years later in Juan Bustillo Oro's *En tiempos de don Porfirio* (In the Times of Don Porfirio, 1939).

Yet the film was enormously successful. Its young cinematographer Gabriel Figueroa received the accolade of a prize at the Venice Film Festival. More importantly to the fledgling industry, it made a lot of money abroad. Perhaps for this reason the Mexican state was prepared to tolerate its feudal, anti-revolutionary sentiment, adapted intact in the dozens of subsequent *comedias rancheras*. In 1938, the film industry was the second largest industry in the country after oil; the *comedia ranchera* formula established Mexico as the major exporter of films between Latin American countries.[41] It was also well received in Franco's Spain.

Throughout the 1930s, therefore, the industry gained in strength. In 1934 it was still shaky: there were some sixteen production companies, but only three or four produced more than one film. In 1935, twenty-five films were produced, in 1937, thirty-eight and in 1938, fifty-seven. After the economic crisis caused by the oil expropriation and by a glut of formula films, production dropped at the turn of the decade. Yet the figure of fifty-seven films, which represented 14.8 per cent of the home market share (compared with the United States figure of 67.7 per cent), showed the capacity of the industry, which was to receive a further boost during the Second World War. The Cárdenas regime provided money for private producers, a practice that was to be continued under Manuel Avila Camacho in the next presidential term (1940–46). These private producers invested in a cinema based on successful genres: singing *charros*, long-suffering mothers (director Juan Orol in particular), and successful comics and musicals drawing directly from the tradition of variety theatre (the comedian Cantinflas made his first film in 1937). The so-called Golden Age of 1941 to 1945 rested on these solid popular bases.

The 'Golden Age' of Mexican cinema

The success of Mexican cinema in the 1940s was due to a series of circumstances: the added commercial opportunities offered by the war, the emergence of a number of important directors and cinematographers and the consolidation of a star system resting on proven formulae. As mentioned above, the diminution of Hollywood's exports during the war, the decline of Argentine cinema due to US hostility, and the financial support given to Mexican cinema through Rockefeller's Coordinator's Office all offered the industry unique opportunities. In 1942, the Banco Cinematográfico was set up, supported by private capital but with guarantees from official bodies such as the Banco de México. The closed-shop union structures which were later to strangle the industry of new talent were evolved in these years.

The group that established the 'image' for the decade was the director Emilio 'El Indio' Fernández, cinematographer Gabriel Figueroa and the actors Dolores

del Río and Pedro Armendáriz. 'El Indio' had first been glimpsed on Mexican screens dancing in *Allá en el Rancho Grande*. He was to become the stuff of legend, a great part of it self-created.[42] In later life, after being blocked by the industry in the mid 1950s, he made the famous Louis XIV statement, 'El cine mexicano soy yo' ('I am Mexican cinema'). His hyperbole contained much truth, for in the 1940s his work encapsulated the 'national' in Mexican cinema:

> Languid *maguey* plants, crepuscular love in the banks of the river, *charros* more macho than those in *Allá en el Rancho Grande*. ... All that seemed to characterize the 'national' was dramatized in the films of El Indio, making up the cinematographic image of a nation.[43]

This statement is correct, but it is difficult to concur with critic Alberto Ruy Sánchez's analysis (one shared by many critics) that 'El Indio' was merely a noble savage who impressed European audiences for a few years, but can now only be viewed in a museum of ethnography. Several of the films of the 1940s are among the most impressive in the history of Mexican cinema and the cinematographer Gabriel Figueroa is now correctly appreciated as a truly original talent.[44]

It is necessary to look behind the stereotypical figure which the films of Sam Peckinpah helped to fix when 'El Indio' developed his career as an actor: the brutish womanizing sadist (see the mad General Mapache in *The Wild Bunch*, 1969) or the vindictive patriarch in *Bring Me the Head of Alfredo Garcia* (1974), and to examine his visionary, mystical exposition of Mexican history and landscape in films such as *Flor silvestre* (Wild Flower, 1943) and *María Candelaria* (1943). Carlos Monsiváis has the exact phrase for these works, '*autos sacramentales* of Mexicanness', offering not realism, but rather lofty visions of courage, the grandeur of the land, machismo, and the feminine spirit.[45] He was Mexico's John Ford. Figueroa's eloquent photography captures, in allegorical fashion, the moment of Adam and Eve in the garden of Mexico, the expressive physiognomies of the main characters which harmonize with the expressive nature of the landscape; its lowering clouds, the emblematic plants, the play of light and dark, the shadows cast by the heat of the sun. Mexico, for Fernández, is elemental, atavistic, the site of primal passions and violence, from which can be forged a new progressive nation.

The face of the woman in the work of 'El Indio' – a face which depicted moral and physical perfection – was that of Dolores del Río who, in 1943, succumbed to the blandishments of the Mexican film industry in an attempt to revive her waning acting career. In Hollywood from 1925 to 1942 she had appeared in twenty-eight films as the instinctual savage who could be tamed by love and Western culture or as the more distant exotic beauty. She had star appeal but this was beginning to fade by the early forties. 'El Indio' Fernández persuaded her to play a humble Mexican girl in *Flor silvestre*. The muralist Diego Rivera hinted

that this would do her international reputation no harm; according to 'El Indio's' daughter, Adela, Rivera said, 'You have an excellent opportunity to play in a film which is so Mexican, for the Europeans are rediscovering Mexico and are attracted by all the mysteries contained here. Mexico is called a country of many fascinations.'[46] For whatever reason, the Hollywood legend became a humble peasant girl who falls in love with the landowner's son and marries him in secret against the wishes of his despotic parents. With the outbreak of the Revolution, the son's father is killed, and he takes his vengeance on the revolutionaries. His wife and child are held as hostages and Juan delivers himself to the firing squad, where his wife faints over his dead body. Such were the catacylsmic moments that forged the modern nation: in the final frames mother and daughter, many years later, look over the lands which were once the *hacienda* and are now owned collectively. A bald plot synopsis seems to suggest a conventional melodrama but 'El Indio' carries it off with gusto while his Edenic couple, Dolores del Río and Pedro Armendáriz, convey tragedy in their stoic faces, a dialogue of eloquent glances.

The same structure of a morally and physically perfect couple thrown into the maelstrom of change is found in *María Candelaria*, the film that made Figueroa's international reputation, with its fable of an indigenous woman stigmatized by her community as a prostitute even though she is innocent. The film has many lyrical moments, especially in its depiction of bucolic Indian life and in the final funereal scene, when the body of María Candelaria, surrounded by flowers, is placed in a canoe and launched onto the canals at Xochimilco. In these films and in later work, Fernández and Figueroa created a 'Mexican aesthetic' through the emblematic use of their screen stars. Dolores del Río was also to work with the directors Alejandro Galindo and Roberto Gavaldón, who gave her the opportunity to move outside the straitjacket of Fernández's lyrical–nationalist vision.

The other major star of the period was María Félix. Unlike her famous contemporaries Lupe Vélez – who never returned to the Mexican film industry, remaining as Hollywood's 'Mexican Spitfire' ('once a fiery hot *tamale*, always a fiery hot *tamale*', in the critic Gabriel Ramírez's felicitous aphorism[47]) – and Dolores del Río, Félix did not have a Hollywood career. She came to personify the figure of 'a strong woman'. Carlos Fuentes, who wrote about her in his short novella *Holy Place* said: 'She was an independent woman in a country where women over the centuries were destined to be nuns or whores. She presented herself as an independent woman, who owned her own body.'[48] She came to play in a number of films whose titles reveal her persona: *Doña Bárbara, Maclovia, La mujer de todos* (Everyone's Woman), *La devoradora* (The Devourer), *La bandida* (The Bandit), *La generala* (The General). After a provincial education and an unsuccessful marriage, she was talent-spotted in the street by director Fernando Palacios and had an impressive début in *El peñon de las ánimas* (The Crag of the Spirits, 1942), playing alongside the already famous Jorge Negrete. In her third film, *Doña Bárbara,* 1943, directed by Fernando de Fuentes, she

became a star. *Doña Bárbara,* based on the famous twenties novel by the Venezuelan Rómulo Gallegos (who helped on the script and approved the choice of actress), gave Félix the image that she would repeat, with variations, over the next decade: the haughty, self-contained woman, the 'devourer of men'. Here was the antithesis on the screen to the 'Santas' of the 1930s and 1940s, women who suffered in silence, without reproach: the parts given to Dolores del Río by Fernández. Her well-publicized *amours* with Negrete and Agustín Lara (who wrote the best-selling 'María bonita' in her honour and sang it on a white piano which contained the inscription 'On this piano I will play only my most beautiful melodies for the most beautiful woman in the world'), not to mention the Mexican president Miguel Alemán, added weight to her legendary status on and off the screen.

Even such a shrew could be tamed in the vision of 'El Indio', who reworked Shakespeare in *Enamorada* (In Love, 1947), the story of the fiery relationship between a wealthy conservative young woman and a revolutionary general. Jean Franco delineates the terms of the debate: 'Beatriz ... is "masculinized" because of the power of her class position and her own independent and proud nature. The narrative therefore must restore the balance by affirming the General's masculinity and subduing the "virile" female.' It manages this resolution by showing 'how militant conservative women can be won over by a post-revolutionary regime that has left the violent past behind.'[49] The freedoms of María Félix's haughty characters are ultimately circumscribed by the strictures of the paternalist state which is personified in a series of male roles, from Pedro Armendáriz's lyric power, to the ebullient machismo of Jorge Negrete to the more humanized macho characters personified by Pedro Infante in a series of 1940s films such as *Nosotros, los pobres* (We The Poor, 1947) and *La oveja negra* (The Black Sheep, 1949), directed by Ismael Rodríguez.[50]

Outside the orbit of the gods and goddesses of Mexican cinema, can be found the comedians, in particular Cantinflas and Tin Tan (Germán Valdez). Cantinflas was the 'logo' of the Mexico 1986 World Cup: T-shirts, mugs and cigarette lighters all bore the emblem of the leering comedian. Today the superstar still has audiences rolling in the aisles, though the cutting edge of his humour has gone. Viewing his current, tired, formulaic comedies it is difficult to imagine that fifty years previously Cantinflas was a genuine original, the best comedian (pace Oscarito in Brazil) in Latin America, with an appeal that transcended that continent's national boundaries. His origins, as Mariano Moreno, were in the popular entertainments of the *carpas* (tents), where he began as a dancer, a tumbler and a comedian. Gradually it was his comic talent that gave him fame, in particular his use of 'nonsense' language (almost completely untranslatable). With his greasy shirt, crumpled sagging trousers and large scuffed shoes, he is the *pelado,* the scruffy street-wise *pícaro* who deflates the pomposity of political and legal rhetoric. In *Ahí está el detalle* (There's the Detail, 1940), in a final court scene, he so disrupts the proceedings that the judge and the officials end up using

the same nonsense language. The *cantinflismo* is a mode of speech where, delivered at breakneck speed, words go in desperate search of meaning.[51] In his best films, in a series of guises – the *pelado*, the inefficient policeman – he ridiculed the pomposity of the middle classes from a popular standpoint, showing the possibility of vernacular speech as a force of subversion.

Another comedian from the *carpa* circuit, Tin Tan, offered a different image of the Mexican. His Mexican-American *pachuco*, the zoot-suited, upwardly mobile con man, could talk and dance his way out of any difficult situation in a mixture of Spanglish idioms and border-music rhythms. The *pachuco* image had to be modified to suit the popular taste of the time, but the origins of Tin Tan – the border towns such as Ciudad Juárez, the mass migrations (legal and illegal) across the border, the Americanization of Mexican culture – were all to become an irreversible part of the Mexican experience. In *El rey del barrio* (The King of the Neighbourhood, 1949), his most memorable film, the verbal patter is exhilarating as are the spectacular dance routines with Tongolele (Yolanda Montes).

Such films were set either in an idealized rural landscape – for instance the Jalisco of Jorge Negrete's *Ay Jalisco no te rajes* (Oh Jalisco, Don't Give Up, 1941) – or in the *barrios* of the capital city. Some directors did attempt to move beyond the stereotypes which were circulating with such success and tried to show the social tensions thrown up by a society going through rapid economic change. Under the presidencies of Manuel Avila Camacho (1940–46) and Miguel Alemán (1946–52), political stability was achieved in conjunction with rapid industrialization:

> Close collaboration with the American war effort stimulated growth and in subsequent decades industrial production continued to boom, affording healthy (and lightly taxed) profits to both foreign and Mexican businesses, and enabling the manufacturing sector to usurp the leading role once held by mining. But while GDP grew fivefold in the twenty-five years after 1940 (and population doubled), agriculture boosted its output fourfold, thus benefiting the balance of payments and keeping industry's labour costs low.[52]

In *Distinto amanecer* (A Different Dawn, 1943), Julio Bracho successfully incorporated the structures of *film noir* into a political thriller in which a labour leader tries to expose a state governor who is repressing his labour unions in the interests of foreign capital. The film deliberately marks out a different space to that of the nostalgic musicals of the time: the two protagonists first meet in a cinema which is showing *¡Ay, qué tiempos señor don Simón!* (Oh, What Times, Don Simón, 1941), the smash hit of 1941, but it is apparent that their world is more immediate, more threatening than the images on the screen. It is the nightworld of Mexico City which might promise a new dawn once the social and sexual tensions in the film (a love triangle out of *Casablanca*) are resolved in the final scenes. Alejandro Galindo's *Campeón sin corona* (Champion Without a

Title, 1945) examines the world of the urban poor and the attempt of a working-class boy to escape his background through his boxing talents. The boy will always be a contender rather than a true champion since he is trapped by his class background, his inability to cope with the riches of his new-found fame, and significantly the inferiority complex he takes into the ring when he faces a Mexican-American opponent who goads him in English.[53] Other Galindo films, including *Esquina, bajan* (Corner, Getting Off, 1948) and *Una familia de tantas* (A Family Like Any Other, 1949) explore the complexity of class society. *Una familia*, in particular, is a frank analysis of a conservative family, headed by a strong patriarch, who try to resist the shock of the new upwardly mobile classes, in the shape of a hoover salesman. Galindo allows the family drama to develop in slow complexity, avoiding the predictable antagonisms of so many melodramas of the period.

One director recently 'discovered' by Mexican critics is Matilde Landeta, the only woman in the forties and early fifties to have acquired temporary recognition and status as a director within the union. She had served a long apprenticeship as a script girl on almost a hundred features and later as an assistant to the major directors of the period. She made three features: *Lola Casanova* (1948), *La Negra Angustias* ('Black' Angustias, 1949) and *Trotacalles* (Street Walker, 1951). The films are interesting not merely as the work of a woman previously 'hidden from history', but because they test the possibilities of an articulate proto-feminism in a male industry and society. *Lola Casanova* traces the history of a creole woman who, defying taboos, goes to live with an Indian and helps to raise the consciousness of the Indian community in their dealings with the wider society. Although Landeta's analysis remains within the recognizable boundaries of 'indigenous' nationalism – all the races and castes of Mexico should work to build a harmonious society – the agent for change is, significantly, a woman. In *La Negra Angustias,* a humble goat-herd, brutalized by men, is swept into the Revolution and becomes a colonel in the Zapatista army. In one memorably brutal scene, she smiles with pleasure on hearing the screams of a man castrated on her orders for attempting to rape her. She also distributes the spoils of a victory to the women of a community since, as she states, ' they deserve it more because they have to put up with the brutality of men'. These fiery feminist touches, combined with some sophisticated camera work, become somewhat dissipated when Angustias (María Elena Márques, badly miscast and badly made-up as the swarthy heroine), falls for a middle-class, white, elegant man who is her teacher. The iron laws of sentimental melodrama then take over, a genre which also ruined her attempts to find a feminine reworking of the prostitute drama, in *Trotacalles*. Landeta was a significant pioneer and Mexico would have to wait for nearly thirty years before other women directors of her stature could appear.

A more exaggerated analysis of the underside of the dream of modernity is to be found in a number of *cabaretera* (brothel) films. At one level, they continue the formula which made Mexican cinema successful in the early thirties with

such films as *Santa* and *La mujer del puerto*, but the conditions of the late forties
are depicted in a tacky dynamism which is quite new. Alberto Gout is the most
audacious film-maker of the genre and *Aventurera* (Adventuress, 1949) is his
most accomplished film. It introduces the Cuban sex symbol Ninón Sevilla who
attracted the attention of critics as far away as Paris – *Cahiers du Cinema* gave
two breathless descriptions of her in 1954.[54] Elena (Ninón Sevilla), a good
provincial girl, sees her mother in the arms of a lover, witnesses her father's
suicide, flees the family home, is duped (drugged) into prostitution, takes to the
new profession rather well, is a talented dancer (of Caribbean rhythms, mucho
mambo), falls in love with Mario, tries to murder her mother's lover, discovers
that Mario's mother is the brothel owner who humiliated her ... and so on, in ever
more cruel and delirious twists. Lara, the famous balladeer and crooner of the
genre, once again supplied the appropriate lyrics:

> Sell your love expensively, adventuress
> Put on your past the price of grief
> And whoever wants the honey from your mouth
> Let him pay for your sin with jewels
> Since the infamy of your destroyed destiny
> Withered your admirable spring,
> Make your road less harsh
> Sell your love dearly adventuress.

Certainly Elena took the lyricist's advice with a vengeance: by the end of the
film, many of the protagonists have met grisly ends, genteel Guadalajara society
is in ruins and the rather sedate rules of cabaret cinema are turned inside out.
Interestingly, Andrea Palma, the statuesque heroine of *La mujer del puerto*, now
plays a middle-aged, wrathful madame, who at the same time represents the
reactionary elements of the polite Guadalajaran middle classes. *Aventurera,* in
its excessive flouting of all the rules, remains one of the major achievements of
Mexican cinema.

The above analyses have included some of the major titles of Mexico's most
dynamic decade of film-making. The volume of output was considerable. Jorge
Ayala Blanco gives an analysis of the share of the domestic market. Whereas in
1941, Mexican cinema had only 6.2 per cent of the domestic market, by 1945 this
had risen to 18.4 per cent and by 1949, to 24.2 per cent. Over the whole decade,
the average was 15.1 per cent.[55] In 1949, Mexico produced a remarkable 107
films.

The decade was marked by the belief that film-makers were doing something
different, were creating a genuinely nationalist cinema, and for some years this
faith had some basis in reality. Yet the seeds of decline were already present in
the lopsided development of the industry which stifled these brief moments of
originality. The restructuring of the North American film industry following the
war meant that Mexico could only maintain its market share by producing quick

films, dozens of *charros*, countless family melodramas, Cantinflas repeating the
same jokes. The structure of financing favoured the increasing monopolization
of a few producers, exhibitors and distributors (Emilio Azcárraga, William
Jenkins), who sought to maximize profits through investments bolstered by the
state. The industry also grew during the war to a level of employment which
could be sustained only with difficulty in the postwar period. This led to
internecine union disputes which were only resolved in an agreement which
effectively excluded any new talent from entering the industry. The unions
entered into pacts with producers, as Alberto Ruy Sánchez points out:

> In 1949 and 1950, even in a situation of crisis, more films were made each year than
> in the time of prosperity for the industry. ... The Latin American markets had been
> gradually lost. Thus the increase in the number of films produced was a way of
> mediating between unions and impresarios. For the former, it offered a solution to
> possible unemployment during the crisis; for the latter, it allowed them to produce
> a large number of films for more restricted markets, where the limited investment
> in each film could be quickly recuperated through the use of stereotypes.[56]

As will be seen in Chapter 6, from the early 1950s, Mexican cinema entered into
a long period of stagnation.

Brazil 1930–55

As in Argentina and Mexico, the coming of sound was greeted with initial
enthusiasm in Brazil. Here, it was felt, was a major opportunity for autonomous
development: the advantages of language would break the Hollywood, univer-
salist, hegemony over the image. The way forward was seen to be rapid industrial
development with up-to-date studios and technicians. Local capital would surely
see the gains to be made in this growth industry and invest in its development:
'"A cinematographic industry": that is the slogan, the key to development'.[57]

The state was also viewed as a possible source of patronage as it developed
from being an uneasy alliance of feuding regional oligarchies to its more modern
structure, the Estado Novo under Getúlio Vargas. The 1930 revolution came
about as a division among the elite concerning the correct way to deal with the
Depression of the late 1920s. The São Paulo candidate was overthrown by an
alliance of traditional groups opposed to São Paulo's hegemony, modernizing
democratic groups based in São Paulo, who wished to end 'bossism', and radical
young army officers, the *tenentes*. Vargas emerged as their leader and he
skilfully wooed each sector, profiting from their divisions, heralding the gradual
emergence to political power of urban industrial sectors. After surviving differ-
ent mass political movements the 'Popular Front' National Liberation Alliance,
the ANL, and the neo-fascist Brazilian Integralist Action, AIB, Vargas imposed
the Estado Novo (1937–45), an authoritarian corporatist structure organized

around nationalism, centralism and industrialization. The state apparatus extended into different areas of industrial support – the Ministry of Labour, Industry and Commerce founded in 1930, the National Coffee Council (1931), the Federal Council of Foreign Trade (1934), the National Petroleum Council (1938) and the National Steel Company (1941) – as a response to the uneven development of the economy.[58] While industry was much vaunted – the opening of the massive Volta Redonda steel mill in 1941 was the symbol of this enthusiasm – the major exports still remained primary products. In this climate, cinema did receive some priority from the state as a means of uniting people around shared cultural symbols.

Private capital, in particular that of the indefatigable Adhemar Gonzaga, was responsible for the first initiatives of the sound era. Gonzaga established the Cinédia Studios in Rio in 1930, and Carmen Santos funded Brasil Vita Filmes in 1933 in the same city. Rio was to become the almost exclusive centre of production for Brazilian cinema in the 1930s and 1940s and Gonzaga and Santos were the driving forces behind the films. Two other producers, Alberto Byington Jr. and the North American Wallace Downey, who set up Sonofilmes, exploited what would become a rich vein of popular culture: the musical comedy, the *chanchada*.[59] Paulo Emílio Salles Gomes has called the *chanchada* a 'popular, vulgar and frequently musical comedy' while Jean Claude Bernadet is equally unspecific: 'I don't know what the *chanchada* is, I think it is the generic name given to all the comedies and musical comedies, with popular pretensions, filmed in Brazil more or less between 1900 and 1960 in which stars like Oscarito appear.'[60] Some of the earliest sound films, Luiz de Barros's *Acabaram-se os otários* (The End of the Suckers, 1929)[61] and Downey's *Cousas nossas* (Our Things, 1931) were based on music, variety acts and comedy. *Cousas nossas,* a 'Brazilian Melody', broke all box-office records in São Paulo on release. These films incorporated singers already popular on record on the radio and in popular theatre: the famous crooners Paraguaçu and Noel Rosa and the orchestras of Gaó and Napoleão Tavares and Alzirinha Camargo. Wallace Downey was also a high-ranking executive in Columbia records.

Cinédia Studios would become established, from the mid 1930s, through the successful exploitation of musicals and carnival, in particular with Gonzaga's *Alô, Alô Brasil* (1935) and *Alô, Alô Carnaval* (1936), featuring the talents of the Miranda sisters, in particular Carmen Miranda. Within a short period of time, Hollywood had poached Carmen Miranda, who became one of the highest-paid stars of the 1940s. Before finding this successful formula, however, Cinédia had experimented with other 'quality' films produced in its new modern studios. Humberto Mauro was the most favoured director of the moment and he directed *Lábios sem beijos* (Lips without Kisses, 1930) and *Ganga Bruta* (Brutal Gang, 1933). *Lábios*, set in the modern Rio of new cars, stylish clothes and dance crazes, is a delightful comedy about a young woman eluding the amorous advances of her suitor until he gives up his lecherous ways and is conquered by

love. *Ganga bruta,* acclaimed by the young directors of Cinema Novo in the early sixties, takes the hero from Rio,where he has killed his wife after discovering on the wedding night that she is not a virgin, to the interior of the country where a factory is being built. There, in a landscape both primeval and in a transitional stage of modernization, he is captivated by an erotic adolescent. Their developing love affair is stylishly portrayed in a blend of expressionism, Soviet montage and Freudian surrealism. Yet it had no recognition at the time of its release, either from critics or from the public, and a disillusioned Mauro left Cinédia, teaming up later with Carmen Santos's Brasil Vita Films. Here he made *Favela dos meus amores* (Favela of My Loves, 1935), starring Carmen Santos, a film which entered the *favelas* (shanty towns) of Rio to record their popular culture, in particular music. Mauro broke a taboo by treating the *favelas* not as a site of urban depravity, but rather as a vibrant cultural entity, the cradle of samba.[62]

Cinédia and later Brasil Vita Filmes soon realized that they could not survive on 'quality' pictures alone. The initial euphoria of the early 1930s, a 'permitted' moment caused by Hollywood's readjustment to the different demands of sound in the global market, was soon dispelled. Hollywood did not fade into the background and the Brazilian public soon adapted to the subtitling of North American films. Brazilian cinema resumed its marginal place in the market and the number of features fell from seventeen in 1931 to seven in 1936 and 1939. The Vargas government's measures to stimulate the industry had little effect. A decree of 1932, in Randal Johnson's terms,

> does nothing to hinder the massive importation of foreign films which have histori-cally glutted that same market; in fact it makes importation easier by reducing customs tariffs on imports, ostensibly to support the exhibition sector. The American film industry saw the decree as an ostensibly cooperative measure.[63]

A clause in this decree stipulated that a Brazilian short should accompany imported films, but this was easily avoided by exhibitors.

Vargas was interested in film as an educational tool for national integration and in 1937 set up the National Institute of Educational Cinema (INCE), which produced documentaries, including a number by Mauro. Gonzaga and other producers, however, received little benefit from these measures and it was only the success of *chanchadas* that kept them from bankruptcy, generating limited profits which could be invested, on occasion, in more ambitious projects such as Santos's *Inconfidência Mineira* (Conspiracy in Minas, 1947), a historical reconstruction which took many years to complete. Outside the three main production companies, other individuals and companies made the occasional feature, usually without any financial success or critical acclaim, although Raul Roulien, a Brazilian actor returning from Hollywood in the mid thirties, did manage to direct several features.

At the turn of the decade therefore, the panorama was bleak; the Second World War caused a further complication by making access to raw film stock increasingly difficult. A new production company, Atlântida, however, did for

a time manage to maintain a coherent production strategy. Atlântida was the brainchild of cineastes José Carlos Burle, Alinor Azevedo and Moacyr Fenelon, and they sought initially to promote a critical realist cinema, dealing with popular themes. Their first film, *Moleque Tião* (Boy Tião, 1943) was based on the life of Sebastião Prato, 'Grande Otelo', already a well-known theatre and film actor. The focus on a black protagonist was a progressive choice in a society where blacks remained racially, economically, politically and socially oppressed.[64]The structure of Atlântida was artisanal: it functioned with few resources and in rudimentary studios, while the production team worked in a variety of jobs. Socially committed films, however, as the title of a later film *Tristezas não pagam dividas* (Sadness Doesn't Pay Off Debts, 1944), points out, could not guarantee financial stability. Their greatest success came in teaming Oscarito, Brazil's most brilliant comic, with Grande Otelo. The duo appeared in a number of successful comedies throughout the forties. This success attracted Luiz Severiano Ribeiro, who ran the country's major distribution and exhibition circuits. He bought Atlântida in 1947, and for the first time Brazil could boast a vertically integrated industry, making money essentially from *chanchadas*, exploiting the comic – and in particular verbal – skills of Oscarito, Grande Otelo and a number of other stars such as Zé Trinidade, Wilson Grey and Zezé Macedo. Severiano Ribeiro's buy-out occurred at the moment when Vargas decreed that each movie house should show three Brazilian films a year. He thus made films for his own theatres, keeping profits within the family. It was a genuinely 'popular' cinema, drawing its audiences in the main from working-class groups. As such, it would become the butt of middle-class scorn, which condemned the genre as lightweight, sloppy and hurried, pandering to the worst tastes. The *chanchadas* might make money, but they could not be considered as 'Cinema'. The desire to provide an alternative to this low-brow Rio-based, argot-ridden, entertainment would be one of the reasons for the development, in São Paulo, of the Vera Cruz Company founded in November 1949.[65]

Cinema production rose in Brazil from ten features in 1946, to twenty in 1950. Atlântida helped to generate a partial revival of the industry, Cinédia started up once again, and had a major success with *O ebrio* (The Drunk, 1947), directed by the multitalented Gilda de Abreu.

> With her husband, Vicente Celestino, she had her own production company that staged light operas in Rio theatres. Together they became known as a kind of Brazilian Jeanette MacDonald–Nelson Eddy duo. An extremely dynamic and productive woman, she not only performed as a singer and actress in radio, theatre and cinema ... she also wrote and adapted novels, plays and musical numbers. Her first film as director, *O ebrio* (The Drunk), in 1947 adapted a successful play by her husband, based on one of his musical compositions. The film was a huge box-office success.[66]

Moacyr Fenelon, who left Atlântida in 1947, also found a popular touch with films based on radio programmes. The most sophisticated comedy of the period,

far removed from the farce of *chanchadas,* was by the independent producer and director Silveira Sampaio, *Uma aventura aos 40* (An Adventure in the 40s, 1947). The decade ended with Atlântida's stylish *Carnaval no fogo* (Carnival in Flames, 1949), directed by Watson Macedo. In this plot of mistaken identities (an artistic director at a hotel during Carnival is mistaken for a gangster), Macedo achieves an excellent blend of tongue-in-cheek gangster movie overlaid by carnival cabaret and humour (Oscarito and Grande Otelo ham it up to great effect). There is also a complicated triangular relationship between hero, villain and girl, a formula that would be used in successive comedies in the 1950s.[67] Such was the paradigm for success at the turn of the decade, a paradigm rejected by the Vera Cruz Film Company.

Vera Cruz grew up in the optimistic conditions of postwar São Paulo. Following the break up of Vargas's Estado Novo, and a return to democratic practices, Brazil was governed from 1946 to 1951 by a conservative general, Eurico Gaspar Dutra, who oversaw a country benefiting from a brief postwar boom. The new-found freedoms and relative prosperity created ideal conditions for critical debate and cultural initiatives:

> Postwar São Paulo was experiencing at that time a moment of intense cultural activity. In the short space of six years the city witnessed the birth of two art museums, a prestigious theatre company, several schools, a film library, a biennial exhibition of plastic arts and myriad concerts, lectures and expositions. This cultural process accompanied the city's industrial development and was in large part promoted by the São Paulo bourgeoisie. ... Many of these cultural initiatives were financed by a group led by Francisco Matarazzo Sobrinho and Vera Cruz was linked to the complex of institutions based on his prestige and fortune, notably the Museum of Modern Art and the Brazilian Comedy Theatre.[68]

The Museum of Modern Art organized film screenings and debates, while the Comedy Theatre, under Franco Zampari, began to modernize Brazilian theatre. Vera Cruz would draw many of its actors from this company. In 1949, this financial group set up the Vera Cruz Film Company as part of the dynamic vanguard movement which sought to establish authentic, high-quality, Brazilian culture.

The analysis of the group was that national cinema could only develop if it could compete on some basis of equality with its international competitors/models. The reasoning was initially economistic: Hollywood's hegemony was based on adept use of the latest technologies; Vera Cruz would therefore compete by throwing money at the industry, thus assuring international quality. To this end the company built massive, costly studios, imported the latest technologies and attracted skilled European technicians. The import of equipment was made less expensive by a 1949 piece of government legislation which exempted all the materials needed for equipping film studios and laboratories from tariff duty for a five-year period.[69] Vera Cruz also asked the only Brazilian cinematographer

with a distinguished international reputation, Alberto Calvacânti, to run the organization. He accepted, but stayed with the company for only a year.

Vera Cruz was intended to be the dream factory of development, the coming of age of Brazilian cinema, with backing from all the main sectors of intellectual opinion. The project was doomed to failure since it was too costly and ambitious for the home market and could not penetrate international ones.[70] The international strategy was flawed. In the first place, the company asked Columbia Pictures to act as its distributor, a rather ingenuous move since it would not be in the interests of a Hollywood company to promote a rival national cinema. However, there was also the more general lack of appreciation that 'internationalism' was not a neutral concept. It did not signify the free flow of ideas and materials between countries, but rather that cultural power was in effect a one-way marketing device, with Hollywood as 'producer' and the rest of the world as 'receivers'. The United States and Europe have never been open to a regular supply of films from any Latin American country, except at certain very specific conjunctures (such as the radicalization of the late 1960s). Despite one or two small successes in international festivals, the markets abroad remained closed to Vera Cruz.

With this rejection, the company was forced to rely on the domestic market. Once again there were major difficulties. On average the first Vera Cruz productions cost ten times that of the average Atlântida films, which made it impossible for them to amortize in the home market. By 1952, the company was forced to trim its expenses and make concessions to the well-tried successes of *carioca* cinema that it had previously scorned. But it was too late – by 1953 the banks refused any more loans and the operation came to an end in 1954. What had Vera Cruz achieved? It had produced a great number of films: eighteen features between 1950 and 1953. It had also improved the quality of film production considerably, though major budgets would not be available again until the state began funding cinema from the mid sixties. However, the technical lessons, once learned, would not be forgotten. It also provided a number of sophisticated films in a number of different genres, the most popular of which was *O Cangaceiro* (The Cangaceiro) directed in 1953 by Lima Barreto. This film achieved the dream, albeit too late to save the fortunes of the company, of major international success. Exploring the status of social banditry in the barren northeast of Brazil, it focused on the band of the ruthless captain Galindo. One of the bandits, Teodoro, falls in love with a teacher and must defend his choice against the wrath of his former brothers-in-arms. The music and the epic stylization of the characters helped to generate a series of myths which would be exploited by the next generation of film-makers, in particular Glauber Rocha. The company also produced the first colour pictures in Brazil. In the end, though, the projects were too grandiose. The closure of the company also caused a crisis in other smaller São Paulo production companies such as Maristela and Multi-films.

Most importantly, perhaps, the high visibility of Vera Cruz helped to generate a bitter critical debate as to the nature of Brazilian cinema in the cine clubs, film journals and film congresses of the time. Was deliberate internationalism the correct strategy? Could the *chanchada* be seen, not just as low-brow *divertissement,* but as a struggle of the periphery against the colonial hegemonic powers? Was the parody which formed the basis of many *chanchadas* – in particular the spectacular *Nem Sansão nem Dalila* (Neither Samson nor Delilah, 1954)[71] – a weapon of demystification or a reinforcement of the models that the film hoped to laugh out of existence? Was there any alternative to these models? The debates of the early fifties were complex and wide ranging and were to lead to theoretical and practical initiatives that would transform Brazilian cinema over the following decade.

Developments in the Rest of Latin America

Argentina, Brazil and Mexico are the only countries in Latin America that can be said to have established regular film production in this period. Other countries found the transition to sound too costly and too complex. There is no sustained development of cinema, but rather a series of short-lived initiatives which could not compete either with the overwhelming attractions of Hollywood or with the lesser, but still significant, appeal of Argentine and Mexican movies, especially the *comedias rancheras*. Argentina and Mexico became successful exporters of films to the rest of the continent, and helped to define or even co-produce the first stammering attempts at national cinema in other areas. In Colombia, for example, cinema developed under the influence of Mexican musical comedy, in such works as *Allá en al trapiche* (Down at the Mill, 1941). Mexican cinema also invested in Cuban locations and filmed several exotic, 'fun-loving' comedies on the island. All these early attempts followed the 'big three industries' in employing stars from the radio and from musical comedy. As Paolo Antonio Paranagua points out, 'the Mexican film industry dominated film production in Guatemala, Colombia and Venezuela, the Argentine film industry dominated Uruguay, Venezuela and in particular Chile.'[72] Many Cubans and other Caribbean singers and dancers became incorporated into Mexican cinema, including Rita Montaner, Maria Antonieta Pons and the redoubtable Ninón Sevilla.

Even state attempts to foster local cinema tended to be swamped by outsiders. When the Prío Socarrás government in Cuba supported the establishment of Estudios Nacionales (National Studios), under the directorship of the prolific Manuel Alonso, they were used almost exclusively by Mexican production companies. In Chile, the state development agency CORFO, set up by the popular-front government, sought to increase Chile's import-substitution industrialization and economic modernization. CORFO supported the development of cinema as an important growth industry and in 1942 the state provided 50 per cent

development capital for Chile Films. Expensive studios were built, the new technology was purchased, and the Argentine company Argentina Sono Films provided a series of technical services. Yet the whole project was overambitious. Argentine directors made most of the films produced and these were unsuccessful in Chile and in the rest of Latin America.

In Bolivia film-making was intermittent. There is one film of the Chaco War, the Bolivian Luis Bazoberry's *Infierno verde* (Green Hell, 1938), a silent film which had sound added at a later date. The first sound films were made by two young enthusiasts, Jorge Ruíz and Augusto Roca. With the support of a North American patron, Kenneth Wasson, they set up a small production company, Bolivia Films, and began making short documentaries. In Colombia, the period 1930 to 1950 was dominated by newsreels. There were some ten features made, only two of which have survived.[73] In Venezuela only a few titles emerge from what local critics describe as a generalized mediocrity.[74] In Peru, the same timid imitations of Argentine and Mexican genres prevailed.

There was a slow shift in sensibilities in the continent from the late 1940s and early 1950s as cine clubs began to be set up, which explored, at least in theory, alternatives to the current conditions. In Cuba, for example, critic José Manuel Valdés-Rodríguez set up a cine club in the University of Havana and later a film department.[75] He was the precursor of the more modern critics such as Guillermo Cabrera Infante and Néstor Almendros who began to emerge in the 1950s. In Chile, the first cine club was founded at the University of Chile in 1955 and led eventually to the foundation of a Centre of Experimental Cinema in 1959, headed by Sergio Bravo.[76] In Uruguay, the Cine Club de Uruguay was founded in 1945, a movement which spread in the early fifties to the university.[77] There was an increasing critical awareness of the gap between the modern possibilities of film and the actual, badly made commercial genre films which provided the staple for these precarious industries. From the 1950s the gap between the traditional and the modern, the theory and the practice, began to close. By the mid 1950s, the continent was on the threshhold of a new era.

Notes

1. Manuel Puig, interview with Teresa Cristina Rodríguez, *O Globo*, 30 August 1981, p. 8.
2. J.L. Borges, 'Sobre el doblaje', *Sur* 128, June 1945, quoted in Cozarinsky, *Borges y el cine*, p. 72
3. J. Bruce, *Those Perplexing Argentines*, Longman, New York 1953, p. 332.
4. Michael Grow, *The Good Neighbor Policy and Authoritarianism in Paraguay*, Regents Press of Kansas 1981, p. 2.
5. Sumner Welles, *Where are We Heading?* Harper & Brothers, New York and London 1946, p. 184.
6. Hubert Herring, *Good Neighbors*, Yale University Press, New Haven 1941, p. 82.
7. See Paul Vanderwood's introduction to *Juárez*, The University of Wisconsin Press 1983.
8. García Riera, *México* pp. 197–257.
9. For a history see, *History of the Office of the Coordinator of Inter-American Affairs*, Government Printing Office, Washington 1947.

10. Frank Ninkovich, *The Diplomacy of Ideas: U.S. Foreign Policy and Cultural Relations 1938–1950*, Cambridge University Press, Cambridge 1981.

11. Nelson A. Rockefeller, *Program of the Communications Division*, sent to Vice-President Wallace, 1 April 1941, p. 1. I am very grateful to my colleague Callum McDonald for making these documents available to me. Also for his guidance with the historiography of the Good Neighbor policy.

12. Ibid., p. 7.

13. Barbara Leaming, *Orson Welles: A Biography*, Penguin, Harmondsworth 1987, p. 252.

14. Guback, 'Hollywood's International Market', p. 471.

15. Quoted in Guback p. 471.

16. Simon Collier, 'Carlos Gardel and the Cinema', J. King and N. Torrents, eds, *The Garden of Forking Paths: Argentine Cinema*, BFI, London 1987, p. 28.

17. Jorge Miguel Couselo, 'Argentine Cinema: From Sound to the Sixties', ibid. p. 29.

18. O. Getino, 'Argentina', in G. Hennebelle, A. Gumucio Dagrón, eds, *Les Cinémas de l'Amérique latine*, Lherminier, Paris 1981, pp. 28–31. For other general guides to the period, see J.M. Couselo et al., *Historia del cine argentino*, Centro Editor, Buenos Aires 1984 and Domingo di Núbila, *Historia del cine argentino*, Cruz de Malta, Buenos Aires 1960.

19. Enrique Colina, Daniel Díaz Torres, 'Ideology of Melodrama in the Old Latin American cinema', in Zuzana M. Pick, ed., *Latin American Film Makers and the Third Cinema*, Carleton University, Ottawa 1978, pp. 50 and 53.

20. See the recent documentary on García Márquez by Holly Aylett, *Tales Beyond Solitude*, London, South Bank Show, November 1989. Ana López discusses melodrama and the *telenovela* in 'The Melodrama in Latin America: Films, *telenovelas* and the Currency of a Popular Form', *Wide Angle*, Vol. 7, 3, 1985 pp. 5–13.

21. See in particular C. Gledhill, ed., *Home is Where the Heart is: Studies in Melodrama and the Woman's Film*, BFI, London 1987 and the essays in *Screen*, Vol. 29, 3, Summer 1988.

22. Gledhill, p. 34.

23. Ibid., p. 30.

24. J.L. Borges, 'La fuga', *Sur* 36, August 1937. In Cozarinsky, p. 54.

25. Mary Ann Doane, 'The "Woman's Film": Possession and Address' in C. Gledhill, ed., *Home*, p. 284. See also E. Deidre Pribram, ed., *Female Spectators*, Verso, London 1988. The work of Beatriz Sarlo, *El imperio de los sentimientos*, Buenos Aires 1985, begins to map out a field where such research might take place in Argentina. Her analysis of mass female audiences for novels, non-fiction books, and magazines would seem to indicate a public for the woman's film.

26. Ana López, 'Argentina 1955–1976', in King and Torrents, p. 50.

27. Carlos Fuentes, 'Una flor carnívora', *Artes de México*, Nueva época, No. 2, Winter 1988, p. 29.

28. From Fernando de Fuentes, *Vámonos con Pancho Villa* (1935).

29. Quoted in Paco I. Taibo, *La música de Agustín Lara en el cine*, UNAM, Mexico 1984, p. 66.

30. Carlos Monsiváis, 'Agustín Lara' in *Amor Perdido*, Era, Mexico 1977, p. 73.

31. Ibid., p. 74.

32. Ibid., p. 80.

33. See Jorge Ayala Blanco, *La aventura del cine mexicana (1931–1967)*, 3rd edition, Posada, Mexico 1985, pp. 141–3.

34. For an analysis of Eisenstein's work in Mexico, see: Mary Seton, *Eisenstein*, Seuil, Paris 1967; Gabriel Ramirez, ed., *¡Qué viva México!*, Era, Mexico 1964; Harry M. Geduld and Ronald Gottesman, eds, *Sergei Eisenstein and Upton Sinclair: The Making and Unmaking of ¡Qué viva Mexico!*, Indiana University Press, Bloomington 1970; Emilio García Riera, *México visto por el cine extranjero*, Era and Universidad de Guadalajara 1987; Aurelio de los Reyes, *Medio siglo de cine mexicano (1896–1947)*, Trillas, Mexico 1987.

35. Synopsis of *Qué viva México* sent to Sinclair. Quoted in Garciá Riera, *México*, p. 190.

36. Quoted in Ramirez, *Qué viva México*, p. 45.

37. Carlos Monsiváis, 'Gabriel Figueroa: la institución del punto de vista', *Artes de México*, nueva época, 2, Winter 1988, p. 63.

38. The most complete study of Fernando de Fuentes's work is Emilio García Riera, *Fernando de Fuentes (1894/1958)*, Cineteca Nacional, Mexico 1984.

39. Monsiváis, 'Gabriel Figueroa', p. 63.

40. For an interesting analysis of the film, see Aurelio de los Reyes, pp. 142–54.

41. Ibid., p. 153.

42. See in particular Adela Fernández, *El Indio Fernández: vida y mito*, Panorama, Mexico 1986 and Paco Ignacio Taibo, *El Indio Fernández: el cine por mis pistolas*, Joaquin Mortiz/Planeta, Mexico 1986.

43. Alberto Ruy Sánchez, *Mitología de un cine en crisis*, La Red de Jonás, Mexico 1981, p. 73.

44. This reappraisal of Figueroa is best exemplified in the beautifully illustrated recent edition of *Artes de México*, already quoted.

45. Monsiváis, 'La institución', p. 65.

46. Adela Fernández, p. 191.

47 Gabriel Ramírez, *Lupe Vélez: La mujer que escupía fuego*, Cineteca Nacional, Mexico 1986, see in particular chapter 3, pp. 43–69.

48. Carlos Fuentes, an interview with John King, in J. King, ed., *Modern Latin American Fiction: A Survey*, Faber and Faber, London 1987; Farrar, Straus & Giroux, New York 1989.

49. Jean Franco, *Plotting Women: Gender and Representation in Mexico*, Columbia University Press and Verso Books, New York and London 1989, p. 149.

50. See Monsiváis, '¿Pero hubo alguna vez once mil machos?' in *Escenas*, pp. 103–17.

51. For a brilliant analysis of the art of Cantinflas, see Monsiváis, 'Instituciones: Cantinflas. Ahí estuvo el detalle' , in *Escenas*, pp. 77–96.

52. Alan Knight, 'Mexico', in S. Collier, H. Blakemore, T. Skidmore, eds, *The Cambridge Encyclopaedia of Latin America and the Caribbean*, Cambridge University Press 1985, p. 226.

53. See Jorge Ayala Blanco, *La aventura del cine mexicano*, 3rd edn, Posada, Mexico 1985, pp. 253–9.

54. *Cahiers du cinema* 30 and 32, 1954.

55. María Luisa Amador, Jorge Ayala Blanco, *Cartelera cinematográfica 1940–1949*, UNAM, Mexico 1982, pp. 373–8.

56. Alberto Ruy Sánchez, p. 60.

57. Maria Rita Galvão, Carlos Roberto de Souza, 'Le parlant et les tentatives industrielles: années trente, quarante, cinquante', in P.A. Paranagua, ed., *Le Cinéma Brésilien*, Centre Georges Pompidou, Paris 1987, p. 67. This article is the best concise guide to this period.

58. Randal Johnson, *The Film Industry in Brazil: Culture and the State*, University of Pittsburgh Press, Pittsburgh 1987, p. 43.

59. Afrânio M. Catani and José I de Melo Souza, *A chanchada no cinema brasileiro*, Brasiliense, São Paulo 1983.

60. Quoted in Sergio Augusto, 'Le film musical et la chanchada' in Paranagua, p. 179.

61. See Luiz de Barros, *Minhas memórias de cineasta*, Artenova/Embrafilme, Rio de Janeiro 1978.

62. See Carlos Roberto de Souza, 'Humberto Mauro', in Paranagua, pp. 139–40.

63. Johnson, p. 48.

64. See Robert Stam, 'Blacks in Brazilian Cinema' in John D.H. Downing, ed., *Film and Politics in the Third World*, Autonomedia, New York 1987, pp. 257–65.

65. See Maria Rita Galvão, *Burguesia e cinema: o caso Vera Cruz*, Civilização Brasileira/Embrafime, Rio de Janeiro 1981.

66. Elice Munerato, Maria Helena Darcy de Oliveira, 'When Women Film' in R. Johnson, R. Stam, eds, *Brazilian Cinema*, Associated University Presses, New Jersey and London 1982 p. 343.

67. See João Luiz Vieira, 'Tarnished Mirrors: Studio Cinema in Brazil 1930-50', in P. Aufderheide, ed., *Latin American Visions*, Neighborhood Film/Video Project of International House of Philadelphia, Philadelphia 1989, p. 26.

68. Maria Rita Galvão, 'Vera Cruz: A Brazilian Hollywood', in Johnson and Stam, p. 273.

69. Johnson, p. 61.

70. My subsequent analysis is based on Galvão, *Burguesia* and Galvão, 'Vera Cruz'.

71. Among its many felicitious moments, *Nem Sansão nem Dalila* offers a hilarious parody of Getúlio Vargas, the great populist whose powers were waning (he committed suicide in 1954). Oscarito, as Samson, clearly uses many of Vargas's rhetorical and gestural tics.

72. Paolo Antonio Paranagua, *Cinema na America Latina*, p. 62. A chapter in his book has been translated in the *Latin American Visions* catalogue, pp. 13–19.

73. Hernando Salcedo Silva, *Crónica del cine colombiano, 1897–1950*, Carlos Valencia, Bogotá 1981.

74. For an analysis of critics' responses, see Ambretta Marrosu, *Exploraciones en la historiografía del cine en Venezuela: campos pistos e interrogantes*, Cuadernos INICO, Universidad Central de Venezuela, Caracas 1985.

75. For an account of the film programming of the university cine club, see J.M. Valdés-Rodríguez, *El cine en la universidad de la Habana*, Mined, Havana 1966.

76. See Jacqueline Mouesca, *Plano secuencia de la memoria de Chile*, Ediciones del Litoral, Madrid 1988.

77. See Ana M. López, 'Towards a "Third" and "Imperfect" Cinema: A Theoretical and Historical Study of Filmmaking in Latin America', D. Phil. Thesis, University of Iowa 1986, p. 339.

3

The 1960s and After: New Cinemas for a New World?

We understand the hunger that Europeans and the majority of Brazilians have failed to understand. For the European, it is a strange, tropical surrealism. For the Brazilian, it is a national shame. He does not eat, but is ashamed to say so; and yet, he does not know where this hunger comes from. We know – since we made those ugly, sad films, those screaming, desperate films in which reason has not always prevailed – that this hunger will not be assuaged by moderate government reforms and that the cloak of technicolor cannot hide, but rather only aggravates its tumours. Therefore, only a culture of hunger can qualitatively surpass its own structures by undermining and destroying them. The most noble cultural manifestation of hunger is violence.

Glauber Rocha[1]

This is the revolutionary function of social documentary and realist, critical and popular cinema in Latin America. By testifying, critically, to this reality – to this sub-reality, this misery – cinema refuses it. It rejects it. It denounces, judges, criticises and deconstructs it. Because it shows matters as they irrefutably are, and not as we would like them to be. ...

Fernando Birri[2]

A new poetics for the cinema will, above all, be a 'partisan' and 'committed' poetics, a 'committed' art, a consciously and resolute 'committed' cinema – that is to say, an 'imperfect' cinema. An 'impartial' or 'uncommitted' one, as a complete aesthetic activity, will only be possible when it is the people who make art. ... The motto of this imperfect cinema (which there's no need to invent since it already exists) is, as Glauber Rocha would say, 'We are not interested in the problems of lucidity'. ... Imperfect cinema finds a new audience in those who struggle, and finds its themes in their problems.

Julio García Espinosa[3]

Revolutionary art will always be distinguished by what it shows of a people's way of being, and of the spirit of popular cultures which embraces whole communities

65

of people, with their own particular ways of thinking, of conceiving reality and of loving life. ... By observing and incorporating popular culture we will be able to develop fully the language of liberating art.

Jorge Sanjinés[4]

Real alternatives differing from those offered by the system are only possible if one of two requirements is fulfilled: *making films that the system cannot assimilate and which are foreign to its needs, or making films that directly and explicitly set out to fight the system.* Neither of these requirements fits with the alternatives that are still offered by the *second cinema*, but they can be found in the revolutionary opening towards a cinema outside and against the system, in a cinema of liberation: the *third cinema.*

Getino and Solanas[5]

The Sixties

The film-makers who were also the theoreticians of 'new' cinema were clear about the difference of their own filmic practices. The various manifestos of the 1960s, usefully collected by Michael Chanan in his *Twenty-five Years of the New Latin American Cinema*, all point to a distinctive break with the past and with dominant hegemonic discourses. Theirs would be a lucid, critical realist, popular, anti-imperialist, revolutionary cinema which would break with neo-colonialist attitudes and the monopolistic practices of North American compa-nies. No aesthetic formulae were laid down: flexibility would be needed to adapt to different social situations. Yet there was always the desired intention, in Paul Willemen's phrase,

to speak a socially pertinent discourse which both the mainstream and the authorial cinemas exclude from their regimes of signification. Third Cinema seeks to articulate a different set of aspirations out of the raw materials provided by the culture, its traditions, art forms etc., the complex interactions and condensations of which shape the 'national' cultural space inhabited by the film-makers as well as their audiences.[6]

This cinema also had 'Pan-American' aspirations and declared itself part of the struggles of the Third World peoples: Franz Fanon is a theoretician often quoted by Glauber, Solanas and others. Yet it also contained many utopian elements, fuelled by the maximum utopia of the proximity of social revolution in the sixties, which was brutally stifled in the seventies. 'New' cinema, in the 1980s, differs very considerably from its founding moments in the 1960s. Pan-Americanism also proved beguiling, but elusive: it is the argument of this work that the cinema of the last thirty years can only be understood by examining national situations. This short chapter, however, seeks to sketch out the field of

Latin American social and cultural development from the late 1950s to the late 1980s, offering a framework for the subsequent, detailed, analyses of specific countries.

The 'new' cinemas grew up in the optimistic conditions of the late fifties and early sixties in different parts of the continent: Castro's Cuba, Kubitchek's Brazil, Frondizi's Argentina, Frei's Chile. The enthusiasm was generated by two fundamentally different political projects which served to modernize and to radicalize the social and cultural climate: the Cuban revolution and the myths and realities of 'developmentalism'. It is difficult to underestimate the importance of Cuba in helping to shape the growth of a radical consciousness throughout Latin America. It was a nationalist, anti-imperialist revolution which seemed exemplary and demonstrated a need for commitment and for political clarity. Especially in the sixties it offered an attractive model for many artists and intellectuals in pursuit of the elusive goal of fusing the artistic and the political vanguards. The novelists that represent the 'boom' of the Latin American novel in this period – Carlos Fuentes, Julio Cortázar, Mario Vargas Llosa and Gabriel García Márquez amongst others – all reflect the optimism that a wave of social change could sweep through the continent. The fact that the Cuban 'model' for revolutionary change was not ultimately successful in other areas of the continent should not detract from either its actual achievements or its symbolic charge. The artistic community, in general, lived a honeymoon period with Cuba until at least the early seventies. The 'Padilla affair' – in which a Cuban poet was imprisoned in 1971 for anti-state activities and later gave a grovelling self-critique – caused widespread disenchantment among Latin American and European liberal fellow travellers and provoked a furious response from Castro. It can be seen as marking a watershed between the optimistic sixties and the grim realities of the seventies.

The new cinemas grew up in imaginative proximity of social revolution.[7] It was the moment when García Márquez's gypsy muse Melquíades in *One Hundred Years of Solitude* seemed to indicate that all of Latin America's contradictions could be resolved, when decades of unequal struggle could be vindicated in a period of new awareness: 'Melquíades had not arranged events in the order of man's conventional time, but had concentrated a whole century of daily episodes in such a way that they coexisted in a single instant.'[8]

The imaginative proximity of social revolution was combined with a sense of cultural modernity. The sixties was the decade in which the artistic community felt that it had 'come of age' and could be 'contemporary with all men' in Octavio Paz's evocative phrase. This new-found optimism was, at least in part, grounded in economic and political reality. The sixties heralded a period of economic growth in the region. In the period 1960 to 1979 the annual average real GDP growth rate was 7.2 per cent. In this era it was hoped that economic modernization, led by the industrial developmental strategies promoted by the UN Economic Commission for Latin America (ECLA), would break the dependency on primary production. The 'stages of development' models from basic non-

durable consumer goods through to the establishment of a capital-goods industry
received the approval of such theoreticians as Talcott Parsons and in particular
Walt Rostow, J.F. Kennedy's Cold War economic guru, whose influential work
The Stages of Economic Growth was published in 1960. Rostow's 'Stages of
economic growth' moved in five relentless steps: the traditional society, the
preconditions for take-off, the take-off, the drive to maturity and the age of high
mass consumption, in which the economic emphasis shifted to the supply of
goods and services to the wider community. This steadily articulated progres-
sion, as Henry Fairlie points out, bears a strong resemblance to

> the method of argument which was used by Winnie-the-Pooh, who made his way
> by a process of ponderous – but, in his case, beguiling – ratiocination from the
> empirical observation that there were bees in the vicinity, to the rational specula-
> tion that where there were bees there was likely to be honey, to the positive
> resolution that where there was honey there he had a right to be; and in this manner
> succeeded in achieving a high level of personal consumption and even, on
> occasions, an accelerated rate of physical growth.[9]

In Rostow's logic, the countries of the underdeveloped world would need US
aid in order to build up nation states and to guarantee regional stability. They
would need help to resist the siren call of Marxism, whose shrill tones could
already be heard from a small island less than a hundred miles from the US coast.
'Give them a share', the US dictum for Latin America in the 1930s, was updated
into the 'Alliance for Progress' in the early sixties. The open US support for
certain forms of social democratic development in Latin America, its uneven
successes and the intellectual and social backlash that it caused within Latin
America were part of the breeding-ground for the new cinemas whose discourses
were, almost invariably, nationalist and anti-imperialist. They were prepared to
look at the shadow side of the dream of progress: the cycles of expansion and
recession in individual countries, the nature of imperialism, the widespread
failure in many countries to redistribute the gains of expansion equitably to the
majority of the population.

The dream had its shadow side, but it also became a reality, at least in part. In
broad terms, consumption across a whole range of goods increased, and this
included scientific, cultural and intellectual expansion. The 'intellectual field',
in Pierre Bourdieu's terms, increased greatly in this period in terms of universi-
ties, cine clubs, publishing houses, critical journals, the assimilation of the latest
scientific and theoretical advances, which helped to propel the decade forward.
Latin America could share some of the optimism of the period which Marshall
Berman has described with such verve:

> All the modernisms and anti-modernisms of the 1960s, then, were seriously
> flawed. But their sheer plenitude, along with their intensity and liveliness of
> expression generated a common language, a vibrant ambience, a shared horizon of

experience and desire. All these visions and revisions of modernity were active orientations toward history, attempts to connect the turbulent present with a past and a future, to help men and women all over the contemporary world to make themselves at home in this world. The initiatives all failed, but they sprang from a largeness of spirit and imagination and from an ardent desire to seize the day.[10]

The artist Claes Oldenburg wrote in 1961,

I am for an art that is political-erotical-mystical, that does something other than sit on its ass in a museum. I am for an art that embroils itself with the everyday crap and comes out on top. I am for an art that tells you the time of day, or where such and such a street is. I am for an art that helps old ladies across the street.[11]

The new cinemas would take up the thrust of this argument, finding their symbolic spaces in the streets of cosmopolitan Buenos Aires or the *favelas* of Rio de Janeiro, going out with their cameras to capture everyday social reality, using an artisanal, flexibile, low-budget form of filming.

The new cinemas began with an 'idea in the head and a camera in hand', in Glauber Rocha's resonant phrase, adopting flexible positions which were adapted to the changing historical and political moment. These strategies can only be explored by looking at the specific developments within each country which are outlined in the following chapters. Yet it should also be recognized that the decade saw various attempts to achieve a movement that was Pan- or Latin American, internationalist as well as nationalist. All the major theoreticians mentioned in the preface to this chapter articulated a space which transcended national boundaries. The enemies were North American imperialism, multinational capital, the seamless diegesis of Hollywood cinema, the fragmentation caused by neo-colonialism. The goals were national and continental liberation. The precursors were the practices evolved in Argentine, Brazilian and later Cuban cinemas which placed on the agenda a whole range of important problems: the development of cinema under the auspices of a socialist state; the relationship between film-makers and the state in a dependent capitalist context; the problems not only of production in conditions of scarcity, but also the possibility of either entering the established distribution and exhibition networks or creating alternative structures for dissemination; the question of the appropriate filmic language for particular situations; the whole vexed question of what was a 'national reality'; the uneasy relationship between film-makers (largely middle-class intellectuals) and the 'people' they hoped to represent; and the nature of 'popular' culture.[12] All these questions would be answered in a variety of ways over the next decades.

Obviously these practices did not emerge as self-contained movements within Latin America: the subcontinent's culture has always evolved in a dynamic relationship of attraction and rejection with work produced in Europe and North America. Two important influences recognized and quoted by the

film-makers were neo-realism, which had emerged in Italy since the Second World War, and the 'politique des auteurs', proposed by film critics and practitioners in the 1950s in France. Robert Kolker defines the project of neo-realism:

> The neo-realists wanted the image to deal so closely with the social realities of postwar Italy that it would throw off all the encumbrances of stylistic and contextual preconception and face that world as if without mediation. An impossible desire, but in it lay the potential for yet other assaults on cinema history. ... I have noted some of its basic elements – location shooting, poor working-class subjects played by non-professionals, use of the environment to define those subjects, an attitude of unmediated observation of events. ... But something was needed to bring those various elements together, and that immediate cause was the end of World War II and the defeat of fascism.[13]

A number of Latin American film-makers trained with the neo-realists in Italy in the 1950s, or saw their work in film clubs. They approved of the choice of the working classes as subjects and of the desire to document their culture of survival without resorting, in Rossellini's terms, to the superfluous or the spectacular. Jacques Rivette could speak for a generation when he stated:

> For there is no doubt that these hurried films, improvised out of very slender means and filmed in a turmoil that is often apparent from the images, contain the only real portrait of our times; and these times are a draft too. How could one fail suddenly to recognise, quintessentially sketched, ill composed, incomplete, the semblance of our daily existence? These arbitrary groups, these absolutely theoretical collections of people eaten away by lassitude and boredom, exactly as we know them to be, as the irrefutable, accusing image of our heteroclite, dissident, discordant societies.[14]

Jacques Rivette, of course, was one of the major disseminators of 'la politique des auteurs', and traces of this influence can be found all over the subcontinent, from Cuba in the north, with Guillermo Cabrera Infante's collection of film criticism, *Arcadia todas las noches* (Arcadia Every Night, conceived in the early 1960s and finally published in 1978), to Glauber Rocha in Brazil. For some critics and film-makers in Latin America, this critical practice spoke against the domination of bland and anonymous commercial studio productions and rediscovered individual voices rebelling within the system. For others, especially as the decade progressed, the emphasis on 'authorship' was seen to take film out of the realm of political and social debate. The most extreme statement of this view came in Getino and Solanas's espousal of 'Third Cinema', as shall be seen in Chapter 4. These European genealogies are clearly definable in Latin American debates of the early sixties and helped to clarify and to define practical problems.

It was felt, however, that these problems could or should be shared. The obstacles were great. There were no established lines of communication between

Latin American countries apart from the traditional commercial channels that had made Argentina, and in particular Mexico, into important exporters within the region. In 1967, a Chilean doctor-cum-cineaste, Aldo Francia, organized a 'Meeting of Latin American Film-makers' at the Viña del Mar film festival. The histories of the New Latin American cinema all stress the importance of this meeting. Francia talked of the isolation that his festival would seek to end:

> There can be no Chilean view of Latin American cinema for the simple reason that we do not see here cinema from Latin America, and I think this occurs in every country. In this Festival we have only seen one Peruvian film. Through the Festival we know that Latin American cinema is one of debate, a cinema of struggle; more formalist in Argentina, more social in Brazil, of extremely high quality in Cuba, from the little we have seen. But we know nothing about Mexico, or other countries, only a few scattered meetings.[15]

The festival saw the arrival of delegates from seven countries and films from nine, the strongest contingents from Argentina and Brazil. The meeting set out an ambitious set of resolutions concerning future collaborative work and the sharing and dissemination of materials, many of which remain elusive goals twenty years on.[16] It succeeded, however, in allowing personal contacts to develop and numerous films to be screened. It was a first step towards the elusive goal of Pan-American solidarity.

Other meetings followed, in Mérida, Venezuela in 1968 and in Viña again in 1969, and eventually mushroomed in other countries in the continent. Each congress offered similar declarations of intent:

> The authentic New Latin American cinema was, is and will be one which contributes to the development and strengthening of our national cultures, as an instrument of resistance and struggle; one which works with the objective, over and beyond the specificities of each one of our peoples, of integrating this body of nations so that one day the great nation, stretching from the Río Grande to Patagonia, will become a reality; one which participates in the defence and fight against imperialist cultural penetration and their anti-national collaborators ... one which increases awareness in peoples, so that history will be transformed.[17]

This statement, drawn up in 1985 by the 'Committee for Film-Makers of Latin America', expresses the continuing struggle for an elusive utopian dream of Latin American cooperation and solidarity. In the late 1960s, the dream seemed close to becoming a reality and there appeared an important cluster of films from all over the continent which reflected a maturity of style and a confidence in the transforming potential of the medium. The period 1968 to 1970 saw remarkable work by Gutiérrez Alea in Cuba, Solanas and Getino in Argentina, Sanjinés in Bolivia, Glauber and Pereira dos Santos in Brazil, Littín and Raúl Ruiz in Chile and many more. There were links between the countries of Latin America and a sense that cinema had, at last, come of age. Raúl Ruiz makes the point:

Suddenly we found ourselves with a cinema which in a very obvious and natural way, without any cultural inferiority complex, was being made with very few resources, with the resources that we could acquire, and with a freedom that earlier Latin American and European cinema did not have. Suddenly we found ourselves with all the advantages. Glauber Rocha's *Black God, White Devil,* is Sartre's 'Devil' and 'God' but it is many more things beside. It is a cinema that has no problem in quoting, accepting and swallowing Sartre, without any complex, whilst remaining very Brazilian. It is in this sense that the Festivals [at Viña del Mar] were very important to us.[18]

This is the moment when the theoretical statements of a 'cinema of hunger', an 'imperfect cinema' and a 'Third Cinema' were allied to a dynamic practice. Perhaps this indeed was the 'hour of the furnaces' which would light up and guide liberation struggles throughout the continent.

The Seventies

These cinemas, as Julianne Burton has noted, occupied a brief 'permitted' space in the late sixties and early seventies.[19]

What happened in the 1970s was that as the gigantic motors of economic growth and expansion stalled, and the traffic came close to a stop, modern societies abruptly lost their power to blow away their past. All through the 1960s, the question had been whether they should or shouldn't; now, in the 1970s, the answer was that they simply couldn't.[20]

Marshall Berman's general statement on the closures experienced in the 1970s is true to an acute degree in Latin America. A wave of military dictatorships swept through the Southern Cone. The 1964 coup in Brazil led to a more extreme dictatorship between 1968 and 1971. In Bolivia General Hugo Banzer ruled with repressive severity between 1971 and 1978. In Uruguay, the military overthrew one of Latin America's most stable democracies in 1973. Later the same year, the armed forces under General Pinochet ended Chile's three-year experiment of democratic revolutionary change. In Argentina, after the death of Perón in 1974, the country was torn by near civil war, a violence that was extended and systematized when the military took power in 1976. The intellectual community suffered the same fate as those in the wider community: imprisonment, murder, torture, exile or extreme censorship. In Cuba the decade saw ideological austerity, a marked slowing-down in the pace of artistic experimentation. Only in Colombia, Peru and Venezuela could the cinema make advances within national boundaries, aided by state investment, although Brazilian cineastes could also walk the tightrope between state repression and state largesse, trying to make use of the 'philanthropic ogre' (Octavio Paz's evocative phrase), without becoming stifled in its embrace.

Exile is a space permeated with ambiguity: a displacement from a sense of home, but also a movement offering the possibility of the freedom and insights of distance. The Chilean exile director Raúl Ruiz would, in 1974, quote Brecht ironically in the film *Diálogo de exilados* (Dialogue of Exiles):

> The best school of dialectic is emigration, the most skilful dialecticians are exiles. It is change that forces them in to exile and they are interested only in change. ... If their adversaries prevail over them, they calculate the price they must have paid for their victory and they have a sharp eye for contradiction.[21]

The truth or otherwise of Brecht's observation and Ruiz's palimpsest will become evident when personal biographies are traced through their long odyssey. In general terms, the only significant 'national' cinema in exile was the Chilean. Individual directors from other countries made successful films in exile, but the delays and frustrations of finding finance and infrastructural support would dissipate much of the energy engendered by the late sixties films, when the cineastes were part of active processes for political change. The Argentine Fernando Solanas's *Tangos: el exilio de Gardel* (Tangos: The Exile of Gardel, 1983) explored the hopes and daily problems of a dance troupe of Argentine exiles in Paris, hoping to stage a *tanguedia* (a tango comedy/tragedy); the director himself appears in a cameo rule where he literally explodes in frustration. The *tanguedia* is eventually staged, the film is made and both are an artistic triumph of optimism and solidarity. Yet – and the film explores the questions with great subtlety – what is the function of artistic production in such conditions? Who is the audience? Why produce? The Paraguayan writer Roa Bastos outlines the problem for artists such as himself who worked in the 'alienating and obsessive atmosphere of exile, in the unreal reality of his lost land and the sorrowful knowledge that it has all been an "absentee's biography".'[22]

One answer to these questions would be to use film as a weapon to denounce militarism and injustice. The links between individual film-makers, the infrastructural support they received in such countries as Cuba and Mexico (briefly), and the need to create international solidarity gave the films of the mid seventies a focus and an audience, however temporary. For artists remaining under dictatorship, it was necessary to keep alive a catacomb culture, to prevent intellectual asphyxiation. The forms of internal repression varied in intensity: from the mid 1970s, a *dictablanda* (a 'soft' dictatorship) in Brazil allowed artists to work with a degree of freedom. In Uruguay, Chile and Argentina, on the other hand, socially relevant films had almost no space and the local industries kept alive with a diet of inoffensive comedies and sex films. The various responses to dictatorship are outlined in the subsequent chapters.

As the hitherto major 'industries' of Latin America – in terms of both commercial and oppositional films – stagnated, there were impressive signs of growth in Venezuela, Colombia and Peru, all responding to initiatives originat-

ing in the state sector. Some film-makers continued the 'oppositional' practices of the 1960s, but many worked in forms that had a proven popular appeal: political thrillers, comedy, melodrama (linking to the tastes formed by television), rediscovering some of the forms that had made Latin American cinema successful in the 1940s and which had been confined to the dustbin of history by the new wave of sixties directors. Social criticism could therefore be insinuated into the market-place, rather than overturning all the stalls.

At a moment when revolutionary change had disappeared from sight in most of Latin America, the Sandinista final offensive overthrew the Somoza dictatorship in Nicaragua in 1979. At the same time, liberation forces in El Salvador and Guatemala began engagements against local oligarchies massively supported by US aid and armaments. Film-makers took up their cameras again to record the liberation struggles and the Nicaraguan revolutionary government sought to promote an active film culture across a range of media (including super-8 and video), though in conditions of acute shortage. Central America thus offered a site where the practices of the sixties could usefully be applied, but in a continent where the utopias of that decade had largely failed to materialize. Central American film practices seemed to run against the grain of history, which made their aspirations and achievements all the more difficult to consolidate.

The Eighties

> And if you find her poor, Ithaka hasn't deceived you
> So wise have you become, of such experience,
> That already you'll have understood what these
> Ithakas mean.
>
> Cavafy[23]

> In Latin America, we want to make films only to triumph, that's to say, we want the Nobel Prize from the start without going through that phase of suffering and learning. ... I think the period of suffering and learning is over, the example of the novel helps us to jump stages. Let's try to do a much better commercial cinema than has been done up to now and some two or three films that have artistic expression and go to Festivals, but we can't go on making films that nobody sees and which don't win festivals either.
>
> García Márquez[24]

Developments in the eighties are perhaps too recent to keep sharply in focus. Film-makers still talk of the 'new' Latin American cinema, though the use of the term is increasingly holistic. Julianne Burton correctly states that,

> rather than becoming more cohesive over the past three decades, Latin American cinema has become more diffuse. ... What aspired to be a single movement seems

more than ever to be an amorphous grouping of mutually supportive individuals and groups brought together by the common economic and political difficulties they face.[25]

The economic problems were immense. All over the world, cinema had been forced to fight against the other attractions of the entertainment industry, in particular television and the new deregulated world of satellite and cable. In order to survive, Hollywood companies diversified and became part of con-golomerate networks: 'Conglomerization has proceeded in three ways: motion picture companies were either taken over by huge multifaceted corporations, absorbed into burgeoning entertainment conglomerates, or became conglomer-ates through diversification.'[26] Diversification offered a hedge against losses, a luxury that no Latin American film-maker could enjoy unless the state, in a few cases, was willing to pick up the tab. Cinema was maintained, precariously, against a background of declining audience and the attractions of the new electronic media.

The film-makers worked within extremely shaky support structures. There were attempts in the decade to unify Latin American cinema as a power group which could occupy its 'natural' place in the Latin American market and also enter the international circuits. García Márquez, as a latter-day Bolívar, was most vocal in support of this idea:

What happens is that we always try to make films to win in international festivals. I think we should make films to win over spectators in our countries. We have to make a common film market because when you produce a film in Colombia, for example, only for the Colombian market, that film never recoups its costs and is a very costly investment. If you produce for all Latin America, as a continent, that needs only two languages.[27]

To this end, a committee of Latin American cineastes was set up together, with a Latin American film foundation. A Latin American film festival took place annually in Havana, which included an arena for marketing Latin American films. These were all positive steps, but they were a long way from making any real impact on the regional and international distribution of cultural power. García Márquez has recently written a fictional biography of Bolívar, the great Latin American liberator, and records that the dying General uttered these final words: ' "Fuck it", he sighed, "How am I going to get out of this labyrinth?" '[28] The question, with or without the expletive, remained pertinent at the close of the decade.

The state, a somewhat reluctant and unreliable Ariadne, offered a vital thread, or lifeline, through the labyrinth; there is now a great danger, given the profound economic crisis, that this thread will be broken and that the Minotaurs will duplicate. The state in Peru, Colombia, Venezuela, Mexico, Argentina and Brazil has cut back drastically on funding in recent years, as the subsequent

chapters reveal. Film-makers spend most of their time looking for production money: Jorge Sanjinés recently stated that over 90 per cent of his time was spent in this way, a story repeated throughout the continent.[29] Contracting state capital, nervous private investors within Latin America, invaluable though inevitably limited production funds from European organizations such as Channel 4 in Britain – these are the main alternatives for production money.

Despite these difficulties there still seems to be an unquenchable desire to make films. The 1980s saw the return to democracy in many countries in Latin America: even Stroessner, the oldest dictator of all, finally fell in Paraguay, and cinema has been in the vanguard of cultural production. The early years of the Alfonsín government in Argentina (1983–89), were accompanied by a number of films of the highest quality offering a range of different styles and themes. One film of the period, *La película del rey* (A King and his Movie, 1985) analysed the enthusiasms, but also the difficulties of film production. A film-maker, anxious to make an epic in the south of Argentina, finds that his backers withdraw and his cast dwindles: a huge troupe of marauding Indians is played by a cast of two or three reluctant horses and actors. The director's task, in these conditions, is seen as both demented and necessary, a struggle against the odds that must be won. Luckily, many are prepared to take up the struggle.

These brief observations have attempted to show that there is a network of formal and informal contacts that unites film-making practices across and within their national diversities. The order of the chapters is arranged to signal this larger evolving story. The cinemas of Argentina, Brazil and, in a more minor way, Mexico, pioneered work in the late fifties and early sixties. Cuba set the tone for radical cultural change in the sixties, and was followed by Chile and Bolivia. Peru, Colombia and Venezuela offered different alternatives for the seventies and the liberation struggles in Central America become highly visible in the eighties. The reader will, hopefully, keep making the cross-references which are signalled explicitly or implicitly in the evolving histories.

Notes

1. Glauber Rocha, 'The Aesthetics of Hunger', in Michael Chanan, ed., *Twenty-five Years of the New Latin American Cinema*, BFI and Channel 4, London 1983.

2. Fernando Birri, 'Cinema and Underdevelopment', in ibid., p. 12.

3. Julio García Espinosa, 'For an Imperfect Cinema,' in ibid., pp. 31–2.

4. Jorge Sanjinés, 'Problems of Form and Content in Revolutionary Cinema', in ibid., p. 36.

5. Fernando Solanas, Octavio Getino, 'Towards a Third Cinema', in ibid., p. 21.

6. Paul Willemen, 'The Third Cinema Question: Notes and Reflections', in Jim Pines, Paul Willemen, eds, *Questions of Third Cinema*, BFI, London 1989, p. 10.

7. Perry Anderson, 'Modernity and Revolution', *New Left Review* 144, March–April 1984, pp. 96–113.

8. Gabriel García Márquez, *One Hundred Years of Solitude*, Cape, London 1970. I am following Gerald Martin's analysis of the novel in G. Martin, *Journeys Through the Labyrinth: Latin American Fiction in the Twentieth Century*, Verso, London 1989, pp. 218–25.

9. Henry Fairlie, *The Kennedy Promise: The Politics of Expectation*, Doubleday and Company Inc., New York 1973, p. 130.

10. Marshall Berman, *All That is Solid Melts into Air: The Experience of Modernity*, Verso, London 1983, p. 33.

11. Oldenburg, quoted in Berman, p. 320.

12. I have extracted some of these questions from Randal Johnson and Robert Stam, *Brazilian Cinema*, pp. 56–7.

13. Robert Kolker, *The Altering Eye: Contemporary International Cinema*, Oxford University Press, Oxford 1983, p. 44.

14. Jacques Rivette, 'Letter on Rossellini', in Jim Hillier ed., *Cahiers du Cinéma*, Vol. 1, Routledge and Kegan Paul, London 1985, p. 195.

15. 'Entrevista con Aldo Francia', in *Hablemos de Cine* 34, March–April 1967, reprinted in *Cine Cubano* 120 (1987), p. 11.

16. For an outline of the resolutions approved at Viña, see *Cine Cubano* 42–44, pp. 8–9.

17. 'Constitución del Comité de Cineastas de América Latina', *Hojas de Cine: Testimonios y documentos del Nuevo Cine Latinoamericano*, Vol. 1, UAM, Mexico 1988, p. 546.

18. Raúl Ruiz, 'No hacer más una película como si fuera la última', interview with V. Luis Bocaz in *Araucaria de Chile* 11, 1980, pp. 101–18.

19. Julianne Burton, 'The Hour of the Embers: On the current situation of Latin American Cinema, *Film Quarterly*, Autumn 1976, pp. 33–44.

20. Berman, p. 332.

21. I am using the translation quoted in *Afterimage 10*, p. 121.

22. Augusto Roa Bastos quoted in J. King, ed., *Modern Latin American Fiction: A Survey*, Faber and Faber, London 1987, p. 294.

23. C.P. Cavafy, 'Ithaka', in *Four Greek Poets*, Penguin, Harmondsworth 1966, p. 16.

24. Gabriel García Márquez, Interview with Holly Aylett in *Tales Beyond Solitude*. I am grateful to Holly Aylett for sending me the complete script of the interview, which has been published in part in the *TLS*, 20–26 October 1989, pp. 1152 and 1165.

25. Julianne Burton, *Cinema and Social Change in Latin America: Conversations with Film-makers*, University of Texas Press, Austin 1986, p. xv.

26. Tino Balio, in T. Balio, ed., *The American Film Industry*, University of Wisconsin Press, Madison 1985, p. 443.

27. García Márquez, interview with Holly Aylett.

28. Gabriel García Márquez, *El general en su la berinto*, Sudamericana, Buenos Aires 1989, p. 269.

29. Conversation with the author, Birmingham, April 1986.

Argentina, Uruguay, Paraguay: Recent Decades

Hollywood cinema is becoming increasingly predictable, to the point where you have the impression of having seen it all before, with a different plot. It is as if there were no longer any images. How, then, do you construct a world of your own images, if all films are alike? What do you do if all films take place in streets, in bedrooms or in cars? How to film, with what optic, with what frames, with what camera movements, in order to narrate in another way, to capture time better, to express what is said and what is not said. ... And of all these problems the most difficult remains: which are your images and how do you achieve them?

Fernando Solanas[1]

Argentina

Even with the downfall of Perón in 1955 and the outlawing of his party, Peronism remained Argentina's most important political force: from 1955 until Perón's return in 1973, every government had to come to terms with a party which still maintained mass popular support. Yet from 1955 every effort was made to extirpate this movement. After a period of military repression, power was handed in 1958 to a civilian government led by Frondizi, which seemed to embody progressive democratic ideals that could steer the country away from the excesses of populism and militarism. Argentina had remained culturally cloistered under Perón, almost entirely cut off from the scientific and artistic development that had taken place in other parts of the world. After 1955, a large number of people were eager to renovate Argentine culture by opening the country up once again to Europe and the United States. At this time, the older elite groups were partially replaced by new middle-class politicians who, it was felt, would blow away the remaining vestiges of traditional Argentine society. The rhetoric of 'modernization', however, could not become a reality in a country which was economically stagnant and politically volatile. There was a brief period of optimism between 1956 and 1965 when Buenos Aires seemed to reflect a number of the characteristics that we loosely associate with the sixties: an

increase in consumerism, not just of goods, but of many different aspects of culture. This was the time in which considerable sums were spent on advertising, visits to the psychoanalyst became an integral part of middle-class Buenos Aires life, people flocked to the films of Ingmar Bergman and helped to create a 'boom' in Latin American fiction by buying works in tens of thousands. The recent Nobel Prize winner Gabriel García Márquez first published *One Hundred Years of Solitude* in Buenos Aires. The publishing house expected small sales, but the book sold thousands of copies in the first months. Weekly journals grew up to reflect and direct these new tastes, and fashion in all its aspects became extremely important. Argentine 'new wave' cinema grew up in these conditions. The other face of this seemingly euphoric period was the constant military plotting and coups, the persecution of the unions and of Peronism, the anti-subversion 'Contintes' plan developed by the military, all set against the background of economic decline.

Two 'authors': Leopoldo Torre Nilsson and Fernando Ayala

Cinema benefited from the new conditions offered by the late 1950s. The established director who seemed to embody the process of modernization by giving Argentine cinema a cosmopolitan international reputation was Leopoldo Torre Nilsson. *La casa del ángel* (The House of the Angel, 1957) was included in the newly established London Film Festival and in the Cannes Film Festival, where it received unqualified praise. The 'New Wave' critic Eric Rohmer described it, rather hyperbolically, as 'the best film to have arrived from South America since the beginnings of cinema'.[2] Informed by Bergman, the French New Wave and its British contemporaries Reisz and Anderson, and collaborating closely with his wife, the novelist and screenwriter Beatriz Guido, he explored in this period the contradictions and decline of Argentine upper-class and genteel bourgeois society.[3] Constant themes are the clash between protagonists and their environment (and an almost Proustian reaction of characters to stimuli from the real world, a taste or smell triggering a series of voluntary or involuntary memories); the relationship between innocent adolescence, which has no clear consciousness of evil, and a world of adults that corrupts them; the explorations of a society with almost medieval religious prejudices and a corrupt political system; sexual conflicts; the amorality of childhood; and a total lack of communication between characters.[4]

Torre Nilsson's best work, at the end of the decade, was *La casa del ángel* and *La caída* (The Fall, 1959). By 1959, Torre Nilsson could for the first time act as an independent producer and director, though in 1957 the studio to which he was contracted, Argentina Sono Films, trusted his reputation sufficiently to give him great independence. He tended to work with the same team of scriptwriter, technicians, a few favourite actors – Elsa Daniel, Lautaro Murúa, Leonardo Favio, Graciela Borges – and the avant-garde musician Juan Carlos Paz (who had

introduced Schoenberg and post-Schoenberg debates to Argentina).

The concerns of these two major films are anticipated in his earlier *Graciela* (1955), which tells of a young girl who comes to Buenos Aires for university studies and meets in her lodgings a strange group of human specimens. The closed, claustrophic world asphyxiates the characters and draws out their abnormalities. *Graciela* is the first of a number of films which explore the corruption of adolescence by the adult world. *Angel* is structured as an extended flashback from the moment in the present when the protagonist Ana Castro is trying to understand how her ideals have been ruined. The flashback takes us to 1925 when Ana, almost fifteen, is beginning to experience the awakening of sexuality. Her cousin has discovered a naked faun in a sculpture park and forces Ana to kiss its stone lips – she recoils in horror and fascination, instinctively embracing another cousin. Torre Nilsson then examines the cloying restrictions of the girl's class, the nanny who preaches hellfire, her mother's religious bigotry, the father's womanizing, the fears of the body (she takes baths in a robe). A counter-argument from her cousin Vicenta, that sex and love need not be a sin, is stifled by her first experience of sex, through rape. The atmosphere of prurience and moral decay is insidiously, erotically, evoked in this depiction of the girl's troubled spirit. *La caída* subtly evokes a class in decline as Albertina, the descendant of a conservative family, comes to study in Buenos Aires (the continuity with *Graciela* is explicit), renting a room in a house dominated by four monstrous little children. Lack of communication, fatalism and lack of conformity characterize the relationship between the protagonists: the four children (instinctive rebels against ethical, religious and social conventions), the bigoted Catholic nationalist suitor, Indarregui, the corrupt mother, the dream character of Uncle Lucas who evades reality. In the final scene, as Albertina goes off in an impossible search for this uncle, the four children sit and listen devotedly to a record of his voice. The return of repressed desires is, however, stifled by the conformity and bigotry of society. These films gave Torre Nilsson a reputation on the international film circuit, but did not guarantee financial security. His projects in the 1960s would always be made in difficult financial circumstances.

Fernando Ayala also made a significant impact in this period, in particular with *El jefe* (The Boss, 1958). Ayala, like Torre Nilsson, had grown up within the industry (though without the benefit of a famous father), working as an assistant to Mugica and Tulio Demichelli. He formed his own production company, Aries Cinematográfico, with Héctor Olivera, anticipating that the new government would be more generous with film credits; the company has continued successfully to this day. He began a collaboration with the young writer and critic David Viñas (one of the intellectuals responsible for injecting a social dynamism into cultural criticism from the pages of magazines such as *Contorno*) and based *El jefe* on a Viñas short story about young men who follow a charismatic but corrupt leader. The leader – a clear reference to Perón – eventually falls, but a new man is ready to take his place, who might be equally

successful in beguiling the young generation. Ayala continued in the same mode with *El candidato* (The Candidate, 1959), which was less successful and followed it with the splendid, but largely ignored, *Paula la cautiva* (Captive Paula, 1963). Here, in the Torre Nilsson–Guido world of the decaying Argentine aristocracy, owners of an old country estate offer tourist shows for North American visitors: barbecues, horse-breaking, folkloric dancing and abundant prostitutes. The prostitution of former patrician values, either literally or metaphorically, was a recurrent theme of the early sixties, reflecting the confident expectation that new social actors were occupying positions of power. Yet such optimism was not based on financial security and Ayala and Olivera found that their means of survival throughout the decade would be sex comedies such as the enormously popular *Hotel alojamiento* (Hotel Lodging, 1965).

The New Wave

Ayala and, in particular, Torre Nilsson gave a prestige to Argentine cinema and helped to encourage a younger generation of cineastes, formed in the cine clubs and in film-making societies. The Argentine Cine Club, for example, organized many programmes where hundreds of shorts were exhibited and the Association of Experimental Cinema gave basic training and lobbied the government for support.[5] The universities also began to open film departments. The government passed the Cinema Law of 1957, which was only partly successful: it did not resolve the perennial problem of an exhibition circuit dominated by North American movies, but it did offer, through the newly constituted National Cinematographic Institute (INC), advance credits for national film-making. All of these conditions helped to spawn the movement which, in homage to its French contemporaries, was known as the 'nueva onda' (the New Wave).

Critics have tended to ignore or dismiss this movement, overwhelmed, perhaps, by the weight and rhetoric of militant cinema which became established later in the decade. Ana López provides the most intelligent critique of the New Wave:

> It was an intellectualised cinema designed for a small, elite, Buenos Aires audience, and its major achievement was to bring to the screen, with the technical fluidity of the European cinema, the world view and individualistic experiences of the Buenos Aires middle class. ... The *nueva ola* filmmakers autobiographically depicted the world they knew – the streets of Buenos Aires, the middle-class problems of angst, alienation and *anomie*, the sexual confusion of the young and the sexual boredom of the old.[6]

All this is true, but should not necessarily be interpreted as a condemnation. This cinema was 'elitist', since it rejected the structures of populism and the dead weight of traditional film-making. The public for such cinema would always be small, as Torre Nilsson pointed out in 1962:

Our public is divided in two. There is a minority that has grown a lot and really supports the cinema, they go constantly and like good films. I don't know if there is a sufficient number of such people. The people who like bad cinema do not go regularly now. ... The quantity of people who want to see a vulgar film may be, for argument, a million, and the people who want to see good cinema only 150,000. That means we will have to work with these 150,000 because the other million cannot be guaranteed as an audience. The problem our industry has in the future is to continue to make good films, economically adjusted to this small audience and its potential overseas sales.[7]

Overseas sales proved to be a chimera, which left a small domestic market that was simply not large enough for the film-makers to cover costs. As artisanal directors, their mode of production was small scale and thus, in a dependent capitalist economy, lay outside the dominant system of large-budget Hollywood productions. Without adequate patronage they would be doomed to failure.[8] Art cinema in Argentina did not work with a sufficiently broad cultural consensus to guarantee its survival.[9]

Yet the New Wave did attempt to incorporate modern themes and language and tried to be specifically national by drawing inspiration from contemporary Argentine writers like Borges and Cortázar. Manuel Antín, for example, a writer turned film-maker, concentrated on the work of Julio Cortázar, who was to become the *auteur-phare* in Argentina in the 1960s and early 1970s.[10] In order to understand the intellectual field in Argentina in the early sixties, one of the best guides is the novel *Rayuela* (*Hopscotch*, 1963).[11] *Rayuela* was modern, openly experimental, relentlessly intellectual, offering a guide to the latest political, intellectual and sexual trends, almost a checklist of the new. The novel moved, as Argentine culture has always moved, in a hopscotch between twin poles of attraction – Europe and America, Paris and Buenos Aires – but without demonstrating any sense of cultural inferiority. Cortázar was an inspirational writer, and his short stories, with their surprising twists, the eruption of the fantastic into everyday reality, attracted European as well as Argentine directors. Antonioni's famous *Blow-Up* comes from the same book of short stories as Antín's *La cifra impar* (The Odd Number, 1962). *La cifra* adapts the story 'Cartas de mama' ('Letters from Mother'), which tells of a couple in Paris who receive letters from the husband's mother. She evokes memories of his dead brother, the wife's former lover, and confidently announces that he will be arriving in Paris. Antín skilfully creates a narrative which weaves two times and two places (Buenos Aires and Paris), isolating the couple in a no man's land where a fantastic intrusion seems the most natural occurrence.

David Kohon's *Tres veces Ana* (Three Times Ana, 1961) is a memorable portrait of three aspects of women's relationships: a student's affair with a businessman which leads to pregnancy and an abortion; a boy who has a weekend beach party of drugs and sex; and a graphic artist in a grim job who dreams of a woman's face glimpsed through a high window. Kohon captures the mood of

the early sixties with assured lyricism and also converts the streets and cafes of Buenos Aires into an important protagonist. Two established actors made important directorial debuts. Lautaro Murúa, Torre Nilsson's favourite, painted a complex portrait of the Buenos Aires lumpen proletariat in *Alias Gardelito* (1960). A frustrated tango singer aspires to rise out of his sordid environment, but is forced into crime and ends up a corpse on a rubbish heap. Murúa shows the underside of the 'city of dreams' Buenos Aires, a degrading, poverty-ridden world where only debased activities have any chance of survival. Favio developed this theme of marginalization in his *Crónica de un niño solo* (Chronicle of a Boy Alone, 1964) focusing on a young boy in an orphanage, treated to all manner of deprivation. He manages to escape from his prison, steal money and find his mother in a slum, where he lives until he is recaptured. Favio eschews senti-mentalism, showing implacable images of child abuse and prostitution which offended the censors of the day. Even though there are clear echoes of *Les quatre cent coups*, Favio's world is more bleak than that of Truffaut. He was to become one of the most interesting directors in Argentina in the sixties and early seventies.

The films of the early sixties, therefore, reflected the new mood of change, the development of an artistic vanguard. Later political radicalization, however, would brush aside their achievements, demanding of film-makers a clear political consciousness.

Towards realist, critical and popular cinema: Fernando Birri

While in Buenos Aires artists were experimenting with vanguard movements, further north, in the city of Santa Fé, Fernando Birri began research which would later be recognized as seminal to the developing 'new' cinemas of Latin America. What was new? Birri had trained at the Centro Sperimentale in Italy, returning to Argentina in 1956. He was optimistic about the lessons learned there, unlike a co-pupil, fellow Argentine cinephile Manuel Puig, who thought that the school was oppressive and dogmatic, employing neo-realist theories as 'a series of principles which they used as a bludgeon against any sort of cinema which differed from that espoused by Zavattini and his followers'.[12] At a time when, according to Puig, the cinema of social protest in Italy had become so rarefied that only an elite could follow it, Birri sought to use neo-realist principles to alter profoundly the nature of Argentine cinema. Birri is currently one of the most visible, accessible and voluble directors in Latin America, and his story has been told on a number of occasions in specialist journals and histories:

> I returned from Europe with the idea of founding a film school modelled after the Centro Sperimentale, where directors, actors, cinematographers, scenographers, sound technicians and so on, would all receive their training. Back in Santa

Fé, once I saw the actual conditions of the city and the country, I realized
that such a school would be premature. What was needed was a school that would
combine the basics of filmmaking with the basics of sociology, history, geography
and politics. Because the real undertaking at hand was a quest for national
identity.[13]

He was invited to teach a four-day seminar by the sociology department at the
Universidad Nacional del Litoral and set the students the task of making
'photodocumentaries' of their environment. According to Birri, this successful
experiment led to the foundation of a film school and to its first important
documentary *Tire Dié* (Throw Us a Dime, 1958) on which some eighty students
observed and recorded the local children of a shanty town who daily risked their
lives running along a main railway line begging for coins. The film developed
as a dialogue with the local community: a first version was shown to different
audiences and the final cut was made after incorporating their suggestions. It
was, in many ways, their film. The film also toured the area with a rudimentary
mobile cinema, a projector loaded on to an old truck, anticipating the mobile
cinemas to be used in Cuba some years later. Other documentaries followed,
including *La primera fundación de Buenos Aires* (The First Founding of Buenos
Aires, 1959), which made extensive use of cartoons by Oski, a well-known
humorist, and *La pampa gringa* (The Gringo Pampa, 1963), which traced the
development of Italian immigration. Birri also made a fictional film, *Los
inundados* (Flooded Out, 1961), a black comedy which depicts the interminable,
picaresque journey of a family, headed by the roguish Don Dolores Gaitán to find
new quarters after their home has been flooded. Some uneven acting and sloppy
editing cannot detract from the power of its social message, as the bureaucracy
of aid organizations and local political bosses offer nothing to the displaced
family. Don Dolores, the trickster, realizes that he is being swindled in a very
direct way. 'We are all Argentines', he says, 'but some people have played us for
fools.'[14] With such work, Birri pointed out a new path for future film-makers:
'The idea was born when Argentine cinematography was disintegrating, both
culturally and industrially. It affirmed a goal and a method. The goal was realism.
The method was training based on theory and practice.'[15]

 With the downfall of Frondizi in 1962 and the ensuing military interregnum,
Birri was subjected to increased censorship and took up residence in Brazil
where he remained until the coup of 1964. He then lived in Italy, returning to
Cuba in the late seventies, reincarnated as the 'pope' of the new Latin American
cinema. Perhaps 'precursor' is a more apt description than pope, for the lessons
he taught were important: the emphasis on national popular cinema, the attempt
to adopt and transform neo-realism in the context of Latin America, and the effort
to break with the distribution and exhibition circuits of commercial cinema,
incorporating new working-class and peasant audiences into more democratic
cultural practices.

Resistance to the military dictatorship: a 'Third Cinema'

Birri's example seemed particularly pertinent in Argentina in the aftermath of the military coup of 1966. The military had firm ideas as to how the country should be run, but little expertise in the cultural field. It intervened in the universities, closing down many faculties, seized magazines, shut theatres on the grounds of morality, ordered imported political textbooks such as works by Marx and Engels to be burned by the Post Office, closed radio news services and television shows. A number of artists and intellectuals reacted to these conditions by leaving the country, but many others became politicized and fought the government in all areas of cultural activity. Their analyses varied in sophistication, but the dominant strands of thought were nationalist, populist and, in many cases, Peronist. Perhaps for the first time in Argentine history, young middle-class intellectuals were predominantly nationalist and anti-imperialist (for it should be remembered that Peronism in the 1940s attracted little support among intellectuals). The European 'universalist' model was called into question for having distorted national development. In a number of research institutes in Argentina and Latin America, work began to appear on the nature of economic and cultural dependency, which explored the links between dependency and underdevelopment, and provided theoretical justification for rejecting the old tradition of uncritically assimilating the latest European trends. Concepts such as 'the people', the 'national' and 'the Third World' were given a new positive value, and the word *extranjerizante* became widely used as a term of abuse to describe those who blindly followed ideas from abroad. However, perhaps the most important aspect, post-Cuba, was that this movement was consciously Latin Americanist. Solanas's film *La hora de los hornos* (The Hour of the Furnaces) is the most sophisticated example of its rhetoric.

Solanas, Getino and the Grupo Cine Liberación (Cinema Liberation Group) made *La hora de los hornos* between 1966 and 1968. It is a colossal four-hour work, divided into three parts. Part I, 'Neo-colonialism and Violence', deals with Argentina's economic and cultural dependency on Europe. Part II, 'An Act for Liberation', talks of Peronism as a force for change in government, both when in power, from 1946 to 1955, and in exile. Part III, 'Violence and Liberation', is a series of interviews with militants discussing the best way of achieving revolutionary transformations. It includes a long interview with Julio Troxler, a survivor of the massacre of Peronist militants by the army in 1956, who would later be murdered by a right-wing death squad, the Triple A, in late 1974.[16] The film demands the activity and involvement of the spectator, in screenings which were political acts and exceptional moments of communication. At the end of Part II a voice declares 'Now the film is pausing, it opens up to you for you to continue it. Now you have the floor.' At the beginning of the second part, the film quotes from Fanon, a passage that sums up the intentions of the film-makers:

> The political meeting is a liturgical act, it is a privileged moment for men and women to hear and speak. To politicize is to open up the spirit, awaken the spirit,

give birth to the spirit, it is, as Césaire says, a means of 'inventing souls'. If it is necessary to involve the whole world in the fight for common salvation, then there are no clean hands, no spectators, no innocents. We all dirty our hands in the mud of our soil and in the emptiness of our brains. Every spectator is a coward or a traitor.[17]

The film is formally complex and ideologically Manichean. Indeed the monological nature of its discourse, which admits no nuance, paradoxically allows the spectator to concentrate on the dazzling nature of its formal composition. Robert Stam says of its complexity:

As a poetic celebration of the Argentine nation, it is 'epic' in the classical as well as the Brechtian sense, weaving disparate materials – newsreels, eyewitness reports, TV commercials, photographs – into a splendid historical tapestry. A cinematic summa, with strategies ranging from straightforward didacticism, to operatic stylization, borrowing from avant-garde and mainstream, fiction and documentary, cinema verité and advertising, it inherits and prolongs the work of Eisenstein, Vertov, Joris Ivens, Glauber Rocha, Fernando Birri, Resnais, Buñuel and Godard.[18]

This stylistic inventiveness is put to the service of revolutionary Peronism and populist nationalism. It follows the analysis of nationalist critics such as J.J. Hernández Arregui, Arturo Jauretche and Jorge Abelardo Ramos in terms of its stark contrasts: on the one hand, the 'national consciousness' – Latin American identity defined in terms of suffering and exploitation – on the other hand, imperialism, the dependent oligarchy and the colonized middle sectors. One important set of images in the first part contrasts the brutality and poverty of outlying areas such as Tucumán with superficially 'swinging' Buenos Aires, full of psychedelic lights, flower children and mini-skirts. The mask of modernization is stripped off to reveal the 'true' nature of Argentine society.

After making the film, Solanas and Getino theorized their concerns in a seminal, bombastic essay 'Towards a Third Cinema', which has had a significant impact in Latin America and in the Third World.[19] The essay covers four themes: cultural neo-colonialism in Argentina, the dependent nature of the Argentine film industry, the Third Cinema, and militant cinema as a crucial aspect of Third Cinema. It argues that in Argentina and in the Third World generally, film-makers must pose an alternative to both the first cinema, Hollywood and the second cinema, the 'auteur' cinema, which does not commit itself to popular struggle:

The first alternative to this type of cinema [Hollywood] arose with the so called 'author's cinema', expression cinema, nouvelle vague, cinema novo or, more conventionally, the second cinema. This alternative signified a step forward in as much as it demanded that the film-maker be free to express himself in a non-standard language and in as much as it was an attempt at cultural decolonization. But such attempts have already reached, or are about to reach, the outer limits of what the system permits.

Instead, the authors continue,

> Real alternatives differing from those offered by the system are only possible if one
> of two requirements is fulfilled: making films that the system cannot assimilate and
> which are foreign to its needs, or making films that directly and explicitly set out
> to fight the system.[20]

This then is the cinema of liberation, the Third Cinema, a production strategy and
a political strategy, which is a mixture of Third World and Peronist 'Third Way'
rhetorics.

Solanas and Getino argued that not only production but also distribution and
reception spheres should be changed. Indeed, their film was banned by the
Onganía government, and was shown through clandestine organizations, in
private houses, on the shop floor, in villages or, on one occasion when the
students in Córdoba occupied their university, to an audience of three thousand
students. It was estimated to have been seen by several hundred thousand people
in this way. Viewing *La hora* with the benefit of hindsight, its faith in Perón
seems pathetically misplaced. Such a caveat cannot, however, deny the radical
impact of the film and its directors in the society of the time.

Solanas and Getino claimed that their film helped to foster a militant film
movement. Certainly several more films were produced by Cine Liberación and
by other left groups. Gerardo Vallejo made *El camino hacia la muerte del viejo
Reales* (Old Reales's Road to Death) in 1971, which dealt with the organization
of sugar-cane workers in Tucumán. Another Peronist, Jorge Cedrón, filmed
Operación masacre (Operation Massacre) in 1969 based on a book by the
journalist and writer Rodolfo Walsh, which revealed that a number of Peronist
militants had been secretly murdered in 1956 by the military government under
General Aramburu for planning the possible return of Perón. Aramburu was later
killed by Peronist guerrillas for his part in this crime. One survivor of the
massacre, Julio Troxler, mentioned above, plays himself in a film that was
initially viewed through clandestine channels, but later became almost a public-
ity film for the future Peronist government. Over two million people are reported
to have seen the film in the period 1969 to 1974.

Another militant cinema group, Cine de la Base, whose main director was
Raymundo Gleyzer, adopted a revolutionary socialist programme which was
extremely hostile to Peronism. Gleyzer's *México: la revolución congelada*
(Mexico, the Frozen Revolution, 1970) examines how the Mexican Revolution
had been betrayed by an institutionalized revolutionary party. The film implies
quite clearly that, like the PRI in Mexico, Peronism is another mass-based,
corrupt, reactionary party, which will also attempt to stifle socialism in Argen-
tina. His following film *Los traidores* (The Traitors, 1973) is even more direct.
It tells of a Peronist union leader, Roberto Barreto, who becomes corrupted by
power and who is eventually gunned down by young militants in his own party

as a class traitor.[21] These two oppositional films reveal the tensions and divisions among populist and left-wing groups throughout this period.

Perón, Perón

The mood of nationalist, populist, anti-imperialist euphoria spread to other sectors of the film industry, especially with the return of Perón in 1973. Getino took over running the state censorship board and liberalized censorship. The veteran actor and cineaste Hugo del Carril was put in charge of the INC. In the period 1973 to 1974 there was a great increase in film production – fifty-four films in just over a year – and cinema attendance rose by some 40 per cent. Torre Nilsson made several films based on heroes of Argentine history and also adapted literary texts of Hernández, Arlt and Puig. The most successful films of the period were anti-imperialist, including *La Patagonia rebelde* (Rebellion in Patagonia, 1974) made by Héctor Olivera, which denounced British control in the south of Argentina in the 1920s. *Quebracho*, 1974, by Ricardo Wullicher also tells of the workers' struggles against British interests in the first half of the twentieth century. Most successful of all in terms of the public was the epic *Juan Moreira*, directed by the multi-talented Leonardo Favio, which takes up, once again, the theme of the oppressed but honourable gaucho fighting for his dying way of life at the end of the nineteenth century. Not every film adopted this rhetoric. Renán's *La tregua* (The Truce, 1973), an intimate sentimental account of an affair between a middle-aged office clerk from Buenos Aires and his young colleague, received an Oscar nomination, and Murúa's *La Raulito* (Tomboy Paula, 1974) was a successful and moving picaresque account of a young girl making her way through the slums of Buenos Aires. The freedom and pluralism of the early seventies were, however, stifled by the death of Perón, the factionalism within Peronism, the terror and impunity of right-wing death squads, in particular the Triple A, and the near civil war which culminated in the military coup of 1976.

In the spiralling violence of 1975 and 1976, film-makers were just one sector affected by the growing terror and repression. A number of directors received death threats and were forced, eventually, into exile. Solanas, Getino and Vallejo left after Vallejo's house was bombed. Lautaro Murúa took up residence in Spain, and a number of actors (Norma Aleandro, Héctor Alterio) and technicians also went into exile or were blacklisted.[22] In May 1976, Raymundo Gleyzer 'disappeared'. In 1977, Rodolfo Walsh also disappeared after delivering an open letter to the regime denouncing its campaign of genocide. A film was later directed in exile based on the Walsh letter, *Las tres A son las tres armas* (The Triple A [death squads] Are the Three Armed Forces), which makes explicit the link between the terror and the armed-forces government. Walsh states:

The Three As today are the three Arms of the military, and the Junta, which you
constitute, is not the point of balance between 'opposed violences', nor is it the just
judge standing between 'two kinds of terrorism', it is rather the very source of the
Terror, which is now running out of control, with death as its only message.[23]

The military dictatorship 1976–83

Under the conditions of terror, censorship and increasing self-censorship,
cinema in Argentina declined rapidly. Production dropped and a diet of inoffen-
sive comedies and musicals become the norm. In the main it was foreign
producers and distributors that benefited from these conditions. The North
American Motion Picture Export Association recorded a great increase in profits
in Argentina in the late 1970s. Yet no one benefited from the blatant censorship
which banned certain foreign films or mutilated others, rendering them incom-
prehensible. These conditions provoked an outraged response from Héctor
Olivera in 1980:

> From the industrial point of view, Argentine cinema appears prosperous. From an
> artistic point of view, it is very poor. Few projects are accepted and I believe that
> the main reason for this state of affairs is censorship, which in Argentina has
> become the most arbitrary, reactionary, incoherent and castrating in the Western
> world.[24]

Occasional films could allude to this reign of censorship. Alejandro Doria's *La
isla* (The Island, 1978) examines the solitude of certain marginal characters
interned in a mental-health asylum. The film was a success, since it dealt with the
continuing Argentine fascination with psychoanalysis, but also alluded in-
directly to the pressures of Argentina under a military dictatorship.

The grip of the military began to slacken in 1981, and film critics and film-
makers became more active as can be seen in the growing confidence of a journal
such as *Cine Boletín*, which began regular publication in May 1981. Important
films by Adolfo Aristarain, *Tiempo de revancha* (Time for Revenge, 1981) and
Los últimos días de la víctima (Last Days of the Victim, 1982) caught the mood
of the new time, adopting a hard-boiled thriller format to deal quite explicitly
with the violence and repression of Argentine society. María Luisa Bemberg also
made a notable debut with *Momentos* (Moments, 1980) and *Señora de nadie*
(Nobody's Wife, 1982), focusing on sexual politics. Bemberg's treatments
caused initial problems with the censors:

> When I wanted to do *Señora de nadie*, there was a military regime in power, and
> they told me that it was a very bad example for Argentine mothers and that we
> couldn't put a *maricón* ... in the film. The colonel said that he would rather have
> a son who had cancer than one who was homosexual, so I couldn't do it. I had

thought that both a homosexual and a separated woman were marginals, and so in the film they get together.[25]

Señora de nadie was premiered the day before the invasion of the Malvinas/ Falklands, a military adventure that would help accelerate the demise of the military government. By mid 1982, the regime was crumbling and the transition to democratic government was underway.

Very few films were produced by Argentines in exile, unlike the astonishing quality and quantity of the Chileans. The latter, of course, had made use of different circumstances, organized solidarity campaigns and a much greater public awareness of the destruction of their country. The Argentine genocide did not receive the same publicity, despite the efforts of a number of countries in support of refugees. Solanas eventually completed post-production work on *Los hijos de Fierro* (The Sons of Fierro) in France and it was released in Paris in 1978. The celebrated gauchesque poem of José Hernández is used as a frame of reference to explore Peronist militancy in the years between1955 and1973, and the film had some success in international festivals and in Paris. Yet Solanas did not find it easy to raise production money in France. It took him a number of years to finance *El exilio de Gardel* (The Exile of Gardel) which was released in 1985. He made only one documentary in exile called, significantly, *La mirada de los otros* (The Gaze of Others). He felt himself to be caught ambiguously in the gaze of the French, a militant of the sixties and seventies, but a strange breed, a militant *Peronist*: 'There was nothing more marginal than to be from the south and, on top of that, a Peronist. ... Everyone was anti-Peronist. For that reason my years in Europe were years of a double exile: as an exile and as a Peronist.'[26] He was never, in his own words, 'a spoilt child of the critics, as is Raúl Ruiz', and he was hostile to the new French intellectuals, from *Cahiers* to Baudrillard. Other directors were scattered across Europe and Latin America without access to finance for filming. Jorge Cedrón committed suicide in Paris in 1980 in mysterious circumstances.[27] From amongst the 'voluntary' Argentine exiles in Paris, interesting work was produced by Eduardo de Gregorio (*Sérail*, 1976 and *La Mémoire courte*, Short Memory, 1979, a meditation on the rise of neo-fascism in Europe)[28] and Edgardo Cozarinsky (*Les Apprentis-sorciers*, The Sorcerer's Apprentices, 1977 and *La Guerre d'un seul homme*, One Man's War, 1981, a brilliant examination of the truth and lies of documentary film).

The return of democracy

In the year up to the election in December 1983 of Raúl Alfonsín, the Radical Party president, nineteen films were made. The most audacious of these was Héctor Olivera's biting black comedy of Peronist militancy in the early seventies *No habrá más penas ni olvido* (A Funny, Dirty Little War, 1983). Based on Osvaldo Soriano's best-selling novel, the film traces the outbreak of civil war in

a small provincial town, where both the good and the bad characters (it is a spoof of the Western genre) die in bloody shoot-outs shouting 'Long Live Perón'. Perhaps fortunately for Olivera, the Peronists did not win the elections, as they had confidently predicted, and the new Radical government abolished censorship and put two well-known film-makers in charge of the INC, Manuel Antín as president and Ricardo Wullicher as vice-president. Antín's granting of credits to young and established directors and his internationalist strategy had an immediate effect. For several years there was a great flowering of talent, a development that was only halted in 1989 by an economy in ruins, with inflation running at 1000 per cent a year. The trade paper *Variety* commented on the success of Argentine films in 1987:

> Argentine films currently are one of the darlings of the festival circuit. You see them at festivals from New Delhi to Montreal, from London to San Sebastian. So invites no longer make headlines, since Argentine films have been winning awards at a dizzying rate. ... Never before has there been such a mass of tangible approval as in the years since democratic rule returned at the end of 1983. In 1986, the Hollywood Academy sealed the trend with its first Oscar for an Argentine picture, 'The Official Story'.[29]

In 1989, however, very few films were released as the economy spiralled out of control.

Economics was the Achilles heel of this process of renovation. According to 1987 figures, it cost on average $300,000 to make a feature-length film in Argentina. Although this represented a tiny fraction of the budget of a Hollywood film, it was a very considerable sum to be recouped in the domestic market. Film audiences have been shrinking in Argentina, as in every other part of the world – it has been estimated that there was a reduction of 50 per cent between the years 1974 and 1984.[30] The number of cinemas also fell by 50 per cent from 2,100 in 1967 to 1,100 in 1985. A production costing $500,000 would need to attract an audience of nearly a million in the domestic market, a figure achieved by only a handful of films. Argentine films receive no protection on the exhibition circuits, with no effective quota system (as for example in the case of Brazil, Venezuela or Colombia), to guarantee that a percentage of the films shown locally are Argentine. Films are largely in the hands of two major exhibition companies, the Sociedad Anónima Cinematográfica and Coll Di Fiore y Saragusti, which control most of the principal cinemas in Buenos Aires. Since money is to be made principally from North American imports, an informal arrangement has grown up whereby the maximum possible number of releases of Argentine films in the central cinemas of Buenos Aires is about thirty a year (roughly one a week, discounting holiday periods). All these constraints make film-making a very high-risk business. The situation is very well analysed in Carlos Sorín's *La película del rey* (A King and His Movie, 1985), which recounts a young film-maker's desperate attempt to tell the story of Orelie

Antoine de Tounens, a Frenchman who in 1861 founded the kingdom of Araucania and Patagonia. The Frenchman's deranged utopic quest is mirrored by that of the film-maker, struggling with no money, a dwindling cast and an inhospitable terrain. Despite winning the award for the best *opera prima* at the Venice Film Festival, the film could still not cover its costs.

The state, while offering no protection in distribution and exhibition, does advance money to initiate projects. The Instituto Nacional de Cinematografía, ably directed by the film-maker Manuel Antín in the Alfonsín years, gave financial backing to nearly all the major films that appeared. However, this money, which covered about 30 to 50 per cent of the total costs, was a loan, not a subsidy. Also, in a country of high inflation, delays in disbursement often mean that the actual sums received are a fraction of their original value. Film-makers are thus constantly demanding more state protection in an economically and politically volatile society. Increasingly the only way to guarantee the financial viability of a project is to enter into co-production arrangements with other countries, which often means attracting foreign stars. *Miss Mary* by María Luisa Bemberg was a co-production with New World Pictures in the United States starring Julie Christie. *La amiga* (1989) by Jeanine Meerapfel used German money, and had Liv Ullmann in the main role. Both these films have Argentine and English versions. Luis Puenzo, the director of *La historia oficial* which won the Oscar in 1986, completed filming the *The Old Gringo* with Hollywood money in 1989 using a galaxy of North American stars.

The attractions but also the disadvantages of such a system of financing projects are obvious. The late eighties did not coincide with the 1960s rhetoric that Latin American cinema should be a 'third' cinema, 'an imperfect cinema', or should express an 'aesthetic of hunger', as there was a deliberate move from film-makers across the political spectrum to capture the market-place. Yet such a strategy raised even more insistently the perhaps unanswerable questions: What is Latin American cinema? What is Argentine cinema? What discursive practices distinguish these cinemas from the Hollywood mainstream? What languages are appropriate and available to current film-makers?

The Argentines would seem to answer these questions with Borges's celebrated phrase that the patrimony of Argentine culture is the universe. The films of the Alfonsín government (1983–89) revealed a great heterogeneity of styles and themes which cannot be fully surveyed here. Two brief points can, however, be made. The first is that after so many years of persecution, direct and indirect censorship, deaths, blacklists and exile, the film-makers showed a great energy and inventiveness in exploring their new freedom – there was a great desire to make films. Secondly, many of the films produced focused directly or obliquely on the traumas of recent history, denied by the 'official version' of the military dictatorship. The conditions that gave rise to a militant cinema of the 1960s (the Grupo Cine Liberación, Cine de la Base, and so on) no longer existed and, as Silvia Hirsch points out,

New movies do not call to arms but to a reflection on the society's ills and conflicts. The new film directors do not attempt to provide solutions to socio-political and economic problems, but instead they are interested in presenting diverse aspects of Argentine society and history, which were previously repressed and which must be analysed in order to construct more solid democratic institutions and overcome the tragic past.[31]

Certain films dealt directly with recent traumas. The Falklands/Malvinas war provided the frame for two major features, Bebe Kamín's *Los chicos de la guerra* (The Boys of War, 1984, a film 'not so much about the Malvinas, but rather the portrait of a generation of young people, a sector of the community which was condemned without being guilty'[32]) and Miguel Pereira's *La deuda interna*, renamed *Verónico Cruz* (1987), a British–Argentine co-production which traced the life of an Andean peasant boy through to his death in the Malvinas.

Many films alluded to the experiences of exile and return or the internal exile suffered during the dictatorship. Instead of offering a long list of titles, which has been provided elsewhere,[33] I will concentrate on two films by Fernando Solanas which may represent these major tendencies: *Tangos, el exilio de Gardel* (1985) and *Sur* (South, 1988), both Argentine–French co-productions. The leading member of Cine Liberación in the late sixties and early seventies, whose film *La hora de los hornos* (1966–68) defined the aspirations (and also the brutal simplicities) of revolutionary Peronism, Solanas received death threats in the mid seventies and took up residence in France. *Tangos* is the distillation of his experiences of these years in exile. It is set among the Argentine exile community in Paris, a group of artists choreographing a *tanguedia* (a tango comedy/tragedy). The tango is made to represent many aspects of the Argentine experience. It is the quintessential popular dance and song form in Argentina. As a dance, it maintains certain steps and rhythms unchanged since the turn of the century, but these are combined into new sequences by the young troupe in the film (the new musical combinations are set out by Argentina's most famous jazz-tango musician, Astor Piazzolla). Argentine culture, Solanas argues, has a tradition which is constantly renewing itself. The lyrics of tango deal with exile and return: a narrator, often far from his native land ('Anclado en París') tells of his longing for the city of Buenos Aires ('Volver', 'Mi Buenos Aires Querido'), its bars and cafes ('Cafetín de Buenos Aires'), its sense of place (the *barrio*), home (the *bulín*), friends (the *barra*). The most famous tango singer of all, Carlos Gardel, represents the image and voice of the tango: he is a folk myth in Argentina. He evokes nostalgia but also personifies a truly Argentine popular culture. Solanas is also conscious of evoking a progressive tradition in the tango, from the sardonic lyricist, Discépolo, of the late 1920s, to the musician Homero Manzi. Both, significantly, were Peronist. It seems that Solanas is still articulating a militant Peronism – like the tango, Peronism must constantly renew itself, adapting to changing circumstances, a point well taken by Carlos Menem who began to turn the traditional orthodoxies inside out after he became president in 1989.

The film focuses on many aspects of the exile experience, the relationship between Europe and Latin America, with their different sources of inspiration for the artist, and in particular, on the young generation. As Solanas states, 'the core of the story is the exile of the new generation, the kids who were teenagers at the time of the coup and were forced to cut their hair and dress in this way or that, or those who had to leave and found themselves caught between two cultures.' A final, optimistic, image posits these young people as the future for the new Argentina.

What Solanas seems to have learned from the exile experience, however, is that films need not be simply didactic weapons, but should also be a source of pleasure, crystallizing desire. He has always attacked the Hollywood cinema (the 'first' cinema in his terms), but his analysis seems now to be more complex. Instead of just dismissing Hollywood as false imperialist consciousness, he now appears to recognize why this cinema has such a great appeal, for Hollywood has rigorously applied the pleasure principle as a structure for articulating, or manipulating, psychic and emotional energy.[34] These dreams and desires cannot be combated by the hectoring denunciatory discourses of the late sixties, but by seeking to release new dreams, new desires, in a language that does not ape the dominant Hollywood languages, but rather seeks creatively to deploy the conventions of theatre, plastic arts and literature. *Tangos* and *Sur* contain hauntingly evocative images, an effect enhanced by the brilliant cinematography of Félix Monti, Argentina's most accomplished and innovative lighting cameraman.

Sur is structurally radical, deploying a number of Brechtian techniques, but it also engages the emotions. A young man, released from many years in prison under the dictatorship, returns home and on this journey revisits all the moments of his earlier life during the military regime, with the guidance of a dead (murdered) narrator, who comes to life for the duration of the narrative. The title *Sur* has many resonances. The south contains the prison camps of the dictatorship, but it also offers the open roads and wide landscapes of freedom. *Sur* is the south side of Buenos Aires, the home of the *compadrito,* the birthplace of tango (which once again structures the narrative). It is the Bar Sur where the 'table of dreams' is laid, around which the characters can plot their projects for liberation. The four old men who sit around the table of dreams are a nationalist intellectual, a union organizer, a progressive military man and a tango singer, the voice of the people: their dialogue and their solidarity posit an alternative past, present and future for Argentina. *Sur* is the dream of a strong independent Argentina, freed from the peripheral status implied by the equation Norte/Sur. The south is the place where the characters, as in Borges (there are several references to Borges in this film, an indication that Solanas's pantheon of intellectual precursors is becoming less exclusive) encounter their 'American destiny', hopefully a utopic one of political freedom and love. The trajectory of Solanas from 1968 to 1988, from *La hora de los hornos* to *Sur*, charts in microcosm the development of committed film-making in Argentina.

Solanas's work implied a constant re-examination of traditional codes in his search for a revolutionary language, 'the utopia of a look that can invent a world'.[35] Other directors deliberately worked with established conventions such as the suspense film or the family melodrama. *La historia oficial* (The Official Version, 1986) makes no attempt to question the language of representation: the family drama has its impact through the weight of its story (the adoption of the child of a disappeared prisoner) and the build-up of its emotions through the central characters. It would be churlish to say (as many critics do) that it deserved the Oscar since it explains away the traumas of recent history in a bright Hollywood form. We must beware of using sixties rhetoric to condemn the very different realities of the 1980s.[36] María Luisa Bemberg also successfully worked within the codes of melodrama in 1984 with *Camila*, which was a huge box-office success. Bemberg deploys melodramatic elements very skilfully in this true story of a young woman of the aristocracy who eloped with a Catholic priest and was executed by the dictator Rosas in the mid nineteenth century.

In *Camila*, the spectator can perceive the contrast between the traditional patriarchal family and the utopic family established by the lovers, between the state power and love, and between traditional and progressive Catholicism. When Rosas's *mazorca* (cut-throat) gangs of state terror kill and maim, the parallels between them and the anonymous killers in the dirty war, in their unmarked Ford Falcons, become inescapable. The film also undermines the stereotypes of women, enshrined in such codes as the nineteenth-century American 'Cult of True Womanhood', a blend of piety, purity, domesticity and submissiveness, or in the idea of the 'fallen woman', a character who populates literature and film and who must be punished for the transgression of sexual mores. *Camila* and *The Official Version* also allowed the Argentine audience a form of collective catharsis, enabling them to experience, in public, emotions that had remained private during the years of the dictatorship. Over two million people wept at the story of Camila O'Gorman, which was their own story: for several months the film outgrossed the main Hollywood features, *E.T.* and *Porky's*.[37]

Bemberg, Puenzo and Solanas were the most visible directors of this period; their reputation guaranteed a continuity of work, despite marked differences of approach. The same stylistic diversity can be found in the films of Sorín, Subiela, Mórtola, Felipelli, Beceyro, Pauls, Barney Finn, Doria, Fischerman, Kamin, Polaco, Pereira, Santiso and Tosso, to list a number of directors who made significant films in the period 1983 to 1989. A major film about the horrors of the military government is yet to be made; there has been a tendency to make quick films alluding to the subject, before moving to something else. Perhaps more distance is needed before that particular moment can be analysed success-fully. The most immediate danger is that this movement – for all its differences it can be called a movement – will be atomized by economic conditions. At the time of writing, it has been announced that Octavio Getino will be in effective

control of the INC under the new Peronist regime. It remains to be seen if he can repeat his brief successes of the years 1973 to 1974, and what part the state will play in fostering and developing cinema into the 1990s.

Uruguay

A report presented in 1967 outlined the parlous state of Uruguayan cinema in that decade:

> Independent production in 1964 totalled two hours: in 1965, two and a half hours and in 1966 one hour. ... Efforts are always sporadic and circumstantial. ... Equipment is incomplete and scarce. ... Virgin film stock is not imported and everything is brought as contraband from Buenos Aires, costing 30 per cent or 40 per cent more than Argentine prices. There are no subsidies or credits. Prizes are almost worthless. Neither the government, nor the creators, nor the critics, nor the cine clubs nor the *marchands* have felt the overwhelming need to establish a national cinema.[38]

Uruguay has quite a dynamic film culture, but one almost exclusively based on foreign films. Always oriented towards Europe, Montevideo has also had to struggle to maintain cultural and economic independence from Buenos Aires. In the early 1950s, Uruguay had one of the highest per capita movie-going rates in the world (fifteen to twenty visits per capita per year). By the late 1960s this had declined to between six and eight visits due to the economic crisis and the impact of television. There were also important institutional initiatives to encourage cinema. The arts organization Sodre (which worked in all aspects of the performing arts), sponsored a bi-annual film festival which was an important early meeting-place for documentary film-makers of the 'new' film movement in Latin America. In 1958, for example, a number of films from Latin America were shown in Montevideo and there was an attempt to organize a Pan-American association of film producers and directors. Little came of this, but it was a significant precursor of later developments in the sixties. At that festival, John Grierson was the guest of honour and could see films from Brazil (Pereira dos Santos's *Rio zona norte*), Bolivia (Ruiz's *Vuelve Sebastiana*), Peru (Chambi's *Carnaval de Kanas*) and Argentina (Birri's *Tiré Dié*). Several cine clubs functioned throughout the country and the left-wing cultural journal *Marcha* also ran a cinema club and a festival in the sixties. There were, therefore, exhibition possibilities for Uruguayan film-makers who began to emerge in the late fifties, possibilities that were always circumscribed by the lack of financial capital invested in their enterprises.

By the late 1950s Uruguay, named the 'Switzerland of Latin America' due to its stable, prosperous democratic society, its modern welfare state based on the riches of the primary export economy, was entering into crisis due to stagnation

of exports, low economic growth and rapid inflation. These contradictions, which the traditional Blanco and Colorado political parties struggled to contain, led to the emergence of an urban guerrilla organization, the MLN (National Liberation Front), also known as the Tupamaros, after the eighteenth-century Andean Indian leader Túpac Amaru, who led a major rebellion in 1780 against imperial Spain. Among those who joined the ranks of the Tupamaros were students, professionals and state employees, predominantly the young and middle class. They began to harass the government with bombings, bank robberies and kidnapping of high-ranking citizens and foreign residents. The civilian government, unable adequately to combat the Tupamaros, called in the military. Many innocent citizens were casualties of the ensuing successful military operation that crushed the Tupamaros and led to the coup of 1973, heralding one of the least publicized and most severe military dictatorships in the history of Latin America. The country became, in the Uruguayan writer Eduardo Galeano's phrase, 'a vast torture chamber'. In the following years, some three hundred thousand people were forced into exile. Film-makers participated in the struggles of the sixties and suffered in the persecution of the seventies.

The few documentary film-makers that began to emerge reflected the crises and the radicalization of these years. The two most important names are Ugo Ulive and Mario Handler. Their aesthetic stimulus came from the Latin American documentaries viewed at the Sodre festival in 1958 and, importantly, from Italian neo-realism. Mario Handler acknowledges that influence: 'In particular the Italian's incorporation of certain documentary-like conventions and techniques to portray intimate aspects of the everyday lives of ordinary people had a great impact on us.'[39] Ugo Ulive began working in theatre but went into documentaries in the mid fifties. He made a fifty-minute fictional film *Un vintén p' al Judas* (A Dime for the Judas, 1959), which tells of a failed tango singer who swindles his friend on Christmas Eve.[40] This neo-realist work was the last fictional film to be produced in Uruguay in twenty years. Ulive next filmed *Como el Uruguay no hay* (There's Nowhere Like Uruguay, 1960), an attack on the stagnation of the two main political parties, the Blancos and the Colorados, and on the general economic and social crisis. It was 'an eight-minute collage that combined contemporary and archival footage with primitive animation and other unconventional devices to create the first effective political satire in Latin American film history.'[41]

Impressed by this innovative short, the Cuban film institute ICAIC invited Ulive to work in Cuba. He returned to Uruguay in 1963 and was to team up with Mario Handler, a young film-school graduate who had studied in Germany, Holland and Czechoslovakia. Handler's first major work was a portrait of a tramp he had befriended in the port area of Montevideo, and the thirty-minute documentary *Carlos: Cine-retrato de un caminante* (Carlos: Cine-Portrait of a Tramp, 1965) examined Uruguayan society through the activities of one of its marginal members. The filming and editing was done with scraped-together

materials. 'The shooting was slow, exhausting work, and so was the editing, which had to be done with a viewfinder and a projector because there was no moviola in Uruguay at the time. I made all the cuts on the original negative, since I had no money to pay for a work print.'[42]

With Ulive, Handler made a documentary of the upcoming elections of 1966, won by the Colorado party. *Elecciones* is a caustic examination of the way in which political machines generate votes in campaigns that are concerned with power rather than an analysis of political and social tensions. It was screened at the Marcha festival in 1967, but banned by the Sodre in the same year. Despite a vocal campaign in the film's defence the ban was upheld and Ulive left once again for Venezuela where he was to become an important member of the Venezuelan cinema boom of the 1970s. The film did receive an important commercial release thanks to the enterprise of independent producer and exhibitor Walter Achugar, who pioneered the distribution of the Latin American new cinema in Uruguay as a way of stimulating local production:

> My idea has always been to use distribution as the foundation stone for production. Rather than coming *after* the production stage, a coherent distribution policy should precede it and guarantee its continued existence. I have always thought that, in economic terms, *films should nourish film.* Why not use movies to make movies?[43]

Achugar, in close collaboration with an Argentine colleague, the producer Edgardo Pallero, rented a cinema in Montevideo, appropriately named Cine Renacimiento (The Renaissance Cinema) and began programming Cuban, Brazilian and other Latin American movies, including *Elecciones*. Achugar also encouraged Handler with his subsequent short documentary *Me gustan los estudiantes* (I Like Students, 1968) which was produced for the 1968 Marcha film festival. Handler went out to film the student demonstrations that occurred in protest against the holding of a Conference of American Heads of State in the elegant seaside resort of Punta del Este in April 1967, a conference which included dictators such as Stroessner from Paraguay, Costa e Silva from Brazil and Onganía from Argentina. He later filmed a sequence shot of the heads of state in Punta del Este, and intercut the two movements of Punta del Este luxury and student militancy in Montevideo (which was brutally repressed by the police). He added a musical score to the student activities – Violeta Parra's 'I Like Students', sung by Daniel Viglietti, a leading exponent of 'new song' – and left the Punta de Este shots silent. Handler edited the six-minute print without adequate equipment, but it proved to be a major success. At the Marcha festival,

> the members of the audience were so indignant at the visual proof of official violence in their enlightened country that they rushed out of the theatre and staged a spontaneous demonstration in the Plaza de la Libertad across the street. *La Nación*, Argentina's leading newspaper, ran a headline that read 'Uruguayan Film Provokes Tumult'.[44]

The success of Handler's film, the impact of the films of the New Latin American Cinema and the general climate of cultural and political militancy in the country, helped to inspire the foundation of the Cinemateca del Tercer Mundo (Third World Cinemathèque) in Montevideo in November 1969 which worked in all aspects of film production, distribution and exhibition. The Cinemateca assisted Handler in the making of two documentaries in 1970: *Liber Arce, liberarse*: (Liber Arce, Liberation), a silent film which followed the funeral cortège of the first student killed by the police in 1969 and *El problema de la carne* (The Meat Problem, 1969), around a mass strike of packing-house workers. Other film-makers involved at that time included Mario Jacob, Marcos Benchero and Eduardo Terra.

As the political polarization increased the Cinemateca became a very visible site for military raids and seizures. In October 1971 seven of its members were imprisoned for a short time and film prints were taken away. In May 1972, two of the directors of the Cinemathèque, Eduardo Terra and Walter Achugar, were arrested, tortured and held incommunicado. Achugar was detained for two months, then freed after a widespread international campaign in his favour. Terra was imprisoned for four years. As the long night descended, the artistic community spread into exile.

Film-makers exiled abroad, such as Ulive and Handler, maintained a steady output in the 1970s and 1980s. Within the country itself, a group of cineastes started up the Cinemateca Uruguaya once again, funded by around ten thousand members' subscriptions. This organization has had an extraordinary success. It has built modern vaults for the safe storage of its five thousand film titles from all over the world. It runs daily programmes in five different theatres, has a library, edits a journal and film books and encourages film projects including a feature-length fiction film *Mataron a Venancio Flores* (They Killed Venancio Flores, 1982) directed by Juan Carlos Rodríguez Castro which, in its depiction of the bloody feuding and violence of the 1860s in Uruguay, referred clearly to the recent history of terror. The Cinemateca helped to keep film culture alive during the military dictatorship and has continued that role in the first tentative years of democracy.[45] The most recent developments in Uruguay have been predominantly in video, and a number of small production companies have been formed, working in film and video. The fresh and lively talent demonstrated in the work of such groups as Producciones del Tomate promise an interesting future.

Paraguay

Unlike its River Plate neighbours, Paraguay has not, until now, been able to sustain a national film culture. A local elite, allied to foreign capital, ruled the country between 1870 and 1940, fighting over control of lucrative foreign trade. A moderate nationalist coalition did emerge at the time of the Chaco War with

Bolivia in the mid 1930s, but these brief moments of political debate were finally suppressed in a bloody war in 1947, in which the centre and left parties were decimated. After the war, the first mass exodus from Paraguay occurred. It is estimated that by 1979 almost one third of Paraguay's two million inhabitants were living outside the country, often forming a shifting, impoverished population around neighbouring cities such as Buenos Aires. Out of the war, General Alfredo Stroessner gradually emerged as a military leader and head of an authoritarian single-party state. He invited massive foreign investment benefiting a small, corrupt elite, allowed Brazil to make incursions into the country, waged war against the native Indian population and increased an unequal system of land tenure. At a time when Argentina and Uruguay lived through the optimistic conditions of the sixties, the country was controlled, until the fall of the dictator in 1989, by fear, torture, imprisonment and ruthless suppression of political opposition. The cultural community was harassed and divided: many lived the loneliness of exile or remained asphyxiated in the country. Some artists produced remarkable work in these conditions – the writing of Augusto Roa Bastos is exemplary in this respect – but in cinema the work was scattered and isolated.

In the 1950s, which saw the emergence of Torre Nilsson and New Wave directors in Argentina, some commercial Argentine cineastes saw in Paraguay a place to obtain cheap film stock (avoiding Argentine taxes and restrictions) and exotic locations. The extremely successful light pornographic team of Armando Bo and his favourite actress Isabel Sarli – known as the most hygienic actress in cinema since she was always taking her clothes off to have a bath[46] – took advantage of the conditions. There was the beginnings of an independent film movement in the mid sixties pioneered by Carlos Saguier and Jesús Ruíz Nestosa, who produced several documentary shorts on different aspects of the country's diverse culture. In 1969, Saguier directed, against the odds, a forty-minute documentary, *El pueblo* (The People) which caused the Lima-based film journal *Hablemos de Cine* to exclaim, in agreeable surprise, 'Paraguayan cinema exists'.[47] The Peruvian critic Isaac León Frias went on to explore the technical complexity and assured style of the film, which traces a day in the life of a remote village representing the whole Paraguayan people (*pueblo* can be translated as people or village). The daily routine, the monotonous and insistent rituals, the power of religion and the grinding poverty are all captured in an implacable portrait of this 'land without men and men without land' in Roa Bastos's phrase.

The state's repressive apparatus soon silenced this film and the country lived through a further twenty years of dictatorship, described here by Roa:

> The fragmentation of Paraguayan culture, together with the imbalance of its forces of production and this paralysing fear which has taken on the characteristics of both a public and a private, an individual and a collective consciousness, has had a profound effect both on the creative forces of a society which, to add insult to

injury, is situated on the banks of one of the world's most beautiful rivers, a river which gave the country its mythical name *Paragua'y*, 'plumed water' or 'river of the crowns'. Brutality and terror have dried up the sources which feed those works of writers and artists that illustrate the originality of a people.[48]

In such conditions only works promoted by Stroessner, such as the epic *Cerro Cora* (1977), a paean to reactionary nationalism, had any chance of reaching an audience. It is to be hoped that film-makers will play an important role in Paraguay's new post-Stroessner regime, producing works 'at the centre of a community's social energy and drawn from the essences of its life, reality, history, and those social and national myths which fertilize the creative subjectivity of poets, novelists and artists.'[49]

Notes

1. Fernando 'Pino' Solanas, *La mirada: Reflexiones sobre cine y cultura*, Puntosur, Buenos Aires 1989, p. 88.

2. Quoted in Jorge Abel Martin, *Los filmes de Leopoldo Torre Nilsson*, Corregidor, Buenos Aires 1980, p. 30.

3. For an interesting analysis of Torre Nilsson see Alberto Ciria and Jorge M. López, 'Sobre Leopoldo Torre Nilsson (1924–1978): Literatura, cine e historia.' I am grateful to Professor Ciria for sending me this as yet unpublished paper.

4. Tomás Eloy Martínez, *La obra de Ayala y Torre Nilsson*, Ediciones Culturales Argentinas, Buenos Aires 1961.

5. Ana López, 'Argentina 1955–1976, The Film Industry and the Margins', in J. King, N. Torrents, eds, *The Garden of Forking Paths: Argentine Cinema*, BFI, London 1988, p. 52.

6. Ibid., p. 55.

7. Leopoldo Torre Nilsson, 'How to Make a New Wave', *Films and Filming*, November 1962, p. 20.

8. See Pam Cook, 'The Point of Self Expression in Avant-Garde Film,' in J. Caughie, ed., *Theories of Authorship*, Routledge and Kegan Paul, London 1981, p. 272.

9. For an analysis of the situation in Germany at that time, see Thomas Elsaesser, *New German Cinema: A History*, BFI, London 1989, in particular his chapters on *auteurs*.

10. Here I am using the term of Pierre Bordieu in the sense of 'guiding' intellectuals who help to shape the intellectual field.

11. For an analysis of Argentine culture in this period see J. King, *El Di Tèlla y la cultura argentina en la década del sesenta*, Gaglianone, Buenos Aires 1985.

12. Manuel Puig, 'Cinema and the Novel' in J. King, ed., *Modern Latin American Fiction: A Survey*, Faber and Faber, London 1987.

13. Interview with Birri, in J. Burton, *Cinema and Social Change: Conversations with Film-makers*, University of Texas Press, Austin 1986, p. 284.

14. See the analysis of the film by Jorge Abel Martín in *Latin American Visions*, The Neighborhood Film/Video Project of International House, Philadelphia 1989, p. 9.

15. Fernando Birri, 'Cinema and Underdevelopment' in M. Chanan, ed., *Twenty Five Years of the New Latin American Cinema*, BFI, London 1983, p. 10.

16. For Solanas's homage to Troxler, see Fernando 'Pino' Solanas, *La mirada: Reflexiones sobre cine y cultura*, Puntosur, Buenos Aires 1989, pp. 50-53.

17. Ibid., p. 207.

18. Robert Stam, 'The Hour of the Furnaces and the Two Avant-Gardes', *Millenium Film Journal* 7–9, Fall/Winter 1980-81, reprinted in C. Fusco, ed., *Reviewing Histories: Selections from New Latin American Cinema*, Hallwalls Contemporary Arts Center, New York 1987, p. 92.

19. See Roy Armes, *Third World Film Making and the West*, University of California Press, Berkeley and London 1987.

20. F. Solanas and O. Getino, 'Towards a Third Cinema' in Chanan, p. 21. See also Solanas and Getino, *Cine, cultura y descolonizacion*, Siglo XXI, Buenos Aires 1973; O. Getino, *A diez años de 'hacia un tercer cine'*, Mexico 1982; O. Getino, *Notas sobre cine argentino y latinoamericano*, Edimedios, Buenos Aires 1984.

21. For an analysis of Gleyzer's films, see *Raymundo Gleyzer*, Cinelibros 5, Cinemateca Uruguaya 1985.

22. See Andrés Avellaneda, *Censura, autoritarismo y cultura. Argentina 1960–1983*, two volumes, Centro Editor, Buenos Aires 1986.

23. Rodolfo Walsh's letter appears in *Index on Censorship* 5, 1977.

24. 'Only authorised films are works of art', Index on Censorship 4, 1981, p. 27.

25. 'Pride and Prejudice: María Luisa Bemberg. Interview by Sheila Whitaker' in King and Torrents, p. 116.

26. Solanas, *La mirada*, p. 189.

27. 'Death of Jorge Cedrón', *Index on Censorship* 4, 1981, pp. 28–9.

28. See Jim Hiller and Tom Milne, 'Out of the Past: An Interview with Eduardo de Gregorio', *Sight and Sound*, Vol. 49, No. 2, Spring 1980, pp. 91–5.

29. *Variety*, 25 March 1987, p. 85.

30. Octavio Getino, *Cine latinoamericano, economía y nuevas tecnologías audiovisuales*, Universidad de los Andes, Mérida 1987, p. 48.

31. Silvia María Hirsch, 'Argentine Cinema in the Transition to Democracy', *Third World Affairs*, 1986, p. 430.

32. Conversation with Bebe Kamin, Buenos Aires, August 1984.

33. See the article by Nissa Torrents in King and Torrents, pp. 93–6.

34. T. Elsaesser, 'Vicente Minelli' in C. Gledhill, ed., *Home is Where the Heart is: Studies in Melodrama and the Woman's Film*, BFI, London 1987, p. 219.

35. This is the final line of Solanas's book, *La mirada*.

36. Torrents, pp. 93–6.

37. For a more complete analysis of Camila, see J. King, 'Assailing the Heights of Macho Pictures: Women Film Makers in Contemporary Argentina', in J. Lowe, P. Swanson, eds, *Essays on Hispanic Themes in Honour of Edward C. Riley*, University of Edinburgh 1989, pp. 360–82; also Alan Pauls, 'El rojo, el negro, el blanco', *Cine Libre* 7, 1984, pp. 4–7.

38. Walter Achugar, et al., 'El cine en el Uruguay', quoted. in *Hojas de Cine*, Vol. 1, UAM, Mexico 1988, p. 497.

39. Mario Handler, interview, in Burton, p. 16.

40. Peter B. Schumann, *Historia del cine latinoamericano*, Legasa, Buenos Aires 1987, p. 286.

41. Handler, p. 18.

42. Ibid., p. 19.

43. Walter Achugar, 'Using Movies to Make Movies', in Burton, pp. 223–4.

44. Handler, p. 22.

45. See the articles 'Cinemateca Uruguaya' and 'Ese gran lío del cine', in *Hojas de Cine*, Vol.1, pp. 517-33.

46. Rubén Bareiro-Saguier, 'Paraguay' in *Les Cinémas*, p. 417.

47. 'El cine paraguayo existe', *Hablemos de Cine* 63, January–March 1972, p. 45.

48. Augusto Roa Bastos, 'A metaphor of exile', in King. ed., *Modern Latin American Fiction*, p. 301.

49. Ibid., p. 301.

Brazil: Cinema Novo to TV Globo

Cannibalism has merely instutionalized itself, cleverly disguised itself. The new heroes, still looking for a collective consciousness, try to devour those who devour us. But still weak, they are themselves transformed into products by the media and consumed. The Left, while being devoured by the Right, tries to discipline and purify itself by eating itself – a practice that is simply the cannibalism of the weak. ... Meanwhile voraciously, nations devour their people.

Joaquim Pedro de Andrade[1]

Cinema Novo

Developments in Brazilian cinema from the mid 1950s must be seen within the broader context of cultural modernization stimulated by the developmentalist strategies of presidents Kubitschek, Quadros and Goulart (1955–64). Kubitschek came in on a triumphalist note, promising fifty years of progress in five, and indeed the country did witness a remarkable growth: between 1956 and 1961 industrial production increased by 80 per cent. His strategy should be seen, in Skidmore's terms, as developmental nationalism:

Underlying the government's statements and actions was an appeal to a sense of nationalism. It was Brazil's 'destiny' to undertake a 'drive to development'. The solution to Brazil's underdevelopment, with all its social injustice and political tension, must be rapid industrialisation. The success of Kubitschek's economic policy was a direct result of his success in maintaining political stability. ... His basic strategy was to press for rapid industrialisation, attempting to convince each power group that they had something to gain, or at least nothing to lose. This required a delicate political balancing act.[2]

One important symbol of enthusiasm for the modern was the construction of the capital of Brasília, under the direction of the internationally renowned

architect Oscar Niemeyer and town-planner Lucio Costa. The rapid building of the capital was successful in generating a sense that winds of change were blowing away the vestiges of traditional dictatorial or populist practices.

Kubitschek was careful to woo the intellectuals. One influential think-tank of the period was ISEB, the Instituto Superior de Estudos Brasileiros (The Higher Institute of Brazilian Studies) which formulated an important analysis of Brazilian society, condemning the underdevelopment of all sectors of society and producing a series of books and papers in support of developmentalist nationalism.[3] The idea that an intellectual elite should be the analysers and critical conscience of a nation's underdevelopment was central to the early work of the Cinema Novo directors.

Developmentalism, however, was based on massive foreign investment and short-term loans, and Brazil was soon behind with its repayments. The IMF stabilization programme of the late 1950s met with bitter opposition and there grew up a left-wing populism which denounced the control of the economy by foreign capital. Kubitschek's regime dissolved in accusations of mismanagement and corruption and the electorate voted in an independent candidate, Jânio Quadros. His term of office lasted only eight months, and he was replaced by João Goulart, the vice-president under Kubitschek. Goulart sought the support of the left, and his economic plan, directed by Celso Furtado, ambitiously attempted to maintain growth rates, reduce price increases and undertake basic reforms. Yet the regime fell apart under pressure from different sectors and in the face of a growing radicalization from right and left. The military finally intervened on 31 March 1964. The coup brought to an end what is seen as the first phase of Cinema Novo, which in broad terms supported the project of a modernizing Brazil led by progressive elements of a national bourgeoisie.

Cinema Novo was also a product of debates and movements from within the industry. With the failure of the Vera Cruz experiment outlined in Chapter 2 – an attempt at internationalization based on the studio system – workers within the industry debated the options for further, alternative development. Film journals such as *Fundamentos* openly questioned the wasteful spending of Vera Cruz and suggested industrial modes based on low-cost production values. The consensus at two film congresses in São Paulo and Rio in the early fifties was that there was still a pressing need to build up a strong film industry with state support, but there were strong disagreements as to the appropriate models to be adopted.[4] The climate of debate and criticism was further developed in the programmes of cine clubs and the filmothèques in Rio and São Paulo and in the important theoretical works of Alex Viany and in particular Paulo Emílio Salles Gomes. From the mid 1950s, Salles Gomes was developing an influential analysis of Brazilian film history as the site of colonial penetration, criticizing the cosmopolitanism and universal values of 'good' cinema as mere instruments of colonial domination. He encouraged 'peripheral' artists to make creative use of their situation instead of yearning for the models of the metropolis.

The model that was to emerge, of low production costs, location filming and use of non-professional actors received its theoretical justification in the examples of Italian neo-realism and the French New Wave. Nelson Pereira dos Santos, the precursor and leading director of Cinema Novo acknowledged his debt to neo-realism:

> The influence of neo-realism was not that of a school or ideology but rather as a production system. Neo-realism taught us, in sum, that it was possible to make films in the streets; that we did not need studios; that we could film using average people rather than known actors; that the technique could be imperfect, as long as the film was truly linked to its national culture and expressed that culture.[5]

Another dynamic force in Cinema Novo, as a theorist and as a film-maker, Glauber Rocha, triumphantly proclaimed the *auteur* theories of French New Wave as a way of casting off the dead hand of commercial cinema:

> François Truffaut asserted very well that ... 'il n'y a pas davantage ni bons ni mauvais films. Il y a seulement des auteurs de films et leur politique, par la force même des choses, irréprochable.' If commercial cinema is tradition, *auteur* cinema is revolution. The politics of a modern *auteur* are revolutionary politics.[6]

This rather broad statement is sharpened throughout his book-length study of Brazilian cinema: the revolution, for Glauber, is the intersection of *auteur* cinema with a social conscience and the invention of a language of underdevelopment which incorporates into fiction the stylistic traits of the documentary. The break with the language of industrial cinema opens up a possibility of 'transforming the poverty of means into stylistic invention'.[7]

Glauber chose Nelson Pereira dos Santos as an exemplary *auteur*. It was his early documentaries such as *Rio 40 Graus* (Rio 40°, 1955) that, for Glauber, set the example for young film-makers.

> It was possible far from Studios of Babilonia, to make films in Brazil. At that moment many young people freed themselves from an inferiority complex and decided that they could be directors of Brazilian cinema *with dignity*; they also discovered from that example, that they could *make cinema* with 'a camera and an idea'.[8]

Rio 40 Graus focuses in the main on the slum dwellers of Rio de Janeiro, following the activities of five peanut-sellers in different parts of the city. They encounter a number of stock characters who represent a cross-section of Brazilian society, all of whom fall under dos Santos's critical gaze. The film skilfully uses both melodrama and humour in charting the boys' struggle to eke out a living.

Two years later, dos Santos made *Rio Zona Norte* (Rio Northern Zone, 1957), about the life and death of a Samba composer, Espirito da Luz Soares; played by

Grande Otelo, the black star of myriad *chanchadas*. However, instead of remaining the comic side-kick, which was his designated role in the *chanchada*, Grande Otelo is seen here as the main protagonist, a source of a vibrant popular culture, who is exploited by class and also by race. In Robert Stam's phrase, 'race ... is both a kind of salt rubbed into the wounds of class and a wound in itself',[9] as Espirito is excluded from the main sources of cultural power and is exploited by unscrupulous music entrepreneurs. Yet the film maintains a faith in spontaneous popular culture and in the possibilities of rebellion of the underprivileged sectors. Dos Santos intended to complete a trilogy of Rio films, but lack of funds prevented the making of the third film.

Cinema Novo developed through the different practices of young filmmakers largely resident in Rio in the early sixties: Glauber Rocha, dos Santos, Ruy Guerra, Carlos Diegues, Joaquim Pedro de Andrade. Their early work, for all the heterogeneity of styles, shares certain common traits. There was a perhaps idealist assumption that they were a radical expression of Latin American 'otherness' in the face of the neo-colonial cultural system.[10] 'Cinema Novo is not one film but an evolving complex of films that will ultimately make the public aware of its own misery', proclaimed Rocha, the most enthusiastic theoretician of the process. Here he articulates one of the paradoxes of Cinema Novo, which attempted to create popular cinema not for popular consumption (there is an important ambiguity between the words *people* and *public*), a political cinema outside the formal political parties and a film industry without producing industrial films.[12] Cinema could be one part of the process of 'conscientization', educating the people out of alienation.

Consciousness is seen as an essential prerequisite to efficient political and revolutionary action. In 1962 Glauber Rocha filmed *Barravento* (The Turning Wind), the first feature-length Cinema Novo film. There is a very clear message that religion prevents a fishing community from understanding the real conditions in which they live. Firmino, a character who returns from the city, educates them out of this religious mystification. The city, the bourgeois and the urban proletariat are largely absent from these early films: the privileged space is that of the desolate Northeast of Brazil, the deserted backland, the *sertão*, with its social bandits, *cangaceiros*, and messianic leaders. Three films in 1963, dos Santos's *Vidas secas* (Barren Lives), Ruy Guerra's, *Os fuzis* (The Guns) and Rocha's *Deus e o diabo na terra do sol* (Black God, White Devil) were all filmed in the Northeast and, in their very different ways, explored the problems of unequal development and the oppression of landowners.

Dos Santos's *Vidas secas* is based on the novel of the same name by Graciliano Ramos, the great critical realist writer, whose Northeast novels were a clear reaction to the avant-garde modernism of the 1920s. The book describes the grinding poverty of Fabiano, a cowhand, his wife Sinhá Vitória, their children and dogs, and manages to find some humanistic concern for people who have been brutalized by their living conditions and by the authorities in the town. Dos

Santos finds a remarkable economy of means in his filmic recreation of the novel, as he follows the trail of the family forced by drought to leave the Northeast and travel south to the equally unwelcoming city: 'dos Santos presents images as harsh and inhospitable as the landscape; the spectator lives there only at the price of a certain discomfort. The relentlessly blinding light of Luis Carlos Barreto's camera leaves the spectator, like the protagonists, without respite.'[13] The optimism lies not in the rebellion of the family, who are resigned to the fact that they will always be the losers and that violence would be ineffectual, but rather in the film's assault on its middle-class audience, forced to realize, at a time of widespread debates over land reform, that only far-reaching structural changes could alleviate the pain and misery of the protagonists. The work of Graciliano Ramos, as we shall see, was the inspiration for two further major films, *São Bernardo* and *Memórias do cárcere* (Memories of Prison).

Ruy Guerra's *Os fuzis*, following the success of his dissection of middle- and upper-class urban society in *Os cafajestes* (The Hustlers, 1962), also turned to the Northeast. A detachment of soldiers is sent out to a village to protect the warehouse of a local landowner at a time when the peasants are starving in a drought. No communication is possible between the passive, fatalistic community and the more 'complex,' psychologically developed soldiers.[14] The drama instead focuses on the relationship between the soldiers, and the attempt of a truck-driver, an ex-soldier, to mediate on behalf of the peasants, which leads to his violent death as he tries to hijack a truck carrying stores out of the village. Yet change is possible. The peasants initially worship a sacred ox, since they are told by a messianic figure that their homage will see an end to the drought. They seem passively fatalistic: in one scene, a man advances out of the blinding light, holding the body of his dead child, and lays it in a shack. It is the truck-driver, Gaucho, who explodes at this seeming passivity and attempts a heroic but ultimately futile opposition to the soldiers. The local girl gives herself to the soldier Mário, even though she despises him: power contains its own erotic charge. But at the end, the peasants devour the sacred ox, in an act that might be desperation, or the beginnings of a critical consciousness – what Guerra calls 'the first stage in the growth of a collective consciousness in which individual violence does not find expression in a revolutionary reality.'[15]

The soldiers, and in particular the protagonist Mário, also undergo a change. They patronize and despise the peasants, flaunt their technological superiority (there is a pervasive image of the guns which, in a significant scene, are stripped down and reassembled in front of an uncomprehending audience) and kill Gaucho in an orgy of violence, trying to suppress their own doubts at being members of an oppressive elite. Yet Mário by the end is questioning his actions, beginning a growth of consciousness made explicit in Guerra's later film *A queda* (The Fall, 1977) where Mário, demobbed from the army, is a worker on a building site who understands the economic and social exploitation of the community in which he lives.

While the two films offer a critically realist analysis of the Northeast, the work of Glauber Rocha is openly metaphorical and theatrical.

Only a culture of hunger, weakening its own structures, can surpass itself qualitatively; the most noble cultural manifestation of hunger is violence. Cinema Novo shows that the normal behaviour of the starving is violence, and the violence of the starving is not primitive.[16]

Glauber's tone of violent exasperation is reflected in *Deus e o diabo*, as the peasant couple Manuel and Rosa pass through various stages of revolt. After Manuel kills a landowner, they take up with the messianic religious leader, Sebastião, the Black God. When Rosa kills Sebastião and Antonio das Mortes kills his followers, the couple are led to the *cangaceiro* Corisco, the White Devil bandit. When he in turn is killed by Antonio, a bounty-hunter but also the agent of an obscure destiny, Manuel runs across the *sertão*, seemingly liberated from God and the Devil. This bald account does not hint at the complexity of the film. At a literal level, the two leaders represent different levels of alienation. Sebastião is seen to be in the line of messianic figures whose most remarkable representation was Antonio Conselheiro who, between 1895 and 1897, led a motley rag-bag of followers in Canudos and held out against the might of the modern Brazilian army. His story was recorded by the journalist Euclides da Cunha in his *Os sertões* (Rebellion in the Backlands, 1907) and later rewritten in Mario Vargas Llosa's novel, *La guerra del fin del mundo* (The War of the End of the World, 1981). The ambivalence of both these writers to the nature of millennial movements is initially reflected in the film. Manuel is at first hypnotized by the force of religious conviction, and there is a conflict at the level of representation between Sebastião's supposed sanctity and the regressive actions of his followers. Rosa and Antonio das Mortes eventually rescue Manuel from his thraldom, yet he wanders blindly into the arms of Corisco, a social bandit who kills the poor as a form of euthanasia, to prevent suffering. This violence is also purposeless, and only when Manuel is free from both influences can he escape. Earlier in the film Sebastião had prophesied that the *sertão* would become the sea; in the final image, the camera cuts to the sea. We do not know, as Johnson points out, 'if Manuel himself is conscious of his new role; based on past actions, probably not. But it matters little – what is important is the *moment* of transformation, the explosion, the ecstasy of resurrection and not necessarily the results of the transformation.'[17] The spectator is made aware of the inevitability of revolution in the *sertão*.

The film denies realist representation and seems to be based on oral literature. It is narrated by Julio, a blind singer, and draws on *cordel* (Northeastern broadsheet) literature. This popular form is rewritten and reworked by music from the modern Villalobos, and Julio's discourse is only part of a broader narrative controlled by an authorial voice which, in turn, is constantly contra-

dicted through the editing. The film contains a dazzling array of techniques and changes of mood and pace. These are not mere formalist flourishes; rather, in Xavier's terms, 'The internal movement of the narrative, in its swift changes and irreverent lack of measure, asserts the discontinuous but necessary presence of human and social transformation.'[18] In these and other important fictional films of the first phase of Cinema Novo (Carlos Diegues's *Ganga Zumba*, 1963, a film based on the seventeenth-century maroon community of Palmares, and Paulo Cesar Saraceni's *Porto das Caixas* (Box Port, 1962) there was a similar focus on the urban and rural poor and a similar political optimism that the film-maker, with a camera in hand and an idea for social change in mind, could transform society.

Documentary cinema showed a similar dynamism. One important film, *Aruanda*, made by Linduarte Noronha in 1959 and 1960 in Paraiba, a poor state in the Northeast, shows the miserable conditions of a community descended from slaves. The poverty of resources available to the film-maker was greeted by Glauber Rocha, amongst others, as an important precursor of the 'aesthetics of hunger'. Another symptomatic film of the period, *Artigo 141* (José Eduardo M. de Olivera, 1964), shows images of slum dwellings while a voiceover reads from Article 141 of the Constitution, which proclaims that all citizens have equal rights to food, education and proper living conditions.[19] A group of documentary film-makers also began work in São Paulo. The most interesting work of this region, which appeared the year after the coup, was Geraldo Sarno's *Viramundo*, an analysis of migrant workers from the Northeast who settle in São Paulo. For the first time in the 1960s a documentary focused on the working class, a sector that had been ignored in the early period of Cinema Novo as part of a tacit agreement among film-makers not to criticize too openly the developmental projects of the national bourgeoisie, the basis for Brazilian modernization. Indeed certain film-makers received funds from such national groups as the Bank of Minas Gerais. However, the hopes for the revolutionary potential of this sector were shattered by the coup of 1964.

The Dictatorship and the Role of the State in Cinema

The coup installed a military regime which sought to put an end to left-wing and populist politics. The military perceived that Goulart had tried to place new men in power – radical groups, labour leaders, student activists and left-wing politicians such as Leonel Brizola. They intervened to save the old guard and to guarantee capital and the continent against socialism. Even though the new president, General Castello Branco, mediated between two distinct camps in the military, the hardliners and the pro-constitutionalists, the repressive measures introduced were still severe: the military intervened in the unions, rural organizations were terrorized, there was a fall in wage levels, a purge of liberal elements

within the armed forces, an assault on the student movement, censorship and other restrictions. Yet, to everyone's surprise, left-wing culture was not erased by these measures; rather, it continued to grow until a coup within the coup in late 1968.[20] Bookshops were full of Marxist titles, theatre productions – occasionally raided by the police – were exciting and festive, the student movement continued and radical clergy made significant pronouncements. Cinema Novo also continued to flourish. After the coup, the intellectuals could score a number of effective propaganda points against torture, US imperialism and the stupidity of censors. There was a late flowering of the results of twenty years of previous democracy. There was also increased radicalization on the left (the growth of voluntarist, guerrilla strategies) and the right, which placed intellectuals in an ambiguous position. One of the themes of a number of books and films of the period was the halting conversion of intellectuals to revolutionary struggle with an accompanying analysis of the failure of the left.

The period 1964 to 1968 also witnessed the growth of state funding in culture. Already, in 1961, the Grupo Executivo da Indústria Cinematográfica GEICINE (The Executive Group of the Film Industry) had been set up to examine the nature of the Brazilian film industry. GEICINE worked to increase the exhibition of Brazilian films. It also tried to interest foreign distributors in co-productions and began to give limited financial help. GEICINE's measures did not have time to have much effect, but pointed to the beginning of a state intervention which was to increase greatly after the coup. The Instituto Nacional do Cinema (National Film Institute) was set up in 1966. Its work, as analysed by Randal Johnson, fell into four main categories: '1. financing of imported production equipment, 2. financial awards and subsidies, 3. production financing and 4. compulsory exhibition of national films'.[21] It also gave annual awards to the best films and directors of the year. Production subsidies were based on a share of box-office income, but there was also an additional subsidy for 'quality' films. The film-makers' reaction to accepting favours from such a 'philanthropic ogre', in Octavio Paz's evocative phrase, was varied. Nelson Pereira dos Santos and Glauber Rocha were initially very critical of the perceived fascist nature of state intervention.

Such purity was difficult to maintain in the face of an urgent need to obtain film financing and exhibition. As part of an overall self-questioning, the directors realized that their rather abstract notion of the 'popular' – the film-maker putting his/her art at the service of the people – had to meet the crude facts of the market-place. There was no point in making films that nobody saw. One attempt to capture audiences was to set up a distribution cooperative, Difilme, which worked as a pressure group in the market-place, but the film-makers also perceived that the state offered important guarantees. Cinema Novo directors took most of the money guaranteed for quality films. They also benefited from the screen quotas for Brazilian films.

The possible alliance with the state, the function of the middle-class intellectual and the need to define and to reach its public were all concerns explored in

the period 1964–1968. Glauber Rocha once again offered an acute, complex analysis. His *Terra em transe* (Land in Anguish, 1967) explores

> the contradictions of a socially engaged artist who, misinterpreting himself as a decisive agent in the struggle for power in society, is obliged to confront his own illusions concerning the 'courtly life' in an underdeveloped milieu and discovers his peripheral condition within the small circle of the mighty. Defeated, the artist enacts the agony of his illusory status, the death of his anachronistic view.[22]

In a delirious allegory of the coup, the characters represent the different social forces at play in Brazil in the early to mid sixties. There are the contradictions of the intellectual, torn between attraction and disgust for the power of the court (as part of the allegorical imagery, the head of state is a king with all the trappings of absolute power), attracted to militant action which is ineffective. As he lies dying, Paulo analyses his political role and the events leading to the coup. The left committed errors in supporting Viera, a liberal oligarch, believing in the power and loyalty of the national bourgeoisie and not analysing sufficiently the opportunistic practices of Díaz the dictator. As in Fuentes's novel, *The Death of Artemio Cruz*, the character of Paulo is seen from the inside, his own desires, and from the outside, a critique of these desires. Yet such allegorical analysis can only come later since the film assaults the spectator with a land in a 'trance', a delirious agitated state, where words and sounds bombard the image track, where baroque images point to the continuity of colonial violence between past and present. Other films that deal with the ambiguous nature of the commitment of intellectuals are *O desafio* (The Challenge, 1967) by Paulo Saraceni and *O bravo guerreiro* (The Brave Warrior, 1968) by Gustavo Dahl.

The coup within the coup of December 1968 further radicalized the situation, heralding what critics call the third phase of Cinema Novo, the 'cannibalist–tropicalist' phase. Both terms, cannibalism and tropicalism, refer to strategies of resistance. Tropicalism explores the clash between the traditional, anachronistic modes of Brazilian life and the ultra-modern discourses of the sixties: uneven development is thus explored for its comic possibilities, seen through the lens of those sophisticated artists who realize and express the poverty and stupidity of the country.[23] Cannibalism refers back to the modernist movement in 1920s culture when, as we have seen, Oswald de Andrade posed the provocative 'Tupy or not Tupy, that is the question' as part of his anthropophagous manifesto. Cannibalism is a form of wilful cultural nationalism, suggesting that the products of the first world can be digested and recycled by the colonized, as a way of countering economic, social and cultural imperialism.

Joaquim Pedro de Andrade's filmic adaptation of the 1920s masterpiece *Macunaíma* has cannibalism as central to all the relationships in the work,[24] revealing both voracious capitalist exploitation and also the self-inflicted wounds of the left. *Macunaíma* was a major box-office success, a vindication of Cinema Novo's attempt to attract a major audience through adaptations of literary works.

Another major cannibalist film is Pereira dos Santos's witty critique of the
revenge of the colonized, *Como era gostoso o meu francês* (How Tasty was my
Little Frenchman, 1971). A French explorer is washed up on the shores of Brazil,
becomes incorporated into the Tupinambá Indian community and is allowed to
live for eight months before being killed and eaten in a cannibal feast: his lover
for the period is seen at the end gnawing contentedly on his neck-bone. The film
is spoken almost entirely in a language that approximates to Tupy, with
Portuguese subtitles, a splendid inversion of normal commercial cinema, where
the dominant metropolitan languages are subtitled for Third World consump-
tion.

Though the Cinema Novo directors maintained their domination in the
industry (despite temporary exile and severe censorship), their hegemony would
be questioned and ridiculed by a vigorous underground cinema movement of the
late 1960s: Udigrudi (the supposed Portuguese pronunciation of underground).
Ismail Xavier calls the movement's preoccupations an 'aesthetics of garbage':

> 'Hunger' for Cinema Novo's filmmakers was related to an active impulse, a source
> of rebellion within a dialectic by which the peripheral is converted into a centre of
> historical process. The metaphor of garbage, for the post-Cinema Novo independ-
> ent filmmakers is related to the sense of the peripheral as an inescapable and
> hopeless situation, with no salvationist utopia ahead.[25]

In this vision, the periphery offers no nostalgia for a centre nor does it offer the
eclectic liberating freedom of distance. The periphery is a dump where influ-
ences are recycled through *parody*, a very urban, lumpen form of cannibalism.
Rogerio Sganzerla's *O bandido da luz vermelha* (Red Light Bandit, 1968)
defines this movement. Drawing from the tropicalist interest in bricolage, kitsch
and the manipulation of the culture industry, the film traces the trajectory of a
picaresque hero, the King of Boca do Lixo (the mouth of garbage), through an
underworld of prostitution, drugs, violence and exploitation. There is nothing
redemptive about his actions, he is marginal and a failure. The film-making pro-
cesses, the 'dirty screen' and the recycling of different styles and discourses are
also a deliberate attempt to assault the spectator. According to Sganzerla, the film
is 'a film-summa, a Western, a musical documentary, detective story, comedy
chanchada and science fiction'.[26] He declared his intentions as wanting to make

> an execrable cinema, free, paleolithic, atonal, pamphletist. That is the cinema
> Brazil deserves today. ... The *Bandido da luz vermelha* is a political figure in so far
> as he is a pathetic hood, an impotent rebel, an unhappy, inhibited guy who cannot
> manage to channel his vital energies. ...[27]

Interpreted as an attack on Cinema Novo, and engendering fierce debates, the
film also took the 'aesthetics of hunger' to its logical late-sixties conclusions,
replacing the redemptive optimism with a caustic sarcasm.

For a brief period Sganzerla founded a production company with Julio Bresanne, before both were forced into exile in Britain in the early seventies. Bresanne's *Matou a familia e foi ao cinema* (Killed the Family and Went to the Cinema, 1969) suggests in its title a parricidal assault on the dominant cinema. The horrific deaths, clinically viewed, occur in the first five minutes and the protagonist heads off to view a pornographic film, which becomes merged into the main film. It is an extremely shocking statement, or lack of statement, laconically viewing a series of banal, horrific and erotic scenes, mixing Carmen Miranda with urban squalor, and languid, erotic killings with trite pop songs.[28]

Andrea Tonacci's *Bangue-Bangue* (1971) carried meta-cinema to extremes. The film is plotless, though it seems to use some of the conventions of detective fiction, a genre which requires extremely careful plotting. Towards the end of the film one of the characters, a transvestite glutton, tells, between mouthfuls of food, the possible 'plot': 'Once there were three very nasty bandits. One of them was said to be the mother of the others, but no one knew for sure. They stole everything, killed everybody, screwed everybody. But no one is sure of that either.'[29] In the best traditions of Umberto Eco's *Opera aperta* the spectator must be a co-director, aware that the custard pie thrown at the director in the film might also be aimed at the spectator. Custard pies are thrown by these films, torrents of vomit are unleashed, animality is revealed, dramatic 'overdosing' is the norm. The period of their scandalous success was 1968 to 1972. Many returned from exile in 1973, but their works remained isolated, never recapturing the ferocious disgust of the late sixties.

'Garbage cinema' hurled its disgust at everyone as a scattergun tactic, and as the Cinema Novo directors were wrestling with the problems of censorship and the need to define and reach a 'popular' audience, the state increasingly defined the parameters of future development. By the time directors such as Rocha and Ruy Guerra returned from exile in the early seventies, Cinema Novo had largely disappeared as an integrated *movement* for social change. It was the Cinema Novo directors, however, who were to dominate film-making in the next two decades under the aegis of the state. Embrafilme, the state organization, was initially set up as an international distribution agency for Brazilian cinema. Its activities gradually extended until it began to work extensively in production, exhibition and distribution following its reorganization in 1975. After this time Embrafilme had a virtual monopolistic control over cinema in the country. The screen quota for Brazilian films increased dramatically from 42 days in 1959 to 140 days in 1981. Under the direction of Roberto Farias (1974–79), Embrafilme's budget rose from six hundred thousand dollars to eight million dollars. Embrafilme distributed over 30 per cent of Brazilian films in the 1970s and was responsible for between 25 and 50 per cent of annual film production. The market share of Brazilian cinema increased from 15 per cent in 1974 to more than 30 per cent in 1980. The number of spectators for Brazilian cinema doubled.[30]

Such figures seem to provide irrefutable evidence of the beneficial role of the state. Yet the dilemma remained for film-makers that the state body was supported by an extremely repressive government. The worst period of the military dictatorship came between 1968 and 1972, with severe censorship and brutal measures against guerrilla groups and unions. For a time it seemed that the Brazilian economic miracle was working, with high growth rates. At the 150th anniversary celebrations of independence in 1972, the elite at least had something to celebrate. The oil crisis of 1973, however, severely affected Brazil's balance of payments, and it became increasingly clear that the social cost of the economic miracle was extremely high. In the 1974 elections (to those few posts in the senate and chamber of deputies that were open to elections), the civilian parties made significant gains. A compromise candidate for presidency, Ernesto Geisel, was appointed and supervised a gradual 'decompression' (a term used by the regime) of political repression. But a return to democracy was only a distant possibility. In such a climate, critics of Embrafilme saw it as one of a number of attempts by the state to gain hegemony over elite culture through such organizations as the National Theatre Department, the National Music Institute and Funarte, the National Arts Foundation. Jean Claude Bernadet explicitly stated in 1979 that Geisel's government strategy was to co-opt intellectuals to defuse opposition:

> Without taking over production completely, but through a complex system of legal measures and incentives, the state acquired immense powers of control over the evolution of production, not only industrially and commercially, but ideologically as well. It is reasonable to think that today cinema provides the state with a privileged area to experiment with the elaboration of social control mechanisms in the cultural domain.[31]

National unity could thus be reconstructed at the level of superstructure.

The film-makers disagreed. Carlos Diegues, who became sub-director of Embrafilme under Farias, argued that there was a difference between the state and the government of the day: 'I defend Embrafilme as fundamental at this moment in the economy and development of Brazilian cinema. It is the only enterprise with sufficient economic and political power to confront the devastating voracity of the multinational corporations in Brazil.'[32] Other directors echoed this analysis: 'As long as Embrafilme fights for the expansion of the Brazilian market and looks after exports, I think it is a good thing. It doesn't concern itself with the ideological aspects' (Glauber Rocha, 1976).

> The only credit that remains available [to producers] is Embrafilme, a state-controlled island in a shark-infested ocean of cinema multinationals. Although it shares in the defects of a mixed-economy society, such as suffering from administrative sluggishness, Embrafilme for the moment doesn't show any tendency towards imposing rigid controls, towards dirigisme (Arnaldo Jabor).[33]

It is clear that even if the state body was not *dirigiste*, it did help to define the parameters of the space open to film-makers: an institutional underground, for example, would have been a contradiction in terms. The task, therefore, was to work creatively within the conditions available, without making too many concessions and to attempt to avoid the trap of turning Cinema Novo into a 'cinema nouveau-riche'.[34] Censorship, both self-censorship and direct state censorship, was a daily reality – prints were cut, held back from distribution, scripts were censored. On occasions one arm of the state censored what another state organization had funded. This was the case of *Pra frente Brasil* (Onward Brazil, 1982), directed by Roberto Farias, which despite its rather bland analysis of state repression, was banned for several months. The most visible demonstration of the persecution of intellectuals which provoked major public demonstrations was the death in 1975 of the television journalist and documentary film-maker Vladimir Herzog, killed by the military who then disguised his death as 'suicide'.

The interest of the state can be seen in its encouragement of films based on literary works by deceased authors: an annual prize was set up in 1982 for such works. This was clearly a move to legitimate Brazilian cinema while at the same time neutralizing ideological debates: the present could only be dealt with in allegorical terms. Such a strategy could allow film-makers a great deal of freedom and indeed neatly dovetailed with sixties cinema's interest in adapting the modernist writing of the 1920s and the social novels of the Northeast, in particular Graciliano Ramos. The work of Jorge Amado also offered many opportunities for sexual comedies – *Dona Flor e seus dois maridos* (Dona Flor and Her Two Husbands, 1976), filmed by Bruno Barreto, became the most successful film of Brazilian history, with audiences of over ten million, outgrossed at the box-office only by *Jaws*. One author that eluded successful conversion to the screen was the extraordinary Guimarães Rosa, although traces of his experimentalism can be found in works of the 1960s.

Leon Hirszman's *São Bernardo*, 1973, revealed how a literary adaptation need make no concessions to any homogenizing state discourse. Based on Graciliano Ramos's 1934 novel, it tells of a cynical man who has managed eventually to own the estate of São Bernardo, only to find his triumph eroded by his inability to understand his sensitive wife Madalena. The struggle for recognition and legitimation requires necessary props: a house and a wife, who will produce an heir (parallels with Faulkner's magisterial novel of the South, *Absalom, Absalom*, are clear). Yet Madalena refuses to become a commodity – she reads, uses language in a complex way that her husband cannot understand, holds left-wing political opinions and eventually eludes him through suicide. The protagonist, Paulo Honório, is not merely a one-dimensional character, and the spectator follows his economic and personal disintegration with a mixture of empathy and disgust. The slow pacing of the film and the primacy of long single-sequence shots allow the spectator time and room for critical debate. Hirszman says of the work:

Graciliano Ramos's novel is so rich that it surpasses its temporal limitations and reaches through to our days in its unveiling of the process of a man who gears himself towards capitalist consolidation. ... The audience itself becomes aware of the general and social process, by force of which the character cannot be aware of himself and therefore lives his tragedy. This is a situation that could happen either in 1927 or in 1977.[35]

The military clearly saw the contemporary implications of the work – brutality at the service of capital accumulation – and banned the film for a number of months. Other successful literary adaptations of the seventies included Eduardo Escorel's *Lição de amor* (Lesson of Love, 1975) and Nelson Pereira dos Santos's *Tenda dos milagres* (Tent of Miracles, 1977) which greatly improved on Jorge Amado's wordy novel.

The state was also interested in recuperating history through film, especially at the time of the 150th anniversary of Brazilian independence. From 1975, the state was prepared to give massive credits for the development of historical themes, once again with little success.[36] The two most interesting 'historical' films of the decade, *Os inconfidentes* (The Conspirators, 1972) by Joaquim Pedro de Andrade and *Xica da Silva* (1977) by Carlos Diegues, represent history against the grain of the nationalist, triumphalist desires of the government. *Os inconfidentes* draws its inspiration from a conspiracy organized by intellectuals, led by Tiradentes, against the Portuguese in the late eighteenth century. The birthday of Tiradentes is now a national holiday, but the film constantly subverts heroic vision, the myths of history approved by successive regimes. The conspirators in this version talk endlessly about revolution – the sets are almost always interiors, theatrical spaces where the plotters act out their drama, unable to move from words to action, rehearsing schemes that will fail because they lack any popular support. The use of history as allegory is made explicit at the end of the film when black-and-white footage of a military parade is included. The intellectuals in this analysis repeatedly fail to act effectively in the political sphere because of an inability to link desire to reality.

Xica da Silva presents a more boisterous, optimistic view of colonial history: the slaves, for a brief moment, overthrow the traditional hierarchies. It is a Bakhtinian blueprint: carnivalesque subversion, the rule of disorder, the power of Eros. *Xica* is based on an incident in Minas Gerais in the late eighteenth century, when a powerful Portuguese trader, João Fernandes de Olivera, made a fortune in diamonds and took a black slave mistress who rose to a position of great power over the local society. In Diegues's whacky version, the way to the top is through the clever manipulation of the power of sex. In scenes reminiscent of the Cuban Alejo Carpentier's novel about slave revolution in Haiti, *The Kingdom of This World*, Diegues contrasts an effete European culture with a dynamic, vibrant, 'American' popular culture. Xica dons the accoutrements of courtly splendour: she is a Sun Queen with a whitened face. Yet beneath the

trappings there lies a vibrant, animal dynamism. Although on many occasions the film falls into duplicating those sexual and racial stereotypes that it purports to be satirizing, it is lively, irreverent and was extremely popular at the box-office, being seen by over eight million people in the first few months of its release. It helped to spark a bitter debate as to the nature of 'popular' cinema.

We have seen that early Cinema Novo articulated an analysis of popular culture, and especially of religion as false consciousness, that could be overcome by the modernization of society, itself effected through a progressive bourgeois revolution. Intellectuals could therefore serve as educators, in alliance with the bourgeoisie. The military dictatorship dispelled these illusions, and provoked a profound questioning of the role of the intellectual with respect to the 'people' and to 'the public'. Working-class movements and peasant mobilization were not recorded in the early sixties. The seventies and early eighties saw a radical shift in the subject matter dealt with by cinema: new definitions of the popular emerged and working-class struggle appeared in both fictional and documentary film-making.

An important, somewhat idealist examination of 'o povo' (the people) can be found in two films by Pereira dos Santos, *O amuleto de Ogum* (The Amulet of Ogum, 1974) and *Na estrada da vida* (Road of Life, 1980) and in a documentary by Geraldo Sarn, *Iaô*, 1975.[37] *Iaô* focuses on a *candomblé* ceremony in Bahia, following the purification rights of a group of religious initiates. The film-maker himself undergoes the purification rights, bathing himself in the waters of popular religion. Because the people believe in these ceremonies, they are seen to be progressive and important. Glauber Rocha had already suggested in *Antonio das Mortes*, 1969, that revolution could be found in an ecstatic blending of messianic religion and social banditry – the people are not alienated masses, they are repositories of wisdom that intellectuals must tap into. *O amuleto de Ogum* offers a positive view of *umbanda* (an Afro-Brazilian religous cult). Dos Santos made clear the shift in his own thinking in his 'manifesto for a popular cinema' in which he talked of the need to affirm the principles of popular culture which had previously been ignored or hidden from view.[38] To talk of *umbanda*, therefore, was to concentrate on a religion of the oppressed, which had been persecuted by Western colonizing, universalizing values. The protagonist Gabriel is protected by the amulet of Ogum, the warrior divinity which protects him from bullets and even allows him a 'resurrection' at the end of the film. These propositions are further radicalized in *Na estrada da vida*, in what Bernadet calls a 'Franciscan mise-en-scène', where the values analysed are those of popular music from the Northeast. Two popular singers, Milionário and José Rico (one of the most important musical duos of Brazil, selling over a million records a year), travel the roads of Brazil, around São Paulo, until they gradually achieve widespread success. Their picaresque adventures, their good humour and their values are presented in a transparent way: there is no attempt at authorial, intellectual judgement and no irony. This 'transparency' made the film a huge

box-office success. Dos Santos's work in this period is important in its humility and affection towards 'o povo'. Intellectuals, of course, also read Gramsci and Marx, and Gramsci, in particular, warns against any essentialist analysis of the popular: such a discourse is profoundly contradictory, containing as it does elements of the dominant, hegemonic discourse. For other film-makers, therefore, dos Santos's work was ultimately idealist. They proposed different readings of popular struggle, based on analyses of class struggle.

A queda (The Fall, 1977), directed by Ruy Guerra and Nelson Xavier (the protagonist in this film as in *Os fuzis*) is exemplary in its analysis of the urban proletariat. It takes the soldiers from *Os fuzis* and charts their development fifteen years after their spell in the army. The film uses a great deal of footage from the earlier work, contrasting the black-and-white of the Northeast with the colour and vitality of the late seventies. Mário and Zé are now construction workers on the Rio underground. Zé is killed falling from a construction platform and Mário, attempting to obtain compensation for his friend's family, is caught in a web of company prevarication and deceit. The management of the company are viewed in freeze-frames: they are not individual characters, but part of an impersonal body which wields ultimate power, co-opting or coercing the workforce into obedience. The social world of the workers, on the other hand, is vividly real; the hand-held camera accompanies them in their dirty, dangerous work and explores the intimacy of their personal relations. The antagonism is not Manichean – the working-class protagonist is not idealized, but his growth in political consciousness is clearly signalled. In the brutalized conditions of dependent capitalism, with its shaky edifices on the point of collapse, Mário struggles to build a home of his own, the labour of communal work and solidarity.

Two important films explore the relationship between the artist and the working-class. João Batista de Andrade's, *O homen que virou suco* (The Man Who Became Juice, 1980) follows the migration of a Northeastern poet to São Paulo. Taken for a man who has killed his boss, he must go into hiding, looking for anonymous work. He decides to seek out his double and tell his story, discovering in this way the other side of capitalist exploitation. In the city, he rejects the patronizing, exploitative attitude shown to northern immigrants and, in a dream sequence, dons the garb of a *cangaceiro* and stalks the street of São Paulo threatening passers-by. He therefore remains true to his cultural origins but also seeks to come to terms with his new urban environment by piecing together the story of his double. Like a documentary film-maker, he gathers information, interviews colleagues, trying to capture an elusive reality in art. The gap still remains: he cannot interview the man and cannot hand him his broadsheet, entitled 'The man who became juice'. The artist can only attempt to bridge the gap between himself and his audience by remaining true to his sources of inspiration.[39]

Dos Santos's magisterial *Memórias do cárcere* (Memoirs of Prison, 1984), based on Graciliano Ramos's account of his imprisonment under the Vargas

dictatorship in 1936 and1937, traces the encounter of the writer with people of different classes and types on the penal island of Ilha Grande (where many prisoners of the military in 1964 were also held). As he writes his memories, the prisoners around him contribute to his enterprise, stealing paper, notebooks and pencils for him. They furnish him with their stories and they defend the work against censorship and destruction. When the prison authorities raid the dormitory building to seize Graciliano's scribblings, they find nothing, since each prisoner has hidden a leaf of paper under the bed or in clothing. In the event, the papers stayed in the prison and the writer put down his experiences twenty years later, from memory. In the same way the film-maker,

> filmed from memory, concerned to use the prison as a metaphor for Brazilian society, 'the prison in the broadest sense of the term, the prison of political and social relations which keep the Brazilian people captive'. A fiction, yes, with a certain documentary tone because (in the book as in the film) the expression depends more on the direct contact with the social and political environment that the artist lives in, than with a great concentration on the means of expression chosen. A certain documentary tone, that is, but used to generate a fiction.[40]

Documentary flourished from the late seventies, recording the events of the partial abertura (opening), and in some cases offering the intellectual a role in supporting working-class militants (Greve! by João Batista de Andrade in 1979), especially in the strikes and mass mobilization of the metallurgical workers at the turn of the decade. The most important documentary reconstruction of the period, Cabra marcado para morrer (A Man Marked Out to Die, 1984) bears many similarities to Memórias, especially in the technique of piecing together the stories of its participants. The director, Eduardo Coutinho, set out to film the circumstances surrounding the murder of a leader of the Peasant Leagues, assassinated in 1962. He began work in 1964, using the local peasants and the widow of the leader, Elizabeth Teixeira. The filming was interrupted by the coup, though some film was saved since it was being processed in a laboratory. Elizabeth Teixeira went into hiding, together with her family. Almost twenty years later, Coutinho went in search of the family and the community. Triumphantly, the woman had survived and taken on her true identity once again. Both the film-maker and Elizabeth offer a continuity of struggle that the events after1964 had not managed to erase. In Schwarz's phrase, 'engagé cinema and popular struggle emerge together'.[41] The film recuperates the past, the attempt of students to become engaged with the peasant movement, the dignity of the peasant groups, the nakedness of the class struggle, but it does not suggest any pre-1964 'Golden Age'. The protagonists, as they watch their images of twenty years before, criticize their actions, although in the end declare themselves satisfied with the sense and purpose and commitment that they witness on the screen. If the film-maker and Elizabeth offer an optimistic vision, Elizabeth's

children, scattered throughout the country, paint a different picture. Only one, a doctor in Cuba, has any real job security – the others are victims of the economic 'miracles' which proved illusory.

Towards Democracy and Towards the Crisis

It is misleading to talk about Brazilian cinema in the eighties – there were many cinemas practised by film-makers who experienced gradually increasing political freedoms, but who lost the massive state investment in culture that characterized the seventies. Cinema was thus in crisis. The Brazilian economy, battered by two petrol crises and saddled with a massive foreign debt and the massive increase in interest rates worldwide, suffered severe recessions. By the end of 1983, for example, average wages had fallen about 15 per cent since 1980 and there was severe unemployment: about four million unemployed and eight million underemployed (about a third of the country's economically active population). Only one in four workers achieved the minimum wage. A massive popular mobilization in protest against these conditions eventually ushered in an elected civilian regime, but the economists enjoyed little success in finding a way out of the huge debt problem inherited from the military years. In these conditions, cinema audiences declined dramatically. Randal Johnson provides telling figures:

> The number of registered 35 mm theatres declined from a high of 3,276 in 1975 to a mere 1,553 in 1984. ... Per capita attendance went from 2.6 times a year in 1975 to 0.8 times per year in 1983. The number of spectators dropped from 50,688,000 in 1980 ... to a mere 30,637,544 in 1984.[42]

Television, in particular in the form of the conglomerate TV Globo, had long been a rival to, rather than a sponsor of, film-makers, though there is some evidence that this situation is gradually changing.[43] Production costs rose considerably.

On the threshhold of the 1990s, then, cinema in general lacks the dynamism and experimentalism of the sixties, and the interesting contradictory nature of state-led expansion in the seventies and early eighties. Paranagua puts it thus:

> Brazilian cinema is no longer a large family, but a family affair (literally and figuratively). Outside the self-interested polemics caused by the relative lack of means of production in relation to the large numbers of cineastes who consider it their right to demand of the authorities the possibility to continue their work, the question of the hegemony of Cinema Novo raises a more delicate point. Even after their eruption on the scene in the 1960s, the protagonists of Cinema Novo have often continued to undertake the most ambitious, critical and renovative projects. No subsequent group, current, or movement, however talented and successful, can be compared to this true renaissance of Brazilian cinema.[44]

The untimely deaths of Glauber Rocha, Joaquim Pedro de Andrade and Leon Hirszman have robbed the cinema of some of its major talents, but other members of the initial Cinema Novo project, such as Pereira dos Santos and Ruy Guerra, continue to experiment with different forms. In recent years, Ruy Guerra has twice undertaken the project (which increasingly obsesses Latin American cineastes, for both aesthetic and understandably commercial reasons) of filming García Márquez: *Eréndira* (1982), a French, German and Mexican co-production, and *Fábula de la bella palomera* (Fable of the Beautiful Pigeon Fancier, 1988) made as part of the García Márquez film series funded by Spanish television. Co-productions are of course one way to circumvent the scarce resources of national cinema, and Guerra's *Eréndira* makes good use of a 'star' cast (Irene Papas, Claudia Ohana, Michel Lonsdale, Ernesto Gómez Cruz), to tell the fable of an exploitative grandmother who condemns her granddaughter to endless prostitution in order to pay off a debt. García Márquez was pleased with the result.[45]

Ruy chose a desert location in the dusty wastes of rural Mexico for an imaginary Latin America and found an appropriate language to challenge, like García Márquez, the way in which reality is constructed and controlled. In his most recent film, *Fábula,* he adopts a tone of lyric realism appropriate for an adaptation of *Love in the Time of Cholera*, the García Márquez novel about an aristocrat, a product of *fin de siècle* anomie, who seduces a local girl, the 'beautiful pigeon-fancier' and inadvertently causes her murder. Between these two films he directed *Opera do Malandro* (1984), a stylish musical, following the adventures of the *malandro* – a hustler and a ladies' man – Max Overseas, who tries to play the angles in the nightworld of Second-World-War Brazil, a battleground between Nazi and Allied sympathizers. Guerra invests the musical with a thrilling dynamism, using the lyrics and music of one of Brazil's most popular musicians, Chico Buarque. He has thus managed to present a clear political analysis in a range of different styles. Guerra's most recent project, *Quarup* (1989) is a multi-million-dollar epic based on Antonio Callado's brutal but magnificent novel which breathes new life and vigour into the perennial Latin American debate about civilization and barbarism. Recent austerity measures make it unlikely that such a level of funding will be available to future Brazilian films.

Of the more recent directors, three women stand out, Ana Carolina, Tizuka Yamasaki and Suzana Amaral. Ana Carolina describes her first two fictional films as dramatic comedies. In *Mar de rosas* (Sea of Roses, 1977), a woman cuts her husband's throat and runs away with her daughter, constantly pursued by a threatening masculine presence constantly changing his identity. As in a Borges story, all the characters are facets of one character: all the women are one woman, all the men are one man. The institution of marriage is held under a microscopically cruel gaze:

it is there, in the daily life of each of us, that the reality of the country is to be found, because the repression, the power and the escape, elements on which *Mar de rosas*

is based, are like parallel lines between which my generation jostles along in the most basic aspects of day-to-day life.[46]

In the end, the daughter seems to triumph, making a V-sign to camera after throwing her mother and father substitute out of a train, out of her world. Yet perhaps such a description is a bit too pat: the film cannot be collapsed into a category of being 'about' the middle classes, as Jean Claude Bernadet warns us. The most interesting films, for him, are those in which the director does not totally control his or her material: '*Mar de rosas* is not a film about the middle classes, which tells us that the middle classes are this or that, but rather a film that proposes an aggressive, joyful way of facing up to a historic moment.'[47] Her second feature, *Das tripas coração* (Heart and Guts,1982) explores the male gaze and female revolt in the story of a state school inspector called in to close down a boarding school for rich girls. As he waits for a meeting at the school to begin he dozes and dreams of all the women in the school. Five minutes later he wakes up. The film has the freedom of the dream, exploring the unfocused rebellion of the young adolescent girls, the incompetence and frustration of their women teachers, the lascivious school cleaners, the debauched priest, in a welter of surreal images. Just as the dream becomes an impossible nightmare, the inspector can wake up, sign the paper to close the school and end the film. The spectator, however, does not have such a simple 'closure', forced to compete with an identification with the dreamer and his male obsessions or with the liberating, subversive nature of the dream itself.[48]

Her recent film, *Sonho de valsa* (Dream of a Waltz, 1987), contains a similar quest for the liberation of female desire, as the protagonist is caught in a labyrinth of male 'sign-posts': fathers, brothers, lovers. Her own journey, literally a via crucis, is an exploration of the liberating potential of mysticism, an area theorized by recent French feminists such as Luce Irigaray. Here the mystic communion is seen as an alternative space of female empowerment outside the traditional male structures of Church power, the sermon and the confessional. It is also a condition which purports to escape the specular rationality of patriarchy, through the ecstatic vision of the mystic. The protagonist falls, following the logic of mysticism, into a deep abyss. Here she is still surrounded by the male gaze and in order to escape from its power, she smashes with a crucifix in a final powerful scene a mirror which could represent male 'specularization', a subject that reflects its own being and which forces women outside representation. Through breaking with this power, the woman can open up a space where her own pleasure can be articulated.

Tizuka Yamasaki worked in the seventies as a production assistant for Nelson Pereira dos Santos and Glauber Rocha. Her first major feature was *Gaijin, caminhos da libertade* (Gaijin, The Roads to Freedom, 1980) which explored her own origins as a child of Japanese immigrants. *Gaijin* deals with Japanese immigration after the Japanese-Russian war, and the experience of a group of

immigrants in a coffee plantation in São Paulo. The shattered dreams of being able to become rich in America and return home are played out in the small community, which must adapt, ambiguously, to the new surroundings. Her later films, fictional and documentary, *Parahyba, mulher macho* (Parahyba, a Strong Woman, 1983) and *Patriamada* (Beloved Brazil, 1985) deal with female protagonists, independent journalists, who try to map out a space for women's political and sexual liberation. *Parahyba*, for example, recuperates the history of Anayde Beiriz, a poet and a journalist who was the strong-minded lover of João Dantas, a lawyer murdered by political opponents in the State of Parahyba in the 1930s. Perhaps the best sequence in the film is a song 'duel' between Anayde and a blind singer, a representative of the oral culture of the Northeast of Brazil. Their battle of wits punctures and carnivalizes the empty, sonorous phrases of much of the political discussion in the film and the singer, amazed at the deftness of Anayde's replies, predicts that one day, 'women will have a name and be the equal of men, and the devil will be on the loose'.

However, the reality for many women in Brazil – trapped and inarticulate within the given social structures – is explored in Suzana Amaral's *A hora da estrela* (The Hour of the Star, 1985) an adaptation of the famous novel by Clarice Lispector. Macabéa, the female protagonist, is one of life's victims. A migrant from the Northeast, she has a dead-end job as a typist in an office in São Paulo. She cannot type, she is plain, shapeless and without a language to formulate her rather diffuse desires. Her constant companion and intellectual mentor is the radio, especially the clock radio, which bombards her with facts about the wondrous nature of the planet. Her own reality is more limited, though she longs to communicate with her errant boyfriend Olímpico, who is himself trapped in an incoherent macho role. In the end, Macabéa is promised a better life by a clairvoyant. She leaves the clairvoyant's house imagining herself in a Hollywood narrative where a handsome man in a Mercedes is driving over to declare his love. In reality, the man in the Mercedes runs her over, leaving her prone, but still dreaming, in the gutter.

> As she fell to the ground, Macabéa saw in time, before the car sped away, that Madame Carlota's prophecies were starting to come true. The yellow Mercedes was truly luxurious. ... Her head had struck the edge of the pavement and she remained lying there, her eyes turned towards the gutter. The trickle of blood coming from the wound on her temple was surprisingly thick and red. What I wanted to say was that despite everything, she belonged to a resistant and stubborn race of dwarfs that would one day vindicate the right to protest.[49]

When Suzana Amaral received the first prize for the film at the Havana Film Festival in 1986, she declared that all the Macabéas and Olímpicos in Latin America would one day vindicate the right to protest. Her subtle, understated film helps in this process.

In recent years, the rolling back of the state and the increased privatization of the Brazilian economy has caused a new, ambiguous situation. Embrafilme no longer commands lavish state backing and the private sector remains to be convinced that cinema is a good investment. In 1988, for example, after maintaining an annual average of sixty films for a number of years, the industry released only ten films. Under the new regime of President Collor, Embrafilme is bankrupt, and international capital has not been lured by the carrot of 'debt-equity swaps' into funding cinema. Local capital is equally nervous. The many production companies in Rio and São Paulo – often no more than an office with a telephone, as Héctor Babenco has pointed out,[50] are constantly chasing elusive funds. Argentine-born Babenco is one of the few major international successes of Brazilian cinema. His 1981 film about the marginalized youth of the big cities, *Pixote*, was distributed all over the world, and *Kiss of the Spider Woman* made him a Hollywood star. Most producer/directors have far more limited horizons, and it seems likely that there will be a return to the pattern that obtained in the 1920s in Brazil, with a concentration on regionally based small companies attempting to stimulate film production in different federal districts. The return to democracy has created two conflicting movements: the pursuit of popular, participatory, democratic goals and the need, in a more authoritarian vein, to manage the economic crisis. Popular democratic aspirations – in this case for a vigorous independent cinema – have suffered in the face of crisis management.

Notes

1. Joaquim Pedro de Andrade, 'Cannibalism and Self-Cannibalism in R. Johnson, R. Stam, eds, *Brazilian Cinema*, Associated University Presses, New Jersey and London 1982, p. 83.
2. Thomas E. Skidmore, *Politics in Brazil 1930–1964: An Experiment in Democracy*, Oxford University Press, Oxford 1967, p. 167.
3. Ibid., p. 170.
4. For a full analysis of these debates, see Randal Johnson, *The Film Industry in Brazil: Culture and the State*, University of Pittsburgh, Pittsburgh 1987, pp. 64–86.
5. Quoted in Robert Stam and Randal Johnson, 'The Cinema of Hunger: Nelson Pereira dos Santos's *Vidas secas*', in Johnson and Stam, *Brazilian Cinema*, p. 122.
6. Glauber Rocha, *Revisão critica do cinema brasileiro*, Editôra Civilização Brasileira, Rio de Janeiro 1963, p. 122.
7. Ismail Xavier, 'Critique, idéologies, manifestes', in Paulo Antonio Paranagua, ed., *Le Cinéma Brésilien*, Centre Georges Pompidou, Paris 1987, p. 225.
8. Glauber Rocha, *Revisão* p. 84.
9. Robert Stam, 'Blacks in Brazilian Cinema' in John Downing, ed., *Films and Politics in the Third World*, Autonomedia, New York 1987. p. 260. See also Robert Stam, 'Slow Fade to Afro: The Black Presence in Brazilian Cinema', *Film Quarterly*, Winter 1983.
10. For a full analysis of this utopian project, see Ismail Norberto Xavier, 'Allegories of Underdevelopment: from the "Aesthetics of Hunger", to the "Aesthetics of Garbage"', D. Phil. dissertation, New York University, 1982.
11. Glauber Rocha, 'An Aesthetic of Hunger', quoted in Johnson and Stam, *Brazilian Cinema*, p. 71.
12. I am quoting the analysis of José Carlos Avellar, 'Le cinema novo: les années soixante', in Paranagua, p. 93.
13. Stam and Johnson, 'The Cinema of Hunger', p. 127. See also Johnson's extended analysis of the film in his *Cinema Novo × 5*, University of Texas Press, Austin 1984, pp. 176–83.

14. See Roberto Schwarz, 'Cinema and *The Guns*', in Johnson and Stam, *Brazilian Cinema*, pp. 128-33.

15. Quoted in Johnson, *Cinema Novo* × 5, p. 104.

16. Glauber Rocha, 'An Aesthetic of Hunger', quoted in Johnson and Stam, *Brazilian Cinema*, p. 70.

17. Johnson, *Cinema Novo* × 5, p. 135.

18. Ismail Xavier, '*Black God, White Devil*: The Representation of History', in Johnson and Stam, *Brazilian Cinema*, p. 138.

19. Jean Claude Bernadet, 'Le documentaire' in Paranagua, p. 169.

20. Roberto Schwarz, 'Remarques sur la culture et la politique au Brésil: 1964–1969', *Les Temps Modernes* 288, 1970.

21. Randal Johnson, *The Film Industry in Brazil*, p. 113.

22. Ismail Xavier, 'Allegories', p. 116.

23. Roberto Schwarz, 'Remarques', pp. 37–73.

24. On the metaphor of cannibalism, see Randal Johnson, 'Tupy or not Tupy: Cannibalism and Nationalism in Contemporary Brazilian literature and culture', in J. King, ed., *Modern Latin American Fiction: A Survey*, Faber and Faber, London 1987, pp. 41–59.

25. Ismail Xavier, 'Allegories', p. 31.

26. Quoted in João Luiz Vieira and Robert Stam, 'Parody and Marginality: The Case of Brazilian Cinema', *Framework* 28, 1985, p. 41.

27. Quoted in Paul Willemen 'Chronicle of Brazilian Cinema', p. 28. Both these translations are taken from *Arte em Revista* 1, 1979, p. 19.

28. See Robert Stam, 'On the Margins: Brazilian Avant-Garde Cinema', in Johnson and Stam, *Brazilian Cinema*, p. 321.

29. Jairo Ferreira, 'Andrea Tonacci', *Framework* 28, pp. 115-16. This extract is taken from Ferreira's enthusiastic and empathetic account of marginal cinema, *Cinema de invenção*, Max Limonad/Embrafilme, São Paulo 1986.

30. For a full discussion of Embrafilme, see R. Johnson, *The Film Industry in Brazil*, pp. 137–70.

31. Jean Claude Bernadet, 'A New Actor: The State', *Framework* 28, p. 19. This article is taken from Bernadet, *Cinema brasileiro: propostas para uma história*, Paz e Terra, Rio de Janeiro 1979.

32. Carlos Diegues, 'A Democratic Cinema', in Johnson and Stam, *Brazilian Cinema*, p. 100.

33. Quoted in Bernadet, 'A New Actor', p. 7.

34. The phrase is from David Neves, 'Cinema-novo rico, Cinema novo-rico', *Hojas de Cine*, Vol. 1, pp. 199–202.

35. Quoted in Robert Stam and Randal Johnson, '*São Bernardo*; Property and the Personality', in Johnson and Stam, *Brazilian Cinema*, p. 207.

36. See Jean Claude Bernadet, 'Qual é a historia?' in *Piranha no mar de rosas*, Nobel, São Paulo 1982, pp. 57–68.

37. The following analysis is based on Jean Claude Bernadet, 'Consideraçoes sobre a imagem do povo no cinema brasileiro dos anos 60 e 70', paper given at the Americanist Conference in Manchester, April 1982.

38. 'Manifesto por um cinema popular', Federação dos Cineclubes do Rio de Janiero, Cineclube Macunaima, Cineclube Glauber Rocha, Rio de Janeiro 1975.

39. For an interesting analysis of the film, see Jean Claude Bernadet, 'Méandres de l'identité', in Paranagua, p. 232.

40. José Carlos Avellar's 'Conversación indisciplinada', in *Hojas de Cine*, Vol. 1, pp. 216–17.

41. Roberto Schwarz, 'O fio da meada' *in Que horas são?*, Companheras Letras, São Paulo 1987, pp. 71–8.

42. Johnson, *The Film Industry in Brazil*, pp. 171–2.

43. O. Getino, *Cine latinoamericano: Economías y nuevas tecnologías audiovisuales*, Universidad de los Andes, Mérida 1987, p. 48.

44. Paranagua, p. 130.

45. See the script of Holly Aylett's documentary of García Márquez , *Tales Beyond Solitude*, South Bank Show 1989.

46. Ana Carolina quoted in '*Mar de rosas*: Critical Dossier', *Framework* 28, p. 73.

47. Jean Claude Bernadet, 'Qual é a historia?', p. 134.

48. See João Carlos Rodrigues, 'Das tripas coração', *Framework* 28, p. 81.

49. Clarice Lispector, *The Hour of the Star*, Grafton, London 1987, p. 79.

50. Quoted in Randal Johnson 'The Nova República and the crisis in Brazilian Cinema', *Latin American Research Review*, Vol. XXIV, No. 1, 1989, p. 130.

6

Mexico: Inside the Industrial Labyrinth

If only it were free, the cinema would be the eye of freedom. But for the time being, we can sleep in peace. The eye of the cinema is shackled by audience conformity and commercial interests. The day the eye of the cinema awakens, the world will catch fire.

Luis Buñuel[1]

The Golden Age of Mexican cinema, in decline since the end of the Second World War, had ended by the early 1950s. A cumbersome closed-shop industry, a loss of foreign markets and a stereotyped repetition of once successful formulae all contributed to stagnation. Alberto Ruy Sánchez, the film historian and writer, sums up the situation in trenchant terms:

A national little big industry, articulated by world cinema (dominated by North America), sustained on the basis of limited counter-crises: protectionist laws, semi-obligatory exhibition, attempts to form a monopoly which would finally become a State monopoly, a production based on stereotypes and an organization that excludes renovation in all its aspects.[2]

Each presidential *sexenio* (six-year term of office) would witness the introduction of measures to 'save' the film industry, and these measures would on the whole drive the industry further into crisis. Clearly a bureaucratized 'revolution' dedicated to the development of industrial capitalism was not the best context for the renovation of Mexico's cinema industry.

In 1953, under the new presidency of the dour Adolfo Ruíz Cortines, the director of the Banco Cinematográfico, Eduardo Garduño, proposed a set of modifications, the 'Garduño plan', which centralized all distribution under the direction of the Banco Cinematográfico. State credits, from that time, would be decided by the distribution companies; this meant that they would effectively be granted to the most powerful producers within the distribution network (the

major monopolies such as the Jenkins consortium had interests in both produc-
tion and distribution). State capital thus supported the private investment of
certain producers dedicated to the quick commercialization of *churros* ('quick-
ies' named after the doughy sweetmeat, a breakfast staple). The state would also
pick up the tabs of any losses and so keep in place a mafia of directors, actors,
technicians and studio workers. Commercial cinema of the 1950s thus presents
a bleak panorama. Its mediocrity occurred at a low point in Mexican political life
under the repressive, conservative regime of Adolfo Ruíz Cortines. Production
levels were maintained, but the quality suffered: the successful directors of the
1940s did not maintain their earlier levels and the closed-shop unions denied
access to new talent. Myriad middle-class melodramas, increasingly boring
comedies from Cantinflas – whose humour had lost its cutting edge many years
previously – prurient sex films which lacked the tacky dynamism of earlier
'brothel' films, copies of US adolescent rebellion films, non-rebels without a
cause and without an aesthetic, series focusing on masked wrestlers (starring 'El
Santo' (The Saint)), attempts to gloss over the quality by employing colour or
costly Cinemascope – all contributed to an industry at the lowest point in its
development.

Buñuel in Mexico

There were glimmers of light in the gloom. Buñuel was a radical presence, both
inside and outside the industry, but he remained eccentric to the dominant modes
of filming and left very few traces in terms of influence or disciples in Mexico
(outside the Spanish exile community of film-makers). With hindsight we can
see what was not fully appreciated at the time – that Buñuel was working against
the reigning orthodoxies. One anecdote recounted by Carlos Fuentes, a great
friend of Buñuel, illustrates this point. Buñuel used the Mexican cinematogra-
pher Gabriel Figueroa, whose images defined the lyrical nationalism of the
1940s, for his film *Nazarín* (1958).

> While *Nazarín* was being filmed on location near Cuatla – or so the story goes –
> Gabriel Figueroa carefully prepared an outdoor scene for the director Luis Buñuel.
> Figueroa set up the camera with the snow-capped volcano Popocatépetl in the
> background, a cactus at the right-angle of the composition, circle of clouds
> crowning its peak and the open furrows of the valley in the foreground. Looking
> at the composition, Buñuel said: 'Fine, now let's turn the camera so that we can get
> those four goats and two crags on that barren hill.'[3]

Buñuel's role in Mexico is reminiscent of his protagonist Jaibo in *Los
olvidados* (The Young and the Damned, 1950). The Argentine writer Julio
Cortázar, in a brilliant early review of the film, sets the scene:

Everything is fine in the outskirts of the city, that is to say that poverty and promiscuity do not alter the established order, the blind can sing and beg in the squares, while the young boys play at bull-fighting on dry waste-ground, giving Gabriel Figueroa plenty of time to film them at his leisure. The forms – those official, non-written guarantees of society, that well-defined Who's Who – are satisfactorily observed. ... Then Jaibo enters.[4]

Jaibo is an angel: when they meet him, each of the characters reveals his or her true identity. He flaunts the laws and strictures of society, shatters the myth of the Mexican benevolent state, releasing the desires of love and death, signalling the return of what is repressed by the myth of modernity.

Buñuel worked in a similar fashion, although the weight of the Mexican film industry stifled many of the radical consequences of his cinema. Buñuel could also explore melodrama, a genre that had become routinized in Mexico. A film such as *El* (1953) set in the middle-class Catholic world of Mexico City, seems to have all the ingredients of normal melodrama, with the marriage of a middle-aged virgin Francisco to his young bride Gloria, and his subsequent jealousies. Yet what could have been a soap-opera with Hispanic overtones, a Palmolive *tele-tamale*[5] becomes a macabre nightmare as Francisco displays all the instruments of torture to sew up his young bride's vagina. De Sade here explodes the conventions of melodrama.[6] There is no space for a detailed examination of Buñuel's 'Mexican' films[7] – which include some of his best works, from *Los olvidados* to *The Exterminating Angel* – for he could not alone rewrite the dull chapter of 1950s Mexican cinema. Like Simon of the Desert he was very much a voice crying in the wilderness. Even his compatriot and close friend Luis Alcoriza would favour a form of neo-realism in films such as *Tiburoneros* (Shark Fishermen, 1962), rather than Buñuel's critique of neo-realism. For Buñuel, no one can see things as they are: each perception is filtered and shaped by individual desire. Yet his example would be analysed in the early sixties as young cineastes and critics began to wage a battle against the established cinema.

A New Cinema?

A sign that certain light winds of change might be blowing came with the cine club movement of the 1950s. The cine clubs showed the classics of film history as well as the pioneering work of young directors, and also created the space for serious theoretical, aesthetic discussion of film as an art form. The movement gathered momentum with the establishment of the Cine Club Progreso, which drew its inspiration from French theorists such as Georges Sadoul and Louis Daquín. Other groups sprang up, including the influential university-based society, Cine Club de la Universidad; by 1955 there was a Federation of Mexican Cine Clubs. By the early 1960s, the main strength of the movement lay in the

universities and it helped to foster a generation of students who had a more sophisticated and critical view of the function of cinema.

There was also the timid beginnings of 'independent' cinema – cinema produced outside, alongside or against the dominant industrial cinema. Much of this initiative came from the producer Manuel Barbachano Ponce who in 1953 funded a young director, Benito Alazraki, to make a feature film on indigenous communities entitled *Raíces* (Roots). Shot on location among the indigenous people of Mezquital, Chiapas, Yucatán and Tajín with non-professional actors, the film attempted to explore Indian traditions and denounce the exploitation of archaeologists and foreign 'experts'. Even though it has not withstood the test of time, the film was successful and received a jury prize at Cannes in 1955. It remains a precursor of more detailed cinematographic studies of the Indian in the 1970s, from such film-makers as Archibaldo Burns, Paul Leduc and Eduardo Maldonado. Another interesting film produced by Barbachano was directed by the Spaniard Carlos Velo: *Torero* (Bullfighter, 1956) explores the bullfighter's fear of the ring, in a semi-fictional, semi-documentary mode. Barbachano also financed one of Buñuel's most important films, *Nazarín* (1958), and gave support to the fledgling revolutionary cinema in Cuba by co-producing *Cuba baila* (Cuba Dances, 1959), a documentary by Julio García Espinosa.

The election in 1958 of Adolfo López Mateos seemed to augur well for a renovation of the Revolution as it approached its fiftieth year. He talked of a balanced revolutionary regime, which would take up the mantle of Cárdenas. At first the comparison seemed valid: López Mateos nationalized electricity and spent a great deal of money on social welfare and education. He initially recognized the Cuban Revolution and at the same time travelled the world courting foreign leaders. Even though these policies had only a limited success they did have some immediate impact in the cultural field with, for example, the establishment of a filmothèque at the university and the founding of a film school there, the University Centre of Cinematographic Studies (CUEC). The general climate of optimism engendered in intellectual groups by the success of the Cuban Revolution also had its effects.

In this climate of uneven developmentalism and modernization, a group of critics and cineastes formed the group Nuevo Cine (New Cinema). In the best tradition of vanguard *cénacles* they founded a journal and published a manifesto. The participants – among them José de la Colina, Rafael Corkidi, Salvador Elizondo, J.M. García Ascot, Carlos Monsiváis, Alberto Isaac, Paul Leduc and Fernando Macotela – were to become the most important film-makers, critics and chroniclers of the next twenty years. Their manifesto was a plea for renovation, for artistic creativity, for independent cinema and for specialist film courses, journals and the establishment of a cinemathèque.[8] Only seven editions of the journal *Nuevo Cine* appeared, including an excellent double issue on Buñuel, but in this short span the critics debated neo-realism, the French New Wave, the importance of the *auteur* and the need to reform the unwieldy

structures of Mexican cinema. Salvador Elizondo, who in a later novel, *Farabeuf*, would meditate on the exquisite pleasures and pains of the Chinese 'death by a thousand cuts', chose a rather blunter instrument to wield against the industry. In an article of 1962, 'Mexican Cinema and the Crisis', he blames producers for making money out of quickie *churros*, the unions for jealously guarding their own interests and the state for its misplaced protectionism: all these contributed to the current impasse. How can a system, he asks, that plays safe with established stars and genres, be receptive to any change?

> The system minimizes risks and establishes a certain security for investors. The system, in short, approves the following theorem: *A bout du souffle* would have been a much better film if instead of being directed by Godard with Belmondo and Jane Seberg, it had been directed by Cecil B. De Mille with Vivien Leigh and Marcello Mastroianni.[9]

Nuevo Cine could approve one film, made from within their group, *En el balcón vacío* (On the Empty Balcony, 1961) by Jomi García Ascot. García Ascot directed a script written by his wife Maria Luisa Elio, based on her childhood experiences as a young girl during the Spanish Civil War and her later exile in Mexico. The film was made over a year, at weekends, and cost a small fraction of the average film budget. A Proustian evocation of lost time from a director who would later become one of Mexico's leading poets, its secondary parts are all taken by the literary friends of the family.

Another major incentive to renovate the film industry was to come, paradoxically, from inside the industry itself. The film union, the STPC, nervous at the drop in film production in the early sixties due to a partial flight of private capital (lucrative markets such as the Cuban had been lost after the Revolution as the new regime in Cuba tried to impose some quality control and lacked the hard currency to buy in the open market), announced a competition for experimental cinema in 1964 to encourage new directors. The prize was won in 1965 by Rubén Gámez's, *La fórmula secreta* (The Secret Formula), a film in a dozen sequences which employs to great effect a series of shock images in counterpoint with a varied soundtrack: texts by the great Mexican novelist Juan Rulfo, a child babbling an English lesson, scores from Vivaldi and Rossini.[10] It explores the nature of contemporary Mexican alienation, from the atavistic weight of tradition to the impact of the new imperialism. The original title of the film was 'Coca Cola in the blood': and one sequence shows a blood transfusion with Coca Cola. A worthy winner, but Gámez was not to make another film.

The second prize was given to Alberto Isaac's *En este pueblo no hay ladrones* (In This Town there are no Thieves), a film that was to signal an interesting development in Mexican cinema. It saw the first major film adaptation of the work of Gabriel García Márquez who, on the verge of international celebrity after the publication of *One Hundred Years of Solitude* (1967), maintained close links with the film-makers. The film captures the provincial world of García

Márquez, those lost communities where nothing ever happens and where anarchic protest, erupting in the unbearable tedium, is finally stifled. The film's pacing and framing capture this enclosure and inescapability.

Another Márquez adaptation, by the 21-year-old movie 'brat' Arturo Ripstein (son of the influential producer Alfredo Ripstein), also met with success in 1965: *Tiempo de morir* (A Time to Die). Márquez himself and Carlos Fuentes worked on the screenplay, the story of an ex-gunfighter locked up for killing a man, who cannot settle to a new life after his release since the dead man's sons seek vengeance on him. The plot structure conforms to Márquez's usual handling of time, as William Rowe has observed: 'All of them [the plots] show a fascination with the elapse of long periods of time dominated by a fatal event. In most cases, time takes the form of a postponement or a series of postponements.'[11]

There are traces therefore that the modernization experienced in the field of literature, the so-called 'boom' of Latin American fiction in the mid 1960s, which both reflected and created an ever increasing Latin American readership, also had some effect on cinema. Carlos Monsiváis correctly observes that by the sixties, the Mexican public was looking for different images of itself:

> Socially and culturally what happens is that this [new] cinema is a clear product of the demands of the middle classes to find reflected their problems and their desire for access to universality, to cosmopolitanism in the face of the excesses of a cultural nationalism that had lost its force and dynamism and had become a series of grotesque formulae.[12]

Cultural nationalism was opposed by a movement known as 'la onda' which appropriated a rag-bag of the different modernisms of the late fifties and sixties: beat poetry; new fashions in dress; rock music, especially US rock, which culminated in a massive post-Woodstock pop concert in Avandaro, a pilgrimage for Mexico's 'beautiful people'; and linguistically playful novels: an embrace of European and North American culture, invoking a deliberately non-Latin American aesthetic.

The most 'hip' film-maker of the period was the Chilean Alejandro Jodorowsky who had initially brought his own blend of 'theatre of cruelty' to the rather complacent boards of Mexico City in the early sixties. He filmed a version of an Arrabal work, *Fando y Lis,* in 1967 which gave him a *succès de scandale* and followed this with an international cult movie, *El topo* (The Mole), in 1970, which was a showman's raiding of contemporary styles and modishness. *El topo* was a delirious Buddhist Western, a gunfighter in mourning overcoming impossible odds in a series of sequences combining scatology with surrealism, dismembering the old codes and offering creative chaos in their place, a freakshow of impressive proportions. We are far from the pious certain-ties that informed the Mexican mural movement in the 1920s and 1930s – every-thing can be ransacked or turned upside-down. The late sixties would reveal, however, that this solitary rebellion could be co-opted or ignored by the state.

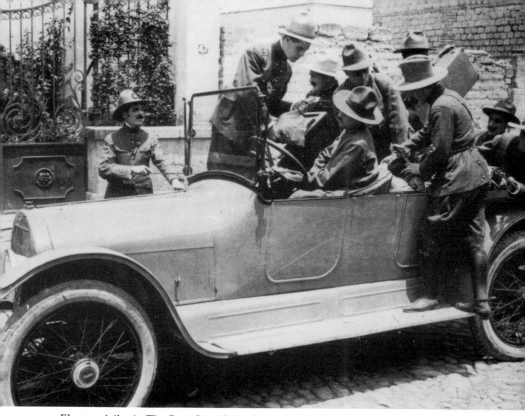

El automóvil gris (The Grey Car, 1919), directed by Enrique Rosas

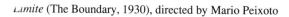

Limite (The Boundary, 1930), directed by Mario Peixoto

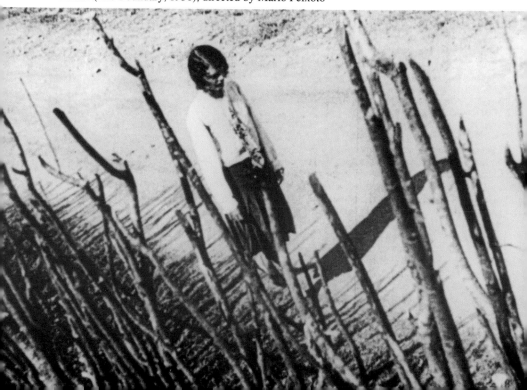

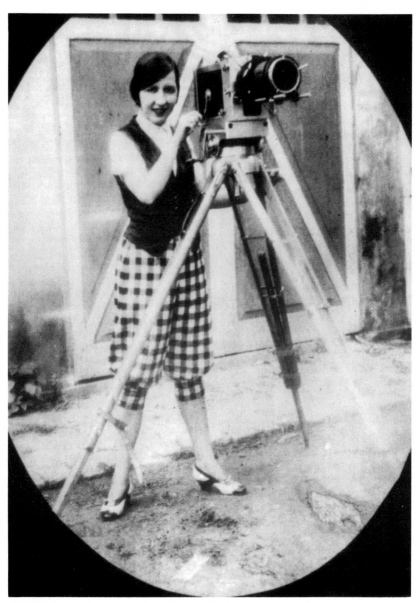

The director, producer and actress Carmen Santos

Dolores del Río and Pedro Armendáriz in Emilio Fernández's *María Candelaria* (1943)

María Félix with María Elena Marqués in Fernando de Fuentes's *Doña Bárbara* (1943)

Oscarito and Grande Otelo in Carlos Mangar's *Matar ou correr* (To Kill or To Run, 1954), *High Noon* Brazilian style

Cantinflas shelters behind Mapy Cortés in Miguel Delgado's *El gendarme desconocido* (The Unknown Policeman, 1941)

Lima Barreto's *O cangaceiro* (1953)

Sara Gómez's *De cierta manera* (One Way or Another, 1974)

Nelson Villagra in Littín's *El chacal de Nahueltoro* (The Jackal of Nahueltoro, 1969)

Grupo Ukamau's *Yawar Mallku* (Blood of the Condor, 1969)

Carlos Vereza as Graciliano Ramos in Dos Santos's *Memórias do cárcere* (Memoirs of Prison, 1984)

Héctor Alterio and Susú Pecoraro in Bemberg's *Camila* (1984)

Modernization and internationalization were accompanied in the late sixties by a major political crisis as the PRI came under assault from different sides. The right-wing party PAN won a series of regional electoral victories which were annulled by the PRI; the most blatant fraud was in Baja California Norte in 1968. The student movement also met with severe repression from July 1968, the police constantly attacking student and secondary schools, at one time blowing down a school door with a bazooka. The constant brutality helped to form a mass student and middle-class campaign against the government's repressive measures:

> Over the course of four months, the 1968 student movement evolved into the most articulate and threatening outburst of public disaffection that a modern Mexican government had ever faced. Not only had the standard techniques of control co-optation and decapitation failed to break the movement, but the students' courage and commitment had begun to inspire other Mexicans. ... Furthermore, the government was pressured to act quickly because the Olympic Games were scheduled to begin on October 12.[13]

In these conditions the government conceived of a 'final solution' to break the students. This occurred on the afternoon of 2 October 1968 when some six thousand people, mainly students, congregated in the Plaza of the Three Cultures in Tlatelolco, Mexico City, to begin a march. The army arrived at six o'clock and opened fire on the demonstrators. Several hundred died in this deliberate massacre, and some two thousand people were arrested.[14] A filmic record of the movement, from July to October 1968, was preserved by the film students at the university and a group headed by Leobardo López Arteche, recently released after a spell in prison, edited a full-length documentary, *El grito* (The Shout, 1968) covering these events.[15] The film is rough cut and relies heavily on the rather emotive eye-witness account of the Italian journalist Oriana Fallaci, but its impact remains very strong, with its raw images of struggle, organization and repression. A number of young film-makers involved with *El grito,* such as Franciso Bojórquez, Raúl Kamffer, Federico Weingartshofer and Paul Leduc, would later make significant contributions to an independent film movement radicalized by the events of 1968.

Echeverría: Intellectuals and the State

The student movement was thus brutally smashed, and the relationship between the state and intellectuals and students was profoundly changed. One example was the immediate resignation of Octavio Paz from his ambassadorial post in India. With the widespread revulsion following the massacre, as all intellectual groups condemned the government, it was clear to the next president, Luis

Echeverría – a man many blamed for the massacre since he was the interior minister in 1968 – that he would have to attempt to restore the prestige of the presidency through conciliatory measures. Echeverría, who took office in 1970, was a very visible and accessible president. He promised a whole gamut of reforms, released the political prisoners of 1968, openly sought to court the intellectual community and, as Rodric Camp points out, 'many intellectuals did allow themselves to be co-opted, whether for prestige or economic security, or on the firm belief that they could influence government policy.'[16]

A bitter debate took place within the intellectual community as to whether or not to respond to such blandishments. Octavio Paz, from the pages of *Plural* and *Excelsior,* kept a critical distance while Carlos Fuentes firmly believed that Echeverría was a committed reformer and should be supported by the intellectuals. He accepted an ambassadorial post in France in 1975[17] and wrote a number of essays in favour of the president. He argued that Echeverría had created a new climate for democratization and had attacked abuses: 'But above all Echeverría lifted the veil of fear that Díaz Ordaz had flung over the body of Mexico. Many Mexicans felt free to criticize, to express themselves, to organize without fear of repression.'[18] One intellectual that Echeverría vigorously sought to win over was the acerbic historian and critic Daniel Cosío Villegas, perhaps Mexico's most important man of letters. Their meetings, wittily recounted by Cosío in his autobiography,[19] came to an end when Cosío published his best-selling analysis of Echeverría's personal style of government, *El estilo personal de gobernar* ('The Personal Style of Government') in 1974. Here he mercilessly analyses the rhetoric and the reality of Echeverría's achievements, criticizing his bombast and empty slogans. He concluded that Echeverría 'is not constructed physically and mentally for dialogue but for monologue, not for conversing but for preaching'.[20]

The same debates were carried on in the cinema sector, although few refused the state's financial help. Echeverría made dramatic changes in this area. He placed his brother Rodolfo in charge of the Banco Cinematográfico, where he introduced a series of wide-ranging reforms. He founded the Mexican Cinemathèque, established a second film school, the CCC (Centro de Capacitación Cinematográfica), and gradually increased the state role in production and exhibition. García Riera[21] provides some telling figures:

Features produced	1971	1972	1973	1974	1975	1976
Private producers	77	61	36	41	33	15
The state	5	20	19	20	24	35
Independents	5	8	4	4	2	6
TOTAL	87	89	69	65	59	56

Private producers thus retreated from competition with the powerful state productions: the Churubusco and América Studios were turned over to state cinema. The state had its own production companies but also offered *paquetes* ('packages') to film-makers and technicians who could work on projects in return for a percentage of the box-office receipts. In 1974, a company of directors (DASA) was set up by film-makers such as Hermosillo and Isaac to work directly with the government. The state also instituted the 'vertical' exhibition of its films (which were released in several cinemas at the same time), and demanded that the best cinemas should screen Mexican films. Also, in line with Echeverría's internationalist, Third-Worldist discourse, there started up a vigorous campaign to capture markets abroad, reviving the dreams of Miguel Alemán in the 1940s that national cinema could develop autonomously and be recognized in the world as a quality product.

What of the films themselves? Was the whole experience just a hype, or a reflection of the president's desire for self aggrandizement? Certainly most film-makers chose to work with the state and made a number of interesting, critical, films which cannot simply be dismissed as the work of presidential amanuenses. The most articulate critique of the Echeverría intervention in film, very much in the style of Cosío Villegas, is Alberto Ruy Sánchez's 'Mythology of a Cinema in Crisis' (see Chapter 2). He sees the films of the period as being suffused with a Third World, nationalist, anti-imperialist rhetoric, similar to that of the president, and employing a film language which effectively stifled analysis or creativity. In this the film-makers are seen to participate in the rhetoric and tactics of Echeverría's democratic 'opening', which in effect negates class conflict since everyone must unite in the struggle against imperialism, sharing in a Mexican Third-Worldist view of national reconstruction.

To a certain extent one can concur with Ruy's assessment, especially when he analyses as his 'model' film *Actas de Marusia* (Letters from Marusia, 1975) directed by the well-known Chilean exile director Miguel Littín. It was a high-budget 'internationalist' film, which combined the talents of Littín, the Italian actor Gian Maria Volonte and the music of Mikis Theodorakis, and attempted to show that Mexico was progressive both politically and aesthetically. Its subject matter, a massacre of miners in Chile in 1907, a clear allegory of the recent coup in Chile in September 1973, showed the Mexican state to be sensitive at least at the level of rhetoric to revolutionary movements in Latin America and to the problem of exile. Its discourse is anti-oligarchic, anti-imperalist and contains the message that 'we failed because we were not sufficiently united', a clear rallying cry to the banner of Echeverría's leather-jacketed, *guayabera*-clad, populism. Its message, however, is written too stridently in the blood of the workers, in an orgy of violence. It is easy to see why many objected to costly, ultimately monologi-cal, Third World epics – Marcela Fernández Violante made her well-known *De todos modos Juan te llamas* (Whatever you Do, It's No Good) in the same year for one eightieth of the cost. The whole strategy was overblown.

There are also traces of populist appropriation in films such as *Los albañiles* (The Building Workers, 1976) directed by Jorge Fons, a murder mystery set on a building site, where we are introduced to a number of working-class types who swear and argue but who are, in the end, good souls. One looks in vain for the critical venom of Raúl Araiza's *Cascabel* (Rattlesnake, 1976), which deals directly with the social responsibility of the film-maker. A director, despite the disapproval of his television station (in league with the government and big business) wants to make a film exposing the conditions of the Lacandonian Indians in Chiapas. His research is blocked and even nature turns against him – in the shape of a rattlesnake up his trouser legs (not even James Bond had to sweat it out at such length with his tarantula, and our hero, alas, did not have 007's luck). Despite the earnestness of the intent, the treatment remains conventional and superficial.

It is one thing to criticize certain films, quite another to condemn out of hand the work of six years. Echeverría certainly did modernize the film industry and gave work to a number of talented directors. It is perhaps too much to expect mature, sustained production from cineastes who were plucked from a position of poverty in the late sixties, given abundant resources in the early to mid seventies and then plunged into poverty once again as the following government reversed all of Echeverría's measures. Certainly the film-makers supported the government's initiatives, as can be seen in a manifesto signed by most of the major young talents:

> The state has shown a desire for change by incorporating a new generation of directors and this attitude, which has gathered in momentum over the past three years, allows us to view the present time as a period of transition towards the creation of an authentic national cinematographic art, which shows a commitment to history and to the great majority of the people.[22]

Within a couple of years of this statement, the industry was moving towards a void, starved of state support.

This new generation produced a number of interesting works. Ripstein developed his precocious talent in *El castillo de la pureza* (The Castle of Purity, 1972) based on the true story of a man who kept his wife and three children locked away from the contamination of the outside world. In this sanitized environment, family codes begin to break down. Jaime Hermosillo also examines the rages and desires that lie hidden behind the masks of bourgeois conformity in his dissection of provincial middle-class life, *La pasión según Berenice* (The Passion According to Berenice, 1976), where the heroine expresses passions that can only be satisfied in the humiliation of her boyfriend and the immolation of the family house and bedridden stepmother. In *Matinée* (1976), the gays in Mexican cinema move discreetly out of the closet as two film-loving boys become involved with two adult gay criminals, sharing some Bonnie-and-Clyde adventures with them, but finally betraying them to the police.

Perhaps the most remarkable film of the period which reveals the freedom of film-making under Echeverría is *Canoa*, 1975, directed by Felipe Cazals. The film is firmly based on events that took place on 14 September 1968 in the village of San Miguel Canoa, a few miles from the city of Puebla. Five young employees of the University of Puebla set out on a climbing expedition, were forced by torrential rain to seek shelter in the village and were later set upon by a mob of villagers led by the Catholic priest who accused them of being communist student subversives out to desecrate the church. Two of the group were hacked to death, together with a villager who gave them shelter; the other three were dragged to the main square where their lives were saved only by the opportune arrival of the police. The incident is a vivid comment on the force of anti-student hysteria generated by the government and the press in the months preceding this massacre (and the massacre at Tlatelolco a month later). It also stresses the uneven development of Mexican society where, only minutes away from a sophisticated urban capital, local communities are still prey to reactionary messianic forces.

The script was written by Tomás Pérez Turrent, who also published a book on the making of the film.[23] The film intercuts 'documentary' footage (obviously fictionalized) into the main narrative in an attempt at distancing the spectator from the hypnotic terror of the events. For example, when an axe smashes through the door that shelters the boys from the crowd, the narrative breaks off to a later 'documentary' statement by the priest. However, the visceral film-making of Cazals is memorable: the meticulous plotting of the events, the orchestration of a mounting tension and the horrible force of real events.

The weight of recent history is counterbalanced in this period by a number of films dealing with the early phase of the Revolution. In films such as *La casta divina* (The Divine Caste, 1976) and *De todos modos Juan te llamas* the emphasis is on the disillusionment and rebelliousness of the young against their parents who have become rich by manipulating the ideals of the Revolution. The most important of these Revolutionary films is Paul Leduc's *Reed: Mexico insurgente* (Reed, Insurgent Mexico, 1970). Made as an independent feature, it was later promoted by the regime and blown up from a 16mm to a 35mm print and released for widespread commercial distribution. Leduc is very conscious of modes of representation: John Reed is constantly photographing the Revolution. Leduc draws inspiration from the Casasola archive of magnificent photos from the Revolution. He tints the print a sepia colour, which adds both a documentary and an authentic 'feel' but also points out to the spectator that this is clearly a photographic re-presentation of events.[24] The film captures the inactivity and long days of travelling of Villa's army, interspersed with scenes of violence. In a final freeze frame, Reed is seen breaking a shop window to replace his broken camera and commit himself to further representation of the achievements of the Revolution.

Leduc captures the optimism of the early years but also, in his next film *Etnocidio: notas sobre el Mezquital* (Ethnocide: Notes on the Mezquital, 1976), points out the areas that the Revolution forgot. Out of six hundred thousand Otomi Indians in the Valley of Mezquital, he reveals, 43 per cent lacked drinking water; the death rate was very high, especially among children under four years of age. The documentary offers an A to Z of indictments against the modernizing state. It avoids the trap of creating an 'aesthetic of poverty' and is one of a series of splendid documentaries that examine the plight of the indigenous and rural poor (two other memorable films are Eduardo Maldonado's *Jornaleros* (Day Workers, 1977) on rural migrants who travel the country in order to scratch out a living, and Archibaldo Burns's *Juan Pérez Jolote* (1973) on the daily life of the Chamula Indians.

Independent Cinema and the Withdrawal of State Support

In the period 1970 to 1976, UNAM was almost the sole producer of independent cinema. In the next *sexenio*, under López Portillo, independent cinema gained in strength as the state withdrew its subsidies. The president placed the direction of the film industry in the hands of his sister, Margarita López Portillo, which proved to be disastrous. A new agency, the Directorate of Radio, Television and Cinema (DRTC) was set up to coordinate all the state's interests in the mass media. This gave the inexperienced new director enormous power, but she worked with an inept set of advisors including her own doctor and a functionary called Ramón Charles who was particularly hostile to official film-making. This body set about dismantling the previous structures: the state production company CONACITE was disbanded, the Banco Cinematográfico lost all its powers and the film school CCC was threatened with closure. Certain officials of the previous regime were accused of fraud, without any justification, and imprisoned for a short time. The state increasingly withdrew from production and left the terrain to the private investor and to the media conglomerate Televisa. There were costly and lamentable attempts to attract international directors to film in Mexico. The Spaniard Carlos Saura made perhaps his worst film, *Antonieta,* based on the life of Antonieta Rivas Mercado,[25] and Serguei Bondarchuk made a risible film about John Reed, *Campanas Rojas* (Red Bells, 1981) with Ursula Andress and Franco Nero looking distinctly unhappy in a Mexican landscape. As a grotesque, horrific symbol of these ineptitudes, the Cinemateca Nacional was burned down on 24 March 1982. An unknown number of lives were lost (official figures are very vague), an archive of six thousand films, one of the most important in Latin America, was destroyed, together with a specialist library and two cinemas. The authorities had repeatedly been warned that the Cinemateca did not have adequate fire-prevention facilities to store the highly inflammable nitrate film stock, but no measures were taken due to financial stringencies. The cost would have been a fraction of the money lavished on *Campanas Rojas.*

The old producers returned, offering a diet for the late seventies of sex comedies, mild pornography, strong language, violent drug-runners and the like. Mexican critics agree that this was perhaps the worst commercial cinema in the history of the country. Some state money was still available in the early years of the *sexenio*, which allowed Ripstein to make two of his most interesting films, *El lugar sin límites* (Hell Has No Limits, 1977) and *Cadena perpetua* (Life Sentence, 1978).[26] *El lugar,* which has recently become something of a cult film, is an extraordinary attack on machismo, in which a transvestite owner of a miserable brothel seduces and is then killed by the local hard-man. In a dazzling fetishistic performance by Roberto Cobo – Jaibo in Buñuel's *Los olvidados*[27] – Manuela traps the macho in a web of seduction, proving that the attraction of difference, of the unknown, can dissolve, temporarily, rigid sexual barriers. The codes reassert themselves, however, in a brutal ending as Manuela is stabbed to death by the man (s)he has seduced, a character straight out of the comic books, the violent photo-novels which are the required reading of many millions of Mexicans. Ripstein adopts a cooler style for *Cadena,* in which an ex-convict cannot reshape his life as a dull bank clerk since he is pursued by a vindictive blackmailing policy chief who knows about his past. This is film noir with no melodramatic flourishes or excessive violence.

Hermosillo showed once again that 'appearances can be deceptive' in *Las apariencias engañan* (1977), an independent film banned from commercial release for five years because of the frankness of its camp homosexuality (concerning a homosexual man in the familiar Hermosillo provincial world of Aguascalientes who discovers that the obscure object of his desire, a woman, really has a penis). Hermosillo's gay *divertissements,* which reached the international market with *Doña Herlinda y su hijo* (Doña Herlinda and her Son, 1984) are accompanied by a series of films dealing with female characters at different stages of liberation. Perhaps the most interesting of these, *María de mi corazón* (Maria of my Heart, 1979), based on a script by García Márquez, moves from the ludic sexual play of a thief and a circus performer to a nightmare where the woman finds herself trapped in an isolated mental asylum.

Both these directors, who had been fêted by the state under Echeverría, continued to make significant films without its support. Indeed most serious work from 1976 to the present has been made independently.[28] The following *sexenio* under Miguel de la Madrid initially promised reforms by setting up the National Film Institute (the INC) in 1983, under the directorship of the film-maker Alberto Isaac. But the INC wielded very little power: the state produced nine films out of ninety-one in 1983 and eleven out of sixty-four in 1984. The studios were turned over in the main to foreign producers such as Dino de Laurentis, who made *Dune* in the Churubusco Studios. The independents survived, despite spiralling costs, through a variety of means: collaborating with the universities, working commercially in order to finance their own films, entering into co-production arrangements with European sponsors (such as

Channel 4 in Britain), participating in alternative distribution and exhibition outlets. The distribution company Zafra offers a list of some three hundred films for rental to clubs, university groups and trade unions.

Despite the pressures, a small number of important films have been made, both documentary and fiction. Nicolás Echeverría made two documentaries on religious faith healers, *María Sabina*, 1978 and *El niño Fidencio*, 1980, and continued his analysis of popular culture with *Poetas campesinos* (Country Poets, 1980) which charted the work of a country circus in the south of Puebla. There has also been an important presence of women film-makers in this period, including Marcela Fernández Violante, the head of the film school at UNAM and María del Carmen Lara who directed a documentary on the struggle for unionization of the seamstress workers in Mexico City following the earthquake in 1975: *No les pedimos un viaje a la luna* (We're not Asking for the Moon, 1986). *Yalaltecas* (1982), a short documentary by Sonia Fritz, traces the events of 1981 when a local Indian community overthrew its boss. The women then formed a union to struggle, successfully, for better living conditions. This theme of solidarity is carried on in Maryse Sistach's fictional *Conozco a las tres* (I know the Three of Them, 1983), which plots the lives of three friends in Mexico City, maintaining their humour and their independence in a society dominated by machista codes. A beautiful cameo fiction of twenty-eight minutes by María Novaro, *Una isla rodeada de agua* (An Island Surrounded by Water, 1984), shows a young girl travelling from the coast to the mountains in search of her mother.

High-quality work by established male directors appeared sporadically in the 1980s. Paul Leduc made *Frida* in 1983, the death-bed reminiscences of the Mexican painter Frida Kahlo. It is a film that deliberately avoids the rich political and cultural background, since the director felt that this would be too cacophonous:

> I am interested in silent film. I had initially hoped to make a black and white silent film on Tina Modotti: but I could not raise the money. But *Frida*, although it is in colour, is still trying to work towards that early cinema. In films today, there are too many words. We have forgotten the silences. Mexico is a country of silences. *Frida* offers the silence of introspection surrounded by the noise of muralism and politics.[29]

The flashback, episodic structure focuses on the salient moments of Kahlo's life and the plasticity of the images echoes her best work. Another director interested in exploring silences is Arturo Ripstein, whose *El imperio de la fortuna* (The Empire of Destiny, 1985) is set in the remote interior of Mexico, the landscape of the novelist Juan Rulfo, whose characters, forgotten by God and by the Revolution, have neither the freedom of language nor of action to escape an implacable destiny. Ariel Zuñiga followed his splendid *Anacrusa* (Anacrusis,

1978) with the esoteric *El diablo y la dama* (The Devil and the Woman, 1983), charting the labyrinths of desire of a woman who fantasizes from her hotel room in Paris, about a journey through the sordid nightspots of Mexico.[30] Younger film-makers such as Alberto Cortés and Diego López have also produced interesting work.

The new regime has offered the directorship of the Mexican film sector to Gabriel García Márquez, who has maintained a close relationship with Mexico since his early scriptwriting days in the 1960s. It remains to be seen if he can provoke any changes in a system curiously unique in Latin America, reflecting a semi-open government which has been successful in co-opting and coercing its population for the last seventy years. Commercial cinema has lost the vigorous strength of the Golden Age of the 1940s, but still continues to churn out films for a loyal working-class or lumpen audience in the country and in the southern states of North America. Oppositional cinema finds it difficult to break out of a mainly middle-class exhibition circuit, or to do much more than throw stones at the pyramid of power – distinctly shaky in the last elections, when the opposition leader Cuahtemoc Cárdenas polled highly, in particular in Mexico City – which still remains in place. Mexico City, for example, contains a huge student body taught a heady diet of Marxism. Yet the possibility for any revolutionary change becomes soaked up in the giant sponge of power relationships and patronage. It is very difficult to demolish such an amorphous target, which often pays for the weapons of its own 'destruction'.

García Márquez, the new general in his labyrinth, seems to have an early strategy for cultivating a more socially responsible commercial cinema, though the sources of funding for this strategy remain vague in a culture industry increasingly dominated by media conglomerates such as Televisa. A recent novel by Carlos Fuentes, *Christopher Unborn*, has given a hyperbolic view of Mexico's debt crisis, its sprawling urban growth, its uneven development and its increasing subjection to the culture industry. One eschatological image left out of his apocalyptic farce is that of a spectator glued forever to a seat by the sticky remains of spilled Coca Cola (in most Mexican cinemas, eating and drinking are as important as the feature film on show), watching the latest comedy by Cantinflas. It is against such dystopias that independent cinema and perhaps the state sector under García Márquez must endeavour to fight.

Notes

1. Quoted in 'Luis Buñuel and the Cinema of Freedom', an essay in Carlos Fuentes, *Myself with Others*, André Deutsch, London 1988, p. 125.
2. Alberto Ruy Sánchez, *Mitología de un cine en crisis*, La Red de Jonas, Mexico 1981, p. 61.
3. Carlos Fuentes, 'Una flor carnívora', *Artes de México*, Nueva Epoca, 2, Winter 1988, p. 29.
4. Julio Cortázar, 'Los olividados', *Sur* 209–10, March–April 1952, p. 170.
5. Fuentes, *Myself with Others*, p. 128.

6. For an examination of melodrama in Buñuel, see Daniel Díaz Torres and Enrique Colina, 'El melodrama en la obra de Luis Buñuel', *Cine Cubano* 78–80, 1972, pp. 156–64.

7. For an analysis of these films, see Francisco Aranda, *Luis Buñuel: A Critical Biography*, Secker and Warburg, London 1975.

8. For the text of the manifesto, see *Nuevo Cine* 1, Mexico, April 1961, reprinted in *Hojas de cine: Testimonios y documentos del Nuevo Cine Latinoamericano,* Vol. II, UAM, Mexico 1988, pp. 33–5.

9. *Hojas de Cine,* p. 42.

10. For an analysis of the film, see Jorge Ayala Blanco, *La aventura del cine mexicano*, 3rd edition, Posada, Mexico 1985, pp. 329–30.

11. William Rowe, 'Gabriel García Márquez' in J. King, ed., *Modern Latin American Fiction: A Survey*, Faber and Faber, London 1987, p. 200.

12. Interview with Carlos Monsiváis in *Hablemos de Cine* 69, 1977–78, p. 26.

13. Judith Adler Hellman, *Mexico in Crisis*, Holmes and Meier, New York 1978, pp. 140–41.

14. See Elena Poniatowska, *La noche de Tlatelolco,* 1971, translated as *Massacre in Mexico*, Viking, New York 1975.

15. For an analysis of *El grito*, see Jorge Ayala Blanco, *La búsqueda del cine mexicano*, 2nd edition, Posada, Mexico 1986, pp. 326–36.

16. Roderic A. Camp, *Intellectuals and the State in Twentieth-Century Mexico*, University of Texas Press, Austin 1985, p. 209.

17. For a defence of his position, see C. Fuentes, 'Opciones críticas en el verano de nuestro descontento', *Plural*, 11 August 1972, pp. 3–9.

18. Carlos Fuentes, *Tiempo mexicano*, Joaquin Mortiz, Mexico 1971, p. 166.

19. Daniel Cosío Villegas, *Memorias*, Joaquin Mortiz, Mexico 1976.

20. Daniel Cosío Villegas, *El estilo personal de gobernar* Joaquin Mortiz, Mexico 1974.

21. Emilio García Riera, *Historia del cine mexicano*, SEP, Mexico 1986, p. 323.

22. 'Manifesto del Frente Nacional de Cinematografistas', *Otrocine*, 3, July–September 1975.

23. Tomás Pérez Turrent, *Canoa: memoria de un hecho vergonzoso*, Universidad de Puebla 1984.

24. I am drawing from the analysis of Deborah Minstron in her 'The Institutional Revolution: Images of the Mexican Revolution in Cinema', Unpublished Ph.D. thesis, Indiana University 1982.

25. Antonieta Rivas Mercado has been the subject of an interesting recent analysis. See Jean Franco, *Plotting Women: Gender and Representation in Mexico*, Verso, London 1989, pp. 112–28.

26. See the appreciation of Ripstein in *Arturo Ripstein Filmemacher aus Mexico*, Filmfest München 1989.

27. See Jorge Ayala Blanco, *La condición del cine mexicano (1973–1985)*, Posada, Mexico 1980, pp. 376-81.

28. For an analysis of this period, see Tomás Pérez Turrent, 'Notas sobre el actual cine mexicano', Part 1, *Cine Libre* 6 1983; Part 2. *Cine Libre* 7 1984.

29. Interview with Paul Leduc, Havana, December 1986.

30. For a commentary on these films, see Ayala Blanco, *La condición*, pp. 398–413.

Cuba: Revolutionary Projections

The fault of our artists and intellectuals lies in their original sin: they are not truly revolutionary. We can try to graft the elm tree so that it will bear pears, but at the same time we must plant pear trees. New generations will come who will be free of original sin. ... Already there are revolutionaries coming who will sing the song of the new man in the true voice of the people. This is a process which takes time.

Ernesto Che Guevara[1]

In the 1950s film *Guys and Dolls,* Marlon Brando takes Jean Simmons down to Havana to court her in order to win a bet with Frank Sinatra. There, in an exotic landscape, she loses her prim Salvation Army inhibitions, gets extremely drunk on 'a nice milkshake' (coconut laced with bacardi), dances spectacularly and gets involved in a brawl before later declaring her true feelings in a moonlit Havana evening.

Before 1959 this was the most typical celluloid image of Cuba, a lush backdrop against which the heroes of Hollywood and Mexican cinema could act out their fantasies. There was very little commercial Cuban cinema: some eighty features were made between 1930 and 1958,[2] mostly melodramas or musical comedies made at breakneck speed by adventurers such as Ramón Peón. There were few Cuban films, but large numbers of people went to the cinema: in the 1950s, out of a population of less than seven million, the figure for film-goers was an astonishing 1.5 million per week, notwithstanding the fact that significant parts of the rural population had little or no access to cinema.[3] Néstor Almendros, the cinematographer who was resident in Cuba at the time, paints the picture:

And yet paradoxically, at that time Cuba was a privileged place to see films. First, unlike the Spanish, the Cubans knew nothing about dubbing so all the films were shown in their original versions with subtitles. Second, since this was a free market with almost no state controls, the distributors brought in many different kinds of

film. I got to see all the American productions there, even the B-movies that had
trouble getting to other countries. I also saw Mexican, Spanish, Argentine, French
and Italian films. Around 600 films were imported each year. The censors were
very tolerant. ... Havana was paradise for a film buff, but a paradise with no critical
perspective.[4]

Almendros was part of a movement of amateur film-makers and aficionados who
founded film clubs and made their own rudimentary shorts in the late 1940s and
1950s as a way of creating some movement in a stagnant national film culture.

In 1985 another group of North American stars, Christopher Walken, Robert
de Niro, Harry Belafonte and Jack Lemmon, flew down to Havana to attend the
seventh Latin American film festival. Doubtless the drink and music were just
as potent as in *Guys and Dolls*, if more authentic, but the images of Latin America
were very different as revolutionary Cuba played host to an annual meeting of
the Latin American film community. These actors had a number of meetings with
Cuban film-makers and could have seen the classics of post-revolutionary Cuban
cinema or more recent films by an emerging younger generation.

The figures of film production demonstrate how far Cuban cinema has
developed since the late 1950s. Between 1959 and 1987, Cuba made 164 feature-
length films (112 fiction, 49 documentary and 3 animation), 109 of these in
colour; 1,026 shorts (16 fiction and 1,010 documentary), 545 in colour; and
1,370 newsreels. These films could be seen in 535 cinemas equipped with 35mm
projectors or in 905 locations equipped with 16mm projectors.[5] In 1987 more
than sixty-one million visits were made to the movies and spectators had a choice
of about 120 or130 releases a year. Of these, about 7 per cent are Cuban films,
but they attract 20 per cent of the market share.[6] These figures disguise a fairly
marked drop in attendance at cinemas and a large increase in audiences for 16mm
projections, especially in the rural areas. The drop in cinema attendance is part
of a worldwide trend in the face of competition from television and video but the
decline is not as marked as elsewhere in Latin America, even though the Cubans
have the second largest percentage of televisions per head of population in Latin
America (after Argentina)[7] and the number of videos has increase to some
hundred thousand recorders.

Unlike other film-makers in Latin America, the Cubans can almost invariably
cover their costs in the home market, even though the price of cinema entrance
is low (one peso, or one dollar at an extremely high official exchange rate). An
audience of less than half a million for a film – a massive number for other parts
of Latin America – would almost be considered a failure. Ten films have had
audiences of over 1.25 million and two of over two million: *Guardafronteras*
(Frontier Guard) by Octavio Cortázar and *Aventuras de Juan Quin Quin*
(Adventures of Juan Quin Quin) by García Espinosa. This represents 20 per cent
of the population. Films amortize in the home market despite the fact that,
compared with the rest of Latin America, it is expensive to make a film in Cuba

(on average $350,000) because of low productivity caused by large numbers working on an individual film (about fifty on a feature film) and the length of shooting time (more than ten weeks on average).[8] The Cuban Institute of Cinematographic Art and Industry (ICAIC) still does a great deal with few resources: its total annual budget is about seven million dollars, or roughly half the cost of one medium US feature film.

The figures seem to point to a dynamic process with the creation and development of a solid film industry, vertically integrated, controlling production, distribution and exhibition and reaching a wide domestic audience. Yet, is it right to talk of Cuba as being in the vanguard of film production, a model for film-makers in Latin America? Some critics hint that this is not the case. Let me quote briefly from three recent sources. Jean Stubbs, the British historian and critic states: 'Even if the film industry, which has over the years produced some excellent work on contemporary Cuba, has paradoxically not proved itself too adventurous in recent productions, film policy has always been markedly open ...'.[9] Octavio Getino, the Argentine critic, remarks: 'However, the evolution of Cuban cinema in recent years is somewhat complacent at times, demonstrating the pressures of a population whose cultural sensibilities have evolved more slowly than their political development.'[10] And the German critic, Peter Schumann, states quite categorically: 'Cuban cinema is rather modest at its twenty-fifth anniversary. The great ambitions that caused the failure of more than one film-maker have been deferred ... it is time for Cuban film-makers to find again their initial drive to take up the experiments of the decade of quest' (the 1960s).[11] In order to examine the tensions that underlie these statements, it is necessary to give a historical account of Cuban cinema since 1959.

The Early Years, 1959–69

There is agreement within the critical literature that the 1960s were the most significant period in Cuban film history; the industry built up from almost nothing and by the end of the decade was producing a number of memorable films. There is space here to indicate only some general lines of development; the topic has been covered exhaustively elsewhere.[12] ICAIC was formed on 24 March 1959, within three months of the success of the Revolution, and was part of a process of cultural effervescence which accompanied the victory. In the early months and years no particular direction was given to the nature and the function of cultural production, apart from the emphasis on education: the literacy campaign began in January 1961 and helped to raise literacy from 76 per cent of the population in 1958 to 98 per cent in 1988. Many different ideological and aesthetic tendencies were represented among the intellectuals and artists who began to define the new possibilities afforded by the Revolution. Also (see Chapter 3), Cuba became a haven, or an example, for many Latin American intellectuals. The Mexican Carlos Fuentes wrote the *Death of Artemio Cruz* in

Havana in 1960. Ten years later Fuentes would be pilloried as a petty-bourgeois lackey of imperialism by the Cubans, a reflection of the hardening ideological attitudes brought on by the political and economic crises of the early seventies.[13] In these earlier moments, however, it appeared that Cuba offered an opportunity for national and continental cultural liberation. Cinema was perceived as an important part of this struggle in the continent.

ICAIC replaced the organization *Cine Rebelde* which had been set up immediately to make documentary records of the first weeks of the Revolution. There was a small nucleus of film-makers with some experience. Looking back at a short independent documentary made in 1954, *El mégano* (The Charcoal Workers), we find that the production staff provide a roll call of the early revolutionary film-makers: Julio García Espinosa, Tomás Gutiérrez Alea, Alfredo Guevara, Jorge Haydu, Jorge Fraga. García Espinosa and Alea had also trained at the Centro Sperimentale in Rome, as had Néstor Almendros, who later gave a jaundiced account of his time there.[14] ICAIC was a government agency directed by Alfredo Guevara and run by film-makers who sought to modify the existing conditions of production, distribution and exhibition.

The problems were great and had to be solved on a day-to-day basis. How to make films with a poor technical infrastructure? How to train new directors? How to define the nature of revolutionary cinema? How to alter exhibition, and change the spectator's tastes that had been fed on Hollywood images and genres? How to reach new audiences? Initially the bulk of resources was put into making documentaries and newsreels (there had been a tradition of commercial newsreels in Cuba in the 1950s). The newsreel section was placed under the direction of Santiago Alvarez who declared it his intention to 'put to the service of newsreel the language of cinema; this must be our most important objective'.[15] Since there was only the money to make some 60 prints for about 550 cinemas, the newsreels had to be made in such a way that they would serve as a permanent record of the Revolution that would not seem easily dated, as would, for example, bulletins for television news. The early newsreels had a great deal to record: the agrarian reform of March 1959, the nationalization of the sugar *centrales* in February 1960, the expropriation of US properties in 1960, the nationalization of the banks, the changing international alliances, the abortive Bay of Pigs invasion of April 1961. Documentaries were also produced immediately and were of varying quality, as could be expected from the rudimentary beginnings of the industry. Fictional films would slowly emerge: the normal pattern for an aspiring director was to progress from a 'didactic' short to a documentary to a feature film. The equipment inherited from the Batista period was old and cumbersome and the industry could not initially afford the new lightweight 16mm cameras that could be carried on a shoulder and give greater flexibility and immediacy to documentary film-making.

Several established directors came to offer advice and expertise. The French director Chris Marker made perhaps the finest documentary of the early 1960s,

Cuba sí. Joris Ivens, the Dutch film-maker, a veteran of the Spanish Civil War and of the Chinese-Japanese conflict in the Second World War, also spent some time in Cuba working on documentaries. He gave young film-makers some interesting advice:

> In the cooperatives, in the industrial centres, you see the dedication of a whole people to construct their own destiny. If I could be allowed to give a word of advice to young Cuban cineastes, I would say that this is the best filmic lesson for you. Forget the problems of technique or style. These will come with time. The important thing is to let life enter the 'studios' [or 'your studies' – the Spanish is ambiguous], so that you do not become bureaucrats of the camera. Film rapidly and as directly as possible whatever is taking place. To accumulate direct red-hot material can be considered the best way of achieving a cinema with national characteristics.[16]

José Massip and Jorge Fraga acted as assistants to Ivens during his stay, and were two of a number of young directors who began to make their first shorts, sometimes surmounting and sometimes falling into the trap outlined by Ivens, of being 'bureaucrats of the camera'. It would be Santiago Alvarez who set the standards for radical, innovative documentary film-making in a very few years. Mature feature films took longer to appear: for these the early 1960s served as a period of apprenticeship.

Culture and Revolution: The Early Debates

García Espinosa gave a thorough critique of the first four years of film-making in *Cine Cubano* in 1964. His article is interesting for a number of reasons. Apart from his criticism of individual films, he alludes to two broad areas of debate that would subsequently fracture the artistic community: what sort of Cuban films should be made and what films should be exhibited? Both areas raised fundamental questions as to the role of cinema in the Revolution. Exhibition was to be a thorny problem. With the gradual nationalization of distribution and exhibition circuits and the flight of US companies, as well as the trade boycott, there was a lot of screen time to be filled for a public used to enjoying Hollywood movies. García Espinosa hints at the strains caused by a rapid importation of socialist bloc films to fill the gaps once the USA had severed diplomatic relations with Cuba in 1961 and Cuba was left to forge alliances with the USSR and other European countries:

> Our film world suddenly received an avalanche of socialist films. When the US production market, with its hundreds of annual releases which had previously fed the 518 cinemas in the country, closed down, the acquisition of socialist films did not obey rigorous selection criteria, for we would have put in jeopardy the jobs of

thousands of workers. ... So now we see the most significant films from the capitalist world and the most interesting, but also the worst films from the socialist countries. Surprisingly some people have begun to idealize the most mediocre products of capitalist societies.[17]

Perhaps not so surprising, given the socialist films on offer: it must have been a shock to get used to images of exemplary East European workers after a diet of Hollywood stars. Czech cinema was dynamic in this period, but the same could not be said of the USSR or the GDR. Even the 'best' of the capitalist world – Italian neo-realism, British independent and French New Wave – was not without its problems. The French New Wave, for example, could offer lessons in low-budget film-making but the existentialist 'anomie' of many of the films was not always seen as exemplary in Cuba. Exhibition would remain problematic over the thirty years from 1959; the main solution was drastically to reduce the number of releases, to about 120 (from 500 or 600).

The Revolution also sought to educate the spectator in a number of ways. The Cinemateca was founded under the directorship of Héctor García Mesa and this body put together programmes of film cycles from existing archive material. Later in the decade television offered programmes of film criticism – in particular Enrique Colina's 'Twenty Four Times a Second', which examined the ideological subtexts of films screened in the country. The film journal *Cine Cubano* was founded in 1960 with the same educational intentions, and has appeared, more or less regularly, for nearly thirty years.

Another fundamental vehicle for disseminating film and critical debate in the country was the mobile cinema. In April 1962 projection equipment was loaded on to the back of thirty-two Soviet trucks and began to tour the provinces, reaching communities previously without access to cinema. In the first year alone, there were some eight thousand screenings with audiences totalling almost two million.[18] The enthusiasm and wonder of these first encounters with cinema was captured in Octavio Cortázar's short, *Por primera vez* (For the First Time, 1967), where a film crew accompanied a mobile unit into an outlying district and recorded the audience reactions. Fidel Castro's speech to the first congress of the Cuban Communist Party in December 1975 charted the development of this initiative:

> The work of the mobile cinemas is the most interesting experience in the formation of a new public. The lack of cinema in rural areas was one of the manifestations of the profound difference in opportunities that had opened up between the population of the cities and that of the countryside. In these years, the mobile cinemas have provided 1,603,000 screenings for 198,200,000 spectators. Now we have 620 cinemas with 16mm facilities, 112 projectors on lorries, 480 in fixed locations, 22 on mules or transported by other animals and two on launches.[19]

These fixed-location outlets were scattered around the country in schools, factories and neighbourhood cultural centres. Today the mobile cinemas are

symbols of a pioneering age, for they have been gradually replaced by video. Exhibition thus remains diverse, though the US boycott and the lack of hard currency reserves make purchases in the open market quite restricted. A combination of sympathetic production companies or distributors (Robert Redford's Sundance Institution and Coppolla's Zoetrope Studios are particularly supportive), together with discreet bootlegging helps to fill the gaps.

García Espinosa's article also refers to an area clouded by simplifications and bitter recriminations: the function of the artist in the Revolution. He speaks of existing polarizations:

> On the one side chauvinism, on the other cosmopolitanism; on the one side tradition, on the other fashion; on the one side sectarianism, on the other pseudophilosophical speculation; on the one side the intransigent revolutionary, on the other the utopic liberal. Spiritual confusion creates its own myths. ... These primitive extremes always lead to unfortunate results. ... It is necessary for the filmmakers themselves to have as their main task the duty to find a more direct relationship with reality.[20]

A clash between the political and the artistic vanguards was perhaps inevitable as the Revolution began to define its terms: the dream of fusing the two had always been one of the elusive utopias of the twentieth century and it was optimistic to think that Cuba might solve the dilemmas satisfactorily. In the film sector, trouble began with *PM*, a short made by Saba Cabrera Infante (the brother of the novelist Guillermo, then editor of the cultural section of the newspaper *Lunes de Revolución*) and Orlando Jímenez in a free cinema style. According to second-hand accounts, it shows groups of people hanging around, drinking and talking on the waterfront, and was televised in a programme organized by *Lunes*. ICAIC did not allow its theatrical release on the grounds that it showed images negative to the ideals of the Revolution. This caused a furore in intellectual circles.[21] The timing of the ban was important: six weeks after the Bay of Pigs invasion when sensitivities were naturally heightened. But the quarrel grew in intensity and eventually led to the intervention of Fidel Castro, who interviewed the protagonists in the National Library in June 1961 and delivered his verdict in the famous speech, 'Words to the Intellectuals'. This statement laid down the guidelines for the following decade:

> The Revolution has to understand the real situation and should therefore act in such a manner that the whole group of artists and intellectuals who are not genuinely revolutionaries can find within the Revolution a place to work and create, a place where their creative spirit, even though they are not revolutionary writers and artists, has the opportunity and freedom to be expressed. This means: within the Revolution, everything, against the Revolution, nothing.[22]

Here Castro was signalling the need for a transition, in Gramsci's terms, from the 'traditional' to the 'organic' intellectual, appreciating the need for 'fellow-

travellers', but also recognizing that these fellow-travellers would need to commit themselves in the long term (for long term, read a decade, up to the 'Padilla affair' of 1971, on which more below). Such a transition would have its casualties: in the film world a number of directors who had been with ICAIC in the early years left the country: Néstor Almendros, Fernando Villaverde (who left after the debate over his feature film *El mar* (The Sea) which was not released in 1965), Fausto Canel, Alberto Roldán, Roberto Fandiño and Eduardo Manet (the main film critic in *Cine Cubano* from the early to mid 1960s).

A number of these film-makers have had successful careers in the United States. Foremost of these are Orlando Jiménez Leal, one of the directors of the notorious *PM* and, of course Néstor Almendros, perhaps the world's most successful lighting cameraman. These cineastes and others were to become increasingly outspoken against the Cuban Revolution from the early 1980s, after a new wave of exiles, the *marielitos*, landed on the shores of Miami after occupying a number of foreign embassies in Havana. The aftermath of the *marielitos* saw the appearance of numerous articles, books and films from Cuba's most vocal artists and intellectuals abroad. Jiménez had built up his career in New York by forming an advertising/publicity agency with the cameraman Emilio Guede. His first fictional film *El Super* (1980) was, according to the credits, a Cuban-American comedy, made by 'the people who brought you the rhumba, the mambo, Ricky Ricardo, daiquiris, good cigars, Fidel Castro, cha-cha-cha, Cuban-Chinese restaurants plus the Watergate plumbers'.[23] *El Super* follows the trials and tribulations of a Cuban supervisor in Queens who dreams of returning to Cuba, but in the end can only opt for Miami. It had a widespread international success and helped to establish Guede Films, the production company, as a base for Cuban film-makers.

The two notorious films made by Jiménez, in conjunction with Néstor Almendros and with Carlos Franqui were *L'altra Cuba* (The Other Cuba, 1983) and *Mauvaise Conduite* (Improper Conduct, 1984). Both used the same format of mixing the testimonies of intellectuals with the vox populi, in dealing with issues of sexual – in particular homosexual – and political freedom. The films condemn the abuses of human rights in Cuba. In both cases the ordinary people interviewed come over more refreshingly and convincingly than the knowing, rather self-satisfied intellectuals. Both films concentrated, some twenty years later, on the fracture of the intellectual community in the sixties, as political pressures demanded new commitments from that sector, a situation that ICAIC sought to negotiate.

In its defence, it should also be said that ICAIC was quick to condemn the sectarianism of the more intransigent elements of the political elite, defended artistic plurality and provided an umbrella organization for artists in other disciplines whose experimentation was frowned upon. Film poster art was encouraged by ICAIC, in particular by Saul Yelin; these posters revealed a refreshing heterodoxy and inventiveness at a time when modern art was

condemned in the socialist bloc, showing that 'pop' and other forms could be reworked and given new meanings. Popular music also benefited from ICAIC's patronage. Sixties youth culture was not received with sympathy by most sectors of the Revolution – it was seen as imperialist decadence. In such a climate of moralism, pop music was condemned as a manifestation of cultural invasion and was banned from the media in 1968. Of course 1968 was the year of the 'heroic guerrilla', a time when commitment in art was felt to be an overwhelming priority (Che himself had a more subtle analysis of culture than the one disseminated in defence of his 'example'). There was little space for those perceived to be effete poets and musicians, such as Silvio Rodríguez or Pablo Milanés, and they found refuge in the newly created Grupo Sonora Experimental at ICAIC, directed by the gifted and innovative guitarist and composer Leo Brouwer, who has been responsible for most of ICAIC's film scores. Certain writers who fell out of favour – the most notable case is the multi-talented Jesús Díaz – also moved into ICAIC.

In brief, the debates over culture during the 1960s were intense; an accurate account of developments and proscription remains to be told. At present, as demonstrated in *Improper Conduct*, the exiles are too vociferously Manichean. The Cubans of the Revolution, in turn, are defensive and are only too eager to put right petty-bourgeois intellectuals who bleat in abstract terms about liberty. The notorious intransigent statement by Fidel Castro in the wake of international reaction to the Padilla affair is still strong enough today to make critics feel nervous:

> We do not pay homage to those false values which reflect the structures of societies that despise our people. We reject the pretensions of the mafia of pseudoleftist bourgeois intellectuals to become the *critical* conscience of society. The critical conscience of society is the people themselves and, in the first place, the working class. ... The fact of being an intellectual does not bestow any particular privileges. ... Hypocrites will be against Cuba. Really honest and revolutionary intellectuals will understand the justice of our position.[24]

It is, however, almost two decades since this statement was made; conditions in Cuba are now different and future research needs to focus more closely upon the cultural field in the mid to late 1960s. Failure to do so would mean just perpetrating the old myths, contributing to the dialogue of the deaf.

Revolutionary Cinema Comes of Age

García Espinosa's article of 1964 was in two minds about the quality of Cuban cinema. It was clearly a time of transition. Yet within several years of his statement, work was produced that would mark a real coming of age of the film industry: the radical documentaries of Santiago Alvarez and the feature films of

García Espinosa, Tomás Gutiérrez Alea, Humberto Solás and Octavio Gómez. Santiago Alvarez established a new style of newsreel and began working in documentary, turning scarcity into a 'signifier', remodelling second-hand sources such as news photos and television clips, and developing a highly poetic and politically effective film collage. His best-known documentaries explore the major events and personalities of the 1960s; *NOW* (1965) on the civil rights movement in the USA; *Hanoi Martes 13* (Hanoi, Tuesday 13th, 1967), his biography of Ho Chi Minh; *79 primaveras* (Seventy-Nine Springs, 1969); *Hasta la victoria, siempre* (Until Victory, Always, 1967), on the death of Che, and *LBJ* (1968).[25] Significant documentaries were also made in the period by Pastor Vega, José Massip and Sara Gómez, among others.

In feature films, 1966 – the date of Alea's *La muerte de un burócrata* (Death of a Bureaucrat) – signalled the beginning of a inventive era. The film has a madcap comic style with homages to comedy greats such as Chaplin, Harold Lloyd and Laurel and Hardy. A playful but devastating assault on bureaucratization and artistic standardization, its opening sequence has a worker killed on a production line that makes endless busts of José Martí. García Espinosa followed with another comedy, *Las aventuras de Juan Quin Quin* (The Adventures of Juan Quin Quin, 1967) in which the eponymous hero goes through a series of picaresque adventures before becoming a guerrilla fighter. García Espinosa also plays with the conventions of Hollywood cinema, revealing its conventionality. But for all the inventiveness of his parodies, the film strengthens as well as subverts the stereotypes of strong silent heroes and wilting heroines.

After these films, comedy largely disappeared from the screens for some fifteen years. A need was felt to rewrite history and rekindle popular memory in a more epic style. As the anniversary of 'One Hundred Years of Struggle' (1868–1968) arrived, Octavio Gómez's *La primera carga al machete* (The First Machete Charge, 1969) took as its theme the early independence struggles of Máximo Gómez. Gómez the film-maker deliberately mixes traditional and modern forms of narrative, using both the 'oral history' device of the wandering troubadour (Pablo Milanés) who comments on the action, and also the documentary interview, interrogating leaders and soldiers as the conflict develops. Gómez also uses high-contrast black-and-white photography to great effect, capturing the texture and grain of early daguerreotypes.[26] Through a number of similar devices, the present becomes past and the past becomes present, making a parallel between Máximo Gómez and Che Guevara inevitable. The exuberant camerawork and the over-exposed filming, especially in the final climactic scenes, have been charitably called abstract expressionist, though for some critics this experimentalism becomes almost unwatchable, spoiling the impact of the machete charge, the instrument of work that has become the arm of the popular revolution.[27]

Another extremely successful historical reconstruction by Humberto Solás, *Lucía* (1968), takes three female protagonists at crucial moments in history: a

provincial aristocrat in the 1890s, a bourgeois girl who becomes involved in the struggle against the Machado dictatorship in the 1930s (a period to which Solás would return in his *Un hombre de éxito* (A Successful Man, 1986), and a mulatta woman in the post-Revolutionary period. Solás is a director who often uses the conventions of melodrama, a genre usually condemned by Latin American critics as deploying a false, lacrimose consciousness.[28] Such an analysis, as we have seen, is too simplistic since it seems to equate melodrama with failed tragedy or failed realism as a second-rate mass cultural form. Solás uses melodramatic elements very skilfully in the first two parts of *Lucía*, 'as constituents of a system of punctuation giving expressive colour and chromatic contrast to the storyline, by orchestrating the emotional ups and downs of the intrigue',[29] in this way putting *melos* back into drama.[30] When Solás keeps a tight grip on melodrama, it works well; when he loosens this grip the results can be lamentable, as in 1982 when he spent most of the ICAIC film budget for the year making *Cecilia*, a six-hour soap opera, a travesty of the great nineteenth-century novel *Cecilia Valdés* by Cirilo Villaverde. The third part of *Lucía*, on the other hand, is a fresh, witty and lively attack on machismo in the countryside.

The function of the intellectual in the Revolution had been on the agenda throughout the 1960s. The most interesting exploration of the problem in any cultural medium is to be found in Gutiérrez Alea's *Memorias del subdesarrollo* (Memories of Underdevelopment, 1968), based on a novel by Edmundo Desnoes. This is probably the most widely discussed[31] of any Cuban film and there is no space here to examine it in detail. Alea himself said of the protagonist:

In one sense Sergio represents the ideal of what every man with that particular kind of [bourgeois] mentality would like to have been: rich, good-looking, intelligent, with access to the upper social strata and to beautiful women who are very willing to go to bed with him. That is to say people identify to a certain degree with him as a character. The films plays with this identification. ... But then what happens? As the film progresses, one begins to perceive not only the vision that Sergio has of himself but also the vision that reality gives to *us*, the people who made the film. They correspond to our vision of reality and also to our critical view of the protagonist. Little by little, the character begins to destroy himself precisely because reality begins to overwhelm him, for he is unable to act. At the end of the film, the protagonist ends up like a cockroach squashed by his fear, by his impotence, by everything.[32]

The spectators must also, therefore, re-examine those values that have made them identify with Sergio. Importantly, also, Sergio is a failed writer, an intellectual who has access to, for example, Alea himself (who appears in his own film, together with a number of other intellectuals) and to the offices of ICAIC. Sergio takes his young pick-up Elena to ICAIC to get her an audition. With Alea, they see a series of light pornographic film clips which the director had found lying around the ICAIC studios, a remnant of Batista's censors. The director says

that he will use them in a film he is making. Forever the pessimist, Sergio asks if it will be released and the director answers affirmatively. The film will be a collage, he says, that will have a bit of everything. The film Alea refers to is the film we are watching, a work that explores, through a subtle interweaving of documentary and fictional elements, the different levels of commitment of intellectuals, the gap between the film-maker and his fictional character.

The time-scale of the film is important. It is made in 1968, but refers to an earlier period in the decade, from the Bay of Pigs invasion in April 1961 to the Missile Crisis of October 1962, when Kennedy and Khrushchev agreed that Soviet troops and weapons be removed from Cuba in return for a guarantee that Cuba would not be subject to aggression from the West. It deals with the consolidation of the Revolution in the face of US imperialist aggression, portraying a Revolution in process, a people constantly alert, and the need for commitment in all sectors of society. These were all important sentiments for the late sixties, in a country trying to survive the extremely tight economic blockade and overcome external political and military interference. After the process of accelerated industrialization in the mid sixties had ground to a halt, emphasis was placed once again on monoculture, and the country was set a goal of producing a ten-million-ton sugar harvest in 1970. *Memorias* supports this process of mobilization, but not in any black-and-white way. It shows that the Revolution is made up not of stereotyped, examplary 'new' men and women (Che Guevara's dream is still a long way from completion), but rather of individuals still crossed by contradictory desires and aspirations. This makes the final resolution of the film all the more effective.

The 1970s

Towards the end of *Memorias*, Sergio is cooped up in his flat, while outside the people mobilize in defence of the Revolution during the Missile Crisis. On the television, Fidel gives his memorable speech,

> No one is going to come to inspect our country because we grant no one the right. We will never renounce the sovereign prerogative that within our frontiers we will make all the decisions and we are the only ones who will inspect anything. Anyone intending to inspect our country should be ready to come in battledress.[33]

Sergio scans a newspaper: a cartoon shows a man with a question mark over his head; at the end of the cartoon strip the question mark flattens him into the ground. There is no space for individual questioning when it denies any active engagement with social reality. This was particularly true of the period 1968 (when the film came out) to 1971 (the Padilla affair) where the siege economy, the failure of the ten-million-ton sugar harvest, counter-revolutionary violence

and political isolation helped to form an embattled mentality which was amply justified. In these circumstances the poet Padilla's criticism of the regime, his imprisonment and his subsequent rather abject public recantation infuriated a number of prestigious North American, European and Latin American intellectuals who wrote two open letters to the Cuban regime complaining about Padilla's shoddy treatment.[34]

Whatever the rights and wrongs of the case, Michael Chanan, the British critic who has written the most complete history of Cuban cinema to date, would seem to be mistaken when he states that,

> the affair was marginal to ICAIC. The collective methods at work at the Film Institute served to save the film-makers from the lingering effect among the writers of isolation from the collective which writing as a profession is prone to suffer. The Cubans themselves have never played on the incident, and were sorely disillusioned by the unfriendly and aggressive reactions from Europe.[35]

This suggests a certain diffidence in the Cuban reaction. Yet Castro in 1971, as in his Missile Crisis speech of 1962, was aggressively defiant. Both speeches expressed the same autarkic sentiment: we are not interested in the 'inspection' of outsiders, those that criticize us are the lackeys of imperialism; honest, revolutionary intellectuals will understand and support us. ICAIC's statement in *Cine Cubano* cannot be said to be 'marginal'. The statement almost tries to 'out-Fidel' Castro:

> It is necessary to unmask this moaning chorus whose only cultural objective is to separate culture from life. The freedom of expression of a minority is just that, the freedom of expression of a minority, and the aristocratic, elitist domination of this minority is almost always something else. ... A writer has recanted, it is good that he and those like him are prepared to change. That is what is important. To have a minimum of sensibility to know where the enemy is and who is the real enemy. A minimum of sensibility to put problems in the correct order. A minimum of sensibility not to be outside the game [a reference to Padilla's recent prize-winning book of poems]. ... It is not a question of keeping silent about our errors: we are the first to analyse these errors. It is a question of rejecting in a revolutionary fashion, deceitful attacks, insidious criticism, 'impartial' analysis which prepares the ground and softens up public opinion to facilitate the direct aggression of the enemy.[36]

At the same time Roberto Fernández Retamar brought out his famous polemical essay, *Calibán* which, glossing *The Tempest,* sees many Latin American intellectuals such as Carlos Fuentes as Arielists, servile to the colonial master Prospero and the Cubans as wilfully nationalist Calibans resisting Prospero and learning 'how to curse'. These statements add up to a major Cuban struggle against the demons, to paraphase the title of Gutiérrez Alea's film released that year, not a 'marginal' skirmish.

Culturally, revolutionary Cuba had its most dogmatic phase in the late sixties and early seventies. This began to ease up after the creation of the Ministry of Culture in 1975 with Armando Hart as minister. An unspoken blacklisting of certain authors was dropped and publications began to open up to more controversial figures and writing.[37]

It is difficult to see the work of ICAIC in this period as being radically different from the caution being exercised in the rest of the cultural field. Few contentious topics are fully broached. Let us take one example. One important movement, a growing black cultural awareness, was viewed by the government as politically divisive. The black film-maker Sergio Giral made the trilogy of films – referred to in Cuba in a jokey racist way as *negrometrajes* – on slavery and slave rebellion, *El otro Francisco* (The Other Francisco, 1973), *Rancheador* (Slave Hunter, 1975) and *Maluala* (1979). At one level one can understand the project as recuperating the culture of resistance of slavery which had often been ignored in pre-Revolutionary historiography and romanticized in nineteenth-century literature (the first two films deliberately gloss and subvert literary texts of the nineteenth century). The films deconstruct historical melodrama, show the brutality of slave hunters and reveal the resistance of the *palenques* (runaway slave communities). Yet, at the same time, the films both reinforce and elide contemporary debates. They demonstrate a sense of nationhood forged by black struggle, posit an unproblematic transculturation and create a pantheon of heroic guerrillas, a useful iconography for a black population about to engage in a bloody war in Angola.

This is not to deny the extraordinary achievements of Cuban forces in Africa from 1975, a period that has seen some three hundred thousand Cubans in active service abroad. The Angolan independence movement was greatly strengthened by Cuban assistance and the political map of the Southern Cone of Africa was redrawn. Perhaps the Cubans' most spectacular achievement was to intervene in the battle of Cuito Cuanavale in late 1987, when Angolan troops were beseiged by UNITA rebels in conjunction with the South African army. Cuito Carnavale was liberated and the Cuban, Angolan and SWAPO forces drove out the South African army, inflicting a humiliating defeat on a seemingly invincible power. Cuba has helped to stabilize Southwest Africa and has been instrumental in facilitating the independence of Namibia. All these are subjects worthy of epic cinema, though with the recent disgrace and execution of the Cuban commander-in-chief for drugs offences it is unlikely that this topic will appear for some time. Giral's films, therefore, might be seen as having anticipated these momentous events. But at the same time they have nothing useful to say about contemporary racial problems but rather seem to 'imagine' a community posited on harmony.

A film more sensitive to race, *De cierta manera* (One Way or Another, 1974), was made by Sara Gómez, who died of asthma before the film was finally edited. It was completed by Alea and García Espinosa. The film is set in a new

neighbourhood housing scheme designed to rehouse the tenants of one of Havana's worst slums. It is a love story between a factory worker and a young school teacher and explores a whole range of class, race and gender issues. It interweaves fiction with documentary sections dealing mainly with the marginal elements of Havana and Matanzas; the film argues that the lumpen population, mainly black, has not yet been incorporated successfully into the Revolution. It also offers a feminist critique of religious societies such as Abacua as bastions of male chauvinism. It deals quietly and sensitively with workers' responsibilities and with machismo: a very considerable achievement.

The campaign for women's liberation was enshrined in the Family Code of 1974 which established conditions of equality and responsibility within marriage. Women's rights have been the focus of struggle to this day, for to legislate against discrimination does not mean that male prejudices disappear overnight. ICAIC has made a number of important films about this question; ironically the film-makers, with the exception of the late Sara Gómez, are all men. The four women film-makers currently attached to ICAIC, Mayra Vilasís, Rebeca Chávez, Marisol Trujillo and Miriam Talavera, have yet to make a feature-length film. Other technical jobs such as those of technicians or camera-operators remain male bastions. However, the films of the 1970s and 1980s have at least offered a positive image of independent women struggling with contradictions in the private and public spheres, in particular Pastor Vega's *Retrato de Teresa* (Portrait of Teresa, 1978), which portrays the break-up of a marriage as the wife is involved in the home, in factory work and in work-based cultural activities that incur the wrath of her two-timing husband. To quote Mayra Vilasís:

> We should remember the polemic caused by the exhibition of *Portrait of Teresa*. The polemic embraced the broadest sectors of society. The equalities of the Cuban woman became a theme of public discussion, outside the home. Teresa, as a worker, found a very important interlocutor, a fundamental element of our society, the working-class woman. From one day to the next, Teresa became the *image* of the Cuban woman, typifying her conflicts.[38]

Gender is more interestingly examined than race in the films of the 1970s, and in this the films reflect the political and social imperatives of the time. It is also significant that the experimentalism of the late 1960s seems to be put aside in the following decade. There is a deliberate shift to capture a more 'popular' audience, which in turn implies a more transparent style. There is nothing wrong with this per se – it is obviously a critical cul-de-sac that revolutionary films must continually question the medium – but doubts as to the film-makers' strategy were voiced at the end of the decade by Alea in his elegant theoretical essay *The Viewer's Dialectic* (published as a book in the 1980s, but written partly in the late 1970s). He does not deal specifically with particular Cuban films, but his arguments can certainly be applied to 1970s film-making. It is worth quoting at

length since his thesis is important. Alea asks how in a Tarzan film a hetero-geneous audience in terms of age, sex and colour all feel the same emotions towards actions that might threaten, outside the cinema, the moral integrity of a substantial part of that audience. How is the audience manipulated? Are there discursive strategies to be emulated?

> Some think with the greatest of good will, that if we were to substitute a revolutionary hero for Tarzan, we could get more people to adhere to the revolutionary cause, but they do not take into account that the very mechanism of identification or empathy with the hero, *if it is made into an absolute*, puts the spectator in a position in which the only thing he can distinguish are 'bad guys' and 'good guys' without considering what the character truly represents. So it is intrinsically reactionary because it does not work at the level of the viewer's consciousness; far from it, it tends to dull it.[39]

Equally damning are his remarks earlier in the book:

> The superficial interpretation of the thesis which holds that the function of the cinema – of art in general – in our society is to provide 'aesthetic enjoyment' at the same time as 'raising the people's cultural level' has again and again led some to promote additive formulae in which the social *content* ... must be introduced in an attractive form, or in other words, adorned, garnished in such a way as to satisfy the consumer's tastes. ... Such a perspective can only lead to bureaucratizing artistic activity.[40]

A number of Cuban films in the 1970s fall into the two categories outlined above. Take for example the two films by Manuel Pérez, *El hombre de Maisinicú* (The Man from Maisinicu, 1973) and *Río Negro* (1977), or *El brigadista* (The Literacy Teacher, 1977) by Octavio Cortázar. All these are macho adventure stories, where the good guys are revolutionary and the bad guys are counter-revolutionary. No other nuances are needed or offered. *El hombre de Maisinicú* had a huge impact in Cuba because it told the real-life story of a heroic double agent. The manner of its telling is, however, decidedly black and white.

Not all film-makers took the easy option. Solás's *Cantata de Chile* is a typical *tour de force*, a heady mixture of realism and allegory in its reconstruction of the massacre of miners at Santa María de Iquique in Chile in 1907 (a theme close to the Chilean Miguel Littín's Third World epic, *Actas de Marusia,* made in Mexico in 1975). It is a homage to the Chilean resistance but also a critique of Popular Unity; it draws on Mexican muralism, on Neruda's epic *Canto General*, on the lyrics of Violeta Parra, on popular theatre and iconography. But it received a hostile reaction in Cuba, perhaps for its very complexity. Octavio Gómez was more successful with *Los días del agua* (Days of Water, 1971) which tells the true story of faith-healer Antoñica and the political manipulation of her messianic following. This was the first colour film to be made in Cuba. Gómez's later films in the 1970s did not reach the same levels as his first two features.[41]

Even Alea suffered a lapse of form in *Los sobrevivientes* (The Survivors, 1978), but he also produced a masterpiece, *La última cena* (The Last Supper), completed in 1976, which gives a greater analytical depth to Giral's slavery trilogy, examining in particular the clash between a certain misplaced Christian religious piety and the strength of Afro-Cuban religion. The film is based on a short paragraph from Moreno Fraginal's brilliant work of historiography, *El ingenio* (The Sugar Mill), which tells of a Count de Casa Bayona who, influenced by a learned treatise, the 'Explanations of Christian doctrine suited to the capacity of simple negroes', decided to gather around him twelve slaves and wash their feet, as Christ served his apostles. However, instead of behaving like apostles, the slaves organized a mutiny and burned down the sugar mill. The Christian performance ended with the *rancheadores* hunting down the slaves and decapitating them – though one escaped, the rebellious Sebastián.[42]

As the decade drew to a close, however, there was little to be optimistic about in Cuban cinema: some memorable feature-length documentaries by the consistent Santiago Alvarez and a handful of excellent films. A great deal of mediocre work was also produced and there were few signs of new blood in either directors or actors. The Revolution was growing older and more bureaucratic; tensions – both internal and external – were having an adverse effect on creativity. *Cecilia*, made at the beginning of the 1980s, seemed to sum up a number of different worries. It offered an established director who could not guarantee a quality product (an expensive luxury in an industry of few resources), a rather hackneyed use of old genres and an ageing superstar cast. The part of Cecilia demanded a bewitching actress in her teens or early twenties (in the book *Cecilia Valdés*, Cecilia is a teenager). Instead the part was given to Daisy Granados, a splendid actress, but a woman who looks her forty-something years. Changes were clearly necessary.

The 1980s

The unease over the direction of Cuban cinema might help to explain the change in the directorship of the industry in 1982. Alfredo Guevara became ambassador to UNESCO in Paris and Julio García Espinosa became the minister responsible for cinema in the Ministry of Culture. He made a number of policy changes: an increase in production, in particular of feature films; a reduced budget per feature; the introduction of new directors and a time limit for shooting.[43] The years 1984 to 1985 saw a number of first features, which many critics considered a break with the past. In 1985 Jorge Fraga, one of the heads of production of ICAIC, assessed this 'new wave':

> Perhaps to call it a 'new wave' is to overstate the case. The films made in the last two or three years are different for a number of reasons. Firstly our country is

different. It is a much more mature and organized society. The film-makers are also different, not as young as we would like, but younger than my generation, so they have different experiences, different sensibilities, different ideas. I think there is a continuity between my generation and the new film-makers, we have the same general aims. The diversity is more apparent since we are making many more films. In the sixties there were four of five features a year, now we're making seven or eight a year, so a broader spectrum of subjects is possible. Also the new generation is much more concerned with everyday life in our society. My generation was more concerned with the 'big' subjects, the epic approach, the task of recovering our history and traditions. Also the young film-makers are very popular with the audience. In 1984, 120 films were released in Cuba. 8 were Cuban, but they were seen by almost 20 per cent of the total audience. *Una novia para David* was seen by 800,000 people in the first six weeks.[44]

Having a number of young directors creates as well as solves problems: one cannot expect fully formed, sophisticated works from directors who are learning while they are making feature films. All have served apprenticeships as assistant directors, all have made documentaries and each feature script is discussed widely within ICAIC; there is a competition each year among the young directors and the best scripts are supported. Thus a certain quality control is guaranteed. The films are often comedies, a return to the mood of 1966 and 1967, and a deliberate break with the 'epic' past that Fraga mentions. There is a story, perhaps apocryphal, that when the Polish writer Witold Gombrowicz left Buenos Aires, after a stay of many years, he shouted down from the boat to the well-wishers who had come to see him off: 'Jóvenes, matad a Borges' (Young people, kill Borges!). A similar desire of young directors to cut through the dominant rhetoric seems very salutary and it could be that the patronizing, rather supercilious comments by foreign critics referring to the new work – arguing that any change of style from the heroic days is a 'retreat' into safe domestic themes[45] – are premature, if not misplaced.

Obviously this work has got to be good. Even though *Una novia para David* (A Girlfriend for David, 1985) was an enormous popular success, it was a success in the same way that *Porky's* caught the mood of North American youth: adolescent comedy, very much in the style of US sophomoric films. Similarly Rolando Díaz's *Los pájaros tirándole a la escopeta* (The Birds Firing on the Guns, or Tables Turned, 1984) is a light satire on machismo as a son forbids his mother from having a relationship with the father of the girl he loves. There have been, however, some very impressive works. Jesús Díaz's *Lejanía* (Parting of the Ways, 1985) is a sensitive account of exile and return, setting its domestic drama at the time when Castro allowed a number of exiled relatives to return to see their families. A mother returns from Miami laden with gifts, but cannot reach her son, who rejects her advances. Even though the film becomes somewhat sententious near the end, it has many memorable moments: in particular the balcony soliloquy of the young cousin brought up in the United States and re-experienc-

ing the sights and sounds of Havana. The pain of exile and the sense of displacement of the young girl caught ambiguously between two cultures are expressed in the verses of the Cuban poet Lourdes Casal which she recites. Díaz has a great sensitivity to the nuances of language and a very economical style – his film was cheaply and rapidly shot – but it seems likely that his skills as a director will be lost to ICAIC as he concentrates on his career as a novelist.

Juan Carlos Tabío is another lively talent. His first feature, *Se permuta* (House Swap, 1984) showed a fine comic timing and a sensitivity to colloquial language, both of which are put to great effect in his latest feature, *Plaff* (1988). *Plaff* brings together a number of the tendencies outlined above. It pokes fun at all the sacred cows. Its opening parodies notions of 'Imperfect Cinema', the famous thesis essay of García Espinosa: the film has to start without the first reel, since it has not been developed in time. The missing reel finally turns up and is tacked on the end of the film, thus 'explaining' the mystery. The film jokes with Brecht – a wardrobe door swings open at the wrong moment, revealing the film's 'conditions of production', a film crew huddled in the bedroom. It manages to slip in what must be the first *travesti* filmed in a society whose tolerance of sexual difference has not been notably enlightened. It jokes at the Cuban passion for television soap opera. It has an irreverent view of religious cults, as the protagonist's neighbour runs a thriving business in mystification: 'The saints have their bureaucracy', she remarks to an impatient client. The film tilts at government bureaucracy but manages to have the work of a young heroine, a woman scientist, eventually recognized by her colleagues. It also offers a magnificent comic role for Daisy Granados, as a jealous middle-aged mother-in-law trying to subvert her son's love for his wife. The humour is in the slapstick – lots of eggs, if not custard pies, are thrown – but also in the colloquial language, and the cinema where I saw the film in Havana was in hilarious uproar throughout the screening.

Another inventive area of growth is in animation, especially in the work of Juan Padrón. *Vampiros en la Habana* (Vampires in Havana, 1985), a full-length animation film, is a homage to vampires, to gangster movies of the 1930s and 1940s, and a lively re-creation of the thirties in Havana, under the Machado dictatorship. It is a remarkable achievement, especially given the small number of staff: only three key animators and six assistants worked on the project. The animation series 'Elpidio Valdés' is a great success with children, and Padrón has recently teamed up with the distinguished Argentine cartoonist Quino to produce a series of animated shorts, the *Quinoscopios*.

Cooperation can be said to define a number of aspects of film in Cuba in the 1980s. One important initiative was the establishment of the International Festival of New Latin American Cinema, which from its modest beginnings in 1979 has become the showcase for Latin American cinema in the world, attracting film-makers, critics and marchands, and screening hundreds of films, most of which are seen by the Cuban public. These films attract huge numbers

– in December 1988 the police had to control a Sunday night crowd with tear gas and batons, such was the pressure to get in to see a Venezuelan film. The festival allows Latin American film-makers to meet and discuss strategies of co-operation and marketing, reviving an initiative taken in Viña del Mar, Chile in March 1967, where the film-makers of the 'new Latin American cinema' had come together for the same reasons. The Viña initiative now has a solid structure in the Havana festival: the Latin American Film Market (MECLA), a market-place for the distribution of Latin American Film; a foundation of Latin American cinema under the direction of Gabriel García Márquez; and a parallel, but overlapping, initiative: the establishment of a school of cinema for Latin American, African and Asian film-makers in a village close to Havana, which began teaching in January 1987. The initial report from the school is that the students' work is gratifyingly heterodox, although it was beset by financial problems in 1989 and is currently running a reduced programme.

The activity around the festival, the foundation and the school has also generated a number of co-productions. Cuba has always offered its post-production facilities to Latin American film-makers, in particular the exiles from the military dictatorships in the Southern Cone during the 1970s (Miguel Littín and Patricio Guzmán are two notable cases of film-makers whose work was supported after the coup in Chile). At the present time, however, a great deal of money is being invested in Latin American cinema by Spanish television, in the approach to 1992 and the 500th anniversary of Columbus's discovery. It remains to be seen what impact this new 'colonization' makes as forty films are currently in production throughout Latin America with Spanish funding, a number of those in co-production with Cuba. The first films to appear, a series of six entitled *Amores difíciles* (Difficult Loves), based on García Márquez stories or scripts, are polished and competent, but not major works.

In this new situation of comfortable budgets, the questions raised by the 'Imperfect Cinema' debates are beginning to return insistently as technical 'perfection' seems to replace serious analysis. An example of what money combined with a lack of analysis can produce is the Nicaraguan-Cuban co-production, *El espectro de la guerra* (The Spectre of War, 1988), directed by the head of Nicaraguan cinema, Ramiro Lacayo, a glossy musical which becomes a lacrimose melodrama as a lively break-dancer is crippled by the Contras. A much more ambitious co-production *Concierto barroco* (Baroque Concerto, 1989), directed by the talented Mexican Paul Leduc, attempts to bring the baroque complexity of Cuba's major novelist Alejo Carpentier to the screen. Leduc appears to want to rewrite the history of opera in a work which seductively blends the different cultural strands that make up Latin America: Afro-Cuban music erupts into the Parisian strains of high culture; bodies and rhythms couple ecstatically. The film has been vilified or ignored by the critics, somewhat prematurely.

One recent reform within ICAIC has aimed at avoiding the dangers of bureaucratization and centralization. In 1987 three 'creative groups' were set up

under the directorship of Gutiérrez Alea, Solás and Manuel Pérez. All the directors of ICAIC have now been assigned to the different groups which will be responsible for initiating and developing projects. Tomás Gutiérrez Alea spoke in 1989 of the good working relationship that exists among the groups,[46] adding that these more democratic structures guarded against arbitrary decisions being handed down from on high. How the whole process of rectification – which the Cubans have called *perestrópica* or *Castroika*[47] – evolves in the 1990s remains an open question.

In the thirtieth anniversary year, then, the state of 'revolutionary' cinema was fluid. A small number of established directors have provided interesting work in the 1980s, in particular Alea with *Hasta cierto punto* (Up to a Point, 1983) and *Cartas del parque* (Letters from the Park, 1988), and Santiago Alvarez. Other directors such as Solás and Pastor Vega have produced very uneven material. There is also great pressure from the young, who are enthusiastic and iconoclastic – if also somewhat sophomoric at times. Co-productions can lead the industry into new areas. For example, one of the García Márquez film series was a Mexican-Spanish-Cuban co-production *El verano de la señora Forbes* (The Summer of Miss Forbes, 1988), directed by Jaime Humberto Hermosillo. Hermosillo is now one of the world's cult gay directors and even though *Señora Forbes* is not very explicit, it is certainly a homage to gay beauty. García Márquez is playing a key role in introducing more liberal themes, a strategy that he is uniquely placed to carry out as Castro's close friend and one of the world's most celebrated novelists (although he surely suffered a lapse in taste in allowing the Spanish director, Jaime Chavarri to make the disgustingly misogynist, post-modernist, post-everything and in particular post-Franco, *Yo soy él que tú buscas* (I'm the One You're Looking For, 1988 in his *Amores Difíciles* series). It was also salutary to hear the 'pope of the new Latin American Cinema', Fernando Birri, head of the film school, being attacked by film-makers and critics, including his own students, for his self-indulgent *Un señor muy viejo con unas alas enormes* (A Very Old Man with Enormous Wings, 1988). There is a great deal of movement and debate in contemporary Cuban cinema and the results will come into clearer focus in the fourth decade.

Only an extremely foolhardy critic would predict developments in Cuba in the 1990s in the wake of the military drugs scandal of 1989 and in particular in the aftermath of the recent momentous changes in Eastern Europe. Many of the major advances in Cuban society have been promoted or accompanied by a stable economic relationship with the Eastern Bloc. Advances are very clear, as some statistics reveal: an increase in life expectancy from 57 in 1958 to 74 in 1988; a drop in infant mortality from 60 per thousand in 1958 to 13.3 in 1988; an increase in doctors from one in 5,000 of the population in 1958 to one in 400; an increase in literacy over the same period from 76 per cent to 98 per cent and a primary school enrolment which increased from 56 per cent in 1958 to 100 per cent in 1988.[48] These social reforms were accompanied by the increasingly high

profile of Cuba in the non-aligned movement. All these achievements are linked to the continuing stability of Cuban-Soviet relations, a situation that has existed since the United States, Cuba's main pre-revolutionary trading nation, imposed an effective economic blockade. Whether Castro's typically defiant statement that Cuba is the 'last bastion of Marxist-Leninist purity' is correct or sustainable is the main question for the coming period.

Notes

1. Ernesto Che Guevara, 'The Cultural Vanguard', in A. Salkey ed., *Writing in Cuba since the Revolution*, Bogle-l'Ouverture, London 1977, pp. 139–40.

2. See P. Paranagua, *O Cinema na America Latina*, L & PM Editores, Porto Alegre 1985, pp. 94–5.

3. J. Burton, 'Cuba', in G. Hennebelle and A. Gumucio Dagrón, eds, *Les Cinémas de l'Amérique latine*, Lherminier, Paris 1981, p. 262.

4. Néstor Almendros, *A Man with a Camera*, Faber and Faber, London 1985, p. 27.

5. All figures taken from *Cuba: Estadísticas Culturales 1987*, Ministerio de Cultura, Havana 1988.

6. O. Getino, *Cine latinoamericano, economía y nuevas tecnologías audiovisuales*, Universidad de los Andes, Mérida 1987, p. 37.

7. Ibid., Table 8 in Appendix.

8. Ibid., p. 37.

9. Jean Stubbs, *Cuba: The Test of Time*, Latin American Bureau, London 1989, p. 19.

10. Getino, p. 38.

11. Peter B. Schumann, *Historia del cine latinoamericano* Legasa, Buenos Aires 1987, p. 179.

12. Especially in M. Chanan, *The Cuban Image: Cinema and Cultural Politics in Cuba*, British Film Institute, London 1985, who devotes most of his book to the 1960s. See also J. Burton, 'Cuba' and the three issues of the North American film journal *Jump Cut* which provides a dossier of 20 years of revolutionary Cuban cinema. Part 1 in *Jump Cut*, No. 19 (December 1978), Part 2 in No. 20 (May 1979), Part 3 in No. 22 (May 1980). For a detailed bibliography of Cuban cinema, see J. Burton, *The New Latin American Cinema: An Annotated Bibliography 1960-1980*, Smyrna Press, New York 1983.

13. For the attack on Fuentes, see R. Fernández Retamar, *Calibán: Apuntes sobre la cultura de Nuestra América*, La Pleyade, Buenos Aires 1973. Fuentes took his own literary revenge in his most recent novel *Cristóbal Nonato*, (*Christopher Unborn* 1987), in which a Caribbean revolutionary critic is devoured by hyenas.

14. Almendros, pp. 30–36.

15. Santiago Alvarez, 'La noticia a través del cine', *Cine Cubano* Nos. 23–5, September–December 1964, p. 44.

16. 'Joris Ivens en Cuba', ibid., No. 3, November 1960, p. 22.

17. J. García Espinosa, ibid., Nos. 23–5, September–December 1964, p. 16.

18. 'En Cuba el cine busca al público', ibid., No. 13, August–September 1963, pp. 13–20.

19. Castro, quoted in *Política cultural de la revolución cubana: documentos*, Editorial de Ciencias, Havana 1977, pp. 74–5.

20. García Espinosa, p. 20.

21. For a condemnation of ICAIC, see G. Cabrera Infante, 'Bites from a Bearded Crocodile', *London Review of Books*, 4–17 June 1981; Almendros, pp. 34–9; and Carlos Franqui, *Family Portrait with Fidel*, Cape, London 1983, pp. 129–35. For a defence, see Chanan, pp. 100–109.

22. Fidel Castro, 'Words to the Intellectuals', in Lee Baxandal, ed., *Radical Perspectives in the Arts*, Penguin, Harmondsworth 1972, p. 276. The original Spanish text is printed in *Política cultural*.

23. Guillermo Cabrera Infante, 'Cuba's Shadow', *Film Comment*, June 1985, p. 44.

24. Castro, quoted in *Política cultural*, pp. 61 and 63.

25. For an extended discussion of the work of Alvarez, see M. Chanan, ed., *Santiago Alvarez*, BFI Dossier 2, London 1980.

26. See Chanan's analysis in *The Cuban Image*, p. 248.

27. Daniel Díaz Torres, 'La primera carga al machete', *Cine Cubano*, Nos. 56–7, May–August 1969, p. 18.

28. The best-known analysis of melodrama is by Enrique Colina and Daniel Díaz Torres, first published in *Cine Cubano* and translated into English as 'Ideology of Melodrama in the Old Latin American Cinema', in Zuzana M. Pick ed., *Latin American Film Makers and the Third Cinema*, Carleton Film Studies, Ottowa 1978.

29. T. Elsaesser, 'Tales of Sound and Fury', in C. Gledhill, ed., *Home is where the Heart is: Studies in Melodrama and the Woman's Film*, British Film Institute, London 1987, p. 50.

30. C. Gledhill, 'The Melodramatic Field: An Investigation', in *Home is where the Heart is*, p. 30.

31. For an account of the film, see Chanan, *The Cuban Image*, pp. 236–47, and the section on Alea in J. Burton's bibliography, *New Latin American Cinema*.

32. Alea quoted in J. Burton, ed., *Cinema and Social Change in Latin America: Conversations with Film-makers*, University of Texas Press, Austin 1986, p. 119.

33. Translated. in M. Myers, ed., *Memories of Underdevelopment: the Revolutionary Films of Cuba*, Grossman, New York 1973, p. 106.

34. There are a number of discussions of the Padilla affair, in particular *Index on Censorship*, Vol. 1, No. 2 (1972), pp. 65–134, and *Libre*, No. 1 (September–November 1971), pp. 95–145.

35. Chanan, *The Cuban Image*, p. 257.

36. 'Declaración de los cineastas cubanos', *Cine Cubano*, Nos. 69-70 (nd), pp. 2 and 4.

37. Stubbs, p. 19.

38. Mayra Vilasís, 'La mujer y el cine: apuntes para algunas reflexiones latinoamericanas', in *La mujer en los medios audiovisuales: Memoria del VIII Festival Internacional del Nuevo Cine Latinoamericano* UNAM, Mexico 1987, p. 52. See also the paper by Josefina Zayas and Isabel Larguía, 'La Mujer: realidad e imagen', in the same volume.

39. Tomás Gutiérrez Alea, *The Viewer's Dialectic*, José Martí Editorial, Havana 1988, p. 42. The original Spanish version is published as *Dialéctica del espectador*, Federación Editorial Mexicana, Mexico 1983.

40. Ibid., p. 28.

41. There are, however, signs of revisionist criticism of Gómez's later work. See the special issue of *C.-CAL*, December 1988, dedicated to his work.

42. For commentaries on this film and on Alea's work in general, see A. Fornet, ed., *Alea: una retrospectiva crítica*, Editorial Letras Cubanas, Havana 1987.

43. Information from Schumann, p. 176.

44. Jorge Fraga in conversation with Don Ranvaud, Havana, December 1985. I would like to thank Don Ranvaud for his permission to use this unpublished recording.

45. See in particular the attitude of Schumann.

46. Tomás Gutiérrez Alea, conversation with the author, Warwick, October 1989. See also the text of his Guardian lecture at the National Film Theatre in London, October 1989.

47. Stubbs, p. 16.

48. Stubbs, p. v.

Chilean Cinema in Revolution and Exile

I have faith in our nation and its destiny. Other men will prevail, and soon the great avenues will be open again, where free men and women will walk, to build a better society. Long live the people! Long live the workers! These are my last words. I know my sacrifice will not have been in vain.

Salvador Allende, 11 September 1973[1]

The Roots of New Cinema

The origins of a new film culture in Chile can be traced to the development of cultural activities in the Universidad de Chile in the 1950s. A cinema club was founded in the middle of the decade, which helped to consolidate a more sophisticated approach to film with a film journal, a programme for the radio and weekly screenings of foreign films. This activity generated a desire to intervene in the film-making process itself and in 1959 the Centre for Experimental Cinema was established in the University under the direction of Sergio Bravo, a young documentary film-maker. Bravo speaks of these early pioneering years:

> We wanted to find a new language, to become totally independent from what we considered to be official Chilean cinema. We were very impressed by what Fernando Birri was doing. He had founded in 1956 the first Latin American documentary film school ... in Sante Fé, Argentina. He defined his work as 'critical realism', a sort of neo-realism, although it was not exactly the same. Many went to study in that school. We, in the meantime, organized exhibitions of ceramics, of wicker-work objects, we were fairly mad, discovering the light, our southern light, which is a maritime light of great chromatic richness. ... I filmed all that I could.[2]

Bravo's own documentaries concentrated on local popular customs and practices. He brought this interest in excavating and revealing local popular

culture to his courses at the university, encouraging a series of short documentaries from such incipient cineastes as Domingo Sierra and Pedro Chaskel. Other artists were also actively engaged in recuperating forgotten traditions. The musician Violeta Parra went into the countryside, learning the folk traditions and songs of the rural communities, and bringing them to a wider urban society. She also exhibited *arpilleras*, women's patchwork embroideries, inserting the popular into an art world dominated by European and North American forms. Violeta Parra and Sergio Bravo were two of the educators of a generation that began to transform Chilean culture in the sixties, part of a broad political movement which supported the need for change after the stagnation of the Alessandri and Ibáñez administrations of 1952 to 1964.

In the 1964 presidential elections, two candidates proposed sweeping reforms of the social and economic system – the Christian Democrat Eduardo Frei and the Socialist Salvador Allende – and received over 90 per cent of the popular vote. Frei won the election on his programme of 'Revolution in Liberty',[3] which sought to articulate a new middle way between the antagonistic poles of right-wing and Marxist political parties. Between 1952 and 1964, the size of the electorate trebled and the Christian Democrats attracted a large share of that vote, especially among women and also low-paid male urban workers. They also became the party most favoured by US aid as Chile became one of the test cases of the 'Alliance for Progress', which sought to destroy the power of Marxist parties through economic and social modernization. The fear of 'another Cuba' haunted North American policy-makers at the time. The United States financed roughly half of the Christian Democrat electoral campaign. A great deal of money was spent on media propaganda, featuring scenes of what might happen if the 'Red Peril' was elected: newsreel clips were shown of priests hearing the confession of men about to be shot by purported Marxist forces and the press was full of anti-Marxist scaremongering. At the same time, a documentary made by Sergio Bravo of Salvador Allende's electoral campaign, *Banderas del pueblo* (Banners of the People, 1964) was banned by the censors. Images of Russian tanks and Cuban militias, CIA-sponsored radio propaganda,[4] counterpointed with constant programmes underlining the progressive, moderate nature of the Christian Democrats, had a considerable effect on the outcome of the election. The defeat of the left alliance caused a widespread internal debate not just about the electoral base (why the traditional left parties had not been able to attract the new voters), but also about the function of hegemony and the need for cultural workers to wrest 'common sense' values away from the control of the right or Christian Democracy. The debate about strategy and tactics in the Marxist parties was, therefore, accompanied by a flowering of left activity in theatre, music and the cinema.

This activity can be seen in many different cultural forms. Perhaps the most dynamic was music. By the time of her suicide in 1967, Violeta Parra had helped to stimulate a range of singers and musicians: in her own family (Angel and

Isabel Parra), in the universities, with the appearance of groups such as Quila-payún, and Inti-Illimani, and in the wider society. Song celebrated popular culture and supported social change, in small clubs such as the Peña de los Parra, or massive political demonstrations, culminating in the election rallies of the late 1960s when hundreds of thousands would sing the lyrics of a Victor Jara or a Patricio Manns and would jump up and down on the spot shouting: 'El que no salta es momio' – 'If you're not jumping you're a fascist.' Theatre also experienced a renaissance, with experimental groups such as ICTUS, the El Aleph Group, the Teatro del Errante and the Teatro del Callejón. These groups often supplied the actors for the early films of new Chilean cinema. The poets were also in the public arena, led by the dominant figure of Pablo Neruda, who stood as the Communist Party candidate in the election for the leadership of the Popular Unity coalition in 1970. On the periphery, undermining Neruda's powerful rhetoric, was Violeta Parra's brother Nicanor, the anti-poet of the sixties generation. Cinema would form part of this general movement for social change.

Just as the Christian Democrats attempted some partial reforms, which did not radically confront the inequalities of Chilean society (the 'Chileanization' of copper made the US companies better off; agrarian reform was only very partial), so they made some timid moves to support cinema. They created a council to promote the film industry and in 1967 gave local producers a percentage of box-office takings.

> Government support for Chilean films resembled its partial nationalization of copper mines and its agrarian reform, in that it attempted to reform current practices without basically affecting fundamental interests. In the area of film-making, the above course of action meant emphasizing supportive protectionist measures without affecting distribution and exhibition commercial practices or the hegemonic presence of foreign distributors.[5]

The years 1968 to 1969 are generally accepted as marking the coming of age for young Chilean film-makers. Five features were released: Raúl Ruiz's *Tres tristes tigres* (Three Sad Tigers); Helvio Soto's *Caliche sangriento* (Bloody Nitrate); Aldo Francia's, *Valparaíso mi amor* (Valparaíso My Love); Miguel Littín's *El chacal de Nahueltoro* (The Jackal of Nahueltoro) and Carlos Elsesser's *Los testigos* (The Witnesses). At this time, the cineastes could be seen as a group, albeit with different ideological and aesthetic tendencies. All were working with scarce resources: the films by Ruiz, Elsesser, Francia and Littín were made consecutively, with the same camera. All were part of the cultural effervescence of the late sixties and all were influenced by the flowering of Latin American cinema as witnessed in the meeting of Latin American film-makers organized by Aldo Francia in Viña del Mar in 1967 (see Chapter 3).

· The first film to appear in 1968, *Tres tristes tigres*, established Ruiz as the most experimental cineaste of his generation. The very title of the film, a tongue-

twister in Spanish, points to a work which examines the gaps between signifier and signified, explores genres and poses problems of representation. At one level, it can be read literally: the sad tigers are the petty-bourgeois protagonists, who hang out in bars talking about everything and nothing, unable to relate to the changing realities of society. Yet their language is both realist and highly literary: the model here is the arch-jester Nicanor Parra, a poet who, from the 1950s, had attempted to break through the dominant Nerudian discourse of Chilean poetry in collections of sardonic 'anti-poems' which are extremely self-conscious, witty and caustic. Parra expresses an anarchic sentiment which defines his work and also that of Ruiz:

> Independently
> Of the designs of the Catholic Church
> I declare that I am an independent country
>
> May the Central Committee forgive me[6]

The film is dedicated to Parra, and it forces the spectator to revise his or her expectations about genre (in particular the melodrama) and about composition: characters constantly wander in and out of the frame. The position of the camera is also unconventional: 'The idea was to put the camera not where it would see best, but where it should be, in the normal position. This means that there is always some obstruction and things are not seen from an ideal standpoint. There was also an anti-dramatic tendency. ... '[7] Ruiz had studied for a time with Birri in the Santa Fé school in Argentina, but he was not convinced by its neo-realist documentary approach that taught, 'that it was the duty of every human being in Latin America to make documentary films'.[8] His ironic, lucid examination of the strengths and weaknesses of political culture in Latin America would continue under the Popular Unity government (1970–73), when he would film in a number of different styles.

Aldo Francia, a paediatrician turned film-maker, made use of his professional experience in his neo-realist *Valparaíso mi amor*, about the plight of children as the innocent victims of social injustice and underdevelopment. It is based on the true story of a man who is imprisoned for robbery and cannot prevent his family drifting into delinquency and prostitution. It is also a lyrical evocation of the port of Valparaíso. Soto preferred to paint a broader historical canvas in *Caliche sangriento* (Bloody Nitrate), which gave an anti-imperialist analysis of the 1879 War of the Pacific (Chile against Bolivia and Peru). The victor of these disputes, for Soto, was British commercial interest anxious to exploit nitrate resources in the area in conjunction with a clientelistic sector of the Chilean oligarchy. Chile's victory in the war allowed her to extend her territories by a third (into the nitrate-rich Atacama desert) and gave her the mineral wealth that would make up roughly half of government revenue for the following forty years.[9] In the film's

analysis, the war was the beginning of imperialist penetration in the country's mineral resources, an imperialism that would pass from British into US hands.

The most popular film of this group was *El chacal de Nahueltoro,* seen by some half a million people. Its political importance lay in the fact that although it was set in the period of the previous president, Alessandri, it effectively undermined one of the main claims of the Christian Democrat government: its attempt to develop a social policy for marginal groups to prevent their commitment to the Marxist parties. The Christian Democrats, prompted by the theoretician Jorge Ahumada, had promised to create a hundred thousand landholders among landless peasants. In the event, they fell well short of that target and the film examines the plight of the landless rural poor: a true story of a man who murdered a homeless woman and her five children in a hopeless act of drunken violence. In 1960, the sensationalist press painted the man as a 'jackal', but Littín reveals the social conditions of misery and deprivation that act as breeding grounds for such crimes, and also the rigid social and legal codes that both socialize and condemn its 'criminals': 'Alcohol, religion, smiles, law, gentleness – all are part of the system's tools to train and subdue men.'[10]

Littín spent years researching the case and the film is framed as a documentary reconstruction offering different layers of competing information: the cold 'facts', the sensationalist interpretations; the reconstructed 'interviews' with key witnesses and interlocutors by a journalist, and finally the stumbling voice of the protagonist, José, himself.[11] These narrations are juxtaposed in the first half of the film with images which move from the 'present' of José's capture and interrogation, against a background of crowds baying for his blood, to a 'past' which traces key moments in José's life from his abandoned childhood to his miserable development as an adult in the poverty of the countryside, drifting through a series of menial jobs. The energetic, fluid camerawork and the movement between past and present of the first part of the film are replaced by a relatively stable narrative in the second half when, in prison, José is socialized into the laws and language of culture. Littín mercilessly exposes the ideological state institutions of the law, the penal code, education and religion which distort José's growing consciousness and then support his execution. He acquires feelings of solidarity (kicking a football in the prison yard) and also a number of skills, and is willing, unquestioningly, to put himself at the service of the state. If reprieved, he will be 'humble, hardworking, useful to society and helpful to my mother'. Yet even such malleable figures are ultimately sacrificed to society's misplaced notions of vengeance.

The Popular Unity Period

El chacal came out in the run-up to the presidential elections of 1970 and was an important element of popular mobilization. The Popular Unity coalition won

these elections by the narrowest of margins: Salvador Allende received 36 per cent of the vote, Jorge Alessandri, the right-wing candidate, 35 per cent and the Christian Democrats 28 per cent. The right had thought they could win without entering an electoral pact with the Christian Democrats, and on the basis of fierce opposition to reformism or radicalism. Popular Unity felt a certain optimism since they believed that, with the Christian Democrat vote, over two-thirds of the country was in favour of reform. The constitution was upheld and Allende was elected to power; but he was to find his measures hampered at every stage by a united and vociferous opposition. Popular Unity itself was an electoral alliance, but Allende found it exceptionally difficult to overcome the main policy differences between the two Marxist parties. Faúndez's analysis is illuminating:

> The Popular Unity government did nothing to resolve the differences between Socialists and Communists. Indeed, instead of trying to resolve these differences, it circumvented them, expecting, mistakenly as it turned out, that they would be superseded by the political struggle. This unresolved conflict led in practice to innumerable policy deadlocks and contradictory policies. All this contributed, in turn, to reinforcing the opposition perception of the government as both ruthless and aimless; and the ultra-left's view of it as both hesitant and revolutionary.[12]

The communists assumed that an alliance with representatives of progressive bourgeois elements would lead to a national, democratic revolution. The socialists assumed that working through the existing state mechanisms would lead to a political impasse.

Popular Unity, therefore, lacked a well-planned strategy and was prey to external and internal forces: right-wing and foreign-directed subversion, constant opposition in congress, and conflict among its six-party membership which turned every decision into a fragile compromise. Yet despite all these difficulties, the government's initial measures were quite successful in taking over what were called the 'commanding heights of the economy': nationalizing mainly US-owned mineral resources, the banks, a number of manufacturing enterprises and nearly 2.5 million hectares of land.

The same successes and limitations were reflected in the film sector. The victory was greeted with euphoria and film-makers put out an enthusiastic manifesto (penned by Miguel Littín); it promised, in the vaguest of terms, that Chilean cinema would become national, popular and revolutionary. It called on the cinema to bear witness to the heroes of Independence, to labour leaders and to the anonymous workers, and in this way to wrestle popular memory from the hegemony of the right. The manifesto also declared its aim to fight sectarianism and stifling bureaucratic controls and to educate the spectator into new ways of seeing.[13]

Miguel Littín was given the task of turning this rhetoric into a reality from the institutional base of Chile Films. He faced a number of difficulties. Firstly, distribution was run by a small number of companies, either US-owned or

owned by national capital which derived profits from US cinema. Given the government's electoral promises to nationalize US interests it was inevitable that the North Americans would take retaliatory measures against a country which, in Henry Kissinger's words, had been 'foolish' enough to elect a Marxist government. IT & T, the communications network, had declared its intention to make the economy 'scream'.[14] After the nationalization of US companies, an informal economic boycott (though not of arms supplies) was accompanied by increased CIA covert action, which included funding opposition newspapers and parties. As part of these 'informal' measures, the head of the Motion Pictures Export Association, Jack Valenti, ordered the suspension of US film imports from June 1971. US distributors also demanded that small exhibition outlets should pay film rental in advance, a reversal of current practices. The prospect of empty screens and a closure of theatres was very real and Chile Films reacted by organizing a series of bilateral exchanges with Bulgaria, Cuba, Hungary and Czechoslovakia, which disappointed spectators and caused the right-wing press to claim that the market was being flooded with Marxist propaganda. Distribution and exhibition would remain problematic and there was no time to implement any effective policies. By mid 1973, Chile Films controlled only thirteen theatres and ran four mobile units. By 1973 the state-owned distribution company had 25 per cent of the market, but met with sustained opposition: on a number of occasions private theatres refused to screen the state's weekly newsreel.

Miguel Littín took over the directorship of Chile Films with great enthusiasm and a number of innovative ideas. Yet within ten months he had resigned, tiring of bureaucratic opposition (many officials had guaranteed jobs in Chile Films and could not be replaced) and inter-party feuding, as the different members of Popular Unity demanded their own quota of resources. This rivalry led to a diffusion of energy and a lack of coordination. Littín proposed setting up a series of *talleres* (workshops) covering the main areas of cinema: documentary, features, children's cinema; but little came of these ideas apart from some work on documentary. No feature films funded by Chile Films were completed under Allende. Increasingly, therefore, the film-makers decided to make their own films outside the official sector, though they would still use the facilities of Chile Films. Littín, however, argued that some useful developments had occurred from within the state:

> The official structure of the cinema led at least to a number of important things such as: the creation of a national distribution company, the progressive nationalization of cinema, the showing of films from the new Latin American cinema across the whole country, ... the palpable improvement of technical resources, especially dubbing theatres, labs, camera equipment.[15]

Among those who benefited from these measures were young film-makers such as Sergio and Patricio Castilla and Claudio Sapiain, whose talents would later

flower in exile. Differences of outlook, meagre resources and the pace of events, however, denied the formation of a coherent group practice. The history of cinema under Popular Unity offers a mosaic of different tendencies.

Littín finished *La tierra prometida* (The Promised Land) just before the coup, but the post-production work was completed in Paris, where Littin was fortunate enough to take refuge as an exile. Arrested in a sweep of Chile Films after the coup, he was allowed to escape thanks to a sympathetic army sergeant who was an admirer of his work.[16] The film became a success on the international circuit as it seemed to predict with accuracy the bloody coup of 11 September 1973. Set in 1932, it has as its frame of reference the successful socialist rebellion of air commander Marmaduque Grove against the president, Estebán Montero. Grove's regime was to last a mere eleven days, but his real populist appeal (he had massive support from organized workers and the urban dispossessed) had made him the stuff of popular legend. Littín exploits this popular memory by tracing the odyssey of peasant leader José Durán and his companions, who sought to establish links with the progressive forces of Grove and form their own utopian socialist state in Palmilla in the south of Chile. He employs a number of devices which allow for historical, allegorical and mythic readings. An old man narrates his story of the 1930s events, a narration reinvented by memory. Folk songs continually punctuate the film, asserting their claim as an authentic popular history, preceding the hegemony of print culture. Figures from history, such as O'Higgins, appear alongside the protagonists. The patron saint of Chile, the Virgin of Carmel, gives support both to the rich and to the poor. The hyperbolic, non-naturalist modes of story-telling are used to great effect. Yet history as a text must be reconstructed and the events of the 1930s eerily parallel those of the early 1970s. After a long journey the workers take power; their relationship with the local bourgeoisie is hostile and vacillating; the established authorities control language and therefore power. José Durán says at one point: 'Enough of words and discussion, because in words and discussion it's always the rich who get the better of it.' If the rich control language, they also control naked power: the army intervenes to massacre Durán and his followers. For Littín, the peaceful, democratic road to socialism was a strategic and a tactical mistake.

Raúl Ruiz was the most productive film-maker of the period, making a number of films in different styles. He lucidly declared that Popular Unity cineastes should work in three areas: cinematic activism (working with mass organizations), official cinema (arguing for government policies) and the cinema of expression (a more personal mode).[17] His own films show this range. *Ahora te vamos a llamar hermano* (Now We are Going to Call you Brother) is a didactic short. *La colonia penal* (The Penal Colony, 1971) is a Kafkaesque tale set on an island where everyone is dressed in military uniform – another presentiment of what was to come. All the characters speak a language invented by Ruiz and the actors were asked to improvise many of the scenes. Such an approach was seen

in more dogmatic sectors of the left as ludic wilfulness. *La expropriación* (The Expropriation) was shot in four days late in 1971, not finished until 1973, and not given a general release since it was considered to be too provocative: when land is given to peasants through government expropriation, they do not want the landowner to leave and end up assassinating the government official. In 1973, *El realismo socialista* (Socialist Realism) dealt with the problem of factory take-overs, once again in an ironic fashion. It was aimed at provoking debates within the Socialist Party.

Raúl Ruiz was a Socialist Party militant, a party he found congenial since it had such fluid positions, ranging from the ultra-left to social democracy, with members shifting positions with great alacrity, as is portrayed in *El realismo socialista*. Yet increasingly he took an ironic attitude towards official policies, against the kitsch of government-led popular culture, a 'Quilapayun' culture he once savagely called it:

> It is not a question of pessimism, but for me irony is an important tool of political analysis. The present tragic situation is the result of a certain political process: it is important to be lucid rather than bemoan our fate; irony is necessary to refresh and clarify our perception of things.[18]

His 1971 film *Nadie dijo nada* stresses the bad faith of intellectuals who believe that their world is all that exists. It is set, like *Tres tristes tigres* in the twilight world of Santiago bars, a private city where intellectuals can talk and drink the night away, only glimpsing at the reality that lies beyond their class perspectives. Petty-bourgeois intellectuals are also placed in an ambiguous situation in *El realismo socialista*. Ruiz supported the strategy of popular power, a radical grassroots movement which attempted to quicken the pace of Popular Unity's policies in the face of the right-wing offensive of late 1972. Attention was focused on the *cordones industriales* (industrial belts) which grew up around Santiago and in Concepción and Valparaíso. By August 1973, nearly half the workers in industrial areas belonged to a *cordón*, a fact which was a threat to the government – since initiatives were taken outside the channels of government agencies – and also to the organized unions, since the representatives of the *cordones* were elected by the workers themselves. Film-makers analysed the basic paradox of Popular Unity: it could not oppose popular power by naked force; on the other hand it could not be seen, since it was working within the state apparatus, as approving these actions.

The most exemplary film examining this process of radicalization which led to the coup, was Patricio Guzmán's *La batalla de Chile* (The Battle of Chile), a documentary in three parts which was edited in exile in Cuba. Guzmán had been a film student in Spain before returning to Chile with the victory of Popular Unity. Like a number of other film-makers, he decided to work outside Chile Films. He obtained a grant and materials from the School of Communications at

the Catholic University which enabled him to complete *El primer año* (The First Year, 1972), a documentary on the first few months of government.[19] He then planned to work on a fictional documentary of the Independence hero Manuel Rodríguez, which he shelved due to the quickening pace of political activity in late 1972. The lorry-drivers' strike of October 1972 was joined by taxi drivers, shopkeepers and local industrialists. Well organized, with CIA funding, it was greeted by an extraordinary left-wing mobilization as workers took over factories and controlled distribution networks. Guzmán filmed these events; the resulting documentary, *La respuesta de octubre* (The Reply in October, 1973) is somewhat monotonous in its recording of the emergence of the *cordones industriales*. It was after the events of October that Guzmán and his group decided to film the process that was developing rapidly, in order to produce an analytical rather than a denunciatory or agit-prop film.

The filming was planned like a military campaign by the Equipo Tercer Año (The Third Year Group) made up of Jorge Müller (a cinematographer who was used by most of the directors of the period, in particular Raúl Ruiz, and who 'disappeared' with his *compañera*, the actress Carmen Bueno, in 1974), Federico Elton, José Pino, Patricio Guzmán and Angelina Vásquez. With borrowed equipment, a Nagra sound-recorder and an Eclair camera, and with film stock donated by the French film-maker Chris Marker, they began shooting in February 1973:

> The 'screenplay' thus took on the form of a map, that we hung on the wall. On the one side of the room, we listed the key points of the revolutionary struggle as we saw them. On the other side, we would list what we had already filmed. ... So we had the theoretical outline on the one side and the practical outline of what we had actually filmed on the other.[20]

They filmed nearly every day for seven months and gained access to all sectors of society though various guises, accumulating extensive and almost unique coverage of the developing class struggle. With the coup, the film stock was smuggled out of the country and edited in Cuba in the studios of ICAIC. The resulting structure is in three parts: 'The Insurrection of the Bourgeoisie' deals with the middle-class offensive against the government in the media and in the streets; 'The Coup d'état' continues the analysis of the first part, adding the dimension of the bitter quarrels among the left over strategy; the third part, 'Popular Power', looks at the work of the mass organizations in 1973. The main analysis is given by protagonists in the film, but an authoritative voiceover narrator also offers background information and an analysis which is sustained or contradicted by the image track.[21] The film became Chile's most important testimony for the outside world and received worldwide distribution in the campaigns of solidarity.

Exile and Resistance

The coup, which many expected, was accompanied by a ferocious assault on left-wing and trade-union movements. Film workers were amongst the tens of thousands killed or disappeared, the hundreds of thousands imprisoned in temporary camps such as the National Stadium, or sent into exile. *The Battle of Chile* contained a chilling image from June 1973 which prefigured the later slaughter. An Argentine cameraman, Hans Herman, filming an army insurrection, actually filmed his own death. The footage shows soldiers from a truck aiming shots at the camera which keeps in focus for a long time before spinning out of control. The international solidarity campaign did offer many visas to Chileans and all the major directors apart from Aldo Francia, who resumed his work as doctor in Valparaíso, went into exile.[22] Littín took up residence in Mexico, where he was fêted by the ebullient president, Luis Echeverría. Guzmán was offered facilities to edit his film in Cuba, where he joined Pedro Chaskel. Soto went to France, as did Raúl Ruiz, who settled initially in the immigrant Parisian quarter of Belleville.

Within Chile, film production was effectively destroyed for a number of years. All the film schools and production centres were occupied by the military, installations were destroyed and old film stock burned.

> The state production and distribution company Chile Films bore the brunt of the repression. Its premises were occupied and its irreplaceable negative archives indiscriminately destroyed, including a priceless collection of the country's earliest newsreels. Its staff were sacked *en bloc*, many being arrested, imprisoned and tortured. Several died, including the director Eduardo Paredes ... and, some months after the coup, Carlos Arévalo, who had distributed films to trade unions and shanty-town communities, and the cameraman Hugo Araya. Chile Films productions were banned. Film and sound-tapes were burned in the streets together with books, magazines, pamphlets, posters and university theses.[23]

The government's general censorship of the arts and the mass media was directed, in the film sector, by a Council of Cinematographic Censorship. Among the films it banned in the mid 1970s was *Fiddler on the Roof* (for Marxist tendencies!) and *The Day of the Jackal*, which was felt to encourage violent, anti-social tendencies. It would be a number of years before film-making within Chile was to make some tentative advances out of the destruction of late 1973. It is to the exile community that we must look for the significant developments in the 1970s.

Work in exile can be said, crudely, to take place between the two poles represented by the careers of Littín and Ruiz. Ruiz went penniless to Paris, with his wife, the editor and film-maker Valeria Sarmiento. He began by making a film about the exile community in Paris, *Diálogo de exilados* (Dialogue of

Exiles, 1974). However, instead of portraying an optimistic, exemplary group of expatriates, he shows how inappropriate their desires are to the new circumstances. He uses Brecht's words on exile ironically at the beginning of the film. 'The best school of dialectic is emigration, the most skilful dialecticians are exiles. It is change that forced them into exile and they are interested only in change.'[24] In counterpoint to this statement, the Chileans grouped in the long-corridored house, who kidnap a singer (a fascist sympathizer), go on hunger strike, collect money for the resistance or talk endlessly about their situation, are seen through an ironic gaze. The reaction of the Chilean community was hostile; Ruiz, in a form of double exile, was forced to seek access to the world of French film-making.

He was fortunate in that his arrival coincided with changes in French television and the creation of a number of specialist institutions, including the INA, Institut National de l'Audiovisuel, which commissioned experimental work. It was the INA that was to support Ruiz's initial projects for television, offering him a range of sophisticated technical equipment and launching an extraordinarily productive career in France, where he is now widely recognized as the most important, innovative director working in that country. The director of *Cahiers du Cinema,* Serge Toubiana, in a special issue dedicated to Ruiz's work in 1983, gave the following homage:

> In contemporary French cinema, the small troupe that gravitates around this magician who makes the shadows move and allows all languages to be spoken within one language, is one of the most lively places that exists today. Ruiz's rhetoric is beautiful, cultivated, doubtless perverse, and above all happy, never plaintive. This rhetoric moves us out of our habitual French moroseness.[25]

Ruiz, his Christian name changed to Raoul to facilitate pronunciation, now runs the innovative arts centre, the Maison de la Culture at Le Havre. Le Havre, of course, is a major sea port for the Americas, and it would be tempting to see Ruiz, the son of a sea captain, as constantly navigating the space between Europe and America.

Coded autobiographical traces can be found in many of these French films. Many seem to deal with the basic problem of exile, the absent centre, the displaced home. Exile has its negative and positive aspects: to be eccentric implies the nostalgia for a centre, but also offers the freedom of distance. *Les Trois couronnes du matelot* (Three Crowns of a Sailor, 1982) deals with the voyage of a displaced person in search of his roots. Origins might be found in childhood, a moment of possible harmony before the Fall, where grandparents weave fictions, telling endless ghost stories – yet a Ruiz child is rarely innocent. Origins might be found in the movies. In *La vie est un rêve* (Life's a Dream, 1986) a man goes back to the cinema of his childhood in order to find images of the Chilean resistance that he has suppressed in his subconscious. The dominant images he

finds, however, are of Flash Gordon, Mongo, Captain Marvel: North America B-serials which were the staple diet of Ruiz's childhood film-going. B-serial movies can easily be read as crude forms of cultural imperialism, but for Ruiz they also offer an interesting example of establishing an immediate rapport with an audience, and of direct, improvised film-making:

> There is a statement by Ford Beebe where he says that he was so pressed to finish a film (and often he only had a week to film) that when he wrote a story, he put down the first thing that came into his head and waited for a sort of inspiration. Without realizing it, he is describing techniques of automatic writing which he invented or reinvented for cinema. These are true surrealist films in the proper sense of the word.[26]

A sense of place might also be found in an institution such as a church or a political party. Yet Ruiz is far from the rhetoric of Neruda who could write an 'Ode to My Party' (the Communist Party), as offering strength, unity and purpose. Ruiz's ode to a party is *La Vocation suspendue* (The Suspended Vocation, 1977), where the project for a new society is thwarted by the suspicions of the hierarchy and the stagnation of church institutions. A sense of place might also be found within the medium of cinema itself, within the fixities of genre and convention. Yet Ruiz constantly explores and parodies conventions: the documentary (*De grands événements et des gens ordinaires*, Of Great Events and Ordinary People, 1979); the arts programme and the 'thriller' *(L'Hypothèse du tableau vivant*, The Hypothesis of the Stolen Painting, 1978); the melodramatic photo-novel, mixed with Borges and Cervantes's 'exemplary' novels (*Colloque des chiens*, The Colloquy of Dogs, 1977). As Ian Christie puts it, 'Ruiz has devised a rhetoric or rather a play between rhetorics, which allows him to speak in terms recognizable to Europeans, without either wholly accepting their culture or betraying his own.'[27] Each film is an exploration, a geographical exploration of forests, towns, gardens, chateaux or paintings, an exploration of all the narrative, technical, visual and sound possibilities of cinema and an exploration of all possible pictorial and literary styles in cinema[28] (in particular the 'baroque' experiments of the Cuban novelist Lezama Lima). It is a remarkable oeuvre.

The trajectory of Miguel Littín has been very different. Circumstances allowed him to become the epic film-maker of Latin American resistance, mainly thanks to the financial aid offered by the Mexican government under Echeverría (see the analysis of *Actas de Marusia* in Chapter 6). Without referring to Littín by name, Ruiz offers a critique of his style of film-making:

> I think there is a version of the 'official art' attitude which sets out to make 'history' exist. They start with the history of Latin America, which is a history of betrayals and of imperialism, the massacres are mostly hidden and the record of the peasants' and people's movements is equally unknown. So there is an obvious point in

making films to reveal this forgotten history and make known the secret massacres. But this is more difficult to accept when it becomes an imperative duty to follow the political line, showing even more massacres and creating a vast funeral ceremony.[29]

In fairness, however, Littín did not remain in that mode. He turned to two ambitious co-productions of literary works, *El recurso del método* (Reasons of State, 1977) and *La viuda de Montiel* (Montiel's Widow, 1979). *El recurso*, based on the Cuban Alejo Carpentier's novel about a roguish dictator who alternates between the civilization of Europe and the supposed barbarism of his native land and is quite surprised when he is overthrown by a Marxist rebellion, has some stylish set-pieces (such as the lavish carnival in Cuba) and a sustained central performance by Littín's preferred actor, the Chilean Nelson Villagra. But the weight of having to make an allegorical statement about early dictators in Latin America and their necessary overthrow by the people, sometimes traps the narrative in stereotypes. Also, in terms of its contemporary relevance to dictatorships in the subcontinent in the 1970s, the spectator is left wondering whether the technocratic dictators of the 1970s, the Pinochets, can be quite so easily laughed out of existence. The work, which had a clear internationalist and Latin Americanist perspective, was not given much distribution in Latin America and failed to convince European critics. Littín had been the darling of *Cahiers du Cinema* in the early seventies, when those critics had a Maoist, Third-Worldist orientation. By the end of the decade, critical ideologies had shifted, Ruiz had become the model for a more personal, impish, ironic form of film-making, and *Cahiers* laughed away *Recurso* in a short, sarcastic review in August 1978.

Montiel's Widow is Littín's attempt to film García Márquez, an author who would continue to obsess cineastes from the 1960s to the present: it seems to be the fate of any major Latin American film-maker to try at least once. Littín achieves some impressive settings in the tropical landscape of Tlacotalpán (in Veracruz), for the 'chaotic and fabulous hacienda of José Montiel',[30] the hardman who had monopolized local business through terror. After death Montiel remains a presence in his widow's fantasies and in the alternative views of the townspeople. Geraldine Chaplin is competent as the widow but in the end the narrative tension that Márquez can generate in a few pages eludes the director in his rather sprawling, two-hour film.

As the reign of Margarita López Portillo gradually deprived Mexican film-making of any resources, Littín made his next feature, *Alsino y el condor* (Alsino and the Condor, 1982), in Nicaragua, the first Nicaraguan feature film in colour. He drew once again on a literary source, this time from a well-known novel of the 1930s by Pedro Prado, which was for a time obligatory reading in Chilean schools. This fable of a boy crippled after attempting to fly is given a new location (Nicaragua in the late 1970s) and a new optimism: the dream of flying becomes the dream of revolution come true with the overthrow of the Somoza dictator-

ship. Littín worked without the lavish resources available for his three previous
films, and provided a film free of much of the grandiloquence that had marred
these works: 'The smile of Alsino, when he calls himself Manuel – this is the
moment when he is going to join the guerrilla forces and in which he smiles for
the first time in the film – becomes a sign of the imminent historical break, which
is more vigorous and eloquent than the waving of a hundred red flags.'[31] The will
of the people is seen as overcoming the condors of US imperialism, the
helicopters of the counter-insurgency forces.

In 1985, Littín embarked on a dangerous project to film clandestinely in Chile.
His movements have been registered and eulogized in a book by García
Márquez,[32] written in the form of a long interview with Littín filtered through
Márquez's very particular vision and language. Both the book and the film are
a homage to the resistance of the Chilean people. Both succeeded well in 'tying
a donkey's tail on the dictatorship' in García Márquez's phrase. In November
1986, the military authorities in Valparaíso in Chile burned fifteen thousand
copies of the book. *Acta General de Chile* (General Statement of Chile) is a
massive four-part documentary which 'rediscovers' the landscape of Chile
through exile eyes, charts the struggles of the ordinary people, discusses the
tactics of the guerrilla group, the Manuel Rodríguez Popular Front and pays
homage to the symbol of revolution, Salvador Allende. It contains many lyrical
evocative moments and has a particularly fine sequence of interviews which
chart the last hours of Allende in the Moncada Palace as the troops prepare to
enter and stifle the Chilean experiment in democratic Marxism. Littín is now
filming the life of Sandino, another ambitious co-production.

Other film-makers continued a remarkably fertile cinema in exile from
different centres in Europe and Latin America. The critics David Valjalo and
Zuzana M. Pick list a total of 176 films produced from 1973 to 1983, 56 full-
length features, 34 medium-length and 86 shorts. Zuzana Pick has analysed the
salient characteristics of this cinema in a series of important essays.[33] Only a few
general comments are appropriate here. Firstly, the shock of the Chilean coup
had a widespread repercussion in the international community; the brutality of
the regimes in Uruguay and later in Argentina would never be highlighted in the
same way. The United Nations High Commission for Refugees could organize
a massive refugee programme and certain countries such as Canada, Sweden and
other Scandinavian countries reacted very quickly in granting visas. Chilean
political parties could also place their militants in Eastern Europe. The trauma
of exile was, therefore, softened to a certain extent by the possibilities of work,
and by solidarity groups prepared to support cultural activities. The film-makers
thus had some access to funds and access also to a public: their films could serve
as a basis for meetings and discussion groups.

It was natural that these films initially should focus on the recent past, be
denunciatory and also attempt to reconstitute the resistance abroad – see, for
example, Helvio Soto's *Llueve sobre Santiago* (It is Raining on Santiago, 1975)

or Claudio Sapiaín, *La canción no muere generales* (The Song Does Not Die Generals, 1975). Without the irony of Ruiz, these films needed to posit some sort of utopian unity, summed up in the phrase chanted at the end of every solidarity meeting or concert: 'El pueblo unido jamás será vencido' ('The people united will never be defeated'), which necessarily glossed over the fact that the 'people' had not been united and had been defeated, however temporarily. The work of Helvio Soto, Littín, Sebastián Alarcón, Orlando Lübbert and Sergio Castilla all made denunciatory features aimed at consciousness-raising, in an effort to isolate the dictatorship abroad.

The difficulties of exile and immigration would also become a major theme in films of the period; one of its most exemplary practitioners was Angelina Vásquez, who looked at life in Finland. *Dos años en Finlandia* (1975), is a portrait of the Chilean community there and *Presencia lejana* (Distant Presence, 1975) traces the life of Finnish twins who emigrated to Argentina. One returned to Finland, the other stayed in Argentina, where she 'disappeared' in 1977. Finland in this film is seen from a Latin American perspective and vice versa. In her feature film *Gracias a la vida* (Thanks to Life, 1980), a woman who is carrying the baby of her torturer meets her husband and children in Helsinki. The pain but also optimism of such experiences are portrayed with great skill. Other women directors, Marilú Mallet in Canada and Valeria Sarmiento in France, have also treated the themes of exile and immigration. Sarmiento's two most significant films, however, are not restricted to the thematics of exile: the documentary *El hombre cuando es hombre* (When a Man's a Man, 1982) and the feature *Mi boda contigo* (My Marriage with You, 1984), deal instead with the construction of sexuality in Latin America, in the culture industry and in the wider society. In *El hombre*, filmed in Costa Rica, interviewees give an inadvertently amusing stereotypical view of male–female relationships. Sarmiento compounds the irony with a soundtrack taken from Jorge Negrete, the most macho of all of Mexico's singing *charros*. *Mi boda* explores the conventions and the pleasures of melodrama and the 'rose' novel, or Harlequin Romance, adapting a novel by the Hispanic Barbara Cartland, Corín Telladao. This thematic diversity is part of a general broadening of the range of subjects treated by Chilean film-makers.

As the film community developed abroad and the years of the dictatorship lengthened, film-makers could not remain making and remaking films about Chile in their country of exile. Pablo de la Barra, who has directed successful films in Venezuela, and Ruiz who works exclusively in France are two examples of the vagueness of the term 'Chilean film-maker' after fifteen years of exile. At the same time, the radicalization of events in Chile after 1983 have allowed exiled film-makers to return and film the struggle for democratization. Gastón Ancelovici, whose 1975 documentary *Los puños frente al cañon* (Fists Before the Cannon) traced the growth of the Chilean working class up to 1931, made the documentary *Historia de una guerra diaria* (Story of a Daily War, 1985), filming

a whole range of cultural and political practices. *Dulce patria* (Sweet Country, 1985) by Andrés Racz, also showed a broad spectrum of life under dictatorship, and contained a memorable interview with the mother of Carmen Bueno, the actress who 'disappeared' in 1974.

Returning film-makers, a slackening of censorship and a growing militancy led to a growth of cinema within the country. Cinema in Chile was muted for most of the seventies, tourist documentaries and advertising shorts accounting for the bulk of the work produced. However, by the late 1970s there were some important signs of survival. Silvio Caiozzi had success with *Julio comienza en julio* (Julio Begins in July, 1979), a film which refers back to the early twentieth century, to a time when the rural aristocracy was losing its power to the industrial bourgeoisie. The site is a French-style country house, full of imported furniture; the owner, a feudal landlord, is trying to maintain his grip on power and create a son in his image and likeness. One important rite of passage for the fifteen-year-old boy is the loss of his virginity. The Argentines (Torre Nilsson and María Luisa Bemberg) have treated the theme with greater subtlety but Caiozzi at least had found a metaphor for talking in allegorical fashion about contemporary Chile and put a Chilean film back into commercial cinemas in Santiago. For the situation in 1980, as Caiozzi points out, was gloomy:

> Aldo Francia no longer films. ... Then we have people like Carlos Flores, a documentary film-maker who made a film on José Donoso, our best-known novelist. ... There is also Christián Sánchez, a film-school graduate who made two 16mm features in black and white, one co-directed and the other his own; *El zapato chino* which came out recently. These are experimental films directed at a certain public. ... The government has no interest in cinema.[34]

Julio took three years to make, funded out of the director's earnings from commercials.

The ICTUS theatre group made a number of videos on cultural figures and movements in the late 1970s. Increasingly film-makers began to film in clandestine fashion and smuggle video footage of persecution and resistance out of Chile. A documentary prepared in Germany, *Chile: donde comienza el dolor* (Chile, Where the Grief Begins, 1983), shows the reaction of Chilean exiles to video footage filmed inside the country. Littín would make use of clandestine networks for his *Acta General de Chile*. The most important work of clandestine film-making, which illustrated and was a product of the growing radicalization was *Chile, no invoco en vano tu nombre* (Chile, I do not Invoke your Name in Vain, 1983). Film-makers in Paris edited and processed the raw material from Chile, bringing together in this enterprise the intellectual community fractured by exile.

From the mid 1980s, the opposition to Pinochet increased in intensity and effectiveness, culminating in the 'No' Vote in the plebiscite of 1988, and the

victory for the democratic coalition in the elections of November 1989. In both these campaigns, the opposition used television very successfully, a sign that techniques of film-making fostered abroad or at home could be put to good use. These conditions have allowed a revival of cultural activities in all spheres, and in particular in theatres.

The new freedom in cinema is exemplified in Pablo Perelman's feature film *Imagen latente* (Latent Image, 1987) which was filmed entirely in Chile with funds from the National Film Board of Canada. It contains many echoes of the brilliant Cuban feature *Memories of Underdevelopment* (1968) in its study of a Chilean photographer who cannot decide the nature and purpose of his political and artistic commitment. His brother, a militant of the MIR, disappeared in 1975; many years later, he begins a search for this brother, paralleling his own search for his repressed political commitment. The film speaks boldly of armed struggle (with clear allusions to the failed attack on Pinochet in the mid 1980s); of torture, of disappearance, of the function of art in times of social change. Its treatment of the main character is deliberately ambiguous: the spectator feels both sympathy and hostility towards his doubts. Perhaps the future lies with the young student, the daughter of a disappeared prisoner, who finds her sense of self in political action. This is certainly the message of *A cor de seu destino* (The Colour of His Destiny, 1986) a film made in Brazil by the exiled Chilean Jorge Durán: a depiction of a Chilean teenager in Brazil who comes to terms with his own identity and is thus reconciled to the memory of his dead brother.

These features were made with money from abroad. Within the country, work in video has become increasingly the norm, due to its lower cost and great flexibility. All the momentous events of the last few years have been captured on video. There are a large number of small production companies who work in advertising or sell programmes to television. There is a great pool of talent available for future projects. At the moment of writing, the cultural priorities of the new democratic regime have not yet been formulated, but it is unlikely that there will be many funds available through the state, and the private sector will need convincing that films are a viable investment in a dwindling cinema culture. Yet the need to make films, to explore a fractured past and to imagine different futures, must be part of the new democratic project, one of the great avenues, in Salvador Allende's words, 'where free men and women will walk, to build a better society'.

Notes

1. Salvador Allende's last speech on the radio before his murder in the Moneda palace. I am using the translation in I. Allende, *The House of the Spirits*, Black Swan, London 1986, p. 419.

2. Quoted in Jacqueline Mouesca, *Plano secuencia de la memoria de Chile*, Ediciones del Litoral, Madrid 1988, p. 18.

3. My discussion on Frei is based on J. Faúndez, *Marxism and Democracy in Chile*, Yale University Press, New Haven and London 1988, pp. 133–8.

4. For details of CIA activities in the 1964 electoral campaign see *Covert Action in Chile 1963–1973*, United States Senate Report, Washington 1975 pp. 9 and 15.

5. Jorge A. Schnitman, *Film Industries in Latin America: Dependency and Development*, Ablex, New Jersey 1984, p. 84.

6. Nicanor Parra, *La cueca larga*, Santiago 1958.

7. Quoted in Ian Christie and Malcolm Coad, 'Between Institutions: Interview with Raúl Ruiz, *Afterimage* 10, 1982, p. 106.

8. Ibid., p. 116.

9. See Harold Blakemore's chapter on Chile (chapter 15) in Leslie Bethell, ed., *The Cambridge History of Latin America*, Vol. V, Cambridge University Press 1986, p. 501.

10. 'Miguel Littín: Film in Allende's Chile', in D. Georgakas, L. Rubenstein, eds, *Arts, Politics, Cinema: The Cineaste Interviews*, Pluto, London 1985.

11. For a detailed analysis of the film, see Ana López, 'Towards a "Third" and "Imperfect" Cinema', unpublished D. Phil Dissertation, University of Iowa 1986, pp. 461–70.

12. Faúndez, p. 280-81.

13. For the text of the manifesto, see M. Chanan, ed. *Chilean Cinema*, BFI, London 1976, pp. 83–4.

14. Bertrand Russell Foundation, *Subversion in Chile: A Case Study in United States Corporate Intrigue in the Third World*, Nottingham 1972.

15. Miguel Littín, interview first published in *Cahiers du Cinema* 251–52, 1974. English version in Chanan, p. 58.

16. See Gabriel García Márquez, *La aventura de Miguel Littín, clandestino en Chile*, Diana, Mexico 1986, pp. 35–8. Published in English as *Clandestine in Chile*, Granta and Penguin, Cambridge 1989.

17. See F. Bolzoni, *El cine de Allende*, Fernando Torres, Valencia 1974, pp. 123–4.

18. Interview with Ginette Gervais, *Jeune Cinéma*, 87 May–June 1975, p. 27.

19. For a detailed analysis of Guzmán's work, see Patricio Guzmán, Pedro Sempere, *Chile: el cine contra el fascismo*, Fernando Torres, Valencia 1977.

20. Interview with Burton in Julianne Burton, *Cinema and Social Change in Latin America: Conversations with Film-makers*, University of Texas, Austin 1986, p. 55.

21. Ibid., p. 51.

22. For an account of the international campaign in favour of filmworkers, in particular the 'Emergency Committee to Defend Latin American Filmmakers', see Alfonso Gumucio Dagrón, *Cine, censura y exilio en América Latina* STUNAM/CIMCA/FEM, Mexico 1984.

23. Malcolm Coad, 'Rebirth of Chilean Cinema', *Index on Censorship* 9, 2, April 1980, p. 4.

24. I am using the translation quoted in *Afterimage* 10, p. 121.

25. Serge Toubiana, 'Le cas Ruiz', *Cahiers du Cinéma* 345, March 1983, p. 1. This special issue is the best general guide to Ruiz's work. See also the long section dedicated to Ruiz in *Positif* 274, December 1983.

26. 'Entretien avec Raoul Ruiz', *Positif* 274, December 1983, p. 24.

27. Ian Christie, 'Snakes and Ladders: Television Games', *Afterimage* 10, p. 84.

28. Danièle Dubroux, 'Les explorations du capitaine Ruiz', *Cahiers du Cinema* 345, p. 33.

29. Interview with Ruiz, in *Afterimage* 10, p. 111.

30. Gabriel García Márquez, 'Montiel's Widow', in *No One Writes to the Colonel*, Pan, London 1979, p. 116.

31. Mouesca, *Plano-secuencia*, p. 103.

32. Gabriel García Márquez, *La aventura de Miguel Littín*.

33. See David Valjalo, Zuzana M. Pick, '10 años de cine chileno 1973/1983', special issue of *Literatura Chilena, Creación y Crítica*, 27 January–March 1984, pp. 15–21. This issue is the most complete assessment of Chilean cinema of that decade.

34. 'Silvio Caiozzi: Los restos del naufragio', *Hablemos de Cine* 73–74, June 1981, p. 30.

Andean Images: Bolivia, Ecuador and Peru

Today the rupture is complete. Indigenism, as we have seen, is gradually uprooting colonialism. ... From abroad we simultaneously receive various international influences. But under this swirling current, a new feeling and revelation are perceived. The universal, ecumenical roads we have chosen to travel, and for which we are reproached, take us ever closer to ourselves.

José Carlos Mariátegui[1]

Bolivia

The story of modern Bolivian cinema begins with the aftermath of the National Revolution of 1952. The problems that the revolutionary government of the MNR (Nationalist Revolutionary Movement) had to face were enormous. James Dunkerley paints the picture of Bolivian society on the eve of the Revolution:

Bolivia was notoriously backward. Its gross domestic product (GDP) was a meagre $118.6 per capita, making it the poorest country in the hemisphere with the sole exception of Haiti. ... A country the same size as France, Italy and West Germany combined possessed a population of 2.7 million, of which just 22 per cent lived in settlements of over 2,000 people. Only 31 per cent of Bolivia's population was literate; 8 per cent had completed secondary education. In 1950 there were 3,700 registered students in the country's five universities which issued 132 degrees in that year. ... Nearly three children in ten died in the first year of life and the life expectancy at one year fell well short of fifty.[2]

In the aftermath of the Revolution progressive measures were taken. The mines were nationalized, a sector that produced 25 per cent of GDP. This was a potentially provocative measure, since some 20 per cent of Simón Patiño's shareholders were North American. On the eve of the Revolution Patiño controlled 10 per cent of the world's tin production. However, President Paz

Estenssoro managed to keep the US government neutral, and eventually achieved the reluctant agreement of the companies themselves. An agrarian reform was passed, but its effect on land tenure was not rapid or profound: between 1954 and 1968, about eight million of the thirty-six million hectares of cultivable land was redistributed.[3] Universal franchise was granted, the army was restructured and worker, student and peasant organizations received arms. The first years of the Revolution, therefore, witnessed rapid change.

In July 1952, a department of cinematography was created as part of a Press and Propaganda Ministry and this was replaced in 1953 by the Bolivian Film Institute, the ICB, which was run until 1956 by Waldo Cerruto, the president's brother-in-law. The country did not have sufficient trained cineastes adequately to cover the revolutionary events of 1952. Two young Argentines, Levaggi and Smolij, caught some of the effervescence of those months, in a short documentary *Bolivia se libera* (Bolivia Liberates Herself). The ICB produced regular newsreels, mainly government propaganda, eulogies of leaders or descriptions of folklore,[4] though Sanjinés remembers some striking scenes of 'the presence of thousands of peasants from all over the country who, with arms at the ready, kept watch over the signing of the Agrarian Reform Decree in Ucureña; the processions of brave and fierce miners, swathed in cartridges of dynamite, carrying those arms seized from the army of oligarchy'.[5] More often than not, however, the images would be of rites of power, such as the visit of Vice President Siles Zuazo to the coronation of Queen Elizabeth in London.[6] In general, Dunkerley is right that, with regard to film,

> Bolivia was too backward and the revolution too early to exploit to the full its symbolic and propaganda effort, let alone dynamize creative effort ... only one poor documentary was made in the aftermath of the April rising and over thirty years since, there has been no film of it, fictional or otherwise, in contrast to the cases of Mexico, Cuba, Nicaragua or even El Salvador.[7]

The INC, did however give training to technicians and directors which would bear fruit in the next decade.

The most important film-maker of the 1950s, Jorge Ruiz, did not become involved with the ICB until 1956. He made a remarkable short ethnological film, *Vuelve Sebastiana* (Sebastiana, Come Home), in 1953, with the Chipaya Indians from Santa Ana de Chipaya, a people who were gradually dying out or being acculturated. Sebastiana Kespi, a twelve-year-old Chipaya girl, meets a young boy on the *altiplano*, where she is tending the family animals. He takes her to an Aymara town which has assimilated many Western values. Fascinated but frightened by the new surroundings, she is rescued by her grandfather, who leads her back to the village, communicating all his wisdom to her on the way. On reaching the village, he dies of exhaustion, but the oral tradition has ensured that Sebastiana is now the living embodiment of her culture. Despite its idealism, the film demonstrates a clear preoccupation with the Indian communities: it is

respectful and never intrusive. *Vuelve Sebastiana* is a clear precursor of the work of the Ukamau group in the 1960s: Sanjinés has called it an 'extraordinary' film and it received the favourable attention of the veteran film-maker John Grierson when he visited Bolivia in the late 1950s.

Ruiz joined the ICB in 1956 and made what is considered to be the first major feature-length sound film in Bolivian history, *La vertiente* (The Watershed). Filmed in 35mm with direct sound, it was very much a group project. This was a clear example of a state institute supporting the government's rural develop-mental projects: the people of a rural community fight for drinking water, which is obtained through their best efforts of mutual aid and with some prompting by a young schoolteacher doing her training in an outlying community. She might offer some wisdom and guidance on irrigation but she is introduced to love by a very macho alligator hunter. This rudimentary attempt to fuse romance and melodrama (the death of a child galvanizes the village into action) with social documentary worked well within the country.[8] Ruiz, however, would increas-ingly spend time on contract work for US aid agencies in Bolivia and in other parts of Latin America.

Ruiz's shift to making US-funded films reflects broader patterns of change in the country. The Revolution could not maintain its early momentum. The government of Siles Zuazo (1956–60) attempted a more conservative course of bringing runaway inflation under control with massive financial support from the United States. The stabilization plan of 1956 was 'monetarist' and signalled economic as well as political offensives against the syndicalist working class. Under Siles Zuazo, and later again under Paz Estenssoro, Bolivia became the showcase for the Alliance for Progress attempt to support non-Marxist reformist governments. At the same time it received the highest US aid per capita of any country in the world. It became increasingly difficult for the government to accept US funds and influence over policies, while at the same time remaining true, even rhetorically, to the anti-imperialist drives of the Revolution. It could not eventually resolve these contradictions and was dismissed by a military coup in 1964.

Bolivian social cinema grew up in these contradictory times. Its main impulse came from Jorge Sanjinés and the Ukamau group. Sanjinés had travelled to Chile for his university education and enrolled in the Catholic University's newly opened film school under Sergio Bravo. Returning to Bolivia, he formed a friendship and a partnership with Oscar Soria, Bolivia's most important script-writer, who had worked with Ruiz throughout the 1950s. Together they founded some short-lived institutions, a journal, a film society and a film school, and began making shorts on contract. The first major independent collaboration by Sanjinés and Soria was the ten-minute *Revolución* (Revolution, 1964) a silent montage of images punctuated only by guitar music and percussion revealing the exploitation in the country and the workers' resistance which led to the Revolu-tion of 1952.

The military takeover in 1964, paradoxically, gave Sanjinés further opportunity to develop his ideological and aesthetic positions. The Barrientos government dismissed the personnel of the INC, but then appointed Sanjinés to its directorship in 1965. Some among the left felt that Barrientos would usher in a Bonapartist regime, but this view was shown to be hopelessly misconceived between May and September 1965 when the regime moved to smash workers' organizations in the mines, with widespread repression, assassination and arrests. Sanjinés would thus be uneasily positioned working with a state organization, trying to make socially responsible documentaries and features at a time when open authoritarianism was on the increase. His film *Ukamau* would eventually lead to his dismissal from the INC in 1967, as Bolivia entered into its darkest hour with the killing of Che Guevara and the massacre of miners on the night of San Juan in June 1967. From that time, all his films would be made independent of any state organizations.

Sanjinés has coherently analysed the development of his film-making in a number of articles and conferences.[9] He dismisses his early documentaries made for the ICB as demonstrating but not analysing the suffering of the working classes:

> We began to realize that the people were not interested in seeing films that did not contribute to anything, films that merely satisfied their curiosity to see themselves reflected on the screen. We realized that the people knew much more about misery than any filmmaker who might aspire to show it to them. Those workers, miners and peasants are the protagonists of misery in Bolivia. Except for bringing tears to the eyes of a few pious liberals, the kind of films we had been making were good for nothing.

What these people were interested in was rather 'an explanation, a deconstruction of the mechanisms of power'.[10] This self-criticism is too harsh for, in Western eyes at least, a film such as *Aysa* (Landslide, 1964) is a powerful statement on the great perils of the mining process. On this feature, Sanjinés assembled what would become his regular crew: the scriptwriter Oscar Soria, the cameraman Antonio Eguino and the producer Ricardo Rada. He would also find two non-professional actors in the mining community whom he would use in his next two films, Benedicta Huanca and Vicente Verneros.

Ukamau (That's How It Is, 1966), was shot among the Ukamau Aymara Indians, and is spoken in Aymara, with Spanish subtitles. It tells the story of a young couple living on an island in Lake Titicaca. When the protagonist Andrés Mayta is away, the *mestizo*, who buys local produce from the Indians and sells it to the town, rapes and kills his wife. The film traces how Mayta tracks down and kills the murderer, following him across the landscape of the *altiplano*, his presence signalled on the soundtrack by the music of a solitary *quena* (Andean reed instrument). Critics of the film accuse it of being in the mode of *indigenista*

writers such as Alcides Arguedas,[11] who felt a paternalist sympathy for the Indians but viewed them as mere objects of oppression, with no history and no conscious political strategy of their own; and who collapsed class struggle into an analysis of race (the good white man, the cunning, devious *mestizo* and the noble Indian). These judgements seem unduly severe. The *mestizo* is indeed portrayed as a stock evil character, but the critique of the city merchants who use such figures as agents of their exploitation is very clear. Also the Indians are far from being the 'Bronze Race' of Arguedas's famous novel, creatures both strange and exotic but also threatening. The Indian is a social and political force, not a racial 'problem'. Luis Espinal, the critic who was murdered by a right-wing death squad in March 1980, saw this clearly: 'The picture is not merely anecdotal. The final struggle between those isolated men in the middle of the Altiplano is a symbol of the class struggle. There is also a parallelism between the *mestizo* taking away his wife and taking away the fruits of his labour; the violator and the exploiter are the same person.'[12] The film has an extraordinary plasticity and shows clearly the force of the landscape that the figures move through, without falling into telluric essentialism or into an aesthetic of poverty. For Sanjinés, however, the main fault was that it still showed the struggle of an individual rather than a collective protagonist.

The film enjoyed great success at home and abroad. This irritated Barrientos, who felt that such a theme did not show the country in a favourable light. The whole team, now named Ukamau in homage to the film, was dismissed from the ICB, and the institute was eventually closed down. The group formed their own independent company and in 1968 produced *Yawar Mallku* (Blood of the Condor). They found a theme – the forced sterilization of women in the countryside by US aid agencies such as the Peace Corps – which gave substance to the nature of imperialism, otherwise just a distant abstraction to local communities. But they still had a great deal to learn about the nature of the Indian peoples among whom they wanted to film. Sanjinés tells how when they went up to the chosen Indian village, a long and difficult journey, they found that the people ignored them, treated them with mistrust and refused to cooperate. After two weeks, when the project was about to fall through, the film crew realized that they were approaching the community the wrong way. They had contacted the mayor, thinking that he was the appropriate power, but then, 'we realized that the mayor did not have power. The power was really democratic, it resided in an assembly. The individual was only important as part of a collectivity.'[13] They then asked for the village assembly to discuss their project and have the local shaman read the coca leaves to verify their honesty. In this way they were accepted; the scene of the shaman appears in the film.

The film moves between the country and the city. It charts the gradual awareness in the Indian village that their women's barrenness is due to the young, rather caricatured, North Americans from the 'Progress Corps' who run a medical centre. The community leader, Ignacio, discovers that they are steriliz-

ing the women, following the logic that, in Galeano's evocative phrase, it is more convenient to kill future *guerrilleros* in their mother's womb. The community take a decision to castrate the North Americans. Repression follows swiftly, many are killed and Ignacio is badly wounded. He is taken to La Paz where his brother undertakes a journey through the landscape and social classes of La Paz in a desperate search to find money for medical treatment. The reaction is callous and indifferent, and Ignacio dies in hospital. In a *prise de conscience* the brother returns to the village, joining the Indians in the beginnings of armed resistance. The film is structurally quite complex, with constant use of flashbacks and intercutting of scenes in the city with earlier events in the countryside. It uses suspense and also examines individual psychologies, both strategies that the group would later question.

The film was hugely successful. According to Sanjinés, it was seen by 250,000 people in Bolivia alone in its first years (before Sanjinés's films were banned during most of the 1970s). It also started up a public debate and a campaign against the activities of the US Peace Corps, expelled from Bolivia by General Torres in May 1971. But it did not satisfy the group at the level of form since it still seemed to impose the cultural expectations of the dominant classes on the indigenous people. We should remember that the nation-state of Bolivia is the result of the creole domination over the Indian Aymara, Quechua and Guarani nations, a domination that was only partly successful. In 1950 a million people spoke only Quechua, 664,000 only Aymara, and Spanish was a minority language. By 1976, over a fifth of the population still spoke no Spanish.[14] It was not enough for Ukamau to film in the native languages:

> It was not that they could not understand what was being said, it was rather a formal conflict at the level of the medium itself which did not correspond to the internal rhythms of our people or their profound conception of reality. The substantial difference lay in the way in which the Quechua-Aymara people conceive of themselves collectively, in the non-individualistic form of their culture. The organizing principle in this society is not the isolated individual, but society in its totality.[15]

This attitude would mean rethinking forms that privileged the individual over the social: the close-up, the psychological examination of individual motivation, the standard conventions of the fiction film. Film-making would in future deal with the history of the collective, seeking to reactivate the popular memory denied by the hegemonic powers.

Ukamau's development coincided with an attempt by two military regimes to combat popular mobilization by directing their own form of left or revolutionary nationalism. Generals Alfredo Ovando (September 1969 to October 1970) and Juan José Torres (October 1970 to August 1971) tried to walk the tightrope between the extremes of mass mobilization and repression. The experiment failed and would be replaced by the conservative dictatorship of Hugo Banzer

(1971–78). It did, however, allow a great deal of temporary freedom, a product of which was Ukamau's *El coraje del pueblo* (Courage of the People, 1971),[16] which had funding from Italian television. This dramatized documentary reconstructs the massacre of miners in the Siglo XX mines in June 1967. The official version given by Barrientos was that

> the reds and corrupt old union leaders declared the three most important mines in the country to be *territorio libre*, where nobody could enter without their permission. Because of this the government instructed the armed forces to occupy the mines and restore order and authority. This would have happened in any country.[17]

The film makes it very clear where the responsibility lay: an early sequence names the massacres of miners through history and those government leaders who ordered them. Ukamau use the survivors of the massacre as the sources of information, an extraordinarily well-organized and disciplined community who attended the funeral of their colleagues in tens of thousands and called a two-week protest strike despite the army occupation of the camp. These witnesses also become the protagonists of the film, which recreates the collective memory of persecution and resistance. Sanjinés was making films 'junto al pueblo', alongside the people, not imposing his views from above, but allowing the community to 'speak' through the film-makers. Multiple narrators take up the task of recounting the history. There are no privileged 'heroes', instead the film taps in to what the film-maker calls the 'atavistic solidarity of the group'.[18]

While the group was engaged on post-production work on the film in Italy, the Banzer coup of 1971 ushered in a new hard-line regime. The film could not be shown in Bolivia for nearly a decade and the group split in two. Eguino and Oscar Soria returned to Bolivia to make films. Sanjinés and Rada were forced into exile. They chose to remain in the Andean region and succeeded in making *El enemigo principal* (The Principal Enemy, 1973) in Peru and *Fuera de Aquí*, (Get Out of Here, 1976) in Ecuador until the fall of Banzer allowed them to return temporarily to Bolivia in 1979.

A rare example of trans-Andean cultural cooperation, *El enemigo principal* takes the group's theoretical discussion a stage further.

> We introduced the sequence-shot [long shot] as essential to the coherence of the film. The narrator who presents the facts intervenes during the film, breaking up the flow of the plot to give the audience greater possibility for reflection. The sequence-shot allows us to attempt a more democratic structure ... because of its breadth it offers the viewpoint of the participating audience who can move inside the scene, attracted by the most interesting points.[19]

The film begins with a narrator on Machu Picchu whose function is to anticipate the history/story so that it can be analysed during the narration. He tells of the

struggle of a community to find justice against a murdering landowner maintained in power by the principal enemy, the imperialist forces of the United States. Athough its ambiguous analysis of guerrilla *foco* strategy (the guerrillas support the people, but they also leave them to be massacred), has been supplanted by the impact of The Shining Path guerrillas in contemporary Peru, the film remains a clear testament of Ukamau's theoretical and political work in the mid 1970s.

Fuera de aqui (Get Out of Here), an openly didactic film on imperialist penetration in Ecuador, had an enormous impact there. According to researchers of the University of Quito, which part-funded the project, the film was seen by some three million people, out of a population of eight million, with widespread distribution in alternative circuits throughout the country.[20]

In Bolivia, throughout the seventies, Eguino and a new production company offered an alternative strategy to that of Sanjinés: making commercial but socially responsible films that could be shown in the normal theatre circuits. He proposed not an overtly militant cinema which would have been banned immediately by the military regimes, but one aimed at regular cinema-goers who might ignore the unequal nature of Bolivian society. *Pueblo chico* (Small Town, 1974) addresses this problem through the narration of a young landowner's son who gradually becomes conscious of the need for a thoroughgoing agrarian reform. *Chuquiago*, 1977 (the Aymara name for La Paz) offers an analysis of the city and its social stratification through four social types: Isico, an Indian child lost in the huge city; Johnny, a *mestizo* trying to move up and out of his class through the adoption of North American culture; Carloncho a petty-bourgeois public employee, trapped in *anomie;* and Patricia, a student who becomes a revolutionary. These four 'chapters' reveal clearly the limitations of each 'type' and the lack of any communication or social cohesion between them. *Chuquiago* fulfilled its director's intentions:

Almost five hundred thousand people saw our film, and no other film in Bolivia has achieved this. ... Step by step, we are creating our own cinema, we are talking to Bolivians in their own language and, what is for us very important, we are gaining screen time by replacing, little by little, the alienating commercial cinema, basically backed by American distribution monopolies, that invades us.[21]

After some interruption, the two Ukamau groups have been able to make films in Bolivia in the 1980s. Sanjinés's *Banderas del amanecer* (Banners at Dawn, 1983) charts the people's struggle for democracy from the democratic interlude of 1979 through the vicious but eventually unsuccessful dictatorship of General García Meza (1980–82). This film offers another collective protagonist – this time the whole of the working class in the towns and in the countryside. The group was about to begin work on another documentary reconstruction when events overtook them and their only option was to film what was happening in

the social arena. In the main, however, Sanjinés prefers the documentary reconstruction since it is easier to control the material. Ukamau has never had the funds to field teams of camera-operators in different parts of the country to capture the immediacy of history in the making.

La nación clandestina (The Secret Nation, 1989) reworks a number of Sanjinés's persistent themes. It tells the story of a man who has been dismissed from his Indian village, an isolated community in the *altiplano*, and seeks to atone for his corrupt past by dancing to death in a sacred ritual, a homage to the last Aymara great dancing lord. He sets off from La Paz, buckling under the weight of the ceremonial mask, on a *via crucis* to his village, where he will perform the dance. The journey takes Sebastián from the complex and corrupting city across the severe and beautiful landscape of Bolivia: as in *Ukamau*, Sanjinés reaffirms the majesty of the terrain and the rhythms of life that this imposes on indigenous communities. The film could be called, in the line of Ruiz's earlier documentary, *Vuelve Sebastián*.

As Sebastián travels through space, he reviews his life in a series of flashbacks, a return to a technique that Sanjinés had increasingly abandoned after *Blood of the Condor*. Interestingly, his present and his remembered past all take place under autocratic or military regimes: the democratic and revolutionary interludes of recent history are not referred to. The narrative present is the García Meza coup of July 1980, where Sebastián's decision to leave the city coincides with the early stages of the takeover. As he travels, he meets peasant and workers' resistance groups and an army convoy seeking out a middle-class intellectual, When he finally returns to the village, many of the active population are away helping to fight with the mining community. The hunted intellectual is eventually killed since he does not understand the landscape or the indigenous people that he purports to speak for: his language is Spanish and theirs is Aymara. Just as he is cursing an uncomprehending couple as 'shitty Indians' the army convoy shoot him.

Memory takes Sebastián back to three points in the past. In his early childhood he witnesses the death dance, the complex ritual of community life, but also the grinding poverty before the Revolution of 1952, where Indians are treated literally as beasts of burden for the creole elite and where families are dismembered by poverty and power relations: he is given as a servant to a city-based family. The second privileged moment of memory follows the Barrientos coup of 1964, when Sebastián returns as a young soldier to his village demanding that his brother and the rest of the villagers give up their arms. This ideological conflict between brothers is an echo of the film *Los hermanos Cartagena*. The third moment coincides with the Banzer regime of the mid seventies, where Sebastián is acting as a civilian paramilitary, but is persuaded by his brother to return to his father's death bed. His father had fought in the Chaco War of 1932 to 1935, when tens of thousands of Indians, political pawns from the high Andes, fought and died in the oppressive heat of the plains. After his funeral, Sebastián

remains and becomes the village leader. He betrays them, however, by siphoning off US aid money. The community try him and expel him. It is only after the dance of death, where he is accompanied by the old men of the community who still remember the rituals, that he is resurrected as a member of his village.

Sanjinés's analysis, therefore, deals with the relationship between the individual and the community, the dynamic cultures of survival and resistance, the city and the *altiplano*, Spanish and Aymara, the fight against present and past dictatorships. As yet, however, he gives no analysis of how the left in Bolivia negotiate the complex compromises of civilian rule. James Dunkerley argues that the contemporary left in Bolivia have a clear strategy of resistance to military regimes but find it difficult to find a new political perspective for the different conditions of the 1980s. The focus of this films seems to point to this dilemma.[22]

Eguino filmed the ambitious *Amargo mar* (Bitter Sea) in 1984, a film that explores the events of the Pacific War of 1879, where Bolivia lost its coastline to the victorious Chileans. It was the first film to attempt a historical reconstruction of events that had been forgotten or shrouded in state rhetoric, a project similar to the Chilean film *Caliche sangriento*. It reveals not only the imperialist aggression of Chilean and British interest, but also an incapacity on the part of Bolivia to produce a coherent political and military strategy. It was an important exercise in historical revisionism.

Bolivian cinema in the sixties and seventies is encapsulated in the work of the Ukamau group(s). A younger generation has begun to make films since the late 1970s: the Italian Paolo Agazzi, Hugo Boero, Danielle Caillet, Alfonso Gumucio, Juan Miranda, Pedro Susz and Alfredo Ovando.[23] Increasingly, younger film-makers are working exclusively with video. Gumucio has worked in establishing super-8 workshops in rural and city areas in Bolivia and later in Nicaragua. Perhaps the most successful director of this younger generation is Paolo Agazzi with *Mi socio* (My Partner, 1982), which follows the Eguino line of making critical films for middle-class consumption, using Bolivia's 'star' actor and comedian David Santalla in its leading role, and *Los hermanos Cartagena* (The Cartagena Brothers, 1984), the first serious adaptation of a literary text (based on the novel *Hijo de opa* by Gaby Vallejo de Bolívar).

Independent film-making in Bolivia has been limited by the severe economic climate of the 1980s, in particular the great tin crash of the mid 1980s, where prices fell by 50 per cent on the international market. People living in the United States are some thirty times better off than the Bolivian mining community.[24] Schoolteachers were earning at that time the equivalent of US $15 a month and needed at least $17 simply to pay for transport.[25] In such conditions, going to the cinema is out of the economic range of most of the population, even with low admission prices. It is impossible therefore to recoup even a small percentage of a film budget from the domestic market. The best-known cineaste of his generation, Jorge Sanjinés, who has a worldwide reputation, spends up to 90 per cent of his time looking for money: it has taken him six years to complete his

latest feature. This precarious economic situation had slowed down the advances made by Bolivian cinema, which up to 1984 was massively well attended in the country. The future would seem to lie in video and super-8 work, with the occasional feature made by an established director.

Ecuador

Despite Sanjinés's intervention, film-making in Ecuador has remained weak. The first talking picture *Se conocieron en Guayaquil* (They Met in Guayaquil) was not produced until 1950 and Ecuadorian cinema was dominated by North American and Mexican imports. Documentary pioneers such as Agustín Cuesta in the 1960s had to struggle against almost impossible odds, with rudimentary equipment and no infrastructure for national production. The oil boom of the 1970s exacerbated tensions in the country and led to a wave of protests which were violently repressed by a military junta which ruled between 1972 and 1978. This climate of radicalization, however, did produce some didactic short documentaries, the most important of which were *Quién mueve las manos* (Who Moves the Hands, 1975), which showed the crushing of a strike in a factory, and *Asentamientos humanos, medio ambiente y pétroleo* (Human Settlements, Environment and Oil, 1976), a university-produced short on the dislocations caused in the communities by oil exploration and development. Sanjinés's *Fuera de aqui* thus crystallized a moment of anti-imperialist struggle. Only one short feature film appeared in this period: Gustavo Guayasamin's *El cielo para la Cushi, caraju* (Cushi Goes to Heaven, Dammit, 1975) based on Ecuador's famous indigenous novel, *Huasipungo*. The film was a great disappointment, containing none of *Huasipungo*'s brutal social-realist power, nor any of the artistry displayed by Guayasamin's brother, the great indigenous painter. The eighties have witnessed a more populist mediation of social tensions, but cinema remains an isolated activity. There have been socially responsible documentaries from such organizations as the Kino group, seeking to emerge from the multinational monopolies of advertising and television, and in the 1980 to 1985 period some fifty documentaries have been made, stimulated by a government policy of tax exemptions for film.

Peru

In Peru, the problem of unity is much greater, since here it is not a question of resolving a plurality of local or regional traditions but rather a duality of race, language and feeling, born from the invasion and conquest of autochthonous Peru by a foreign race which has not managed to become fused with the indigenous race, or eliminate it, or absorb it.[26]

As these words of José Carlos Mariátegui reveal, one of the major areas of concern for Peruvian film-makers would be to find an appropriate language for portraying the Peruvian Indian. At the same time, the fascination and disgust for the capital city, 'Lima the horrible' in Sebastián Salazar Bondy's terms, would inform a number of recent films. Against the trend of censorship and repression in other areas of Latin America in the 1970s – in Brazil, Argentina, Uruguay, Paraguay, Chile – Peruvian cinema can be said to have come of age in the mid 1970s, as a result of legislation put forward by the reformist military regime of General Juan Velasco Alvarado (1968–75), which guaranteed compulsory exhibition for shorts and would later help to promote feature films. This 'new' Peruvian cinema, however, should be seen in terms of continuity and breaks with the past.

The 1950s in Peru were a barren period for the development of cinema. According to the figures compiled by Paranagua, only *one* feature film was made in the period 1948 to1960. Successive governments, from the dictatorship of General Manuel Odría (1950–56) to the civilian rule of Manuel Prado and Fernando Belaúnde Terry (1956–68), took no positive measures to promote cinema, and film-making was only possible through individual, high-risk initiatives. One movement, however, did lay the ground for future development: the arts movement in Cuzco, which included the photographer Martin Chambi and the film-makers Manuel Chambi and Luis Figueroa. The work of Martin Chambi has recently received international attention,[27] but the activities of a Cine Club and of documentary film-makers in the area are no less remarkable. From 1955 the Cine Club Cuzco registered on film different aspects of Andean life, the first concerted effort to document the life of the Andean Indians in Peru. In 1956, Figueroa and Chambi directed *Las piedras* (The Stones), an examination of pre-Inca, Inca and colonial architectural forms in Cuzco. A year later Chambi produced two documentary shorts in colour: *Carnaval de Kanas*, a carnival in the province of Cuzco, and *Lucero de nieve* (Light of the Snow), on a local religious festival. Chambi and Eulogio Nishiyama also filmed *Corrida de toros y condores* (Bull and Condor Fight) in that year. These films were shown in Lima in 1957 on the initiative of the great writer José María Arguedas.[28] We should remember that Arguedas's most famous novel, *Los ríos profundos* ('Deep Rivers'), was published in 1958 and begins with the young narrator in Cuzco rediscovering aspects of his Indian heritage through the 'speaking stones' of Inca architecture: the thematic parallels are clear.

Other documentary shorts followed, together with a feature-length film *Kukuli*, directed by Nishiyama, Luis Figueroa and César Villanueva which intertwines documentary with mythical legend (the myth of the bear who disguises himself as a human in order to seduce women). Some years later Nishiyama and Villanueva completed the cycle of the 'Cuzco School' with *Jarawi* (1966), another feature-length documentary/fiction, based on a short story by Arguedas. The Cuzco school gradually became more socially conscious

in their film-making – *Jarawi* for example offers a clear critique of rural exploitation. Manuel Chambi stated in 1974: 'I should point out that in my first works I thought more about cinema, now I think more about the reality of my country and I am not obsessed by the formal beauty of cinema.'[29] Yet the Cuzco school was clearly to influence such contemporary film-makers as Federico García. If Chambi can be said to have 'revindicated' the Indians by focusing on their customs and lifestyle, García would add the dimension of social struggle, even though he would try to deny his precursors. The Cuzco school, he argues, 'is indigenist ... ours is political. We feel a much greater affinity with the Bolivians Sanjinés and Eguino than with the Cuzco school.'[30]

The spread of television in Peru helped to stimulate film-making in the sixties, by training technicians and directors of commercials, but the works produced were mediocre melodramas, comedies and big-screen spin-offs of successful television programmes. The consolidation of a modern film culture in Lima is found in the theoretical discussions of a group of young cinephiles and critics grouped around the magazine *Hablemos de Cine* (1965–84), directed by Isaac León Frías. Also in 1965, the University Cinemathèque was founded in Lima. At first, however, the theory was much more advanced than the practice: the critics could talk about the origins of 'new' cinema in Cuba and Brazil, but had little to support in their own country. The only 'author' of the period was Armando Robles Godoy, but the *Hablemos de Cine* critics did not consider him to be a model: 'The alibi of *cinema d'auteur* has served as a justification for what is just a precarious version of a self-styled new cinema which is pretentious and surely inappropriate to the conditions of cinematographic activity in Peru.'[31] Harsh words for a film-maker who, at least in films such as *En la selva no hay estrellas* (In the Jungle There are No Stars, 1966), tried to impose his own personal style and offered training to young film-makers such as Nora de Izcué, Jorge Suárez and Fausto Espinoza.

In 1968, the military government of General Velasco nationalized several important companies in Peru and expropriated the large coastal landholdings. Its radical gestures and its high spending (borrowing cheap money in the early 1970s, quadrupling the public-sector foreign debt between 1970 and 1975, laying the basis for contemporary Peru's intractable debt crisis) caused a great deal of enthusiasm in the country. These nationalist measures included support for cultural initiatives. In cinema, Law No. 19,327 granted several concessions. It lifted import duties on materials and equipment and at the same time decreed that Peruvian films should receive 'obligatory exhibition' within the country. Since there was no great tradition of feature films, the area that benefited immediately was the production of documentary shorts. Within a brief period, over a hundred and fifty production companies were set up to provide films for this new exhibition space. More than seven hundred shorts were produced in a decade and were shown throughout the countryside, the producer recouping his/her investment from box-office receipts. Cineastes could thus gradually afford

to invest in equipment and began working in groups. Within a few years, the first features would be made, although these were a much more risky investment.[32] Such a system was, of course, open to abuse. The state body COPROCI (Commission for the Promotion of Cinema) approved the films that would be given obligatory exhibition; this led to censorship and also to arbitrary aesthetic judgements. Large numbers of cineastes appeared, interested in commercial gain rather than the promotion of cinema:

> The short, invaded, literally, the cinema screens. But what a sad spectacle. What deplorable standards. With a few exceptions, nothing can be salvaged. ... And the worst films received the best conditions for exhibition. A mafia of distributors has been established to fight for the best places to exhibit their wares. Nelson García has called it, accurately, 'the banquet of the wild beasts'.[33]

The serious film-makers could share, however marginally, in the banquet. Luis Figueroa, Federico García, Arturo Sinclair, Francisco Lombardi and Nora de Izcué all made significant documentaries and the 'Cine Liberación sin Rodeos' group produced a number of political shorts, though these had distribution problems, especially after the military government moved to the right in 1975. The year 1977 saw the release of several memorable features.[34] Luis Figueroa, the co-founder of the 'Cuzco School' adapted Ciro Alegría's novel, *Los perros hambrientos* (The Hungry Dogs, 1976), a work of populist reformism from the late 1930s, which concentrates on the relationship between man and nature, rather than on the social relationships. There are some elements of social criticism in the novel and the film – the relationship between the landowner and the Indians and *cholos* (*mestizos*), corruption, centralism – but Figueroa is faithful to the novel by avoiding detailed analysis of land ownership and class structures. The symptoms are analysed, but not the causes. Figueroa would film Arguedas's novel *Yawar Fiesta* (1941) in 1980, wrestling with but never resolving Arguedas's own attempts at transculturation, outlined by the Uruguayan critic Angel Rama:

> Arguedas lived within a game of mirrors, which sent him from one hemisphere to another as an Indian; he sought to insert himself within the dominant culture to appropriate a foreign language (Spanish) by forcing it to express another syntax (Quechua), to find the 'subtle disorderings which would make Castilian a fit vehicle, an adequate instrument', in short, to impose his cosmovision and his protest on a foreign territory, but simultaneously he is transculturating the literary tradition of the Spanish language by appropriating an Indian cultural message with both a specific thematic and an expressive system.[35]

This dilemma, shared by film-makers such as Sanjinés and García, was that of adopting a 'universal' film language to specific provincial needs.

Federico García's *Kuntur Wachana* (Where the Condors are Born, 1977) is a clear break with an ahistorical and idealist indigenist world. Produced by an agrarian cooperative near Cuzco set up by the agrarian reform movement, its director had been a member of SINAMOS (National System for the Support of Social Mobilization, a government office set up under the government of General Velasco), working on documentary film-making. SINAMOS produced some radical documentaries which failed to receive 'obligatory exhibition' from another state body, the Central Office of Information. The film can stand as a reflection on the 'first phase' of military government, 1968 to 1975, in its approach to agrarian reform. García recounts the Indian struggles in the years preceding the reforms, the confrontations between the Indians and the authorities and their local representatives. Its story bears some similarity to Sanjinés's *El enemigo principal*, shot in Peru in 1973, in that it deals with the fight for justice through or outside the legal system. Most important, however, is Sanjinés's example of working on documentary reconstructions. García uses the vehicle of testimonial cinema, because

> it is a reconstruction of facts from the peasants' perspective and with their participation. ... For us, cinema is not an end in itself, but rather a means. For me this type of testimonial cinema, where they take part and where their own emotional feelings are involved, is much more subversive and more effective than a simple, cold documentary organized by a narrator.[36]

Many Indians acted their own life stories in the film.

1977 also saw the first feature-length film by Francisco Lombardi, *Muerte al amanecer* (Death at Dawn), which proved to be a great box-office success, seen by over half a million people in Peru. This was the first Peruvian film to cover its costs in the internal market. Like Littín's *Jackal of Nahueltoro*, the protagonist is a celebrated child murderer, the 'monster of Armendáriz' and again like Littín, Lombardi is interested in analysing the mechanisms of power in society: the forces on the prison island become a microcosm of Peru. Unlike Littín, Lombardi prefers to work within the codes of traditional Hollywood cinema with a linear structure, suspense, a concentration on the psychology of protagonists and the build-up towards a moment of violent climax.

These film-makers have developed their work in the past decade. Lombardi, the most commercially successful film-maker in Peru, reconstructed another well-known crime of violence in *Muerte de un magnate* (Death of a Magnate, 1980) in which an Indian gardener captures and kills an important businessman. He then turned to two adaptations of literary texts, *Maruja en el infierno* (Maruja in Hell, 1983) and *La cuidad y los perros* (The City and the Dogs, 1986).[37] The first of these films concentrates on the 'city', the second on the 'dogs', the military cadets of Vargas Llosa's important novel. *Maruja* offers a dystopic vision of Lima from the enclosed space of a factory which recycles urban

rubbish, populated by weak, deranged and deformed beings. It became the biggest box-office success of Peruvian history. *La cuidad y los perros* strips down Vargas Llosa's long complex novel with its multiple narrators, flashbacks, stories within stories and juxtapositions into a linear narrative which deals almost exclusively with the military establishment, and with the cadets' incorporation into its violent and hierarchical codes of 'honour' and machismo. Even though many of the nuances of Vargas Llosa's novel are ironed out, the film offers a clear critique of militarism and an ambiguous view of its middle-class, intellectual hero Alberto, a poet. Alberto is a story-teller: he is both a narrator and a liar.

How to tell a truthful story of Peru's principal guerrilla group Sendero Luminoso ('The Shining Path') is the subject of Lombardi's film *La Boca del Lobo* (The Mouth of the Wolf, 1988). He takes the cadets from Vargas Llosa's military establishment and puts them in another enclosed, claustrophobic setting, the site of many Westerns: a small remote village under siege by the Shining Path. *Sendero* is not discussed, it is just there, like the forces in John Carpenter movies, terrorizing the villagers and mutilating and killing the soldiers who leave the encampment. The army and its links to political forces are not analysed; all the attention is focused on two figures: the cadet and the officer sent out to discipline and give leadership to the frightened troops. The cadet is both a hero and a traitor; the heroic officer turns out to be a macho psychopath, who orders the massacre of many villagers to cover up his own errors. The suspense is magnificently orchestrated and the Russian-roulette confrontation between the young soldier and his officer is a clear homage to *The Deer Hunter*. Yet in the end, the film avoids many important issues: the nature of the guerrillas, and the response to them from civil society and the army. It is difficult to see how the lieutenant can be an allegory of the army command structures – massacres cannot be explained away by aberrant psychologism. In the end the film-maker, like his protagonist, runs away from the horror of it all.

Federico García has continued an active career with two further films on indigenous themes, *Laulico*, 1979, and *El caso Huayanay* (The Huayanay Case, 1981), using the Indian community once again as inspiration and protagonists of Manichean political dramas. After this he made a trilogy of historical films in co-production with Cuba. Paranagua points out the limitations of this later work:

> The portrayal of Melgar (*Melgar*, 1982), a young seminarian and provincial intellectual who becomes part of the Independence struggle is a rather primitive work. *Tupac Amaru* (1983) is more solid and careful. However Federico García scarcely departs from a rather burdensome didacticism, reinforced by an omniscient off-screen narrator. ... The companion of God in the next film (*El socio de dios,*1986) is a contemporary of Fitzcarraldo, who takes us into the Amazonian jungle: here is a pretext for a dubious mixture of heteroclite mysticism, basic symbolism and an exposé of the conflict of interests among the great powers.[38]

Young film-makers such as José Carlos Huayhuaca and Alberto Durant have

also made interesting features in the 1980s but the most sustained work in production, distribution and exhibition has come from the Grupo Chaski (Chaski is an indigenous word for messenger), a cooperative of some thirty film-makers, producers and technicians.[39] The group is the major distributor of Peruvian films in the country, supplying commercial cinemas, universities and trade unions. It organizes an active alternative distribution and exhibition network, taking films into the countryside and into the neighbourhoods of the big cities. The group has also produced a number of important documentaries and features, including an ironic look at the Miss Universe competition in Peru (Vargas Llosa was one of the judges). Its most important feature to date, *Gregorio*, traces the life of a young country boy forced by poverty to migrate to Lima, there to be caught up in a life of petty crime. *Gregorio* was seen by a million spectators in cinemas, neighbourhoods and even in prisons. The most recent feature, *Juliana* (1988), continues in the same vein, charting the picaresque adventures of a girl who disguises herself as a boy in order to become part of a 'Fagin's kitchen' of street beggars and entertainers. The realist narrative is broken on two occasions by the boys talking straight to camera, expressing their fears and desires. A final utopian scene posits the possibility of harmony outside the grinding poverty and society.

Utopia, of course, means 'no such place', and the future for Peruvian cinema seems bleak in a worsening economic crisis and spiralling political violence. At the moment of writing, Mario Vargas Llosa, the novelist, could lead Peru into the 1990s, but his centre-right coalition would face enormous problems, from civil war in the countryside to the huge urban sprawl of Lima:

> Over the past few years, I've also gotten used to seeing stray kids, stray men, and stray women along with the stray dogs, all painstakingly digging through the trash looking for something to eat, something to sell, something to wear. The spectacle of misery was once limited exclusively to the slums, then it spread downtown, and now it is the common property of the whole city, even the exclusive residential neighborhoods – Miraflores, Barranco, San Isidro. If you live in Lima, you can get used to misery and grime, you can go crazy, or you can blow your brains out.[40]

Vargas Llosa's writing of the eighties has returned insistently to visions of the apocalypse. It is to be hoped that these nightmares do not become the realities of the next decade.

Notes

1. José Carlos Mariátegui, *Seven Interpretive Essays on Peruvian Reality*, University of Texas Press, Austin and London 1971, p. 287.
2. James Dunkerley, *Rebellion in the Veins: Political Struggle in Bolivia 1952-82*, Verso, London 1984, p. 5.
3. Ibid., p. 73.

4. Carlos Mesa Gisbert, *La aventura del cine boliviano 1952-1985*, Gisbert, La Paz 1985, pp. 47–53.

5. Jorge Sanjinés's Grupo Ukamau, *Teoría y práctica de un cine junto al pueblo*, Siglo XXI, Mexico 1979, p. 37.

6. A. Gumucio Dagrón, *Historia del cine boliviano*, UNAM, Mexico 1973, p. 179.

7. Dunkerley, p. 52.

8. See Mesa Gisbert, *La aventura*, pp. 65–7 and Gumucio, pp. 187–91.

9. For a major collection of these articles, see Jorge Sanjinés and Grupo Ukamau, *Teoría*.

10. In J. Burton, *Cinema and Social Change in Latin America: Conversations with Film-makers*, University of Texas Press, Austin 1986, p. 38.

11. See Gumucio, pp. 212-13 and Mesa Gisbert, *La aventura*, p. 85.

12. Carlos Mesa Gisbert, *El cine boliviano según Luis Espinal*, Don Bosco, La Paz 1982, p. 136.

13. Interview with the author, Birmingham, April 1986.

14. Dunkerley, p. 23.

15. J. Sanjinés, 'We Invent a New Language Through Popular Culture', *Framework* 10, 1979, p. 31.

16. An earlier project, *Los caminos de la muerte* (Roads of Death) had to be abandoned when an original negative was ruined in a processing laboratory in Germany. Sanjinés is convinced that the accident was sabotage.

17. Rubén Vásquez Díaz, *Bolivia a la hora del Che*, Mexico 1976, p. 14.

18. See Sanjinés and Grupo Ukamau, *Teoría*, p. 23.

19. Sanjinés, 'We invent', p. 32.

20. Interview with the author.

21. Antonio Eguino, 'Neorealism in Bolivia', in Burton, p. 166.

22. I am grateful to James Dunkerley for discussing this aspect of his study of recent Bolivian politics with me. Also for sharing his perceptions of this film. See Dunkerley, 'Political Transition and Economic Stabilisation: the Case of Bolivia, 1982–1989', Research Paper, Institute of Latin American Studies, University of London 1990.

23. For an anlysis of their work, see Mesa Gisbert, *La aventura*, pp. 144–67.

24. See Latin America Bureau, *The Great Tin Crash*, London 1988.

25. Figure given by Sanjinés in his Guardian lecture at the National Film Theatre, London, March 1986.

26. Mariátegui, p. 335.

27. Including an exhibition in London and a fine BBC documentary directed by Paul Yule.

28. Isaac Leon Frías, 'Pérou' in G. Hennebelle, A. Gumucio Dagrón, eds, *Les Cinémas de l'Amérique Latine*, p. 428.

29. Quoted in *Cinematográfico* 2, Lima 1974, p. 5.

30. 'Encuentro con Federico García', *Hablemos de Cine* 75, May 1982, p. 18.

31. Isaac Leon Frías, 'Pérou', p. 431.

32. See O. Getino, *Cine latinoamericano: Economía y nuevas tecnologías audiovisuales*, Universidad de los Andes, Mérida 1987, p. 55.

33. 'Cine peruano. ¿Borrón y cuenta nueva?', *Hablemos de Cine* 67, 1975, p. 14.

34. See Isaac Leon Frías, 'La búsqueda de una voz propia en el largometraje peruano', *Hablemos de Cine* 69, 1977-78, p. 16-19.

35. Angel Rama, *Transculturación narrativa en América Latina*, Siglo XXI, Mexico 1982, p. 207. I am using Gerald Martin's translation in his *Journeys through the Labyrinth*, Verso, London 1989, p. 89.

36. 'Encuentro con Federico García', p. 24.

37. For an analysis of Lombardi's work, see Paulo Antonio Paranagua, 'Francisco Lombardi et le nouveau cinéma péruvien', *Positif* 338, April 1989, pp. 34–48.

38. Paranagua, ibid., p. 35.

39. The information on the Grupo Chaski comes from an interview by the author with several of its members in Havana, December 1986.

40. Mario Vargas Llosa, *The Real Life of Alejandro Mayta*, Faber and Faber, London 1986, p. 4.

Colombia and Venezuela: Cinema and the State

When success is not assured, when the state is weak, and when results are distantly seen, all men hesitate; opinion is divided, passions rage, and the enemy fans these passions in order to win an easy victory because of them. As soon as we are strong and under the guidance of a liberal nation which will lend us her protection, we will achieve accord in cultivating the virtues and talents that lead to glory.

Simón Bolívar[1]

Colombia

At the moment when a wave of military dictatorships was engulfing the Southern Cone, dislocating film production and forcing cineastes into silence or exile, countries to the north of the continent, aided by state legislation, were experiencing a strong revival in film-making in the seventies. Colombian cinema had always found it difficult to compete with North American and Mexican films, which dominated the market from the 1930s: production was sporadic and of very uneven quality.[2] The polarized political climate following the Second World War, manifested in 'La Violencia' had also adversely affected work in the area. On 9 April 1948, Jorge Gaitán, leader of the Liberal Party, was assassinated. This proved to be the catalyst for violent social tensions to erupt, leading to a bloody riot in Bogotá and an outburst of sectarian violence in the towns and countryside which could not be contained by the conservative governments of Ospina Pérez and Laureano Gómez. The military under General Gustavo Rojas Pinilla intervened in 1953 and ruled haphazardly until 1957. Eventually a liberal–conservative coalition emerged, which agreed to alternate in power for sixteen years. This agreement helped to end violence, which, according to conservative estimates, claimed more than two hundred thousand lives. Yet even in 1962, when the troubles were presumed over, there were some two hundred

civilian deaths a month.[3] Against this backcloth, in the words of critic Hernando Martínez Pardo, cinema wallowed in 'melodrama, costumbrism, folkloricism and nationalism, as expressions of cultural values which rarely addressed the real or imaginary necessities of the popular classes, which sooner or later rejected it.'[4] The sixties, however, were to see a number of initiatives which were consolidated in the following decade.

The first group of film-makers to appear in the 1960s had studied abroad in Rome, Paris or the United States. They included Guillermo Angulo, Jorge Pinto, Alvaro González and Francisco Norden and were called, perhaps ironically, the 'generation of the teachers'. Their work has been subjected to strong criticism from politicized critics and cineastes, the most outspoken of whom was Carlos Alvarez:

> A number of Colombians went to study abroad and returned to Colombia from the IDHEC and from the Centro Sperimentale and made a commercial cinema which has been attributed with artistic qualities which frankly do not exist. Unthinking and malicious critics talked of them as a 'generation of teachers'. At a certain moment, for the public, they made films that Colombian cinema 'had to make'. And this was another false trail, for it was an escapist cinema, which avoided reality, showed a commercial version of reality without any critical perspective.[5]

Francisco Norden became Alvarez's favourite whipping-boy, condemned since he did not seem to aspire to the work of Brazilian 'cinema novo' or that of the Cubans. Yet the possibilities open to Norden in the early sixties were precisely those of working in commercials for the newly expanding television networks and for local capitalist enterprises – there was no state support and the models of the 'new Latin American cinema' were only slowly beginning to emerge. His documentaries were therefore addressed to this market-place but they do reveal both a technical quality and a certain depth of vision which go beyond tourist descriptions – in particular his analyses of the colonial town Cartagena, *Murallas de Cartagena* (Walls of Cartagena, 1962) and *Balcones en Cartagena* (Balcones in Cartagena, 1964).[6]

As the decade progressed, other alternatives came into focus. These can be seen in the work of three tendencies: Marta Rodríguez and Jorge Silva, Carlos Mayolo and Luis Ospina and Carlos Alvarez. Rodríguez and Silva are the best-known Colombian documentary film-makers, who came into prominence with their *Chircales* (Brick Makers), screened in a rough cut at the Mérida Film Festival in 1968 and finally released in 1972. The post-production on *Chircales* was financed by a prize for their documentary *Planas: testimonio de un etnocidio* (Planas, Testimony of Ethnocide, 1970), which denounced the persecution and torture of an indigenous community in the eastern plains of Colombia. Marta Rodríguez trained as an anthropologist in Bogotá, came into contact with the radical priest Camilo Torres and worked with him in a community-action group

in the Tunjuelito district of Bogotá – the site, seven years later, of the filming of *Chircales*. She studied cinema with Jean Rouch and would be clearly influenced by Rouch who 'spoke to us of a cinema which would use cinematographic artifice without violating the life of the people, filming without altering their customs, their gestures, their activities. He spoke to us of the camera as an observing eye which participated in people's lives.'[7]

She began work with Silva, a photographer, on *Chircales* and they both undertook a detailed 'anthropological' study of the brick-workers, rural migrants who eked out a living making bricks with almost primitive methods. They lived for over six months in the community, taping, discussing, photographing and observing, before gradually introducing a camera. A montage of images of state and religious power at the beginning of the film leads into an analysis of the Castañeda family. The first half of the film deals with the economic unit, the family of brick-makers, its exploitation by the local organizer or 'godfather', who will eventually sack them. The second part, beginning with a first holy communion, works with oneiric sequences, where time seems to stop and the logic becomes that of the dream.[8] The mixing of realism with symbolism works extremely effectively as the 'scientific' voiceover is balanced by the 'poetry' of the dream narrative. Meanings cannot easily be fixed – popular consciousness is the site of competing discourses, which do not point inevitably to social revolution. In the end the family are thrown out after thirty years' work and the final caption, a quotation from Camilo Torres, points to a solution which still seems remote: 'The struggle is a long one, let us begin it now.' Camilo Torres, the radical priest who joined the *guerrilla* and was killed in the late sixties, was the subject of a documentary by Diego León Giraldo in 1967.

Luis Ospina and Carlos Mayolo collaborated on an interesting project in the early 1970s, a short documentary on the Pan-American games held in Cali, from the point of view of those who could not afford entrance tickets. *Oiga vea* (Hear, See, 1971) is divided into two parts: an analysis of the organization of the games followed by a series of interviews with working people. Both parts deal with the gap between official and unofficial versions:

> The official version is that sport eliminates political and class antagonisms and that it is popular. The reality is that there are indeed political and class antagonisms, that there are two sports and that the games disguise economic interests. Parallel to this contrast there is another contrast, between official cinema – which reproduces official truth – and marginal cinema – which looks at events from the perspective of the marginal classes.[9]

At one point, an important bridge between the two parts, the camera spies a group of film-makers whose equipment is labelled 'Official Cinema' – the group directed by Diego León Giraldo who produced the costly and rather predictable government-sponsored documentary: *Cali, cuidad de América* (Cali, City of America, 1971). A member of Mayolo–Ospina's crew asks a policeman what

official cinema is and the policeman cannot give him an answer. From that point, the film-makers, who have given their own vision of the games, ask the working people for their opinions. There are thus three interpretations in play: an official version, a middle-class, radical, alternative version, and a 'popular' alternative version. The film displays caustic, corroding humour, genuine sympathy and some extremely accomplished camerawork: one spectacular shot takes a diver inside the olympic pool at the beginning of her leap, then zooms out before she hits the water, out of the pool, out of the building, behind a wall and behind the backs of the people waiting outside, excluded from the spectacle by their poverty.[10]

Carlos Alvarez was the most outspoken documentary film-maker of the later 1960s, openly supporting the militant, radical tendencies in Latin American cinema such as the Uruguayan Mario Handler and the Argentine Cine Liberación group. His first film, *Asalto* (Assault, 1968), was clearly a homage to the pioneering work of the Cuban Santiago Alvarez, albeit without Alvarez's magisterial control. It did, however, reach a wide university audience since its subject was the assault of government forces on the university. Alvarez was also extremely active as a critic, disseminating theories of 'imperfect' and 'third' cinema, and he helped to set up distribution networks for the new Latin American cinema which had not previously been seen in Colombia – networks such as the Cine Club Universitario. His most widely disseminated film of the period was *¿Qué es la democracia?* (What is Democracy?, 1971), which analysed the elections of 1970. Analysed is perhaps the wrong word, since it implies a complexity of discourse. There is little complexity in the hectoring, rather demagogic nature of the soundtrack which offers a commentary on the electoral process since 1930, a year which saw the peaceful election of the Liberal Party into power. Alvarez points to widespread abstention in voting, the fact that many presidents had been previous ambassadors in Washington, the domination of a few families and other broad simplifications which explain *away*, rather than explain, what is in fact an extremely active electoral process. The texture of the film is also somewhat crude, with the images offering a visual aid to the monological soundtrack. The significance of Alvarez lay not so much in the complexity of his pronouncements, but rather in his questioning of the dominant values, his 'conjunctural' importance. Such questioning, in art and life, led to his arrest together with his wife, the film-maker Julia Alvarez, on suspicion of being members of the guerrilla organization, the Army of National Liberation (ELN). He was in prison from July 1972 to January 1974, when he was pardoned.

The early 1970s were, therefore, a time of some dynamism within the film community – a dynamism expressed in the main in very low budget, super-8 or 16mm black-and-white photography. The luxury of 35mm and colour was available to very few, mostly commercially backed directors. 'Imperfect' cinema was a fact of life for all and a political option for some. This was to change through two important government initiatives.

In 1971 the 'ley de sobreprecios' (the 'surcharge law') was passed to support Colombian film-making. In 1978 a film development company, FOCINE, was established as part of the Ministry of Communications, to develop work in the field. The surcharge law, Decree 879, which was enforced in Resolution 315 of 1972 and extended in 1974, stated that a Colombian short film should accompany any new release in the country. These shorts would be subsidized by raised admission prices, the additional amount being split three ways: 40 per cent to the producer, 40 per cent to the exhibitor and 20 per cent to the distributor. The results were spectacular in terms of numbers. In 1974 two feature films were made, sixteen documentaries made outside the system and ninety-four shorts made through the surcharge system. When faced with such an avalanche of new projects, the government set up a quality control board to decree which films should command the maximum surcharge of three pesos at the box-office.

Such measures, as we have seen already in Peru, had both positive and negative aspects: positive in the creation of independent companies and trained technicians, negative in the poor quality of many of the films and in the accusations of favouritism and government bias. Distributors, for example, could undermine the process by buying local films at a fixed price, thus encouraging cheap and hasty work. Carlos Alvarez, for example, commented that 'the surcharge cinema, for me, is the most organized attempt yet to create a reactionary Colombian cinema, and it has had reasonable success'.[11] Lisandro Duque, on the other hand, one of Colombia's most respected film-makers and critics, was positive about the new opportunities which gave many aspirant film-makers access to a commercial audience that could be influenced by well-made, questioning shorts. To turn one's back on this audience in favour of an undefined, purist public was, in his terms, to support 'a cult of the artisan', showing

a phobia against professionalism, as if consciousness, expressed in this form, would become diluted or absolutely corrupted. 'Marginal cinema', in my opinion, is more than justifiable in difficult times, in work for political causes or in the pre-industrial stage of cinema, but it does not have to exclude a professional attitude.[12]

Certainly film-makers such as Ciro Durán, Duque himself, Mayolo and Ospina and Alberto Giraldo produced inventive work under these conditions.

Government measures also attempted to encourage feature films. A screen quota of twenty days in the year was established in 1977 for national films, rising to thirty days in 1978. Colombia has the third largest cinema audience in Latin America, after Brazil and Mexico, with eighty million spectators in 1984 and seventy million in 1985. A percentage of that market, it was felt, could make Colombian features economically viable. This promotional task was undertaken by FOCINE from 1978, initially offering advance credit to film projects up to 70 per cent of the total cost, with low rates of interest.[13] It also offered credits to buy film equipment and stock. Nearly all the feature films made in the 1980s have had

support from FOCINE. And the numbers of films increased dramatically, averaging about ten a year between 1980 and 1985, from an earlier base of almost zero.[14] Yet very few of these films could cover their costs in the home market and the possibilities for export abroad were greatly reduced since Colombia had no tradition of selling in Latin America or in Europe and the United States. The production sector could not conquer the distribution and exhibition monopolies and the home audience remained unconvinced by national cinema despite the many concessions made to populist humour, a taste imposed by local television. One company, Cine Colombia (CINECO) controls a high percentage of distribution and exhibition outlets and thus acts to filter through only the potentially big box-office successes such as *La abuela* (The Grandmother, 1981) and *Inmigrante latino* (Latin Immigrant, 1981). A major corruption scandal caused a widespread replacement of FOCINE senior personnel in 1984, and the directorship was given to María Ema Mejía, a respected director and producer. This appointment helped to maintain the work of FOCINE into the 1980s.

Film-making in the decade 1978 to 1988 falls into three phases. In the first years private producers sought to make commercial films, usually comedies or dramas based on Mexican melodramatic models. There were some successes, as with Gustavo Nieto Roa's *El taxista millonario* (The Millionaire Taxi Driver, 1980), but the poor returns on private investment caused the state to intervene in granting credits. A number of films were made with advance credits, but FOCINE soon found that it could not recoup its money, and lost considerable resources. In a further attempt to promote cinema, FOCINE took over the full production costs of a number of features from 1984 to 1987. This strategy also proved unworkable; by 1988, state funding was almost at a standstill. In this stop–go world, a number of interesting features were, however, produced.[15]

Outside the main system of state support, Marta Rodríguez and Jorge Silva continued their patient work of analytical documentation. *Campesinos* (Peasants, 1975) dealt with the history of rural violence and exploitation from the 1930s to the present. Once again, they worked directly with the rural population. The camera films the tape-recorder, constantly in use registering the memories of the protagonists who attempt to recapture their past: the labour conditions, lifestyle, customs, religion, the impact of politics, the *Violencia*. The account of one Communist Party militant served as the basis for the first script, which was then discussed and modified by the rural population. Marta Rodríguez remembers that particular interlocutor:

> We recorded all his life. One day we asked him not to talk about his life but about history. And he told us 'I don't know any history. The only history I knew was sacred history which I learned in school.' But all that we had recorded was history. If that individual memory could become collective, what power it would have![16]

The work on the rural and Indian populations furnished material for a further film, *Nuestra voz de tierra, memoria y futuro* (Our Voice of the Land, Memory

and Future, 1981) about the myths and legends which inform the Indian cosmovision, and through which they interpret their political actions. Sadly, Jorge Silva died during the post-production work on their latest documentary on the carnation trade between Colombia and the outside world, *Amor, mujeres y flores* (Love, Women and Flowers, 1988), a sombre account of exploitation and illegal trafficking.

Carlos Mayolo and Luis Ospina have continued to make interesting work together and separately, increasingly with state support. *Agarrando pueblo* (Ripping The People Off, 1977), is a fiction about documentary film-makers who travel round Bogotá looking to film the most miserable, sordid inhabitants. When events and characters are not sufficiently depressing, they invent them. This caustic film tilts at much of the 'surcharge' cinema with its concentration on misery, not in order to understand or overcome it, but rather to receive the box-office percentage. Towards the end of the film one of the protagonists asks a direct question to camera '¿Quedé bien?' ('Was I good?'), a question that goes to the heart of middle-class, intellectual appropriation of 'difference'.

Many film-makers and critics thought that Ospina and Mayolo were attacking them personally – the film does swipe at the 'pornomisery' employed by both left and right. Yet the important films on urban and rural deprivation are clearly not included in this critique. Carlos Alvarez's *Los hijos del subdesarrollo* (The Sons of Underdevelopment, 1975) made shortly after his release from prison, is a close look at the conditions that cause thousands of Colombian children to die of malnutrition. Ciro Durán's and Mario Mitriotti's *Corralejas* (Bullfights, 1974), examined a particularly bloody popular festival in Sincelejo, where the impro-vised bullfighters risk their lives for bottles of spirits thrown down by the presiding Nero/landowner. This film was coupled with *The Exorcist* on general release and thus reached an audience of over a million. Durán's feature-length documentary *Gamin* (Urchin, 1979) deals with the culture of survival of street children in Bogotá. The film has been both praised and vilified; it was certainly the most popular film in the late-seventies shift to feature-length production.

Mayolo and Ospina's work reflects this shift. Mayolo's first feature, *Carne de tu carne* (Flesh of your Flesh), in 1983, and his subsequent *La mansión de Araucaíma* (The Mansion of Araucaíma, 1986) deal with the decadence of the rural aristocracy. In *Carne*, incest between brothers symbolizes the solitude and introspection of a class which survives through violence (the film is set in the 1950s) and domination. In *La mansión*, the dispossessed and the servants now control the landowning classes in a carnivalesque reversal of power where a perverted Eros reigns supreme. Both films become somewhat lost in the labyrinths of their surrealist, rather whacky excesses, but they show a lively, fresh talent at work. Luis Ospina's *Pura sangre* (Pure Blood, 1982) draws on the popular legend in Cali that a series of horrific child murders were the work of a local millionaire with a rare disease who needed gallons of blood to keep alive.

Ospina transforms the millionaire into a homespun vampire, but the film did not manage to achieve the cult status the director had clearly hoped for.

La mansión de Araucaíma was adapted from a novel by Alvaro Mutis, a Colombian writer resident in Mexico, a close friend of García Márquez. Márquez is an overwhelming presence in Colombian culture of course, but it is only in the last few years that Colombian film-makers have attempted to adapt his work (unlike the Mexicans, who have been involved in the task since the mid 1960s). Jorge Ali Triana remade *Tiempo de morir* (A Time to Die, 1985) for television and then for the cinema in the mid 1980s. The television version, as García Márquez correctly points out, is fresher:

> When the actors, the same actors (and I don't know if the director himself thinks that working for television is not working for history) think that their work is nothing transcendental, that it'll die after its first showing, then they are very relaxed, very natural. When they knew it was for film they were immediately ... less spontaneous than in the television version.[17]

The acting was somewhat wooden in parts, but the theatrical 'Sophoclean' tragedy of hereditary violence, passed from father to son, stands as an important allegory for the country's development (the violence, the drug wars): a tangled feud that stands for a whole frightening network, senseless and bloody.

Lisandro Duque's *Milagro en Roma* (Miracle in Rome, 1988), based on a García Márquez script, one of the six in the series 'Amores difíciles', commissioned by Spanish television, is an elegant fable of the redemptive power of love and the chicanery of organized religion. A young girl dies mysteriously; years later her father has to remove her body from its tomb and finds that it has not decayed. He wants to keep her at home and coax her out of her sleep, but the Colombian ecclesiastical hierarchy and the government need to claim a miracle. Father and daughter (in a travelling case) are thus packed off to Rome to tread the labyrinthine corridors of Vatican power. The film's strength lies in Frank Ramirez's depiction of the father's dogged, bewildered tenacity, and in the deadpan description of miraculous events: an aspirant Colombian opera singer, with a little help from the girl's aura, manages to hit a top note that smashes the windows of the conservatory, and the girl eventually awakens from the dead. An amused critique of bureaucratic power, its understated tone captures the world of García Márquez's fiction, so often travestied by baroque over-indulgence on the part of film-makers.

García Márquez is also at the heart of the young film-maker Sergio Cabrera's *Técnicas de duelo* (A Matter of Honour, 1988), a co-production between FOCINE and ICAIC in Cuba. Two old friends, the schoolteacher and the butcher, are going to fight a duel. The reasons are never explained. The film follows the hours up to the event, revealing the mechanisms of a small Colombian town with its hustlers and petty government officials, ruled by incomprehensible codes of

honour and machismo. The director, gesturing to the commercial expectations in Colombian television and cinema, even includes commercial 'breaks' in the texture of the narrative, as the female protagonist periodically bathes luxuriously in a glistening stream. The film parodies the whole stereotypical production of mass television and cinema production, offering a fresh version of the possibilities of comedy which plays to the audience's intelligence.[18]

FOCINE's work in the 1980s has therefore helped to promote film-making of uneven quality: some poor commercial work, but also several innovative features by established directors and newer talents such as Cabrera. In documentary, both inside and outside the state sector, there has been the work of Rodríguez and Silva and the collective Cine Mujer, which has made a number of documentaries charting the progress of the women's movement in Colombia. Whether FOCINE can be revived once again, following its relative stagnation in 1987 and 1989, will be crucial for the further development of Colombian cinema.

Venezuela

As in Colombia, state support for cinema was consolidated in the early seventies, as part of a programme of spending facilitated by the spectacular development of the oil industry in that decade. The peak of Venezuelan oil production was in 1970. In that year, the country nationalized the natural-gas industry, and in 1975 oil itself was nationalized.

> The financial importance of the industry to the State grew astonishingly as the export price of oil rose from $2 per barrel in 1970 to $14 in 1974 and $35 in 1981 even though production fell. ... Government income from oil was $1400 million in 1970, in 1974 it was $8700 million and in 1980 $12,000 million. ... Oil provided Venezuela with 95 per cent of its export earnings in 1982, the government with 75 per cent of its national income, and the average citizen with the highest standard of living of any in Latin America.[19]

These years of relative plenty would last until 1986, when the fall in the price of oil would cause sharp contractions in the Venezuelan economy and severely limit state patronage of culture.

From the late fifties cinema developed in a context of representative democracy with highly organized and well-funded political parties. Democratic politics evolved in opposition to the two major military dictatorships of the twentieth century under General Juan Vicente Gómez (1908–35) and Marcos Pérez Jiménez (1948–58), both of whom ruled implacably, aided by a clique of *andino* (from the West Andean region) advisors. The response to this authoritarianism and ensuing cultural sterility came first with the government of Rómulo Betancourt (1959–64), but his constitutional rule was threatened by more radical groups who sought to emulate the Cuban model of guerrilla struggle in the

countryside. These groups were defeated in the 1960s, and the whole spectrum of the left returned to legal politics. Almost uniquely in Latin America, the last thirty years have seen stable regimes with a relatively low incidence of political violence, and a society which is relatively egalitarian and profoundly consumerist, especially of North American goods and cultural symbols. Cinema would draw a number of themes from the turbulent recent history of dictatorship, the lure and defeat of *la guerrilla,* the growth of North American consumerism and the dreams and dystopias of urban growth. It could grow in the new freedoms and find its place in the expanding market-place. It could also benefit from government patronage.

The state did not create a film industry *ab initio.* In fact, its investment in the seventies came as a result of an organized campaign from producers and filmmakers to seek guarantees for a slowly developing film culture. The origins of this movement are found in initiatives and work dating from the late fifties and gathering momentum in the sixties. Two projects from 1958 and 1959, Margot Benacerraf's *Araya* (1958) and Román Chalbaud's *Caín adolescente* (Adolescent Cain, 1958) point to the future in both documentary and fictional film.

Benacerraf's documentary is a remarkable achievement for its time and place. The director had trained at IDHEC in Paris between 1952 and 1954 and had also experienced first hand the pioneering work of the Cinemathèque under Henri Langlois, who was to have such an important effect on cinematographic culture in France. Returning to Venezuela, she completed a documentary, *Reverón,* on the work of the visionary Venezuelan painter Armando Reverón (1889–1954) which received some critical attention abroad.

Araya, her second (and final) work is filmed on the Caribbean coast, in a small village where the inhabitants survive by collecting salt in an extraordinarily arid region. She captures the moment just before the advent of mechanization when salt was still collected by hand. The film

> has the rhythmic structure of a symphony; it is visually choreographed in terms of plasticity and movement. The human figure is the essential element in every score. The blazing sun of the tropics models faces and torsos in violent contrasts of light and shade. Bronzed bodies appear in silhouette against the relentless white of the salt flat.[20]

Scenes of barefoot and ragged people, the soles of their feet eaten away by daily treading the salt flats, build up into a monotonous but intense rhythm, revealing qualities of survival in the community which defy the inhuman terrain. The graveyard, the site of memory and tradition, is covered in sea shells in the place of flowers that cannot survive the climate. Benacerraf's luminous images, her understated tone, her indignation that does not give way to demagogic pamphleteering, offer a fresh vision of human endurance. Unfortunately, marginalized as a woman director and as an artist who would not compromise with commercial

cinema, Benacerraf did not make another film, despite *Araya* winning the International Critics Prize at Cannes in 1959. She did reveal, however, a range of documentary film possibilities, only some of which would be taken up by a more overtly political generation in the 1960s.

Román Chalbaud's *Caín adolescente* marks the beginning of a long and interesting film career. Unlike Benacerraf's formal European training and her clear assimilation of the lessons of Eisenstein and Flaherty, Chalbaud was self-taught and gained his passion for the cinema in the Argentine of the 1940s and Mexican melodramas, a genre so often despised by 'modern' film-makers.

> I was weaned on Mexican cinema and I saw María Felix and Jorge Negrete as a child. *El pez que fuma* [Chalbaud's 1977 feature] is, in some ways, a homage to Juan Orol, to Ninón Sevilla and to Rosa Carmina. I think that our culture is not just García Márquez and Vargas Llosa, but that Agustín Lara, Toña la Negra and Jorge Negrete are all parts of this culture that we cannot deny.[21]

He began work as a writer and director for theatre and a number of his features would be adapted from his own stage plays, including *Caín adolescente*. He also learned his craft in television, which came to Venezuela in1953. *Caín adolescente* charts the migration of Juana and her son from the purity of the countryside to the corruption and sordid life of the outskirts and slums of modern Caracas. It has a certain rough-cut vigour in its depiction of urban low-life, but also reveals its theatrical origins, insufficiently modified for the cinema: too many dialogues, too much rhetoric and too much theatricality in the action. Yet there are also the seeds of Chalbaud's later, mature costumbrist style,[22] and evidence of competence in montage. After another feature, *Cuentos para mayores* (Stories for Adults, 1963), Chalbaud spent the next decade working exclusively in theatre and television, with plays such as *El quema de Judas* (Burning the Judas) and *El pez que fuma* (The Smoking Fish), which would be adapted for the screen in the seventies.

Another aspirant film-maker, Clemente de la Cerda, whose work, like Chalbaud's, would define the nature of Venezuelan cinema in the seventies, took his first timid steps in the medium in 1964 with *Isla de sal* (Salt Island) and *El rostro oculto* (The Hidden Face, 1965). Once again, the interest is in marginality, both in rural communities and the city: a downtrodden mass which forms the cement of power, a sector which is either overwhelmed by the environment or finds release in frenetic violence, robbery, sex, fights to the death.[23] At this time, de la Cerda was still a decade away from his commercial success, *Soy un delincuente* (I'm a Criminal, 1976), with its mix of fast action, sex, violence and drugs, and these first two films reveal an interesting mélange of styles and early technical ability, a search for a language which came to an abrupt end in 1976 as the public demanded more and more 'delincuents'.

Chalbaud and de la Cerda's characters reveal little capacity to analyse the conditions they are living: they merely react to given situations. The most significant documentary film-makers of the sixties would put political analysis to the top of their agenda. Venezuela had emerged, as we have seen, from a series of military dictatorships from General Juan Vicente Gómez to Marcos Pérez Jiménez into the constitutional democracy of Rómulo Betancourt and Raúl Caldera (1969–74). Yet for radicalized sectors, these social democratic regimes were merely the modernizing face of transnational capital, which guaranteed the continuation of political, economic and cultural dependency. Guerrilla groups were formed to contest state power, but they were comprehensively defeated in the mid sixties. Echoes of *la guerrilla* would be present in later feature films by Chalbaud such as *Sagrado y obsceno* (Sacred and Profane, 1976). The theories of dependency and underdevelopment coming from research institutes throughout Latin America, also helped to form the theoretical basis of documentarists, working in 16mm black and white. Jesús Enrique Guedes's *La cuidad que nos ve* (The City that is Watching Us, 1967) on the marginal districts of Caracas, is one example of this discourse, as is Carlos Rebolledo's *Pozo muerto* (Dead Well, 1967), the first Venezuelan film to analyse the exploitation of oil by transnational companies.

The programming of 'The First Festival of Latin American Documentary Cinema' in Mérida in September 1968 was to act as an important spur to documentary activity. One Venezuelan critic has remarked:

> The history of Venezuelan cinema as a movement, as a collectivity convinced of the necessity for joint action, is really born in Mérida following the brutal shake-up caused by watching the cinema of Fernando Solanas, Jorge Sanjinés, Santiago Alvarez, Glauber Rocha and Tomás Gutiérrez Alea.[24]

Six months later, and as a direct result of the stimulus of the festival, the Universidad de los Andes (ULA) founded a documentary film centre in 1969, which became absorbed into the Department of Cinema. Up to 1986, this department had produced over a hundred newsreels, documentaries and feature films. The university offered trained teachers, excellent equipment and a distribution network through a series of cine clubs, a redoubt for experimentation and pluralism outside the normal commercial circuits. One important early work by Jorge Solé, *T.V. Venezuela* (1969), explored the dependence of Venezuelan television on the multinational information and communications monopolies and the strategies these monopolies employ to ensure their ideological and cultural hegemony. Donald Myerston's *Renovación* (Renewal, 1969) traced the struggle in the universities for reforms in the face of an intransigent academic, political and bureaucratic establishment, while the Uruguayan-born Ugo Ulive took his camera for a walk through the streets of Caracas in *Caracas, dos o tres cosas* (Caracas Two or Three Things, 1969), contrasting daily reality with a

soundtrack taken from radionovelas, news broadcasts and popular music. Other regular directors at the university included Carlos Rebolledo and Michael New, who have helped to make ULA a focus of film work throughout the last twenty years. Other significant documentaries of the late sixties included *Imagen de Caracas* (Image of Caracas, 1968) by the renowned painter and cineaste Jacobo Borges, who formed a group called 'Cine urgente' and taught film-making in working-class districts. He also took his films to these areas to discuss their form and contents. Yet this was an isolated initiative without any wider resonance. The search for the audience would be conducted not in the *barrios* but in the commercial cinemas of the centre.

For a number of years, Venezuelan film-makers – who organized the National Association of Cinematographic Authors (ANAC) in 1969 – had petitioned for protective legislation for national cinema. Prompted perhaps by the critical and commercial success of two feature films, the Mexican Wallerstein's *Cuando quiero llorar, no lloro* (When I want to cry, I don't cry) and Román Chalbaud's *La quema de Judas* (Burning the Judas) in 1974, the state began to support feature films in 1975. Between 1975 and 1980, the state financed twenty-nine feature films, beginning with Chalbaud's *Sagrado y obsceno*.[25] It was also stipulated, during this period, that exhibitors should show at least twelve Venezuelan films a year. For once, exhibitors needed little encouragement when it was found that these films created their own public. Clemente de la Cerda's *Soy un delincuente* broke all box-office records, outselling *Jaws* and *E.T.* Faced with this popular success, US distribution consortia threatened the government with a temporary distribution boycott of new films. At first the government gave way to such pressure by withdrawing credits from national cinema in the late 1970s, but by 1981 its nerves had settled and the Fondo de Fomento Cinematográfico (Fund for Cinematographic Development, FOCINE) was established in 1981 and began operations in 1982.

FOCINE introduced a series of measures, disbursing funds which came from a percentage of box-office receipts and which mixed public and private funding. Credits offered to film-makers were up to 70 per cent of the total cost of a film (the average cost of a film in Venezuela in 1985 was $150–200,000, roughly the cost of one minute of a medium-priced Hollywood film).[26] Special incentives were given to 'quality' films. The industry also benefited from a 'preferential dollar' system which allowed the importation of equipment at a cheap dollar rate, and an agreement with Kodak to supply film stock at a reduced rate. These advantages were converted into an annual production rate of some twelve films, two or three times that of the pre-FOCINE years.

Exhibitors were also wooed by a number of financial incentives:

In 1984, the government authorized an increase in ticket prices which had remained frozen for several years on condition that exhibitors agreed to pay a percentage (6.6 per cent) of profits from foreign films. ... By 1985 more than two

hundred theatres had begun to cooperate, yielding a contribution of ten million bolivars (seven hundred thousand dollars) which was used to finance local production. Also exhibitors received an additional 6.6 per cent of the box-office for Venezuelan films, which helped to increase their interest in the local product.[27]

The support of the public has meant that the large distribution chains Blancica and MDF also invest money in production. Only with the economic difficulties of 1986 did this policy begin to falter.

A number of film-makers adopted the strategy of making deliberately commercial, popular, films which would also contain elements of social protest. I shall briefly consider three examples of this tendency. Ramón Chalbaud's *El pez que fuma* (The Smoking Fish, 1977) has been seen as a metaphor for the power relations and the corruption of contemporary society: the brothel culture reflecting these societal tensions in microcosm. Chalbaud seems inclined to this interpretation: 'I depicted a brothel because I was interested in it, not for the brothel itself, but because it seemed to me that there one finds something magical, cruel, terrible, which is very much like the society in which we live, the buying and selling.'[28] Yet the 'real' world of the Smoking Fish brothel, run by the indomitable but ultimately lonely La Garza ('I haven't had men, I've had metres of men, kilometres of men, motorways of men'), and her henchman and chief pimp Dimas who is soon to be replaced by the young pretender Jairo, is that of popular cinema and popular music. This is the world of the brothel films of 'El Indio' Fernández, or those starring the rumbustious Ninón Sevilla, the lyrics of the *merengue*, the bolero, the tango, played for all their sentimental excess with tongue planted laconically in cheek. Popular songs, taken literally, offer a wonderful, hyperbolic freedom to explore their themes of solitude, thwarted passions and violent destiny. García Márquez understands this better than most, and Chalbaud is equally versed in the language.[29] This film works so well not because it *parodies* popular songs, but because it takes them at face value: the characters are literally constructed by the music that accompanies them – La Garza by the tango *Uno*, Dimas by the *merengue* 'El muñeco de la ciudad' (The City Slicker). Two men dispute the favours of the ageing madame, their rights to her body and to her empire. Shots are fired, she is killed by mistake and her funeral is gloriously accompanied by the tango 'Sus ojos se cerraron' ('Her Eyes Closed'):

> Why did life, so cruel, break her wings?
> Why this sinister grimace of fate?
> I wanted to protect her and death was stronger
> How the wound deepens and grieves me
> I know that now strange faces will come
> With their alms to give solace to my torment
> Everything is a lie, grief is a lie
> Now my heart is alone.[30]

Carlos Rebolledo and Thaelman Urgelles's *Alias: el rey del joropo* (The King of the Joropo Dance, 1978) draws on a famous contemporary figure, a dancing teacher, conjuror and thief. Its narrative is that of the picaresque, the quintessential Hispanic form which expresses the trajectory of a trickster-hero in collision with the dominant values in society. For Rebolledo, the picaresque was a kind of carnivalesque genre:

> I discovered that Alfredo Alvarado (the protagonist) had that picaresque connotation common to all Latin America, in that people – who consume Coca Cola or whisky according to their economic level – preserve a purity of behaviour which places them on the margins of productivity ... their behaviour is not productive but imaginative and unreal.[31]

In a story within a story, the protagonist recounts his life on television until the channel bosses decide that his anecdotes are too sharp, and do not fit their folksy or salacious vision of his life and cancel his contract. However, it is argued that popular culture has a vitality that escapes imposed frames, corrodes hierarchies of taste and values.

Clemente de la Cerda has no time for idealist or picaresque solutions. His young protagonists are caught in an unforgiving world where violence, prostitution and addiction are the dominant codes. The forms he used (he died in 1984) are dangerously double-edged. At one level, they seem to offer a critique of the underbelly of the Caracas, dependent capitalist, consumerist dream. On the other hand he invites a rather voyeuristic consumption of an aesthetic of violence, his mass following reflecting the contradictory nature of popular taste, his very popularity imposing a formula of stereotypes to be repeated.

Not all film-makers were seduced by, or had access to, these possibilities for making full-length colour features. Apart from the work in the Universidad de los Andes, there was also an active group of cineastes working in super-8. The pioneers of both the theory and the practice of super-8, Julio Neri and Mercedes Márquez, organized an International Festival of Avant-Garde Super-8 Cinema in 1976, which caused a great sensation due to the diversity and audacity of their images. Julio Neri developed feature-length filming in super-8, a practice followed by Diego Risquez who now has an international cult following for films such as *Bolívar sinfonía tropical* (Bolívar, Tropical Symphony, 1979), filmed in super-8 and blown up to 35mm for theatrical distribution, *Orinoko, nuevo mundo* (Orinoko, New World, 1984) and *América: tierra incógnita* (America, Unknown Land, 1988). Risquez shows an expansive imagination in creating sweeping, sensual, painterly canvases with very few resources: basic equipment and a group of non-professional actors, mainly friends, who take on the roles of emblematic figures of history and myth. In *Bolívar* and especially in *Orinoko*, plot and dialogue are abandoned in favour of a series of *tableaux vivants* which illustrate different aspects of conquest and colonization.

This film was produced in conjunction with the Universidad de los Andes which co-produced a number of interesting works in the 1980s, including Thaelman Urguelles's *La boda* (The Wedding, 1982) and Fina Torres's *Oriana*, 1985, two of the finest Venezuelan films of the decade. The University also co-produced work of Latin American film-makers such as Fernando Birri, Jorge Sanjinés and Patricio Guzmán. In *La boda*, the wedding ceremony of a young working-class couple, whose invitation list includes parents, friends and employers, allows Urguelles to chart the lives of characters from different social groups over thirty years of Venezuelan history, from the Pérez Jiménez dictatorship of 1950 to the democracy of 1980. Little has changed. The fragmentation of time in this film owed much to contemporary writers:

> My interest in cinema comes from literature, from a specifically modern literature in which the fragmentation of time occurs as an expressive device, causing the reader to pay great critical attention. This seduction for the fragmentation of narrative time was produced by reading the novels of Mario Vargas Llosa, especially *Conversation in the Cathedral*. In this novel there are stories that can only be told through a mosaic of different times ... and if I must recognize any type of influence in my work in cinema, it would be literature.[32]

The blending of three times – past, present and future – is skilfully handled. It allows an analysis of the repression and also the workers' struggles under Pérez Jiménez, and suggests that even though government and other power structures change, the future might well be found in the past: a preservation of popular memory is perhaps the only way of breaking out of seemingly predetermined structures.

Fina Torres's *Oriana*, 1985, won the Cannes Caméra d'Or in that year, with its beautifully evocative search for lost time. Oriana is dead and María inherits her aunt's *hacienda*, where she had spent some time in adolescence. Fragments of the past are placed throughout the house that trigger memory and help decipher the clues of Oriana's past, which is also María's present. Repressed material, buried in the storehouse of the unconscious and in the empty rooms of the house, is seen to be ever present, demanding gratification, the release of desire. Fina Torres has worked specifically on the nature of female desire. Another woman film-maker, Solveig Hoogesteijn, treats the more general themes of Latin American identity in *Manoa* (1979). *Manoa* is the personal and collective history of two different individuals, Juan and Miguel, who come together through love of music and set off in search of their lost roots (parallels between the film and Alejo Carpentier's novel *The Lost Steps* are clear). Her later *El mar de tiempo perdido* (The Sea of Lost Time, 1981) is yet another attempt, only partially successful, to film a García Márquez story.

The borders between art and reality became spectacularly blurred in the government's reaction to a film by Luis Correa, *Ledezma – El caso Mamera*

(Ledezma: the Mamera Case, 1982), which revealed once again that what the state could give with one hand, it could take away with the other. The film is a documentary on a high-ranking police official in Caracas who murdered three young men who had had relations (sexual or of friendship, it was never made clear) with his young wife. For two years the criminal remained undiscovered; then the man confessed. Luis Correa, who had written the script for *Soy un delincuente*, managed to film an interview with Ledezma and he confessed to camera the details of the murder, stating that he would do it again if given the chance. Correa also interviewed other police officials, who made it clear that Ledezma had been protected for a long time since he knew too much about police corruption. The film was banned on the flimsy pretext that it was an 'apologia for violence' and Correa was imprisoned for forty-five days. The case, which was eventually closed in favour of Correa, revealed the potential power of the medium and also the ambiguity of making anti-state films with state support. Now the film appears in a catalogue of Venezuelan cinema sponsored by FOCINE.[33]

At the end of the 1980s Venezuelan cinema remains fluid. FOCINE continues to give credits, though at a reduced level, and private capital is also available. The films range from high-budget commercial successes[34] to university production and to super-8. For some critics, including the lucid cineaste Carlos Rebolledo, demands of the market-place have reduced quality. 'Since 1980', he wrote at the end of 1987,

> Venezuelan cinema, with few exceptions, has tried to emulate the telenovela – a sure way of securing the public – leaving aside the intensive and extensive complexity of the country in order to use schematic dramatic forms which would please a mass, paying public. No, I'm not a cultural pharisee. I'm not saying that the box-office success of a film denies its artistic expressive qualities. It is just that there are certain box-offices that kill'.[35]

It is to these exceptions that Rebolledo alludes to that we must look for the future of Venezuelan cinema.

Notes

1. Simón Bolívar, 'The Jamaica Letter', in D. Bushnell, ed., *The Liberator, Simón Bolívar: Man and Image*, Alfred A. Knopfl, New York 1970, p. 21.

2. For a detailed history, see H. Martínez Pardo, *Historia del cine colombiano*, América Latina, Bogotá 1978.

3. For an analysis of the period, see Robert H. Dix, *Colombia: the political dimensions of change*, Yale University Press, New Haven and London 1967.

4. Martínez Pardo, p. 235.

5. Interview with Carlos Alvarez in Isaac León Frías, *Los años de la conmoción 1967–1973*, UNAM, Mexico 1979, p. 200.

6. Martínez Pardo gives these films a sympathetic criticism, in *Historia*, pp. 292–302.

7. 'Jorge Silva, Marta Rodríguez', *Cinemateca: Cuadernos de cine colombiano* 7, October 1982, p. 4.

8. For a perceptive analysis of this film, see López, 'Towards a "Third" and "Imperfect" cinema, pp. 395–400.

9. Martínez Pardo, p. 286.

10. See the remarks of the critic Andrés Caicedo, quoted in 'Luis Opsina', *Cinemateca: Cuadernos de cine colombiano* 10, June 1983, p. 15.

11. Interview with Carlos Alvarez in Umberto Valverde, *Reportaje crítico al cine colombiano*, Toro Nuevo, Bogotá 1978, p. 76.

12. Interview with Lisandro Duque, in Valverde, p. 114.

13. Getino, *Cine latinoamericano: Economía y nuevas tecnologías audiovisuales*, Universidad de los Andes, Mérida 1987, p. 59.

14. Ibid., p. 60.

15. On the development of cinema in the last decade, see Orlando Mora, Sandro Romero Rey, 'Cine Colombiano 1977-1987: Dos opiniones', *Boletin Cultural y Bibliográfico*, Biblioteca Luis Angel Arango, Vol. XXV, 15, 1988, pp. 31–49 and 'Colombia: en busca del cine perdido', *Gaceta*, July–August 1989, pp. 21–33.

16. Conversation with Marta Rodríguez in *Film/Historia* 1, May 1978, p. 40.

17. Interview with García Márquez taken from script of Holly Aylett's, *Tales Beyond Solitude*, South Bank Show, November 1989.

18. See the interview with Sergio Cabrera in *Arcadia va al cine* 18, June–July 1988, pp. 6–11.

19. 'The Economy', *The Cambridge Encyclopedia of Latin America and the Caribbean*, Cambridge University Press, Cambridge 1985.

20. Angel Hurtado, '*Araya'*, *Latin American Visions*, The Neighborhood Film/Video Project, International House, Philadelphia 1989 p. 7.

21. 'La estética de la marginalidad: Diálogo con Román Chalbaud', *Hablemos de Cine* 75, May 1982, p. 40.

22. See Alvaro Naranjo, *Román Chalbaud: un cine de autor*, Fondo Editorial Cinemateca Nacional, Caracas 1984.

23. See R. Grazione *et al.*, eds, *Clemente de la Cerda,* Consejo Nacional de la Cultura, Caracas, n.d, n.p.

24. Pedro Rincón Gutiérrez, 'Preliminar', in E. Aray, V. Pereira, *Cine venezolano: producción cinematográfica de la ULA*, Universidad de los Andres, Mérida 1986, p. 5.

25. Jesús M. Aguirre, Marcelino Bisbal, *El nuevo cine venezolano*, Ateneo de Caracas, Caracas 1980, p. 37.

26. Getino, p. 63.

27. Ibid., p. 64.

28. Quoted in Naranjo, p. 68.

29. Michael Wood explores the relationship of García Márquez to the *bolero* in his forthcoming book *García Márquez: One Hundred Years of Solitude*. I am grateful to Professor Wood for allowing me to read the work in manuscript.

30. This analysis draws on a splendid review of the film by Nelson García in *Hablemos de Cine* 75, May 1982, p. 42.

31. Carlos Rebolledo, 'Muchos caminos, una sola meta', *Hablemos de Cine* 75, May 1982, p. 48.

32. Quoted in Flor Medina, *Vida ... ; Cámara! Acción: La realización de un film 'La boda'*, Universidad de los Andes, Mérida 1988, p. 49.

33. See Rodolfo Izaguirre, *Cine venezolano: largometrajes*, FOCINE, Caracas 1983, pp. 92–3.

34. For an analysis of box-office receipts, see the first issues of *Revista Económica de Cine* 1, 1987, pp. 14–23.

35. Foreword to Flor Medina, p. 9.

Central America and the Caribbean:
Movies in Big Brother's Backyard

But perhaps Our America is running another risk that does not come from itself but from the difference in origins, methods and interests between the two halves of the continent, and the time is near at hand when an enterprising and vigorous people who scorn or ignore Our America will even so approach it and demand a close relationship. ... The pressing need of Our America is to show itself as it is, one in spirit and intent, swift conqueror of a suffocating past, stained only by the enriching blood drawn from hands that struggle to clear away the ruins, and from the scars left upon us by our masters. The scorn of our formidable neighbour who does not know us is Our America's greatest danger.

José Martí[1]

The Caribbean: Haiti, Santo Domingo and Puerto Rico

While Cuba has remained a crucial focus for debate in Latin America and throughout the world in the last thirty years, the other Latin American countries in the Caribbean basin have received only the most cursory attention, appearing briefly in the world news in September 1989, as a hurricane left a trail of devastation. No mention was made of their economic and social structures, although the images were clear enough: isolated communities, shacks blown away, only the hotels and other physical structures of North American interests holding firm against the elements. Jenny Pearce describes these islands, nestling uncomfortably 'under the eagle':

> The Cuban Revolution had never been repeated elsewhere, though not for want of trying. For twenty years the slow process of decolonisation took place in the Caribbean lake under the watchful eye of American gunboats. But in spite of a degree of surface prosperity – a patina of tourist-induced wealth for the benefit of an elite – the islands large and small were vulnerable to every economic ill-wind that blew through the region.[2]

The island of Hispaniola, Columbus's first sighting of the New World, became consolidated in the mid nineteenth century as two separate states: Haiti to the west and the Dominican Republic to the east. Both regimes were invaded by the United States in 1915 and 1916. In Haiti, the United States oversaw a succession of puppet regimes until troops were withdrawn in 1934. In the Dominican Republic, they controlled the government directly from 1916 to 1924. North American investors could thus profit through the preservation of secure regimes, though the Hollywood marketing agents saw clearly that these were poor, underdeveloped areas. The United Artists representative in the Caribbean, Charles King, wrote in the 1920s that Santo Domingo was an 'unsatisfactory territory' with only twenty-eight movie theatres; his sales manager Abrams agreed: 'It would be a serious mistake for us to open up our own branch there ... the office would never be put on a paying basis.'[3] Haiti offered even fewer opportunities. It was, and remains, the poorest country in the hemisphere and one of the twenty-five poorest nations in the world. The possibilities of establishing national cinemas in such conditions were minimal. There were very few Dominican films being made in the 1920s.

The situation did not improve under the thirty-one-year dictatorship of Rafael Leónidas Trujillo Molina (1930–61) whose idea of the art of cinematography was to give long interviews to foreign newsreel companies. In Haiti, a succession of governments were controlled by the traditional mulatto elite until François Duvalier won the elections in 1957, and neutralized opponents in the army, the church, trade unions and political parties. His son Jean-Claude 'Baby Doc' Duvalier showed the same skill in the seventies and eighties, a combination of astute juggling among elite groups and an extremely repressive state apparatus. The whole cultural field was subject to severe censorship and control. One general in charge of exhibition in the 1970s even banned the films of the Marx brothers, fearful that Groucho might become confused with Karl. The film-maker Arnold Antonin, who directed Haiti's first feature-length film, *Les Chemins de la liberté* (The Roads to Freedom) in 1975, talked in 1977 of the limitations with which, and against which, he worked:

> The level of film distribution is unbelievably poor: we see the worst of international cinema. Parallel to this there is a colour-television network for the oligarchy. Recently satellite television has been installed so that – and this is the literal truth – Jean-Claude Duvalier can see the football internationals. There was an art cinema, but this was closed on the grounds of being subversive. This will give you an idea of the reality of the oppression that we live with.[4]

Film-making by Haitians in the 1970s concentrated on denouncing political repression and human-rights violations to an international audience and to the hundreds of thousands of Haitians living abroad. Antonin's two-hour film offers a history of Haiti from the early 1940s to the mid 1970s, using sound recordings,

newspaper cuttings, documentary materials taken from television, some live footage filmed clandestinely, and reports from politicians and trade unionists in exile. It systematically denounces and demystifies the Duvalier regimes, showing a family that needed over two hundred bodyguards to guarantee their safety.

The success of the film abroad caused Antonin and his group to receive funding to make a documentary on the regime's manipulation of naif art: *Art Naif et répression en Haiti* (Naif Art and Repression in Haiti, 1975). The film details the government's commercial and ideological interests in disseminating abroad an art which is primitive, childlike and ingenuous – and its support from the CIA: the principal promoter of naif art, Selden Rodman, is denounced as a CIA agent. As a contrast to this, artists working in other areas support a progressive culture of liberation. The colonial ideology of the simple, happy native is well expressed on film in the words of Elvine Wilson Price, a North American art collector: 'We want to return to the childhood of humanity through naif art. Haitian art is magnificent, I adore it. It is a solution, at the level of the image, to the world's problems. You Haitians are a happy people. Give you a banana, and you're happy. While we have problems of obesity, of diet.'[5] A further exploration of the artistic community is found in Antonin's 1980 documentary *Un tonton macoute peut-il être poète?* (Can a Tonton Macoute be a Poet?), which discusses the languages and styles open to a poet – writing in creole or French, writing about *négritude* – in conditions of oppression.

Other film-makers in exile such as Benjamin Dupuy and Lucien Bonnet made short documentaries in the seventies and eighties. Inside the country, two films appeared: *Map pale net* (I'll Say It All, 1976) based on a Cocteau melodrama, and *Olivia* (1977), directed by Bob Lemoine. The first Haitian feature-length fiction film, it takes a theme dear to melodrama: a young provincial girl working in the capital who meets her Prince Charming and returns with him to the village, where his superior skills can re-educate a backward community. More of a cutting edge is to be found in *Anita* (1980), a short dealing with the exploitation of children in domestic labour. Exile cinema continued into the 1980s, in its opposition to Duvalier. The most successful of these was *Haitian Corner* directed by Raoul Peck in 1987, which tells the story of Joseph Bossuet, a man who had spent seven years in prison in Haiti and now lives in New York with his family. One day, he thinks he sees one of his ex-torturers and finally confronts him. The events of the late 1980s, which saw the overthrow of Baby Doc in 1987, did not witness any profound transformations or increased political liberties, as after a brief liberal spell a succession of Tonton Macoutes vied for power in increasingly bewildering and bloody confrontations.

In the Dominican Republic, work in film began to appear after the overthrow of Trujillo in 1961. Two commercial films appeared in the early seventies, but perhaps the most important event was the founding of CINEC (The Committee for a National Institute of Cinematographic Studies), in the face of the conservative regime of the US-backed president Joaquín Balaguer. CINEC was a

university-based group, made up of students who had been active in politics but who had also formed part of the cine-club movement which began to gain momentum in the late sixties. They made three short documentaries in 1973 which demanded amnesty for political prisoners and explored the poverty and deprivation of marginal groups. CINEC continued producing shorts into the 1980s[6] and were joined by another radical university-based group, Cine Militante which made a documentary, *Crisis* (1978), on the need for reforms in the Autonomous University of Santo Domingo. Among the most interesting of these 1970s documentaries is Jimmy Sierra's *Siete días con el pueblo* (Seven Days With the People, 1978) a record of a cultural festival in which the various songs are illustrated by documentary pictures from Dominican history. Sierra's *Via Crucis* of the same year dealt sympathetically with the large Haitian exile community which had customarily suffered from persecution from their eastern neighbours. The Trujillo regime, for example, massacred some 30,000 Haitians in 1937.

These documentaries were part of a radical opposition to the dictatorship of Balaguer, who fell in the late seventies, but was re-elected in the mid 1980s and still ruled the country at the end of the decade. The radical hopes of the mid 1970s gave way to the realities of an IMF stabilization programme in the mid 1980s and the maintenance of the old political elites. In these conditions, there have been some advances in film culture. A cinemathèque was set up in 1979, consolidating the work of the film clubs of the previous decade. It has provided a regular programme of different styles, authors and countries.[7] A number of small cinemas were also set up in the 1980s catering to a professional and university audience. Film-making remained sporadic. A number of advertising companies produced 35mm 'spots' for television and the cinema; a handful of documentaries were made each year mainly within the university. Some foreign companies used the country as a backcloth for films such as *The Godfather Part II, The Sorcerer,* and *Pantaleón* (1978). Only one fictional feature was made in the 1980s: *Un pasaje de ida* (One Way Ticket, 1988) by Agliberto Meléndez, which used Dominican actors and locations. This film is based on a real event in which a number of Dominicans stowed away on a boat to the United States and were drowned on the journey. It became a major commercial success, with audiences rivalling those for *Rambo* and *Jaws,* but, such is the size of the home market, it has not yet recovered its costs.

Puerto Rico has witnessed the growth of a sophisticated film culture in recent years, escaping from the stereotypes imposed by US cinema of the 1920s onwards which projected the island as a site for tropical romance. It was, of course, much more than an exotic backdrop for Hollywood, as an editorial in the *New York Times* of 1898 made clear:

There can be no question of the wisdom of taking and holding Puerto Rico, without any reference to a policy of expansion. We need it as a station in the great American

archipelago misnamed the West Indies, and Providence has decreed that it shall be ours as a recompense for smiting the last withering clutch of Spain from the domain which Columbus brought to light and the fairest part of which has long been our heritage.[8]

The development of Puerto Rico's colonial relationship – legislative power resides in the US congress; the island is now democratically self-governed although the first Puerto Rican governor of the island was not elected until 1948 – has made it particularly susceptible to US cultural influence, but has also engendered a strong nationalist response. Cultural producers live inside 'the belly of the monster' in the Cuban José Martí's telling phrase, and can read its entrails.

The first major technological developments in Puerto Rican cinema occurred under the US-led economic modernization programme entitled 'Operation Bootstrap', which from the late 1940s attempted to lift Puerto Rico 'by its bootstraps' out of dependency on sugar and tobacco. The programme was enthusiastically promoted by governor Luis Muñoz Marín, who held office between 1948 and 1964. He offered generous tax incentives, a pool of very cheap labour and a stable political climate as a way of attracting industrial-development capital. A development agency, the Economic Development Administration, was set up under Teodoro Mocoso, and for a time United States capital followed the path to easy and immediately repatriable profit.

> Between 1948 and 1968 foreign control of manufacturing increased from 22 per cent to 77 per cent. In 1947, there were thirteen American-owned factories on the island; by 1970, there were 2,000. At first investment was concentrated in light industry, particularly textiles, which had been given a ten-to-twelve-year tax-free period. As this expired in the mid 1960s, high mechanised, energy-intensive and highly polluting industries such as petrochemicals, oil refineries and pharmaceuticals moved to the island.[9]

A government body, 'The Division of Education for the Community' was set up to promote these economic strategies. It recruited North American cineastes and technicians to train young Puerto Ricans and to produce a number of films which promoted Puerto Rican identity, exploring the customs, traditions and language of the island, and postulating the emergence of modern Puerto Rico, an amalgam of the traditional and the new. Many future film workers received training from this group.

As in many other countries, modernization proved to be a myth for the mass of society. Unemployment was extremely high in the 1960s and between 1950 and 1970 over half a million Puerto Ricans emigrated to the USA in search of better employment opportunities. Income distribution remained grossly unequal with nearly 90 per cent of workers in 1970 receiving under the minimum living wage estimated by the Department of Health. No major investment was made in

Puerto Rican cinema and the island was still used as a cheap source of locations. In the 1960s, Woody Allen's *Bananas*, Richard Fleischer's *Che* and Peter Brook's *Lord of the Flies* were all filmed there, and Hollywood made on average four films a year on the island. Intermittent local productions tended to use popular genres, gangster movies or television melodramas. US capital investment also created advertising companies which helped to train local technicians. A combination of increased technical sophistication and an awareness of the grave inequalities in society caused, rather than solved, by US investment, led to the growth in the 1970s of a critical, national, documentary movement. Its output from early denunciatory films of the early seventies, as in the work by Diego de la Texera and the Tirabuzón Rojo group, to the work of José García Torres in New York's WNET-TV channel, to the more nuanced documentaries of the middle of the decade. Critics agree that the most important of these films are *Angelitos negros* (Little Black Angels, 1976) by Mike Cuesta, *Destino manifiesto* (Manifest Destiny, 1977) by José García Torres, *Alicia Alonso* (1978) by Marcos Zurinaga and *Reflections of Our Past* (1979) directed by Luis Soto.[10] Cuesta shows the agonizing death of a young Puerto Rican child in New York and the subsequent wake, using no dialogue but only the lyrics of one of Puerto Rico's greatest singers, Willie Colón. Zuringa's sympathetic portrait of Cuba's prima donna Alicia Alonso, and García Torres's long political analysis of US imperialism under the guise of 'Manifest Destiny' both demonstrate a subtle and complex handling of different filmic materials.

The first feature film of this new tendency, *Isabel la Negra* (1979), brought together the major talents of Puerto Rico, on the island and in the United States: the writer Emilio Díaz Valcárcel and the Hollywood 'stars' José Ferrer, Raúl Julia and Myriam Colón. The film revealed a certain nervousness as to what a 'national' film should consist of: it took a hoary theme, already overworked by Mexican cinema, of a 'tart with a heart' and was spoken in English in an attempt to facilitate North American distribution. It did not reach its desired audiences. Jacobo Morales's *Dios los cría* (God Makes Them, 1980) was much more assured, offering five vignettes of middle-class Puerto Rican life, receiving widespread critical acclaim.

Through the 1980s, two tendencies could be observed: the continuation of a critical documentary movement, well illustrated in Ana María García's *La operación* (The Operation, 1981), which denounced US sterilization programmes enforced on one-third of all Puerto Rican fertile women. There was also an attempt to make socially responsible commercial films, which could vie with Hollywood in terms of production values. The most daring and successful of these seemed to prove that such a strategy was viable. Marcos Zurinaga's *La gran fiesta* (The Gala Ball, 1986) reconstructs the last formal grand ball at the casino in Old San Juan during the first months of 1942. Ironically the celebration marked the takeover of Puerto Rico's glittering and most exclusive social club by the US army at a crucial time in the island's history. During the party, the film

weaves a complex network of love and political intrigue, as representatives of modern and traditional thinking on the island jostle for power within the orbit of the United States. Zurinaga and his scriptwriter, the distinguished novelist Ana Lydia Vega, manage to convey a lively critique of Puerto Rico's recent history,[11] in a filmic language worthy at times of Visconti: a baroque melodrama, a texture of decadence, a fluid, operatic use of the camera. Zurinaga and his partner Roberto Gandara have recently achieved further success with *Tango Bar*, a film which deals with the reuniting of two tango partners after years of exile during the Argentine dictatorship. By the end of the decade Zurinaga was pointing Puerto Rico towards a commercial cinema that could reflect national interests and attract local and international audiences.

Central America

Little or nothing has been done to alleviate the socio-economic factors that lay beneath the revolts of 1979 onwards and have subsequently been worsened by the world recession. In El Salvador and Guatemala exploitation and oppression remain unabated beneath a 'redemocratization' built upon fear and death. In Nicaragua the revolution cannot stand still upon its present basis for any length of time. Costa Rica remains dependent upon foreign economic largesse to guarantee its economic model. A reduction in US aid to Honduras would most likely prompt a return to social mobilization and political disaggregation.[12]

The development of cinema in Central America is bound up with the growth of revolutionary movements in the last decade, their successes and reversals. The victory of the Frente Sandinista de Liberación Nacional (FSLN) in Nicaragua in July 1979 was the most spectacular manifestation of a shift in political power in the area, and its removal from office in the elections of February 1990 signals another complex realignment of forces. The purported 'domino theory' threat to the isthmus was to dominate Washington's foreign-policy actions in the 1980s, as the muddles of the Carter administration were replaced by the forthright hostility to social change embodied in the Reagan administration. The US government's interpretation of events in Nicaragua – Western democracy hijacked by totalitarian Marxist-Leninists in the pay of Russia and Cuba, intent on spreading revolution to the rest of Central America – meant that Nicaragua spent the 1980s embroiled in a devastatingly costly war against US-backed Contra insurgents. Other liberation movements, especially in El Salvador and Guatemala, have had to fight against local oligarchies massively backed by US aid and armaments. These conditions determine both the form and the content of film-making in the region.

The main focus of the following sections is on the 1980s. Earlier decades witnessed few traces of film-making activities due to the extreme backwardness of the region, unable to sustain a high-cost industry of this type. There was some

economic modernization in the period from 1950 to 1980, but very few of its benefits were distributed to the bulk of the population. Increased prosperity did, however, result in some state- and university-led initiatives in cinema in Costa Rica, Honduras and Guatemala in the 1960s and 1970s. In El Salvador, on the other hand, only a handful of documentary films were made and in Nicaragua the Somoza dynasty ran a small film unit simply to produce propaganda films for the regime. The fact that cinema could have made certain limited progress under less autocratic conditions is confirmed by the brief flowering of the arts in Guatemala in the democratic interlude of 1944 to 1954 which included work by film-makers such as Eduardo Fleischmann, Marcel Reichenbach and Guillermo Andreu. The trend throughout the isthmus from the 1950s was, however, towards increasing authoritarianism and unequal distribution of wealth. The 'new' cinemas of the region would be part of a radical response to these conditions.

Under Western eyes

The popular struggles in Central America from the late seventies attracted the widespread attention of North American film-makers. Not since the Mexican Revolution or the brief 'Good Neighborly' period of the Second World War had so many films, both feature and documentary, concentrated on a particular area of Latin America. Western 'knowledge' about the overthrow of Somoza was partially shaped through the lenses of photographers and cameramen such as those portrayed by Nick Nolte or Joanna Cassidy in Roger Spottiswoode's *Under Fire* (1983). The massacres in Guatemala and the enforced migration to the North of many refugees have been explored in Anna Thomas and Gregorio Nava's *El Norte* (1983). The dystopia of the regional 'red peril' of Cubans and Nicaraguans invading the North was presented in John Milius's *Red Dawn* (1984). The savagery of state repression in El Salvador was glimpsed through the alcoholic gaze of Belushi and Woods in *Salvador*.

The shift in sensibility in Hollywood, post-Vietnam and post-Watergate, reflected in these mainly liberal films, and the depiction of the Northern protagonists and their continuing ambiguous relationship with the South, would require a monograph in themselves. The intention here is, rather, to explore the images produced by Central American protagonists themselves, under conditions of great scarcity, made in the main with old 16mm cameras or video. The budget for *Salvador* alone far exceeded the resources available to Salvadorean cineastes over the past decade. Great efforts are made to work within these resources, but one of the main factors to drive the majority of the Nicaraguan electorate into the arms of the opposition in 1990 was a rejecton of scarcity which awakened a utopian desire for the way of life reflected in the production values of even such 'committed' films as *Salvador*. These North American features were more concerned with the spectacle of images taken under fire, in the heat of battle: the

complex and difficult tasks of national reconstruction were less interesting topics for consideration and also required a clearer political focus. Yet it was in pursuit of this task that the Sandinistas were slowly worn down and finally Bush-whacked.

Developments in the region

Film-making in El Salvador over the last decade has been an integral part of the liberation struggle undertaken by the Frente Farabundo Martí de Liberación Nacional – the Farabundo Martí Front for National Liberation, the FMLN, formed on 10 October 1980 as a coalition of a number of guerrilla groups – and the political organization of the opposition groups, the Frente Democrático Revolucionario (Democratic Revolutionary Front, the FDR). To choose 1980 is to leave aside the 'long war' (the phrase is James Dunkerley's) previously waged by the opposition groups against a powerfully entrenched and cohesive oligarchy which had influence over the army and was supported by US arms and aid, especially after the triumph of the Sandinistas in Nicaragua in 1979. This complex history has been comprehensively mapped elsewhere.[13]

> El Salvador has been either the next domino or the most obvious extension of a regional revolution. Of course, after such a length of time these fears or expectations are less sharp than they were in October 1979 when, a mere twelve weeks after the defeat of Somoza, the military regime in San Salvador was overthrown in an apparently reformist coup leading to a rapid escalation of mass mobilization and, within the space of a year, civil war. In January 1981 the guerrillas of the ... FMLN staged what they called a 'final offensive'. It turned out to be badly mistitled.[14]

The final offensive failed to carry all before it and the opposition settled in to an extended war of attrition, while at the same time the United States sought to reformulate a fractured dominant bloc, in successive military regimes, in the 'elected' government of the Christian Democrat Party under Duarte and finally, in March 1989, with an extreme right-wing president.

Several different film groups responded to the radicalization of the years 1979 to 1981, intent, in the words of Yderin Tovar, a protagonist of these early initiatives, on 'giving an immediate testimony to our revolutionary process. It is the dynamic of the revolution that obliges us to make cinema that is "urgent".'[15] One group, Zero a la Izquierda (Zero, on the Left) came together in 1979. The name came from the fact that

> we began from nothing materially. Without any training, or any cinematographic tradition in El Salvador, we were like a zero on the left. What was important was that we knew that the revolutionary process of our country should be recorded cinematographically and we plunged ourselves into that task.[16]

Their first film was an experimental short, *La zona intertidal* (The Intertidal Zone, 1980), which dealt with the assassination of schoolteachers, their bodies left washed up on the shores. The second feature, *Morazán* (1980) adopted more direct, traditional forms of the documentary, describing the first 'liberated zone' in the north of the country and the organization of the guerrilla forces. The term 'liberated zone' refers to those areas under guerrilla control, which included, by 1984, large areas of Chalatenango and Morazán in the north, parts of Cuscatlán in the centre and San Miguel in the southeast.

La decisión de vencer (The Decision to Win, 1981) by the same group, is a remarkable document of daily life in one of the liberated zones:

> Production, maize, milk, sugar, education, health, international solidarity ... organization, combat. Filming the revolutionary struggle is often to offer an image of death and painful desolation, the people massacred, uniforms and weapons trampling on bodies and dignities. But filming the revolutionary struggle can – should – offer an image of life and this is precisely what *La decisión de vencer* does, and in order to be very clear on this point, it opens with a wedding and ends with a party.[17]

The war is also filmed, but always from the point of view of the FMLN: the enemy is rarely in view, a menacing threat occasionally manifest in a plane or helicopter, or it is seen in the aftermath of battle with stunned and silent prisoners nursing their wounds, ordinary frightened individuals caught up in a conflict of unprecedented bitterness and brutality.

In May 1980 the Revolutionary El Salvador Film Institute was set up by the FDR, mainly to promote the cause of the opposition in the international arena, but also to distribute films within the 'liberated zones'. The institute was a declaration of faith in the importance of film in the revolutionary process, set up before the final victory. A number of Latin American film-makers offered their resources and the film *El Salvador, el pueblo vencerá* (El Salvador, the People Will Win, 1981), was directed by the Puerto Rican Diego de la Texera, co-produced by the Costa Rican firm Istmofilm, with post-production work done in Cuba. The film offers a historical analysis, a trajectory of commitment from Farabundo Martí to the present, exposing Duarte as a right-wing puppet of the Salvadorean oligarchy and the United States. It mixes video, cartoons and 'found' footage, but its emotionally strongest moments – and it is a film, as Michael Chanan points out, which is pitched at a very high emotional level – are the directly filmed sequences, as when a young boy laments the murder of his father at his funeral and vows to join the liberation struggle, accepting the handkerchief and insignia of the rebel army.[18]

Radio Venceremos, the communications organization of the FMLN, which provides daily broadcasts on the situation of the war and political developments, began audio-visual production together with Zero a la Izquierda in the early

1980s. Their first film was *Carta de Morazán* (Letter from Morazán, 1982). This group made extensive use of video:

> *Letter from Morazán* was shot in super-8 and Betamax both for economic reasons and for easy movement, for example, in ambushes and in actual fighting. Later all this material was copied and edited on $^3/_4$" videotape. ... The great advantage we discovered in using video is that the people who have been filmed can see the production directly. ... We edit in $^3/_4$" video and then transfer to 16mm film for distribution abroad. In El Salvador we don't have the capacity to distribute 16mm film, we transfer to $^1/_2$" videotape, which we can show even in the enemy's own zones, that is, in the capital.[19]

The film follows a successful assault on an army unit, contrasting the violence of the war with the humanitarian treatment of prisoners by the FMLN, including the Vice-Minister of Defence Colonel Castillo who was captured in June 1981. Other significant works by the group, which have received international distribution, are *Tiempo de audacia* (Time of Daring, 1983) and *Tiempo de victoria* (Time of Victory, 1988). These films chart the progress of the liberation struggle, denouncing the massive military and political interference of the United States and rejecting the imposed civilian democratic order. The work of this group, and others, is therefore two-fold: to combat the images and distortion of international news agencies and to increase political and cultural education in the liberated and also the war zones. Many of the Radio Venceremos productions are didactic shorts, recordings of sermons, meetings or seminars which can be used for educative purposes. All these images demonstrate the FMLN ability to maintain an extraordinarily effective guerrilla campaign in both urban and rural areas, with widespread popular support in the face of terrible violence.

A massively unequal distribution of income and land resources exists in Guatemala. A few hundred families control most of the productive land and the great bulk of manufacturing output, protected by a caste of military officers who ruled the country from 1954 to 1986. The majority suffer from desperately low wages, lack of access to land and widespread poverty and malnutrition. Disparities in wealth are made more acute by the racist attitudes towards the indigenous people, who make up some 70 per cent of the population. In order to maintain this system of inequality, the forces of the state have applied terror on a wide scale. It is estimated that since 1954, over a hundred thousand people have died as a result of political violence, over half this number since 1978 when the military responded to an increasingly well-organized guerrilla opposition. By the early 1980s, the URNG (Guatemalan National Revolutionary Unity) offered a serious challenge to the state; the military response, as James Painter has argued,

> was to launch a campaign of terror that has been rarely paralleled for its savagery (and lack of publicity) in the history of Latin America. The resulting carnage was so vast that at least another 30,000 Guatemalans have been killed, hundreds more

have been 'disappeared', 440 Indian villages have been wiped off the map and between 100,000 and 200,000 children have lost at least one parent. Over the same period, many of the social conditions that lie behind the dirge of statistics have deteriorated: real incomes have dropped, levels of malnutrition have probably increased, and the gap between the rich few and the poor (and largely Indian) majority has widened.[20]

After thirty years of military rule, a Christian Democrat, Vinicio Cerezo, was elected into office in late 1985, but this government did not substantially alter the economic and political situation: the rules of the game are still dictated by entrenched right-wing forces dedicated to government by violence. In these conditions, the whole cultural field has been under threat and the attempts at oppositional practices have been few and scattered. In cinema the students of the University of San Carlos produced a series of documentaries in the 1970s. The University Cinemathèque in San Carlos founded in 1970 also struggled against the odds to broaden the bases of film culture. In the 1980s, a small group of film-makers named Cinematografía de Guatemala produced a short documentary, *Vamos patria a caminar* (Let's Go Forward My Country), tracing a history of struggle from 1954 to 1983. This group, however, has to work in conditions of almost total bankruptcy and an exceptionally threatening political climate. They occasionally collaborate with foreign cineastes who film in the country. In 1985 they produced an eight-minute short, *El gobierno civil, un engaño* (Civil Government, a Fraud) which accurately predicted the limitations of the Christian Democrat government. The panorama remains bleak. Honduran cinema produc-tion has been very intermittent, despite the pioneering efforts of film workers such as Fosi Bendeck and Samy Kafaty in the 1960s and 1970s and a brief moment of state support in the 1970s, when the cinema department of the Ministry of Culture sponsored ethnic and educational documentaries. In Costa Rica the constitutional stability, a relatively buoyant economy based on foreign investment, welfare provisions and middle-class consumption have created a market for commercial cinema, mainly supplied by North America. From 1973, a department of cinema controlled by the Ministry of Culture began a programme of documentary film-making, reaching a total of forty-five productions in only five years, which were broadcast on the state television channel. Documentaries dealt with health and social welfare, agriculture and other areas of social interest. Some contained sharp criticisms of the existing structures, such as *Costa Rica: Banana Republic* (1975), directed by Ingo Niehaus, which denounced the control of banana production by multinational consortia.[21] The film was banned for a period by the government.

Independent production was promoted by Istmo Films which made its money working in advertising and founded an arts cinema with the profits – the Sala Garbo. The moving spirit behind this institute is Oscar Castillo, an active producer, director and actor. Istmo films co-funded productions for the Nicara-

guan and Salvadorean revolutionary movements and offered their modern facilities for post-production work. Oscar Castillo produced and directed *La Xegua* (1984), the first feature film made by a Central American director, which told the story of a beautiful female spirit who accosted men by the roadside of eighteenth-century Costa Rica and drove them mad. She represents the spirit of the indigenous woman raped by the Spanish *conquistadores* who returns to take her terrible revenge. The film is rather a crude melodrama, a moral fable about the greed and rapaciousness of colonizers. It did, however, strike a chord with the local public and reached a wide audience. In the words of its director, it was 'a melodrama at the service of the people, not at the service of evasion'.[22]

In Panama, a state-supported company, the Grupo Experimental de Cine Universitario (The Experimental University Cinema Group, GECU) was founded in 1972 as part of the progressive nationalist measures taken by General Torrijos. The director of the group, Pedro Rivera, explains the general desire for cultural liberation in a country literally invaded by the presence of the United States:

> Simply, we tried to overcome that state of innocence, acritical attitudes and dilettante amazement when faced with the most perverted cinematographic tendencies made popular by colonialism. From that moment we affirmed that the struggle for national liberation in the economic and political spheres should be accompanied by liberation in the cultural sphere.[23]

From 1972 to 1977, they produced thirty documentaries presenting an alternative, nationalist history of Panama. They also worked to create alternative exhibition circuits in newly created cine clubs, in a cinemathèque and in union bases, halls and schools throughout the country. They also founded a theoretical critical journal, *Formato 16,* which became one of the most serious film publications in Latin America.

The first short produced by the group, *Canto a la patria que ahora nace* (Canto to a Homeland that is Now Being Born, 1972) reveals their political and ideological orientation. Based on a protest poem by Pedro Rivera, it deals with a bloody incident in 1964 when students attempted to fly the Panamanian flag next to the US flag in a school in the Canal Zone. The US military responded with great savagery, killing twenty-one people and wounding five hundred. A subsequent film revealed the support of GECU for Torrijos's modernizing reforms: *505* (1973) focuses on the selection of 505 delegates for a new state assembly, to be based on popular support. It offers a series of interviews with peasants, workers and indigenous people who comment on the new reforms and on the nature of imperialist penetration in the country. From 1977, however, the work of GECU began to lose momentum; it became the butt of reproaches from many sides and gradually lost state funding. National cinema in the last decade has, as a result, faltered. Torrijos's successor, Manuel Noriega, abandoned his progressive nationalism and was later to fall foul of an act of US aggression

masquerading as a crusade against drugs. For a time, Panama loomed large in the lenses of the foreign media, though there was a curious blindness to the fate of the hundreds of Panamanians killed as US forces blundered after their prey. Perhaps a documentary in the style of *Canto a la patria* will reconstruct these tragic events before controlled amnesia wipes them from memory.

In Nicaragua, the FSLN developed a rudimentary film-making movement in the heat of battle. In March 1979, the various tendencies within the FSLN formally united for the final offensive against the crumbling Somoza regime and in April, 'the FSLN decided to begin to develop its own film-making and information infrastructure. It organized two offices: the Office of Information to the Exterior and the War Correspondents' Corps, the first composed primarily of journalists, the second of photographers and film-makers.'[24] The War Correspondents' Corps was made up of several Nicaraguans and a number of Latin American volunteers who had film-making experience lacking in Nicaragua due to the media monopoly created by the Somoza regime. They managed to capture moving images of the final months of the offensive which ended in the occupation of Managua on 17 July 1979. Immediately, a Nicaraguan Film Institute was set up (INCINE) based in Somoza's film production company, Producine. Most of the equipment from this corporation had already been taken out of the country, though some material was rescued at the airport from crates about to be smuggled to the United States. The revolutionaries also found in the archives some 750,000 feet of newsreel footage (about three hundred hours) covering the years of the Somoza regime. To this they could add some eighty-thousand feet of footage of their own, taken during the final offensive. Producine provides a basic infrastructure: in the first months the institute's facilities were a small studio, an editing room with two moviolas, a dark room and a few 35mm and 16mm cameras. There were no processing laboratories since Producine had sent all its material to be processed abroad.[25]

The early years of production followed in part the Cuban pattern, although the Nicaraguans had fewer resources, less expertise and a less sophisticated film culture. Also, unlike Cuba, the communications system is run by both the state and the private sector. There are state and private radio stations, the state controls television, and the state owns about 20 per cent of the cinemas in the country, expropriating the chain of cinemas owned by the Somoza dynasty. All the communications systems lack sophisticated technical resources.

The demands of the war against the Contras put a further strain on limited resources. The country is particularly vulnerable to media bombardment, directly or indirectly ideological, from outside. 'Theoretically, the television viewer can pick up about 15 neighbouring television channels while the radio listener can receive about 80 foreign stations.'[26] These viewers were subjected to organized psychological warfare from such stations as Radio 15 de Septiembre, controlled by the Contras in Honduras. One way to combat such aggression was the establishment of mobile cinemas, to tour the country. In 1984,

fifty-two mobile units attracted audiences of some three million. The then director of INCINE points out the dangerous nature of this work:

> Film projections and the informational and educational work they accomplish are directly aimed at the counter-revolutionary radio stations which inundate the north of the country from Honduras. For the peasants participate in debates. It's not without reason that these radio stations threaten our projectionists. ... All of this is in addition to the classic problems of the blockade of spare parts, the lack of foreign exchange and the delays caused by armed attacks.[27]

The institute's first priority was the production of monthly newsreels. Ramiro Lacayo, Carlos Ibarra and Franklin Caldera, who had participated in the war as media correspondents, were in charge of these early initiatives in production, distribution and exhibition. The newsreels were distributed to all the movie houses to show before the main features; non-state exhibitors were resistant to these screenings. The early newsreels were of necessity rudimentary, though the first, which deals with the nationalization of the Nicaraguan gold mines, is interestingly structured around an old man who was in Sandino's army in the 1930s, proudly wearing his uniform from those early days. Film-makers could gradually learn and hone their craft on newsreels, working creatively with the materials available to them: archive footage from the war and from the Somoza collection, magazine and newspaper articles, television footage, still photographs, contemporary footage of meetings, health care, education, work and leisure. One North American critic, John Ramírez, has viewed this work extremely favourably:

> The *noticieros'* dynamic and unconventional combinations of visual elements accompany soundtracks that are also produced under technically unsophisticated conditions. For example, since sync-sound is not always available or economically feasible, there is a recurring use of voice-over strategies such as first-person narration, anonymous public interviews and citizen opinions, crowds in revolutionary chant, traditional folk music and radio broadcasts.[28]

This view, if somewhat overstated, does underline the sense of the Nicaraguans learning to work with and through underdevelopment, turning scarcity into a weapon. It was almost impossible for the newsreels to reflect the immediacy of day-to-day events since the films had to be processed and copied in Cuba, which provided film stock and editing facilities as North American imports became scarce.

The difficulty in obtaining and processing film stock was also a clear factor in the widespread use of video. During the 1980s, there were five major centres of video production: Sistema Sandinista, the television network; the workshop at the Agrarian Reform Ministry, Communicaciones Midrina; the Taller Popular de Video, a part of the Workers Union; INCINE and Pro-TV.[29] An independent

video company, Video Nic run by Jackie Reiter and Wolf Tirado, also produced a number of programmes which received widespread distribution abroad. The Midrina videos cover the whole range of activities of the Agrarian Ministry, from reforms and new agriculture techniques to healthcare. There are video recorders in each regional centre. The Taller Popular started as a super-8 workshop organized by the US film-maker and critic Julia Lesage. Work in super-8 became difficult when Kodak withdrew all operations in Nicaragua and the group subsequently worked in video. Another ambitious project to develop super-8 filming skills among workers' organizations was set up with United Nations and Ministry of Planning support, by the then exiled Bolivian film director and theoretician Alfonso Gumucio Dagrón. He organized a six-month workshop in the early 1980s in the techniques and practice of super-8, during which workers from different unions made a number of documentary films. Gumucio later wrote that work in super-8 was an important part of the class struggle in Nicaragua, 'not a people's cinema viewed as an abstraction, disseminated by petty-bourgeois intellectuals, but a cinema made up of popular organizations'.[30] The same arguments used for super-8 as a practical, low cost, flexible, 'democratic' form of filming would be used, with reason, for video production. For example, the audio-visual department of the Interior Ministry films the weekly Cara al Pueblo (Face to Face with the People) meetings in video, where government ministers and representatives address different people's organizations and receive their criticisms and comments.

INCINE gradually began extending its work beyond newsreels to incorporate documentaries in black and white and later in colour, medium-length fictional features, co-productions of feature films and eventually a full-length feature. These dealt with the realities of everyday struggle, against a background of imperialist aggression. Ramiro Lacayo's short, Bananeras (Banana Workers, 1982), makes good use of limited resources by contrasting an idealized Somoza newsreel with real images of suffering and exploitation of workers in US companies. Iván Arguello's Teotecacinte 83 focuses on the counter-revolutionary aggression against Nicaragua in May and June 1983 centred around Teotecacinte, a small settlement on the borders with Honduras. It has interviews and images of the Contras in Honduras but also offers the Nicaraguan community as an example of organized resistance. Other documentaries deal with the practicalities of day-to-day living. Fernando Somarriba's Managua de sol a sol (Managua, from Sunrise to Sunrise, 1982) offers a panoramic vision of the capital, its workplaces, markets, restaurants and schools. Iván Arguello's Rompiendo el silencio (Breaking the Silence, 1983) surveys the geographic diversity of the country and the need to integrate isolated communities, as a volunteer brigade of telephonists work to connect the Atlantic coast with the telephone network of the Pacific.

Fictional films also sought to document aspects of a country at war. Two of the most interesting are Mujeres de la frontera (Frontier Women), directed by

Iván Arguello in 1986. Set in Jalapa, a northern town under assault by the Contras, it examines in some complexity the impact of warfare upon women and the changes in male–female relationships caused by the women's active role in the revolutionary process. Mariano Marin's *Esbozo de Daniel* (A Sketch of Daniel, 1984) is set in Las Cruces, a small fishing community where a schoolteacher takes a young *enfant sauvage,* Daniel, under his wing. Their developing relationship, brutally ended with the murder of the teacher by Contra forces, is sensitively rendered, as is Daniel's growing awareness of the nature of injustice. These were all modest, exemplary, fables geared both to the paucity of resources available and to the needs of consciousness-raising among their intended, local audience.

INCINE received generous grants of equipment and training from international organizations and visiting film-makers. Sometimes these were put to good use, but on occasion the infrastructure was insufficient to incorporate the new technologies. The French donated equipment to stock a modern 16mm film laboratory, but as yet there has not been money available to build it. There have also been moves to reach an international audience, though the strategies adopted have differed and caused a widespread debate. INCINE, under Lacayo, supported co-productions such as Littín's *Alsino y el condor* (see Chapter 8), the Cuban Gómez's *El señor presidente* (The President, 1983) and Ramiro Lacayo's *El espectro de la guerra* (The Spectre of War, 1988). Apart from Littín's film, which was nominated for an Oscar and received worldwide distribution, the other two films did not have the complexity to match their glossy production values. The film of *El señor presidente* is a very pale adaptation of the Guatemalan Miguel Angel Asturias's brilliant novel on the nature of dictatorship in Central America, while Lacayo produced a folk melodramatic fable of a breakdancer who has his legs broken by the Contras. The routines of the national folk dance groups are thrilling enough, but it proved impossible to graft a 'Travolta style' sophomoric love story on to the daily reality of the community at war. It is unlikely that the film, sponsored by Spanish television, will reach the wide audience it was so obviously, and perhaps mistakenly, aimed at.

Other directors disagreed with what they perceived as a high-profile 'at all costs' strategy, and have recently formed a union to attempt to guarantee their interests. A number of directors left INCINE and set up small production companies using video equipment. Frank Pineda is the most prolific and successful of these independent directors. By 1989 INCINE was virtually bankrupt and the directors were looking to private capital for their survival. From mid 1988, INCINE no longer received funds from the Ministry of Culture. Nicaraguan films could always be shown in the mobile cinemas and on television, but did not have a guaranteed exhibition in local cinemas. Exhibitors preferred often to dig into their stocks of old North American and European movies rather than encourage local directors. There was not much coordination between the various sectors of the communications network, which meant that

united efforts for distribution were not achieved. Distribution abroad was patchy and 'internationalism' in terms of lavish co-productions was increasingly debated. The desperate economic conditions also militated against any form of consolidated growth. Yet the work of individual directors, increasingly in video, still bore witness to the possibility of a lively film culture.

Concluding this chapter one week after the elections which removed the Sandinistas from power, there is little that can be said that would not appear hasty or opportunistic. The state-backed film institute was in severe decline before and it is likely that the new government will allow it to become swamped in the new market-place. Obviously, the Sandinistas in opposition will have access to video film-makers who will continue the patient work of documenting developments in a remarkable political situation. New Hollywood films will return to the screens in Managua, and Nicaragua is likely to become a cheap location for making Hollywood movies – although it cannot offer any sophisticated techno-logical infrastructure. The struggle for political and cultural power in the new regime will be most faithfully reflected, on television rather than film. It is tempting to end with an epitaph to the previous regime, but it would be unwise rapidly to consign Sandinismo to a completed chapter of a history book.

Notes

1. José Martí, *Our America*, edited by Philip S. Foner, Monthly Review Press, New York 1977, p. 93.
2. Jenny Pearce, *Under the Eagle: U.S. Intervention in Central America and the Caribbean*, Latin American Bureau, London 1982, pp. v–vi.
3. Quoted in Gaizka S. de Usabel, *The High Noon of American Films in Latin America*, UMI Research Press, Ann Arbor 1982, p. 39.
4. Interview with Arnold Antonin, quoted in *Hojas de Cine*, Vol. III, SEP/UAM, Mexico 1988, p. 304.
5. Quoted in Arnold Antonin, 'Panorama del cine en Haití,' *Hojas de Cine*, Vol. III, p. 304.
6. For an analysis of this cinema, see Jimmy Sierra, 'La negra noche larga del trujillismo', in *Hojas de Cine*, Vol. III, pp. 363–75.
7. See José Luis Sáez, 'Panorama del cine en la República Dominicana', *Cine Cubano* 123, 1988, pp. 23–6.
8. Quoted in Pearce, p. 10.
9. Ibid., p. 50.
10. See Luis Antonio Rosario Quilés, 'El nuevo cine', in *Hojas de Cine*, Vol. I, p. 482.
11. I am grateful to Marcos Zurinaga for discussing the film with me in Havana, December 1986.
12. James Dunkerley, *Power in the Isthmus*, Verso, London 1988.
13. See in particular Dunkerley, pp. 335–424.
14. Ibid., p. 337.
15. 'Entrevista con Yderin Tovar', in *Hojas de Cine*, Vol III.
16. 'La decisión de vencer. (Los primeros frutos)', ibid., p. 236.
17. Tomás Pérez Turrent, 'El Salvador, la decisión de vencer,' ibid., p. 237–8.
18. Michael Chanan, 'El Salvador: The People will Win. Resistance', *Jump Cut* 26, 1981, p. 22.
19. 'Betamax and Super-8 in Revolutionary El Salvador: Interview with Daniel Solis', *Jump Cut* 26, 1981, p. 22.
20. James Painter, *Guatemala: False Hope, False Freedom*, 2nd edn, Latin America Bureau, London 1989, p. xiv.

21. Peter B.Schumann, *Historia del cine latinoamericano*, Legasa, Buenos Aires 1987, p. 147.

22. Interview with Oscar Castillo at the screening of La Xegua at the National Film Theatre, London, April 1989.

23. Pedro Rivera, 'Apuntes para una historia del cine en Panamá', *Formato 16*, 3, 1977, p. 19.

24. Emilio Rodríguez Vásquez and Carlos Vicente Ibarra, 'Filmmaking in Nicaragua: From Insurrection to INCINE', in J. Burton, *Cinema and Social Change in Latin America: Conversations with Film-makers*, University of Texas Press, Austin 1986, pp. 70–71.

25. 'Prehistoria del cine "nica"', *Hojas de Cine*, Vol. I, pp. 405–6.

26. Armand Mattelart, ed., *Communicating in Popular Nicaragua*, International General, New York 1986, p. 12.

27. 'Cine por todo el territorio', *Barricada*, 18 September 1984, p. 12.

28. John Ramírez, 'Introduction to the Sandinista Documentary Cinema', *Areito* 37, 1984, p. 20.

29. Dee Dee Halleck, 'Nicaragua Video: "Live from the Revolution"', in A. Mattelart, ed., *Communicating*, pp. 113-19.

30. Alfonso Gumucio Dagrón, 'Aporte de la experiencia a la teoría de la comunicación alternativa', *Cuadernos de Comunicación Alternativa* 1, 1983, p. 28. See also the same author's *El cine de los trabajadores*, Central Sandinista de Trabajadores, Managua 1981.

Conclusion

The revolt against the fixed image and the conventional sequence can find connections with those areas of shared reality where we are all uncertain, crossed by different truths, exposed to diverse and shifting conditions and relationships, and all these within structures of feeling ... which can be reached as common: common in the sense that we so often see them from the past, when otherwise separated or isolated people found their minds forming, their feelings shaping, their perceptions changing, in what to them seemed quite personal but were also historic ways. That is the root: the deep images that preoccupy us and that are in one real sense our history.

Raymond Williams[1]

'Independence was a simple question of winning the war', he said to them. 'The great sacrifices will come later, to make of these people one nation.'

'Sacrifices are all we have made, general', they said.

He did not give an inch.

'We need more', he said, 'unity does not have a price.'

Simón Bolívar, in the words of Gabriel García Márquez[2]

This survey ends as Latin American cinema moves into the 1990s, a decade that will witness a number of significant anniversaries: 1992, the quincentenary of the 'Discovery' of Latin America; one hundred years of cinema, which could be said to correspond to one hundred years of modernity and/or solitude in the sub-continent; 2000, a date which evokes millenarian and apocalyptic desires and fears. It is an appropriate conjuncture to review the developing histories of cinemas in Latin America and to hazard predictions, however tentative, as to their future.

Cinema emerged as a modern and popular cultural medium. The words 'modern' and 'popular' have required close inspection. If the modernity of cinema referred to the new scientific and technological advances, the possibility

245

of new and mobile ways of seeing, then 'peripheral' modernity in Latin America
would always be moving in the shadow cast by uneven development.

> The notion of 'correct' technique assumes the legitimacy of 'universal' values
> embedded in the equipment and the raw material, themselves products of advanced
> technology. ... The technology embedded in the means of production facilitates its
> equivocal transfer of the economic notion of underdevelopment to the level of
> culture.[3]

Latin America competed, on unequal terms, with the high-cost technological
advances of cinema – many national industries took years, for example, to
convert to sound; a great number of these industries today work with annual
funds equivalent to the budget of one Hollywood feature film. The dominant
Hollywood model also universalized a 'correct' way of filming, a 'correct' way
of seeing. Film-makers would consistently be working within or against this set
of values, in a market-place geared to the production, distribution and exhibition
of the Hollywood product. In a recent interview the Chilean Miguel Littín asked
why Latin American cinema had not had the impact abroad of the Latin
American novelists, many of whom are recognized as among the world's most
influential writers.[4] At one level, as Octavio Getino bluntly points out, the answer
is simple: cinema is more conditioned, as an industrial and a technological form,
by the capitalist laws of the culture industry than is literature.

> To aspire to occupy a certain space on the screen of a hegemonic nation implies
> taking this space away from films produced in that country or in other similar
> countries: economic interests will always prevail over the values or the cultural and
> aesthetic qualities of production. Those who run the markets for cinema are not
> motivated by humanist or cultural preoccupations, but by profit. Competition does
> not derive, therefore, from putting one cinema against another but from historical
> circumstances which allow one cinema to dominate another.[5]

The 'popular' is also not a neutral term. While it is true that the major
audiences in Latin America, at the outset, were working-class people in the
expanding cities of the region, this did not make cinema inherently democratic,
or place it at the service of the emerging labour struggles. In fact, as Raymond
Williams saw clearly, commercial entrepreneurs and new-style capitalists could
see their own profit in the new technologies, by quickly disseminating a standard
product across wide areas:

> It isn't really surprising, setting these advantages within both earlier and later
> industrial history, to find a symmetry between this new popular form and typically
> capitalist forms of economic development. Nor is it surprising, given the basic
> factor of centralized production and rapid multiple distribution – so different, in
> those respects, from most early cultural technologies – to see the development of

relatively monopolist – more strictly, corporate – forms of economic organization, and these, moreover, in a significant new phase which followed from the properties of the medium, on a paranational scale. Many attempts were made to preserve at least domestic corporations, but the paranational scale significantly overbore most of them. The road to Hollywood was then in one sense inscribed.[6]

The popular therefore became part of the cultural industry. From the early twentieth century in Latin America, with very few exceptions, cinema did not reproduce real, lived environments, but rather particular forms of spectacle, based mainly on imported genres.

The development of cinema would, therefore, constantly redefine and reappropriate the popular. In Latin America local producers had to acknowledge as a given the inscription of Hollywood in popular taste. There was no need, however, to accept this situation as a fatalistic curse and just lie down and give up: it was a question of working through dependency, through the interstices of power. The earlier producers found a space in the market-place, especially with the advent of sound, by drawing on the strong traditions of popular theatre: melodrama, theatrical spectacle or vaudeville and tent shows, with their blending of song, dance, comedy and short sketches. Some of the most enduring screen actors and actresses came from this background. There was little avant-garde exploration of the medium itself. If the theorists of modernism, such as Walter Benjamin, talked of the inherently radical and experimental nature of cinema, their arguments found few echoes among the practitioners. Some of these early films did, however, have a raw energy which became dissipated as the laws of the market-place demanded rapid reproduction, a steady supply of closed-flow forms. The Mexican industry of the 1940s became a mini-Hollywood within Latin America by successfully exploiting two or three fixed genres.

A reaction to this increased commodification of the popular occurred in the 1950s, part of a process that could draw on, but also quickly transcended, the models of neo-realism and the 'new wave'. It opposed the dominant idealisms by arguing that experience and actions of men and women are formed by concrete environments, that histories are made up of the aspirations, victories, often crushing defeats of real people, who do not necessarily follow the plangent rhythms of singing *charros*. It was the duty of the film-maker to tap into this experience, which could be done in a variety of roles: teacher, prophet, ethnographer, dispassionate observer. Most prominent cineastes of this period were fired by Marxisant, socialist, principles, and they put their camera at the service of developmentalism or the maximum utopia of revolutionary social changes. It was a fruitful period in terms of producing a corpus of remarkable films and generating a series of complex theoretical debates – such as 'Third Cinema' – which are still an issue today. The crushing defeats of the 1970s in many countries generated both an important culture of resistance – in particular exile cinema – but also a reappraisal of the limits of the possible in the slow return to

democracy. Today the popular is once again viewed in terms of the market-place, but a market-place infinitely more precarious than that which obtained in the 1940s. Cinema screens are fighting a losing battle against other more dominant players in the culture industry: television, in particular the new technologies of satellite, cable and video.

Cinema in Latin America has always had to contend with the stop–go nature of weak economies and the continual shadow of censorship. In both areas, the state has played the role of both short-term saviour and censor, sometimes, as in the case of Brazil, actually banning films that it had helped to finance. Censorship can vary from subtle forms of internal persuasion, such as the control of financial patronage, to outright violence and brutality. Particular attention is paid to those media that reach the widest or least-educated members of society: radio, television and cinema. The history of Latin American cinema has lurched between libertarian and authoritarian views concerning freedom of expression. Self-censorship is obviously prevalent in those areas which rely on government largesse or are funded by commercial advertisers, areas which fall uncomfortably under the shadow of the 'philanthropic ogre', Octavio Paz's apt description of the state.

While there have been countless examples of the ogre in action, there have also been a number of significant examples of philanthropy, where the state has developed the market for cinema or even protected cinema from market forces. Most national film industries have required state aid in order to guard them against the power of Hollywood. We have seen that in the case of Latin America, virtually no protection was given to the weak, underdeveloped industries in the first decades and that the big three cinemas of the 1930s to the 1950s – Argentine, Brazilian, Mexican – received varied amounts of state funding. Developments in smaller film cultures such as the Andean countries were accompanied by state funding, in particular in the 1970s. The film historian Jorge Schnitman has classified some ways in which the state has supported film:

> A purely *restrictive* state protectionist policy would concentrate on measures designed to impede a complete takeover of the domestic film market by foreign products (by means of screen quotas, import quotas, high import taxes etc.). A *supportive* state protectionist policy would concentrate on different forms of assistance to the local film industry [bank loans, production subsidies ...]. A *comprehensive* state protectionist policy would include both restrictive (of foreign competition) and supportive (of local production) aspects.[7]

The countries discussed in the present volume either adopted no protectionist measures at all, or partially restrictive and partially supportive measures. These had mixed results: in general the state has been more successful in stimulating production than in altering distribution and exhibition circuits. The transnational and local monopolies have strongly resisted any measures to

restrict the free entry of foreign films and have grudgingly obeyed, or even ignored, laws which purport to guarantee screen time to national products. Even the most striking example of a comprehensive policy towards protection – Brazil since the mid 1960s – has run into difficulties since, as Randal Johnson has convincingly argued, it concentrated too much on production and did not give support to the exhibition sector.[8] In the main also – the cases of Mexico and Argentina in the 1940s and 1950s are clear examples – the logic of state investment was largely economic: to protect the profits of dominantly private investors. There are fewer examples of what Thomas Elsaesser calls 'a cultural mode of production'. In the case of new German cinema, he argues, 'subsidy has become part of the politics of culture, where independent cinema is a protected enclave, indicative of a will to create and preserve a national film and media *ecology* amidst an ever-expanding international film, media and information economy.'[9] There have been some examples of a similar successful strategy – the different cases of Brazil and Cuba, for example – but in the main independent cinema of quality has had to fight for its own survival against both the national and international economic order. At the moment of writing, with a deepening economic crisis throughout the subcontinent, state subsidies are declining everywhere and the chill winds of the market threaten to blow away many of the achievements of the last thirty years. While film-makers have constantly questioned the limitations imposed by working with the state, they realize only too well the further limitations imposed by working without it.

The future, therefore, seems particularly uncertain, especially in a world where all the old fixities are dissolving. We have seen that the history of Latin American cinema has been a constant debate over the attraction or rejection of the Hollywood model. Today Hollywood itself is losing ground to television, and to an increasingly powerful international media order fighting for control of cable and video. Latin America has produced its own media conglomerates, in particular the extremely powerful Televisa in Mexico and TV Globo in Brazil. Some lucid voices realize that accommodation will have to be made with this new order. García Márquez, for example, is currently engaged in making a progressive telenovela. Up to now there has been little contact between film and television – there is no tradition of commissioning feature films for television. The most recent initiatives in this area, such as the García Márquez package of feature films, have been supported by Spanish television. Latin American film-makers also seek to establish links with commissioning European television companies such as Channel 4 in Britain or German TV. Elsaesser has argued that 'television everywhere has co-opted the cinema and its history in order to create a more special viewing experience for its own captive audience. A cinema film still has the power to generate special expectations and a sense of occasion, even when it passes on to the small screen.'[10] His point is less persuasive in the Latin American context. In Brazil in 1981, for example, 1,792 films were shown on television; of these, 88 were Brazilian (4.91 per cent of the total); of the 88, very

few were the quality products of cinema novo: they were in the main *pornochanchadas*.

The audience for television is very large. One television channel, TV Globo, has a daily audience of some sixty million people: three days' TV audience is greater than the annual cinema audience.[11] The situation is aggravated by the growth of satellite television. Getino's figures, published in 1987, showed that Latin America was receiving some ten thousand films a month via satellite, of which less than 10 per cent were Hispano-American (mainly from Mexico and Spain).[12] The increased possibility of privatized consumption of audio-visual material through cable, satellite and video has caused a dramatic decline in cinema audiences. The mutual incomprehension or indifference between the film and television sectors will, therefore, have to give way to a more generous policy of promotion and subsidy if cinema is to survive with any health into the twenty-first century.

Of the new technologies, video has offered the greatest opportunities for the development of audio-visual culture. At the level of the market some mention has been made of the distorting power of the medium, in its encouragement of private, domestic, consumption and its control, in terms of distribution outlets, by international media conglomerates. On the other hand, video has been used to create alternative networks of popular struggle. The director Patricio Guzmán discusses the use of video in Chile under the Pinochet dictatorship:

> The Manuel Rodríguez Front has filmed its own acts of war, like sabotage and attacks against the forces of repression. ... On another level the periodical *Análisis* has begun to produce systematically a video-magazine which contains the major events of the month. Different political and cultural organizations and student groups regularly film the popular mobilizations and demonstrations ... in Chile. In this way, video, because of its low cost and the ease with which it can be edited, has stimulated a documentary impulse whose main aim is to bear witness to reality, strengthening in this way the re-foundation or the continuity of resistance filmmaking within Chile.[13]

Video also allowed for a flexible alternative distribution. The monthly news bulletins of *Análisis* were taken to shanty towns all over the country. Other examples of video being used in popular organizations as an educational or a didactic tool abound throughout the subcontinent. In the 1990s, feature films will obviously continue to be made, but they will be supported by an increasingly vigorous video culture. In a number of countries with few resources, video remains the only practical, low-cost way of capturing and disseminating images in movement.

One further way of attempting to safeguard the survival of cinema has been to try to build larger markets within the continent. Since the time of Simón Bolívar, the dream of the *patria grande* which would transcend national boundaries has beguiled intellectuals. Its most recent cinema incarnation has been in

Fernando Solanas's *South* (1988), where a group of men – an intellectual, a union organizer, a progressive military officer and a popular singer – sit around a 'table of dreams', plotting the possible freedom of the South, in its constant battle against Northern hegemony. It was a dream pursued by the new film-makers of the 1960s, who followed a programme of Pan-American political and cultural independence. As we have seen, however, it remains an agenda on the table of dreams, pursued currently by the Foundation of Latin American Film-makers, the Latin American Film Festival and the film school in Havana. Outside the desire for a Latin American consciousness which could dissolve frontiers there are strong economic arguments to support the case. Getino points out that the Latin American market, in total, is extremely large.

Just in Latin America and the Caribbean, excluding Spain and Portugal, cinema occupies the following space:

Annual production of feature films	220–250
Number of cinemas	10,000
Number of seats	6 million
Number of spectators per year	900–1,000 million

If we add to these figures Spain, Portugal, Spanish- and Portuguese-speaking African countries and the Spanish-speaking population in the United States, the global picture is as follows:

Annual production of feature films	350
Number of cinemas	14,000
Number of spectators per year	1,200–1,400 million[14]

Up to now, this market has been dominated from the outside. As our analysis has revealed, national cultures remain the bedrock for film-making. Yet the quest for more regional cooperation remains essential if the potential of this public is to be realized. The moves towards this elusive goal are taking place, however, at a moment when the ideological and technological bases of the media are making national and regional cultures look increasingly obsolete.

Instead of concluding with the dystopia of a deregulated transnational world of signs and electronic impulses in which the losers, as always, will be those on the periphery of the new technologies, we should point instead to the extraordinary resilience of Latin American cineastes throughout history, who made and continue to make films against the odds. In the present unstable political and cultural environment, there is still a generation of film-makers with an idea in their heads and a camera in their hands. García Márquez summed up this mood of optimism in the speech he made at the inauguration of the Latin American Film Foundation in 1985:

Between 1952 and 1955, four of us who are now on board this boat studied at the Centro Sperimentale in Rome: Julio García Espinosa, Vice Minister of Culture for Cinema, Fernando Birri, the great pope of the New Latin American cinema, Tomás Gutiérrez Alea, one of its most notable craftsmen and I, who wanted nothing more in life than to become the film-maker I never became. ... The fact that this evening we are still talking like madmen about the same thing, after thirty years, and that there are with us so many Latin Americans from all parts and from different generations, also talking about the same thing, I take as one further proof of an indestructible idea.[15]

Notes

1. Raymond Williams, *The Politics of Modernism*, Verso, London 1989, p. 117.
2. Gabriel García Márquez, *El general en su laberinto*, Sudamericana, Buenos Aires 1989, p. 106
3. Ismail Xavier, 'Allegories of Underdevelopment', p. 17, quoted in Randal Johnson, *The Film Industry in Brazil: Culture and the State*, University of Pittsburgh, Pittsburgh 1987, p. 22.
4. Miguel Littín. Interview with John King, The Guardian Lecture, National Film Theatre, London, November 1987.
5. Octavio Getino, *Cine latinoamericano: Economía y nuevas technologías audiovisuales*, Universidad de los Andes, Mérida 1987, p. 144.
6. Williams, pp. 109–10.
7. Jorge Schnitman, *Film Industries in Latin America: Dependency and Development*, Ablex, New Jersey 1984, p. 112.
8. Johnson, p. 196.
9. Thomas Elsaesser, *New German Cinema: A History*, BFI, London 1989, p. 3.
10. Ibid., p. 33.
11. Getino, p. 230.
12. Ibid., p. 233.
13. Patricio Guzmán, 'El video, formato o arma' in Filmoteca Unam, ed., *Video, cultura nacional y subdesarrollo*, UNAM, Mexico 1985, p. 59.
14. Getino, p. 132.
15. Gabriel García Márquez, quoted in *Anuario 88*, Escuela Internacional de cine y TV, Havana 1988, p. 1.

Select Bibliography

This is a guide to the most accessible English-language sources on Latin American cinema used in this study. A more specialist bibliography can be found in the footnotes, and in Burton's bibliography of the New Latin American Cinema, quoted below.

Almendros, Néstor, *A Man with a Camera*, Faber and Faber, London 1985.

Armes, Roy, *Third World Film Making and the West*, University of California Press, Berkeley 1987.

Aufderheide, Patricia, ed., *Latin American Visions: Catalogue*, The Neighborhood Film/Video Project of International House of Philadelphia, Philadelphia 1989.

Bradford Burns, E., *Latin American Cinema: Film and History*, University of California Press, Los Angeles 1975.

Barnard, Tim, *Argentine Cinema*, Nightwood, Canada 1986.

Burton, Julianne, 'Film Artisans and Film Industries in Latin America, 1956–1980: Theoretical and Critical Implications of Variations in Modes of Filmic Production and Consumption', The Wilson Center Latin American Program, Working Papers, no. 102, Washington 1981.

—— , 'Marginal Cinemas and Mainstream Critical Theory, *Screen* 26, nos. 3–4, 1985.

—— , 'Seeing, Being, Being Seen: *Portrait of Teresa* or the Contradictions of Sexual Politics in Contemporary Cuba', *Social Text* 4, 1981, pp. 79–95.

—— , 'The Hour of the Embers: On the Current Situation of Latin American Cinema', *Film Quarterly* 30, 1, 1976, pp. 33–44.

—— , *The New Latin American Cinema: An Annotated Bibliography of Sources in English, Spanish and Portuguese: 1960–1980*, Smyrna Press, New York 1983.

——, ed., *Cinema and Social Change in Latin America: Conversations with Filmmakers*, University of Texas Press, Austin 1986.

Chanan, Michael, *Chilean Cinema*, BFI, London 1976.

——, ed., *Santiago Alvarez*, BFI, Dossier 2, London 1980.

——, ed., *Twenty-five Years of the New Latin American Cinema*, BFI, London 1983.

——, *The Cuban Image*, BFI, London 1985.

Coad, Malcolm, 'Rebirth of Chilean Cinema', *Index on Censorship* 9, 2, 1980, pp. 3–8.

De Usabel, Gaizska S., *The High Noon of American Films in Latin America*, UMI Research Press, Ann Arbor 1982.

Downing, John H., ed., *Film and Politics in the Third World*, Autonomedia, New York 1987.

Fusco, Coco, ed., *Reviewing Histories: Selections from New Latin American Cinema*, Hallwalls Contemporary Arts Center, Buffalo, NY 1987.

Gabriel, Teshome, *Third Cinema in the Third World: The Aesthetics of Liberation*, UMI Research Press, Ann Arbor 1982.

García Márquez, Gabriel, 'Of Love and Levitation', interview with Holly Aylett and Patricia Castaño, *Times Literary Supplement*, 20–26 October 1989, pp. 1152 and 1165.

——, *Clandestine in Chile*, Granta, Cambridge 1989.

Georgakis, Dan and Lenny Rubenstein, *Art, Politics, Cinema: The Cineaste Interviews*, Pluto Press, London 1985.

Gutiérrez Alea, Tomás, *The Viewer's Dialectic*, José Martí Editorial, Havana 1988.

Johnson, Randal, *Cinema Novo × 5*, University of Texas Press, Austin 1984.

——, 'Brazilian Cinema Novo', *Bulletin of Latin American Research* 3, no. 2, 1984, pp. 95–106.

——, *The Film Industry in Brazil: Culture and the State*, University of Pittsburgh Press, Pittsburgh 1987.

——, 'The Nova República and the Crisis in Brazilian Cinema', *Latin American Research Review*, vol. XXIV, no. 1, 1989.

——, and Robert Stam, eds, *Brazilian Cinema*, Associated University Press, New Jersey 1982.

King, John and Nissa Torrents, eds, *The Garden of the Forking Paths: Argentine Cinema*, BFI, London 1987.

King, John, 'Cuban Cinema: A Reel Revolution?', in R. Gillespie, ed., *Cuba after Thirty Years: Rectification and the Revolution*, Frank Cass, London 1990, pp. 140–60.

——, 'Assailing the Heights of Macho Pictures: Women Film-makers in Argentina', in J. Lowe and P. Swanson, eds, *Essays on Hispanic Themes in Honour of Edward C. Riley*, University of Edinburgh 1989, pp. 320–32.

Kolker, Robert, *The Altering Eye: Contemporary International Cinema*, Oxford University Press, New York 1983.

López, Ana, 'The Melodrama in Latin America Films: Telenovelas, and the Currency of a Popular Form', *Wide Angle* 7, 3, 1985, pp. 4–13.

——, 'A Short History of Latin American Film Histories', *Journal of Film and Video* 37, 1985, pp. 55–69.

——, 'Towards a "Third" and "Imperfect" Cinema: A Theoretical and Historical Study of Film-making in Latin America', Ph.D. dissertation, University of Iowa, 1986.

McBean, James Roy, *Film and Revolution*, Indiana University Press, Bloomington 1975.

Mattelart, Armand, *Multinational Corporations and the Control of Culture: The Ideological Apparatuses of Imperialism*, Harvester Press, Brighton1982.

——, ed., *Communicating in Popular Nicaragua*, International General, New York 1986.

Minstron, Deborah, 'The Institutional Revolution: Images of the Mexican Revolution in the Cinema', Ph.D. dissertation, Indiana University, 1982.

Mora, Carl J., *Mexican Cinema: Reflection of a Society, 1896–1980*, University of California Press, Berkeley 1982.

Myerson, Michael, ed., *Memories of Underdevelopment: The Revolutionary Films of Cuba*, Grossman, New York 1973.

Nevares, Beatriz Reyes, *The Mexican Cinema: Interviews with Thirteen Directors*, University of New Mexico Press, Albuquerque 1976.

Paranagua, Paulo Antonio, 'Women Film-makers in Latin America', *Framework* 37, 1989, pp. 129–38.

Pettit, Arthur G., *Images of the Mexican American in Fiction and Film*, Texas A & M University Press, College Station 1980.

Pick, Zuzana, 'Towards a Renewal of Cuban Revolutionary Cinema: A Discussion of Cuban Cinema Today', *Cine-tracts* 7–8, 1979, pp. 21–31.

——, 'Chile: The Cinema of Resistance 1973–79', *Cine-tracts* 9, 1980, pp. 18–28.

——, 'The Cinema of Latin America: A Constantly Changing Problematic', *Cine-tracts* 9, 1980, pp. 50–55.

——, 'Chilean Cinema in Exile (1973–1986)', *Framework* 34, 1987, pp. 39–57.

——, ed., *Latin American Filmmakers and the Third Cinema*, Carleton University, Ottowa 1978.

Pines, Jim and Paul Willemen, eds, *Questions of Third Cinema*, BFI, London 1989.

Ramírez, John, 'Introduction to the Sandinista Documentary Cinema', *Areito* 37, 1984, pp. 18–21.

Ranvaud, Don, 'Interview with Fernando Solanas', *Framework* 10, 1979, pp. 34–8.

256 MAGICAL REELS

—— , 'Interview with Raúl Ruiz', *Framework* 10, 1979, pp. 16–18.
Rocha, Glauber, 'History of Cinema Novo Part 1', *Framework* 11, 1980, pp. 8–10.
—— , 'History of Cinema Novo Part 2', *Framework* 12, 1980, pp. 18–27.
—— , 'Humberto Mauro and the Historical Position of the Brazilian Cinema', *Framework* 11, 1980, pp. 5–8.
Schnitman, Jorge, *Film Industries in Latin America: Dependency and Development*, Ablex, New Jersey 1984.
Stam, Robert, 'Censorship in Brazil', *Jump Cut* 21, 1979, p. 20.
—— , 'The Fall', *Jump Cut* 22, 1980, pp. 20–21.
—— , 'Slow Fade to Afro: The Black Presence in Brazilian Cinema', *Quarterley Review of Film Studies* 36, 2, 1982–3, pp. 16–32.
—— , 'Hour of the Furnaces and the Two Avant Gardes', *Millennium Film Journal* 7–9, 1980, pp. 151–64.
Xavier, Ismail, 'Allegories of Underdevelopment: From the "Aesthetics of Hunger" to the "Aesthetics of Garbage"', Ph.D. dissertation, New York University, 1982.

A number of film journals – *Afterimage, Jump Cut, Cine-tracts, Framework, Cineaste, Screen* – either publish regular articles on Latin American cinema or have published special issues on this topic; see Burton and the footnotes to this book for references. The trade journal *Variety* has also produced an annual 'Latin American and Hispanic Market Survey' over the past fifteen years. The most recent survey consulted in this work was 22–28 March 1989.

Index

Latin America Bureau

LAB

The Latin America Bureau is an independent, non-profit-making research organisation established in 1977. We carry out research, publish books and establish support links with Latin American groups. We also brief the media, organise seminars and produce materials for teachers.

Recent *LAB* books include:

Colombia: Inside the Labyrinth
JENNY PEARCE

Officially, Colombia is a Latin American success story with steady growth and political stability. Yet it has become notorious through the activities of the Medellin and Cali cartels and the violence surrounding the cocaine trade. *Inside the Labyrinth* unravels the threads of this paradoxical country.

'Jenny Pearce has mustered a formidable amount of information ... readers will be rewarded with illuminating accounts of The Violence and the rise of the cocaine barons.'
The Independent

312 pages, ISBN 0 906156 44 0

Fight for the Forest: Chico Mendes in His Own Words

Chico Mendes, charismatic founder of the Brazilian rubber tappers' union, was assassinated on 22 December 1988. In *Fight for the Forest* he talks of his life's work in what was to be his last major interview.

' ... an inspirational and chilling message.'
David Bellamy, *Observer*

96 pages, ISBN 0 906156 51 3

Grenada: Revolution in Reverse
JAMES FERGUSON

Reveals the extent of the US failure - both economic and political - to turn post-invasion Grenada into a model of free-market prosperity.

' ... offers a wealth of hard information and incisive observation ... essential for understanding a new phase in US foreign policy and the current predicament of the region.'
Rickey Singh, *Caribbean Contact*

160 pages, ISBN 0 906156 48 3

For a complete list of books, write to Latin America Bureau, 1 Amwell Street, London EC1R 1UL. *LAB* books are distributed in North America by Monthly Review Press, 122 West 27th Street, New York, NY 10001.

LAB is a UK subscription agent for NACLA *Report on the Americas*, the largest English language magazine on Latin America and the Caribbean. Write for details.